ITALIAN ALTARPIECES 1250–1550

ITALIAN ALTARPIECES
1250–1550

Function and Design

EDITED BY
EVE BORSOOK
AND
FIORELLA SUPERBI GIOFFREDI

CLARENDON PRESS · OXFORD
1994

Oxford University Press, Walton Street, Oxford OX2 6DP

Oxford New York Toronto
Delhi Bombay Calcutta Madras Karachi
Kuala Lumpur Singapore Hong Kong Tokyo
Nairobi Dar es Salaam Cape Town
Melbourne Auckland Madrid
and associated companies in
Berlin Ibadan

Oxford is a trade mark of Oxford University Press

Published in the United States
by Oxford University Press Inc., New York

British Library Cataloguing in Publication Data
Data available

Library of Congress Cataloging in Publication Data
Italian altarpieces 1250–1550: function and design
edited by Eve Borsook and Fiorella Superbi Gioffredi.
Includes bibliographical references.
1. Altarpieces, Italian. 2. Painting, Gothic—Italy.
3. Painting, Renaissance—Italy. 4. Catholic Church and art.
5. Art patronage—Italy. I. Borsook, Eve. II. Superbi Gioffredi, Fiorella.
ND1432.I8I82 1993
755'.2'09450902—dc20 93-23979
ISBN 0-19-817223-0

Typeset by The Alden Press, Oxford
Printed in Great Britain
on acid-free paper by
The Alden Press, Oxford

Preface

THIS volume is the result of an international symposium held in June 1988 at the Harvard University Center for Italian Renaissance Studies at Villa I Tatti in Florence. Since the 1960s, the Italian altarpiece has attracted unprecedented scholarly attention, bringing liturgical, social, and technical considerations to bear on the subject as has never been done before. The work of Julian and Christa Gardner comes to mind as well as that of Hans Belting, Monika Cämmerer-George, Hellmut Hager, Henk van Os, Miklós Boskovits, Joanna Cannon, Dillian Gordon, Gaudenz Freuler, and Hubertus von Sonnenburg—to name but a few. An opportunity for a first summing up of the results of recent research in the field occurred in London in 1987, where the altarpiece was considered in its various European manifestations.[1] The next year the symposium at Villa I Tatti narrowed the focus to Italy. This coincided with the first English translation of Jacob Burckhardt's classic study of the Italian altarpiece—a task undertaken by Peter Humfrey, one of our participants. Then came the memorable exhibition at the National Gallery in London entitled 'Art in the Making: Italian Painting before 1400'.

The essays in this volume do not constitute an exhaustive treatment of the subject; rather, they consider such diverse aspects of the Italian altarpiece as early ecclesiastical legislation, patronage, audience, structure, and artistic invention. The new data and fresh points of view here presented should stimulate further investigations to enhance our understanding of the functions of altarpieces and our appreciation of the beauty of their various artistic formulations.

The symposium and the preparation of the texts for the press were made possible by generous grants from the Eugene V. and Clare E. Thaw Charitable Trust, the Myron and Sheila Gilmore Publication Fund at I Tatti, and the Andrew W. Mellon Scholarly Publications Fund.

We are deeply grateful to someone who prefers to remain nameless without whose interest and

[1] See Peter Humfrey and Martin Kemp (eds.), *The Altarpiece in the Renaissance* (Cambridge, 1990).

initiative these studies would not have appeared under the auspices of the Oxford University Press. We also wish to thank the following for helping us to obtain rare photographic material: Fabio Bisogni, Miklós Boskovits, Marco Chiarini, Keith Christiansen, Cristina De Benedictis, Colin Eisler, David Scrase, and Giusi Testa.

Unfortunately, several paintings in Florence are represented by old, mediocre photographs because we were unable to obtain better examples from the Gabinetto Fotografico of the Soprintendenza.

<div style="text-align: right">

E.B.
F.S.G.

</div>

Florence, 1992

Contents

List of Contributors

HENK W. VAN OS, Director, Rijksmuseum, Amsterdam.

JULIAN GARDNER, Professor, University of Warwick.

JOANNA CANNON, Courtauld Institute, University of London.

GAUDENZ FREULER, Privatdozent, University of Zürich.

MAX SEIDEL, Director, Kunsthistorisches Institut, Florence.

PETER HUMFREY, Reader, St Andrews University.

ALESSANDRO NOVA, Professor, Stanford University.

PATRICIA RUBIN, Lecturer, Courtauld Institute, University of London.

MICHELANGELO MURARO (deceased), Professor, University of Padua.

INTRODUCTION

Henk W. van Os

THE eight contributions to this book were first presented as lectures at a symposium on altarpieces held at I Tatti in the spring of 1988. Taken together, they form an impressive synopsis of the different approaches that have been developed in recent years to enlarge and deepen our knowledge of paintings in terms of their historical function. One can only be grateful to the organizers of that symposium and editors of this volume, Eve Borsook and Fiorella Superbi Gioffredi, for their thoughtful choice of contributors. Patronage, morphology, religious meaning, visual appearance, reception, and spatial setting—all these aspects of current research on altarpieces are discussed in the following pages. In quite a number of cases, new light is shed on paintings that, until a few years ago, were dealt with only as elements within a history of pictorial style. In reflecting on this wealth of new information, I should like to make two observations by way of introduction.

In nearly all these contributions there is an overwhelming concern with reconstruction. Perhaps more than ever before, we wish to know '*wie es eigentlich gewesen*'; and it is striking how much more we do in fact know about the historical setting, in the broadest sense, of individual paintings. Twenty years ago we had no idea that so much diverse information could be gathered about works of art. In the early 1960s the late Ulrich Middeldorf, at that time Director of the Kunsthistorisches Institut in Florence, boasted to me and several other young people just beginning their study of Italian art about how proud he was that he had managed to assemble a nearly complete collection of Sienese guidebooks. After he had left us to go and look over the shoulder of yet another young scholar and ask his habitual question, '*Worüber arbeiten Sie?*', we stared at each other in some puzzlement. Why, for heaven's sake, should one be proud of a collection of old guidebooks? By now, of course, these have reached the status of canonical books for research on Sienese painting.

In the present publication a good deal of new material is presented which increases our understanding of the historical significance of a specific category of painting. By now one may even feel that this zeal for reconstructing the past by enlarging our quantity of knowledge can cause us to lose our sense of perspective. If one steps back a bit, one may ask: 'What sort of art history is produced by these detailed studies?' Certainly, they do not lead to a traditional history of

style. Yet what alternative synthesis would be most suitable to encompass these innovative studies? When this very question was raised during the discussion at the symposium, some colleagues gave an answer characteristic of historicist hardliners: 'It's not time yet for any synthesis. There still remains too much groundwork to be done.' But alas, this can always be said, under any circumstance. What is more, it may simply be another way of saying: 'I want to go on doing my detailed groundwork without bothering about the historical framework.'

I, however, remain firmly convinced that groundwork should be guided by, or at least accompanied by, continuous concern for its implications for art history generally. I make this observation by way of introduction, since I find in the studies collected here a number of fascinating starting-points for such conceptualizing. One can only hope that these new ideas will be further discussed in the future.

My second point pertains to interdisciplinary research. Nowadays, 'interdisciplinary research' has become, in the rhetoric of research grants, a sort of Open Sesame for unlocking treasuries. Since most politicians have only the vague notion that interdisciplinarity has something to do with scholars in one field co-operating with those in another, it is not surprising that a distressing amount of pretence and calculation has been developed in an attempt to demonstrate the superiority of interdisciplinary collaboration. As a result, however, interdisciplinarity often signifies little more than a lack of discipline. But the studies presented in this book are truly interdisciplinary, in the most positive sense of that term. Their authors have looked beyond the traditional frontiers of their fields and have, as it were, asked questions of every school of historian. They have returned from this quest not only with new answers to old questions but also with new questions that cause us to look at well-known paintings in unexpected ways. They have managed to bring together within a strict art-historical approach everything they have discovered beyond traditional boundaries. In a very real sense, historical rigour has been increased as the result of opening windows on to other disciplines. The hidden cause of this is that it came out of individual scholars' desires to enlarge their scope, rather than out of some vague, modish concept of collaboration or some impulse for pretentious generalization.

Finally, when confronted with the immense popularity of the study of altarpieces, one cannot avoid asking oneself why this should be so. Vast numbers of people are leaving the Church today, and yet at the same time an élite group of scholars is focusing more than ever before on the religious function of its most prominent religious props. One can only speculate about the reasons for this. I should like to propose just one. Around 1900 there was a conscious attempt in many countries to reintegrate art within a functional context. In Holland the works of those genial architects Cuypers and Berlage and of artists such as Jan Toorop and Van Konijnenburg bear witness to this striving for a new synthesis. The Beurs and the Rijksmuseum are the realizations—albeit each in different character—of these medievalist dreams of a *Gesamtkunstwerk*. From their theories, it becomes clear that the need for reintegration was based upon a refusal to accept 'the autonomy of the visual arts'—*l'art pour l'art*. Pitying the romantic loneliness of the artist, they indulged themselves in the romantic dream of the medieval craftsman. In our time, the old *l'art*

pour l'art concepts of modern art and of the avant-garde no longer work. Consequently, we have lost faith in the basic principles of development in art defined in terms of artistic progress. Yet at that very same moment, we study medieval paintings as products of craftsmanship, reconstructing their historical context of meaning, ritual, and space. In my opinion, it requires no excessive imagination to relate the scholars of altarpieces, who reconstruct the function of works of art, to those artists of the previous *fin de siècle*, who only wanted to create functional art within a given space.

1

ALTARS, ALTARPIECES, AND ART HISTORY: LEGISLATION AND USAGE

Julian Gardner

THE altarpiece has, once again, become a fashionable topic of study. Such discussion is, however, not new, and there have been notable treatments devoted to it, including those by Burckhardt, Braun, and Hager.[1] At least the central volume of this trilogy, by the German Jesuit Josef Braun, has been regarded as a book of timeless authority, while the first and oldest, Burckhardt's *Das Altarbild* (1898), has been reissued, significantly enough in English translation, with a commentary.[2] Before I come to these modern works, however, I wish to spend a few moments discussing some rather more neglected medieval evidence, which must remain the basis of further

Abbreviations of commonly cited books

Andrieu XII: Andrieu, Michel, *Le Pontifical romain au moyen-âge*, i, *Le Pontifical romain du XII^e siècle*, Studi e testi, 86 (Vatican City, 1938)

Andrieu XIII: (same series), ii, *Le Pontifical de la Curie romaine au XIII^e siècle*, Studi e testi, 87 (Vatican City, 1940)

Andrieu, Durand: (same series) iii, *Le Pontifical de Guillaume Durand*, Studi e testi, 88 (Vatican City, 1940)

Bishop: E. Bishop, *Liturgica Historica* (Oxford, 1918)

Braun: J. Braun, *Der Christliche Altar in seiner geschichtlichen Entwicklung*, 2 vols. (Munich, 1914, 1924)

DDC: R. Naz (ed.), *Dictionnaire de Droit Canonique* (Paris, 1924–65)

Hager: H. Hager, *Die Anfänge des Italienischen Altarbildes*, Römische Forschungen der Bibliotheca Hertziana, 17 (Munich, 1962)

PL: Patrologia Latina

[1] J. Burckhardt, 'Das Altarbild', in *Beiträge zur Kunstgeschichte in Italien* (Basle, 1898), 7 ff. This is not discussed in the monumental biography of Burckhardt by W. Kaegi, *Jacob Burckhardt eine Biographie*, 7 vols. (Basle and Stuttgart, 1947–

82). The literature on altarpieces is considerable, but the topic has not to my knowledge been comprehensively or critically treated, other than in Braun. Important discussions covering the period in question include E. von Sydow, *Die Entwicklung des figuralen Schmucks der christlichen Altar-Antependia und Retabula bis zum 14. Jahrhundert*, Zur Kunstgeschichte des Auslands, 97 (Strasburg, 1912). H. Bunjes, 'Die Steinernen Altaraufsätze der hohen Gotik und der Stand der gotischen Plastik in der Ile de France um 1300', Ph.D. thesis (University of Marburg, 1937). There is an important review article of Braun by the English liturgical scholar, W. H. Frere, 'The Christian Altar', *Church Quarterly Review*, 103 (1926), 2–19, repr. in *Walter Howard Frere: A Collection of his Papers on Liturgical and Historical Subjects*, Alcuin Club Collections, xxxv (Oxford, 1940), 142 ff. Braun developed his views partially in two articles, 'Altar' and 'Altarretable', in O. Schmitt (ed.), *Reallexikon zur Deutschen Kunstgeschichte*, i (Stuttgart, 1937), 412–19, 529–64. Significantly enough, there was no substantial review of the remarkable book by Hager, *Die Anfänge*.

[2] *The Altarpiece in Renaissance Italy*, ed. and trans. P. Humfrey (Oxford, 1988).

consideration. Some of what I shall say may at times sound either elementary or harshly dismissive, but none the less I believe that it needs restating. Altarpieces are not obligatory for the celebration of mass,[3] but in the thirteenth century, which is the period with which I shall be primarily concerned, altars, the mass, and its celebration procedures were all regulated by canon law, in the first instance, and local custom or convention secondarily. Yet, most recent historians of the altarpiece have neglected this legislative background almost completely.[4] The writings of liturgists such as Johannes Beleth (*fl.* mid-twelfth century), Sicard of Cremona (1155–1215), and above all Guillaume Durand (*c.*1230–1296), the eminent papal administrator and latterly bishop of Mende, have received at times passing mention, but often in ways which are symptomatic of the neglect to which I have alluded.[5] Indeed from the point of view of this study, the first two are positively dangerous, while Durand is almost wholly known from his *Rationale Divinorum Officiorum* rather than from his extremely important synodalia for the diocese of Mende, the *Constitutiones et Instructiones*.[6] These latter, from the period under discussion, most nearly approach in explicitness the later similarly named *Instructiones* of Carlo Borromeo. A *Rationale* is a book of liturgical rules, and that of Durand is saturated with the symbolism derived from the school of Saint-Victoire.[7] What I wish to draw attention to initially is ecclesiastical legislation.

The Fourth Council of the Lateran (1215) marks in many ways an essential turning-point for the centralization of observance.[8] The cleanliness and upkeep of the altar and the conservation of the eucharistic species were among the objects of its attention. That they were the concern of a

[3] Bishop, 31. There are a number of important articles in *DDC* which will be cited in the appropriate places below. A difficulty with much canonistic discussion is to establish the dates at which new legislation is introduced and also to monitor compliance. Cf. n. 21 below.

[4] e.g. Bunjes, 'Die Steinernen Altaraufsätze'; M. Ingen-daay, 'Sienesische Altarbilder des sechzehnten Jahrhunderts', Ph.D. thesis (Bonn University, 1976); H. van Os, *Sienese Altarpieces*, i (Groningen, 1984); or B. Lane, *The Altar and the Altarpiece: Sacramental Themes in Early Netherlandish Painting* (New York, 1984).

[5] Little is known of the career of Beleth, a pupil of Gilbert de la Porrée, but there is now a splendid new edition by H. Douteil, *Iohannis Beleth Svmma De Ecclesiasticis Officiis*, Corpus Christianorum Continuatio mediaevalis, 41 (Turnhout, 1976). Beleth, was extremely influential, not least for Sicard, Innocent III, Durand, and Jacopo da Voragine. For Sicard, see E. Brocchieri, 'Sicardo di Cremona e la sua opera letteraria', *Annali della Biblioteca Governativa e Libreria Civica di Cremona*, 11, fasc. 1 (Cremona, 1958). Sicard's *Mitrale* is published in J. P. Migne (ed.), *PL* 213, cols. 13–434. The symbolic aspects of Sicard's *Mitrale* and Durand's *Rationale* are discussed in J. Sauer, *Symbolik des Kirchengebäudes und seiner Ausstattung in der Auffassung des Mittelalters* (Freiburg im Bresgau, 1924), 22 ff., 28 ff.; cf. also ibid. 155 ff. and 166 ff. For Durand there is an elaborate article by L. Falletti in *DDC* v, cols. 1014–75. This

should be modified in the light of M. Dykmans, 'Notes autobiographiques de Guillaume Durande le Spéculateur', *Ius Populi Dei: Miscellanea in honorem Raymundi Bidagor*, i (Rome, 1972), 119–42. See also subsequent note. For Durand in Italy, cf. D. Waley, *The Papal State in the Thirteenth Century* (London, 1961). There are many editions of Durand's *Rationale Divinorum Officiorum*, but a (badly needed) new critical edition is announced by Douteil, *Iohannis Beleth*, 34 n. 10. See also n. 7 below.

[6] J. Berthélé and M. Valmary (eds.), 'Les Instructions et Constitutions de Guillaume Durand, le Spéculateur, d'aprés le manuscrit de Cessenon', *Académie des Sciences et Lettres de Montpellier: Mémoires de la section des lettres*, 2ᵉ Série, iii (1900-7), 1–148; Andrieu, Durand. See also P.-M. Gy, 'L'Ordinaire de Mende, une œuvre inédite de Guillaume Durand l'Ancien', *Liturgie et musique (IXᵉ–XIVᵉ s.)*, Cahiers de Fanjeaux, 17 (Toulouse, 1982), 239–49. R. Cabie, 'Le Pontifical de Guillaume Durand l'ancien et les livres liturgiques languedo-ciens', ibid. 225–37.

[7] Falletti, *DDC* v, col. 1057.

[8] See almost recently R. Foreville, *Latran I, II, III et Latran IV*, Histoire des Conciles Œcuméniques, vi (Paris, 1965), 243 ff. A. Garcia y Garcia, *Constitutiones concilii quarti Lateranensis una cum commentariis glossatorum*, Monumenta Iuris Canonici, Series A. Corpus Glossatorum, 2 (Vatican City, 1981), 3 ff., 8.

pope who had himself written on the symbolism of the mass is hardly astonishing. In his influential *De missarum misteriis*, which was composed by Lotario Conti before his elevation to the papacy as Innocent III, the need for the altar to possess a cross, and two candles for the better reading of the text of the office, was clearly stated.[9] This, as the author noted, was in no sense proleptic, but current Roman practice.[10] Canon 19 of the Council regulated the ornaments of the altar, canon 20 the safe-keeping of the Host.[11] As one reads synodal legislation from all over Europe in the decades following the Lateran Council of 1215 one is aware how sedulously many ordinaries promulgated the new legislation on these matters as well as manifold other points, although, if England is an instance, their efforts met with some resistance. Exemplary are the statutes of the bishop of Winchester, Peter des Roches of 1224, 'Nunquam celebret sacerdos nisi cruce ante se positu', and the bishop of Wells, William Bitton, required two candles on the altar.[12] The annual synod of the diocese itself became a requirement. The diffusion of the decrees of the Fourth Lateran Council can be traced in such magnificent compilations as Powicke and Cheney for England, as well as more sporadically in Italy, France, and Germany, in the less reliable pages of Hartzheim and Mansi.[13] New editions of synodalia appear slowly. But the important consideration to grasp is the role of such synodal legislation as it informed and monitored local practice. It is here that the synodalia of Guillaume Durand concern us. Newly composed for his

[9] *De Sacro Altaris Mysterio, PL* 217, cols. 773–916. '*Ad significandum itaque gaudium duorum populorum, de nativitate Christi laetantium, in cornibus altaris duo sunt constituta candelabra, quae mediante cruce, faculas ferant accensas.* For a recent discussion of this text, under its correct title, *De Missarum Mysteriis*, cf. M. Maccarone, 'Innocenzo III teologo dell'Eucaristia', *Divinitas*, 10 (1966), 362–412, conveniently repr. in id., *Studi su Innocenzo III*, Italia Sacra, 17 (Padua, 1971), 339–431, 345 ff. See also D. R. Dendy, *The Use of Lights in Christian Worship*, Alcuin Club Collections, 41 (London, 1959), 48. Cf. Innocent's sermon *In consecratione altaris, PL* 217, col. 439, '*Templum quod dedicatum est, intelligitur corpus; altare quod consecratum est, intelligitur cor.*'

[10] Innocent III, *De Sacro Altaris Mysterio*, col. 774. '*Consuetudinem autem apostolicae sedis, non illam quam olim legitur habuisse, sed eam quam nunc habere dinoscitur prosequendam proposui . . .*'

[11] Canon 19, *Ne ecclesie mundanis suppellectilibus exponantur*, '*Praecipimus quoque ut oratoria, vasa corporalia et vestimenta praedicta munda et nitida conserventur . . .*' Canon 20, *De chrismate et eucharistia sub sera conservanda*. Full texts conveniently in J. Alberigo *et al.*, *Conciliorum Oecumenicorum Decreta*, 3rd edn. (Bologna, 1973), 224.

[12] F. M. Powicke and C. R. Cheney (eds.), *Councils and Synods with Other Documents Relating to the English Church*, i (Oxford, 1964), 126. Canon 6 of the Lateran made a provincial synod a requirement. In England the provincial council of Oxford specifically refers to the observation of the canons of

the Fourth Lateran Council, see ibid. 124. There is a great deal of information which can be gleaned also from the records of episcopal visitations, I am well aware, although Italy is less well served in this respect also than some other European countries. One must guard, however, against the somewhat negative view which derives from visitation evidence alone, recording as it does non-compliance with regulations. See N. Meoni, 'Visite pastorali a Cortona nel Trecento', *Archivio storico italiano*, 129 (1971), 226 ff. That it can also be disarmingly summary is shown by the description of the altars of the Frari in the visitation of 1581. See R. Ritzler, 'Gli Atti della visita apostolica del 1581 ai conventi di S. Maria Gloriosa e di S. Nicoletto dei Frati Minori Conventuali in Venezia', *Miscellanea Francescana*, 69 (1969), 168.

[13] In general, O. Pontal, *Les Statuts synodaux*, Typologie des sources du moyen age occidental, fasc. 11 (Turnhout, 1975), 92 ff., with a good bibliography for other European countries. J. Gaudemet, *Le Gouvernement de l'église à l'époque classique*, Histoire du droit et des Institutions de l'église en occident, 8/2 (Paris, 1979), 173 ff. Powicke and Cheney, *Councils and Synods*. O. Pontal, *Les Statuts synodaux français du XIIIᵉ siècle*, i (Paris, 1971) with a valuable introduction; ii (Paris, 1983). J. C. Schannat and J. Hartzheim, *Concilia Germaniae . . .*, iii–iv (Cologne, 1759–60); J. Mansi, *Sacrorum conciliorum nova et amplissima collectio*, xxii–xxv (Florence, 1759–98; repr. Graz, 1961). For Italy there is a meagre harvest: Pontal, *Les Status synodaux*, 93, 97, and see following note.

see at Mende, they were swiftly known and disseminated in Italy, most prominently in the synodalia of Papiniano della Rovere, sometime papal chancellor and later bishop of Novara, and they can be traced soon after in legislation in both Bologna and Florence.[14] This confirms the immense authority and influence of Durand's writings, but also the internationality and enduring qualities of canon law. Here, as perhaps also in the study of medieval art, we should be directing our attention to similarities and trying to explain them, rather than, as too often, emphasizing the differences. Quite apart from the pronouncements of Church Councils, such as the first and second Councils of Lyons which succeeded the Lateran, 1240-5 and 1274, not to speak of the Council of Vienne (1311-12), matters were constantly being modified on a broader or narrower scale by the ceaseless flow of papal legislation incorporated in bulls, decretals, and briefs.[15]

Durand also provides the starting-point for another series of observations. Particularly in the English-speaking art-historical community, as the knowledge of ancient languages becomes rarer, Durand is largely known through the translation of the first book of his *Rationale*.[16] What is almost universally overlooked is that this highly tendentious translation is the work of two fervent adherents of the Ecclesiological Movement, intent on the revival of a truly Christian church architecture.[17] Yet the *Rationale* must be seen as a whole, and not in a partial translation. The Ecclesiologists were a part of a wider movement within the Anglican Church, which indirectly was to influence other reformist movements in the nineteenth century, notably the Liturgical Movement inspired by Prosper Guéranger, OSB.[18] The relevance of all this to our present theme

[14] For the date of Durand's synodalia for Mende, see Andrieu, *Durand*, 10. For Novara see G. Briacca, *Gli statuti sinodali novaresi di Papiniano della Rovere (a. 1298)*, Pubblicazioni dell'Università Cattolica del S. Cuore, Saggi e ricerche, ser. 3, Scienze storiche, 5 (Milan, 1971), 19. For Bologna: L. Novelli, 'Costituzioni della Chiesa bolognese emanate nel sinodo diocesano del 1310 al tempo di vescovo Uberto', *Studia Gratiana*, 8 (1972), 449-552. For Florence: R. Trexler, *Synodal Law in Florence and Fiesole, 1306-1518*, Studi e testi, 268 (Vatican City, 1971). Papiniano almost certainly came into contact with Durand in Rome: see G. Briacca, 'Papiniano della Rovere: Contributo ad una biografia', *Raccolta di studi in memoria di Giovanni Soranzo* (Milan, 1968), 60-108.

[15] J. Lecler, *Vienne*, Histoire des Conciles Œcuméniques, 8 (Paris, 1964). Gaudemet, *Gouvernement de l'église*, 211.

[16] J. M. Neale and B. M. Webb, *The Symbolism of Churches and Church Ornaments* (Leeds, 1843). An English translation of bk. 3 of the *Rationale* was made by T. H. Passmore, *The Sacred Vestments* (London, 1899). Passmore noted (p. vii) that 'the greatest and most beautiful of ancient works on worship on the Catholic Church is inaccessible to any but readers of the Latin tongue'. For a recent comment on the same topic, cf. R. Haussherr, 'Marginalien zur Situation der kunstgeschichtlichen Mittelalterforschung', *Kunstchronik*, 40 (1987), 357-62, 359.

[17] For J. M. Neale (1818-68), see G. Rowell, *The Vision*

Glorious (Oxford, 1983), 98 ff. The book by A. G. Lough, *The Influence of John Mason Neale* (London, 1962) is a mere apologia. For Benjamin Webb (1819-85), see C. C. J. Webb, 'Benjamin Webb', *Church Quarterly Review*, 75 (1913), 329-48. In their introductory essay Neale and Webb (1843, p. vii) identify 'sacramentality' as the guiding principle of ecclesiastical design: 'By this word we mean to convey the idea, that by the outward and visible form, is signified something inward and spiritual.' On the ecclesiastical background, cf. W. O. Chadwick, *The Victorian Church*, i (London, 1966), 212 ff.; J. F. White, *The Cambridge Movement: The Ecclesiologists and the Gothic Revival* (Cambridge, 1962), esp. 68 ff.; B. F. L. Clarke, *Church Builders of the Nineteenth Century: A Study of the Gothic Revival in England* (London, 1938).

[18] On Guéranger (1805-75), there is a copious literature. Cf. recently J. Hourlier, s.v., *Dictionnaire de la spiritualité*, vi (Paris, 1967), cols. 1097-106. W. Franklin, 'The Nineteenth Century Liturgical Movement', *Worship*, 53 (1979), 12-39. Most recently the subject has been comprehensively discussed by Franklin. Cf. Hourlier, *Dictionnaire*, col. 1102: '*L'œuvre liturgique de Guéranger poursuit deux objects. Le premier est l'authenticité par la restauration des rites de la liturgie romano-franque. Guéranger compare cette entreprise à la restauration des monuments de l'architecture.*' T. Klauser, 'Henri Leclercq 1869-1945', *Jahrbuch für Antike und Christentum*, Ergänzungsband, 5 (Münster, 1977), 21 ff. Edmund Bishop commented, 'For the

is the wide diffusion of an often-romanticized medievalism in the nineteenth century and its effect on many of the books to which we customarily refer. Thus the works of Louis Duchesne, Pierre Batiffol, Fernand Cabrol, Henri Leclercq, Michel Andrieu, Josef Jungmann, and others must in part be seen against this wider background.[19] Despite the relatively slight impact which the Liturgical Movement had on Italy, its influence on the standard discussions is immense and barely studied. As art historians, we far too often accept what we read in the writings of these modern liturgists and religious without the necessary corrective adjustment, which comes from a knowledge of the writer's special viewpoint. The grinding of axes has gone unheard. Thus the conclusions of Cabrol and Leclercq's *Dictionnaire*, or the opinions of Monseigneur Duchesne, are taken as uncritically as is the massive and magnificent book of Braun on the Christian altar.[20] Besides this we must always bear in mind the importance of local custom, episcopal instruction, legislation of the individual religious orders, lay pressure, and non-compliance, of which we shall doubtless hear much later, and only then can the wishes of individual patrons, let alone the artisan, be viewed as conditioning the form of the altarpiece.

Two candles and a cross were a requirement by the early thirteenth century: what were they to be placed on? Here some generalizations can be made. The altar was where the sacrifice of the mass was offered. It had to be properly consecrated, and for the placement of an altarpiece the altar had to be fixed.[21] Portable altars are entirely distinct. The portable altar, developed initially as an aid to missionary activity, and always subject to specific legislation on usage, normally required

ancient period Guéranger is a mere rechauffé of ideas which later research and method have superseded; whilst for the later period he is so passionate a partisan, and his work partakes, in spite of its size, so much of the character of a party pamphlet to serve a practical end, that he is to be used only with an amount of caution and discrimination that implies almost as much knowledge of the subject as that possessed by the author himself.' Quoted in N. Abercrombie, *The Life and Work of Edmund Bishop* (London, 1959), 273.

[19] Louis Duchesne (1843–1922), cf. P. d'Espezel, 'Louis Duchesne', *Dictionnaire d'Histoire et de Géographie Ecclésiastiques*, xiv (1960), cols. 965–84. Pierre Batiffol (1861–1929), cf. J. Rivière in id. s.v., vi, cols. 1327–30; on the proposal to translate Batiffol's influential *Histoire du bréviaire romain* (Paris, 1895), E. Bishop remarked to W. H. L. Weale, 'It is (a) charming book, and by making a dull subject interesting doubtless does good. Otherwise—hum.' Cf. Abercrombie, *Life and Work of Bishop*, 205. For the Abbé F. Cabrol OSB (1850–1937), see Klauser, 'Henri Leclercq', 28 ff. Leclercq (1869–1945), for whom Klauser, ibid., *passim*. Michel Andrieu (1886–1956), for whom see B. Capelle, 'L'Œuvre liturgique de Mgr. Andrieu et la théologie', *Nouvelle revue théologique*, 79 (1957), 169–77; C. Vogel, 'L'Œuvre liturgique de Mgr. M. Andrieu', *Revue des sciences réligieuses*, 37 (1957), 7–19. For the dispute about the role of the Franciscans in the development of the liturgy in the 13th c., see S. J. P. van Dijk and J. Hazelden Walker, *The Origin of the Modern Roman Liturgy* (London, 1960), 156–7.

[20] Klauser, 'Henri Leclercq', 7, notes that Leclercq never saw the catacombs or basilicas, Ravenna, or the Holy Land. Edmund Bishop regarded Duchesne's early account of the Liturgy in *Origines du culte chrétien* (Paris, 1889) as 'frankly impossible'; cf. Abercrombie, *Life and Work of Bishop*, 148, 213 ff., although Duchesne was for his part a trenchant critic of Guéranger and distrustful of Bishop. J. B. Braun, *Der Christliche Altar in seiner geschichtlichen Entwicklung*, ii (Munich, 1924).

[21] In what follows I have kept citation to an essential minimum. References to the *Pontificale Romanum* are to establish the practice during the period under discussion. I am well aware that many of these observances begin before the 13th c., and continue long after. It should be noted however that the Pontifical of Durand is in the strict sense an episcopal book, and contains a quantity of new material, as can easily be seen in the edition of Andrieu: Capelle, 'L'Œuvre de Mgr. Andrieu', 173. Cf. also C. Vogel, *Introduction aux sources de l'histoire du culte chrétien au moyen-âge*, Biblioteca degli Studi Medievali, 1 (Spoleto, 1966; anastatic repr., 1975), 208 ff.; *DDC* i, cols. 1456–68, esp. cols. 1459 ff. The Council of Epao forbade wooden altars as early as 517 AD for which see Braun, *Der Christliche Altar*, i, 42 ff.; C. Pocknee, *The Christian Altar* (London 1963), 35 ff.

that its owner was a priest.[22] Every church must possess a fixed altar, preferably consecrated at the same time as the church.[23] Its altar, at least from the early middle ages, had to be of stone, and, importantly for our purpose, to contain relics.[24] The stone had to be a monolith, and were it to be broken the altar would cease to be duly consecrated.[25] Sufficient medieval evidence for all this exists, not least a widespread commerce in marble altar-tables.[26] From the fifth century, or earlier, the presence of relics in the altar became general. Normatively the altar would be set in the centre of the sacred space, be it chancel or chapel. Burials too close to the altar were prohibited.[27]

Crucially, every altar had to possess its proper *titulus*, assigned during the prescribed consecration ceremony. If it were the main altar, it must (with some important exceptions) be the same *titulus* as the church itself, although not necessarily that of the relics within the altar.[28] The *titulus* of the main altar is that of the church, while that of the chapels is that of the chapel altars.[29] These *tituli* had to be indicated by an inscription or an image. Thus in England in 1229, doubtless in reaction to the Lateran Council, William de Blois, bishop of Worcester, legislated as follows:

In consecrated churches, the year and date of consecration, the name of the dedicator, and the saint to which the church is dedicated should be clearly set out in suitable place near the high altar. The same should be done for the minor altars.[30]

[22] Braun, *Der Christliche Altar*, i, 420 ff.; Andrieu XII, 197 ff.; Andrieu XIII, 445; Andrieu, Durand, 445. A miniature in the Clifford Pontifical (Corpus Christi College, Cambridge, MS 79, fo. 168) shows a bishop consecrating three portable altars, cf. W. H. Frere, *Pontifical Services Illustrated from Miniatures of the XVth and XVIth Centuries*, Alcuin Club Collections, iii, iv (London, 1901); ii, plate vii, fig. 22.

[23] Andrieu XII, 187; Andrieu XIII, 423; Andrieu, Durand, 445 ff. with considerable new material. *DDC* iv, cols. 251 ff.; Braun, *Der Christliche Altar*, i, 663 ff.

[24] Canon 26 of the Council of Epao read, '*Altaria si non sint lapidea, chrismatis unctione non consecrentur*'. For relics, cf. N. Hermann-Mascard, *Les Reliques des Saints, Formation coutumière d'un droit*, Société d'Histoire du Droit, Collection d'Histoire Institutionelle et Sociale, 6 (Paris, 1975), 147 ff., 158 ff.; Andrieu XII, 187; Andrieu XIII, 434; Andrieu, Durand, 475 ff. Durand in his diocese insisted: '*Illud tamen districte precipimus ut quelibet ecclesia in qua corpus alicujus sancti requiescere dicitur, illius historiam habeat seu legendam.*' Cf. Berthélé and Valmary, 'Les Instructions de Guillaume Durand', 118. In general see M. Heinzelmann, *Translationsberichte und anderer Quellen des Reliquienkultes*, Typologie des sources du moyen age occidental, 33 (Turnhout, 1979).

[25] Braun, *Der Christliche Altar*, i, 101 ff.; *DDC* i, col. 1460. When the nuns of Nôtre-Dame-aux-Nonnains at Troyes wished to disrupt the building of Urban IV's great new church of Saint-Urbain, they broke the altar-slab to this end. See C. Lalore, 'Documents sur l'Abbaye de Notre-Dame-aux-Nonnains de Troyes', *Mémoires de la Société Académique d'Agriculture, des Sciences, Arts et Belles-Lettres du Département de l'Aube*,

38 (1874), 113 ff., 120 ff. Innocent III, *De Sacro Altaris Mysterio, PL* 247, col. 803. '*Per altare signatur Ecclesia, juxta quod Dominus dixit in Exodo, "Si altare lapideum feceris mihi, non aedificabis illud de sectis lapidibus"* (Exod. 20: 25). *Quod sectionem lapidum prohibet in altari divisionem fidelium reprobat, ne ecclesia dividatur per errores et schismata.*' Pocknee, *Christian Altar*, 41; Schannat and Hartzheim, *Concilia Germaniae*, iv, 24 ff. (1298).

[26] P. Deschamps, 'Table d'autel de marbre exécuté dans le midi de la France au Xc et au XIc siècle', *Mèlanges d'Histoire du Moyen-Âge offerts à M. Ferdinand Lot par ses amis et ses élèves* (Paris, 1925), 137–68. The setting of a reliquary or altarpiece on the altar required also that its upper surface be level: this was not earlier the case. Cf. Frere, 'Christian Altar', 151.

[27] The consecration ceremony for the high altar required the ordinary to make a circuit of it. Andrieu, Durand, 474–5. For the prohibition of burial too near the altar, see as exemplary Durand, *Instructiones*, in Berthélé and Valmary, 'Les Instructions de Guillaume Durand', 83, and also G. Durand, *Rationale Divinorum Officiorum* (Venice, 1568), fo. 15v.

[28] Andrieu, Durand, 457; *DDC* iv, cols. 252, 253. See also n. 34 below.

[29] *DDC* iv, cols. 253 ff.

[30] '*Item in ecclesiis dedicatis annus et dies dedicationis et nomen dedicantis et nomen sancti dedicata est ecclesia distincte et aperte scribantur circa maius altare, in loco ad hoc ydoneo. Idem faciat circa minore altaria.*' Powicke and Cheney, *Councils and Synods*, i, 172. Cf. its reiteration, ibid. 292 ff. See also C. Wordsworth, *Notes on Medieval Services in England* (London, 1898), 289 ff.

Comparable injunctions appear at the end of the century in the *Constitutiones* of Durand, as also in the legislation of Papiniano della Rovere for Novara.[31] That this rule was earlier followed may easily be shown by the nobly carved inscription on the Michael altar in the south transept of the Upper Church at Assisi (Plate 1), or the surviving inscription plaques at San Flaviano, Montefiascone (Plate 2), where the high altar of the Upper Church was personally consecrated by Pope Urban IV, and elsewhere.[32] An excellent example is to be found in the Cappella Pazzi at Santa Croce (Plate 3).

Canonically the titulus of a church may be a person, a mystery, for example the Trinity, or an object, such as the Holy Sepulchre.[33] It cannot however be a *beatus*. An important fact however, often neglected, is that if the titular is a person, he or she can be also the patron of the church. If the titular is the deity or a mystery, the patron must differ, on the simple ground that God cannot stand in relation to Himself. For this reason Constantine's great church of the Lateran in Rome, the *Basilica Salvatoris*, has as its patron the Baptist and the Evangelist.[34] The titular is only fixed with the consecration ceremony. Miniatures exist showing the consecration taking place when the walls of the church are incomplete (Plate 4).[35] All these canonical requirements are simple and clear, but their consequences for altarpieces have rarely been fully considered.

Yet the pertinent historical evidence from the thirteenth and fourteenth centuries is relatively abundant. For instance, there are the destruction of false relics which have attracted illicit cult, such as that of Armanno Pungilupo in Ferrara, and the promotion of unworthy persons castigated by Salimbene de Adam and anatomized by Francesco Sacchetti.[36] Salimbene was complaining in the mid-thirteenth century of paintings of uncanonized personages and in 1307 the General Chapter of the Franciscan Order proscribed the representation of inappropriate persons as *beati* or saints in unambiguous terms.[37] Whilst one may readily accept that there are exceptions, and that

[31] Berthélé and Valmary, 'Les Instructions du Guillaume Durand', 107. '*Precipimus ut in unaquaque ecclesia ante vel supra quodlibet altare sit ymago vel sculptura seu pictura vel scriptura expresse designans et cuilibet intuenti manifestans in cujus sancti nomen et honorem sit ipsum altare constructum.*' An almost identical form of words was adopted by the Council of Trier in 1310, cf. Mansi, *Sacrorum Conciliorum*, cols. 5 ff.; Briacca, *Gli statuti sinodali*, 226 ff.

[32] The inscription of the altar at Assisi reads: HOC ALTARE ERECTUM EST IN HONORE BEATI MICHAELI ARCHANGELI. That at Montefiascone: +AN.DNI.M.CC.LXII. DN̄S URBANUS.P̄P.IIII/FIERI FECIT. ISTVD ALTARE AD H̄OREM B̄AT./MARIE VI.SC̄E CRVCIS.S. LUCE.S.URBANI.PP/.S.LINI.S̄COR̄.FABIANI ET SEBASTIANI./S.AUREE. V̄.ET MANIB̄.PRPĪI/COSECRAVIT ILLUD./CV.CARDINALIB̄. ACHEP̄I/ ET ĒPI PLURIB̄. II.ĪD.OCTB̄./TP̄E PRIŌIS PHYLIPPI. Reproduced in G. B. Ladner, *Die Papstbildnisse des Altertums und des Mittelalters*, ii, *von Innozenz II. zu Benedikt XI.*, Monumenti di Antichità Cristiana, 2nd ser. pt. iv (Vatican City, 1970), 142, fig. 64.

[33] *DDC* vii, col. 1277. For Santa Trinita in Florence, see p. 18 below.

[34] P. Jounel, *Le Culte des saints dans les basiliques du Latran et du Vatican au douzième siècle*, Collection de l'école française de Rome, 26 (Rome, 1977), 329 ff. The apse mosaic, originally by Jacopo Torriti, reflects this multiple dedication in our period.

[35] C. R. Cheney, 'Church-building in the Middle Ages', *Bulletin of the John Rylands Library*, 34 (1951), 20–36; M. R. James, *A Descriptive Catalogue of the Latin Manuscripts in the John Rylands Library at Manchester* (Manchester, 1921), i, 97–102; ii, pl. 92.

[36] A. Benati, 'Armanno Pungilupo nella storia ferrarese del 1200', *Analecta Pomposiana*, 2 (1966), 85–123. F. Sacchetti, *Opere*, ed. A. Bortolenghi (Milan, 1958), 1115: '*E chi n'assicura che non siano assai che dubitino che altri Santi non principiassono in questa forma e che li raggi da capo e '1' beatò a' piedi, in ispazio di tempo gli raggi siano conversi in diodema e '1' beatò in 'santo'?* Cf. Salimbene De Adam, *Cronica*, ed. F. Bernini (Bari, 1942), ii, 726.

[37] G. Abate, 'Memoriali, statuti ed atti di Capitoli Generali dei Frati Minori', *Miscellanea Francescana*, 33 (1933), 15–45, 320–36; 34 (1934), 248–53. *Memoriale* of the General Chapter of Toulouse (1307) '*Item memoriale eisdem, quod si quos defunctos*

beati may even have been commemorated in elaborate narrative cycles like Niccolò da Tolentino and Chiara da Montefalco, or be mentioned in altar inscriptions, like Ranieri of Sansepolcro, they are exceptions to a rule generally applied (Plate 5).[38] It is clear, for example, that the pairing of altar patron and the titular of the church is the canonical basis underlying the programme of altars in Siena Cathedral which, in recent years, has attracted much interest.[39]

Altars themselves can have a history or even follow fashion. The smallish, often cubic altars of the twelfth century, which for example conditioned the relatively modest scale of some thirteenth- and fourteenth-century altarpieces, gave way to the wider altars of the early Trecento which accommodate ever larger altarpieces (Plates 6, 7).[40] But which was the chicken and which the egg? Extremely wide altars existed in other parts of Europe, for example at Tewkesbury in England, where there was hardly a tradition of elaborate altarpieces, although here, once again, the Dominican polyptych from Thornham Parva is an exception.[41] The wider altar, for obvious reasons, led to the abandonment of the ciborium, although as we shall see this factor had a particular effect in Rome itself.[42] It cannot be generally argued therefore that wider altars were prompted by a penchant for polyptychs. Edmund Bishop, the finest and most commonsensical of liturgical scholars, suggested a plausible interrelationship between this development and that of great shrines to house relics set behind the altars of major churches, and the shrine-altarpiece nexus is too commonly glossed over.[43]

non canonizatos habent in provinciis suis depictos cum diademate vel corona sanctorum, picturas huiusmodi quantum ad diademata et coronas faciant omnino deleri; nec ullo modo talia de cetero fieri patiantur'.

[38] J. Gardner, 'The Cappellone di San Nicola at Tolentino: Some Functions of a Fourteenth-Century Fresco Cycle', in W. Tronzo (ed.), *Italian Church Decoration of the Middle Ages and Early Renaissance: Functions, Forms and Regional Traditions* (Bologna, 1989), 101–17. For Chiara da Montefalco, see most recently C. Leonardi, 'Sante Donne in Umbria tra secolo XIII e XIV', in *Sante e Beate Umbre fra il XIII e il XIV Secolo, Mostra Iconografica* (Foligno, 1986), 49–60. For the altar inscription at Sansepolcro, cf. J. Gardner, 'Some Franciscan Altars of the 13th and 14th Centuries', in A. Borg and A. Martindale (eds.), *The Vanishing Past: Studies of Medieval Art, Liturgy and Metrology Presented to Christopher Hohler* (Oxford, 1981), 32; Braun, *Der Christliche Altar*, i, 299 ff. Cf. also n. 82 below.

[39] Van Os, *Sienese Altarpieces*; E. Beatson, N. Müller, and J. Steinhoff, 'The St. Victor Altarpiece in Siena Cathedral: A Reconstruction', *Art Bulletin*, 68 (1986), 610–31.

[40] Dendy, *Use of Lights*, 69. Bishop, 21 ff., 30 ff. It might be objected that Braun proposes too complex a formal development for the altar block; cf. Bishop, 21, and Frere, 'Pontifical Services', 154. It is interesting in this context to recall the comment of Bruno of Segni, *Expositio in Exodum*, in *PL* 164 (Paris, 1884), col. 328. '*Hoc autem altare quadrum est, quoniam in quatuor mundi partes sancta ecclesia extenditur et dilatatur.*' For Bruno (mid-11th c., *ob.* 1123), cf. R. Grégoire, *Bruno de Segni:*

Exégète médiéval et théologien monastique, Centro Italiano di studi sull'alto medioevo (Spoleto, 1965); H. Hoffmann, *Dizionario biografico degli Italiani*, xiv (Rome, 1972), 644–7.

[41] G. Webb, *The Liturgical Altar* (London, 1935), 31 ff. For the Thornham Parva retable, see C. Norton, D. Park, and P. Binski, *Dominican Painting in East Anglia* (Woodbridge, 1987). The iconography with John the Baptist in the place of honour, despite the authors' preference for Thetford, makes Norwich more probable as the original site, and the graphically reconstructed setting (endpiece) is frankly impossible. For the Norwich priory, which was being rebuilt in the third decade of the 14th c., see W. Page (ed.), *Victoria County History of Norfolk*, ii (London, 1906), 428–30. There are also rather more comparisons to be drawn with the Italian material than the authors suspect.

[42] Bishop, 29; Braun, *Der Christliche Altar*, ii, 213 ff.; Andrieu, Durand, 531 ff., *De benedictione ciborii seu umbraculi altaris.*

[43] Bishop, 26 ff. On the setting of the shrine at Saint Albans, cf. Matthew Paris, in H. T. Riley (ed.), *Gesta Abbatum Monasterii Sancti Albani a Thoma Walsingham regnante Ricardo Secundo ejusdem ecclesiae praecentore compilata*, i (London, 1867), 189: '*Et loco suo eminentiori, scilicet supra majus altare, contra frontem celebrantis collocavit, ut facie et corde habeat quilibet celebrans missam super idem altare martyris memoriam. Et idcirco in objectu visus celebrantis, martyrium eiusdem, scilicet decollatio, figuratur.*' Pocknee, *Christian Altar*, 85, M. M. Gauthier, 'Du tabernacle au retable', *Revue de l'art*, 40–1 (1978), 23–42.

Thus while legislation and custom played a role in the development of altars, other factors too impinged. The changes in the composition of the religious orders, notably their increasing clericalization, matched by the increasing preference among patrons for private masses, the consequent institution of chantries all over Europe, commonly in discrete chapels, added to the structure of the church—all were elements contributing to the multiplication of altars.[44] Mendicant churches in particular followed the precedent of the reformed branches of the Benedictine Order in multiplying the number of altars and choir chapels in their ever larger churches.[45] But, as was mentioned above, in Rome itself idiosyncrasies in the celebration of the eucharistic sacrifice and the weight of tradition made the use of the altarpiece a rare exception even during the fourteenth century. In Rome the venerable age of many of the churches and the relative absence of major church building in the thirteenth and fourteenth centuries were influential. But primarily it was the conservatism of the milieu and the predominance of celebration *versus populum*, in the fashion of the great basilicas, which virtually proscribed the altarpiece.[46] The significant exceptions in fourteenth-century Rome are invariably Tuscan.[47] An interesting adaptation to similar requirements can be seen outside Rome in the sixteenth century, in Vasari's high altarpiece for the Pieve, now reconstructed in the Benedictine abbey of Sante Fiora e Lucilla in his native Arezzo (Plate 8).[48] It must be remembered that double-sided altarpieces, like those for nunneries, are exceptions and thus subject to special rules.[49]

In the preconditions for the introduction of the altarpiece fashion existed; the question can be modified from why to when. As is the case with the introduction of the effigial tomb into Italy, the written evidence makes it virtually certain that it arrived considerably earlier than the

[44] K. L. Wood-Legh, *Perpetual Chantries in Britain* (Cambridge, 1965); O. Nussbaum, *Kloster, Priester-mönch und Privatmesse: Ihr Verhältnis im Westen, von Anfängen bis zum hohen Mittelalter (Theophaneia)*, Beiträge aus Religions und Kirchengeschichte der Altertums, xiv (Bonn, 1961); L. C. Landini, 'St Francis of Assisi and the Clericalization of the Friars Minor', *Laurentianum*, 26 (1985), 160–73. For moves in the opposite direction, cf. Schannat and Hartzheim, *Concilia Germaniae*, iii, 599, Mainz, 1261: '*Altaria superflua per ecclesias parochiales omnino tollantur, cum singulis ecclesiis, non conventualibus, ad plus tria sufficiant.*'

[45] R. Wagner-Rieger, 'Zur Typologie italienischer Bettelordenskirchen', *Römische Historische Mitteilungen*, 2 (1957), 266–98.

[46] C. Vogel, '*Versus ad Orientem*. L'Orientation dans les "ordines romain" du haut Moyen Âge', *Studi medievali*, ser. 3/1 (1960), 447–69; K. Gamber, *Liturgie und Kirchenbau*, Studia Patristica e Liturgica, 6 (Regensburg, 1976); J. Gardner, 'The Stefaneschi Altarpiece: A Reconsideration', *Journal of the Warburg and Courtauld Institutes*, 37 (1974), 61 n. 23, 78.

[47] Gardner, 'Stefaneschi Altarpiece', 102. For the altarpiece commissioned from Simone di Cino, Gabriello di Saracino, and Spinello Aretino for S. Maria Nuova, cf. U. Procacci, 'La

creduta tavola di Monteoliveto dipinta da Spinello Aretino', *Il Vasari*, 2 (1928), 35–48. The patron, the prior Nicolo Fache, was a Pisan and the altarpiece had to be '*in ea forma modo et qualitate qua est tabula seu imago existens in monasterio Sancti Pontiani de Lucca*'. For the panel by Lippo Vanni in the church of SS Domenico e Sisto, cf. C. Brandi, *Un candelabro dipinto da Lippo Vanni*, Monographie der Abegg Stiftung, Bern, 10 (Bern, 1975), 7, figs. 2, 3; C. De Benedictis, *La Pittura Senese 1330–1370* (Florence, 1979), 36; G. Chelazzi Dini, 'Lippo Vanni', in *Il gotico a Siena* (Siena, 1982), 255 ff.

[48] This construction was originally intended as the main altarpiece in the Pieve, designed by Vasari to replace the high altarpiece by Pietro Lorenzetti. Cf. C. A. Isermeyer, 'Die Capella Vasari und der Hochaltar in der Pieve von Arezzo', *Festschrift für C. G. Heise* (Berlin, 1950), 137–53; T. S. R. Boase, *Giorgio Vasari: The Man and the Book* (Princeton, NJ, 1979), 172 ff.

[49] J. Gardner, 'Fronts and Backs, Site and Setting', in H. W. van Os and J. R. J. van Asperen de Boer, *La pittura nel XIV e XV secolo: Il contributo dell'analisi tecnica alla storia dell'arte*, Atti del XXIV congresso internazionale di storia dell'arte, Bologna, 1979 (Bologna, 1983), iii, 297–322.

surviving examples would suggest. So too with the altarpiece. Questions of terminology are often baffling. *Retrotabularium* is attested as a term for the late thirteenth century, while in that same century we have *ancona, ymago, dossale, frontale, pala, paliotto, tabula, tabernaculum*, and so on.[50] The altar frontal is a problem of its own, although the valuable discussion in Hager clarifies much.[51] The inscriptions placed by Doge Andrea Dandolo on the final remodelling of the *Pala d'Oro* expressly term it *Pala*, while a Dominican preacher at Imola in the 1280s, taking a painting of the Virgin as his text, speaks of it as *ymago*, a word also used by Durandus in his *Instructiones*.[52] *Ymago* of course does not necessarily mean that it was a painting. Shape obviously is a major clue as to position. Thus while the panel of 1215 from the Badia di San Salvatore at Castelnuovo Berardenga, now in the Pinacoteca at Siena (Plate 9) may have been used as either frontal or dossal, the panels of Meliore (1271), or Vigoroso da Siena are, by their shape, unequivocally altarpieces (Plate 10).[53]

One aspect of the problem is fortunately clearer. Whereas the relationship between central Italian painting and Byzantium during the thirteenth century has been greatly illuminated in recent decades, many aspects of that relationship, particularly in matters of localization, style, iconography, and technique remain obscure. But it can be asserted that the problem of the origins of the Italian altarpiece does not form part of the 'Byzantine question'. Altarpieces are not part of the liturgical altar furniture of the Orthodox Church, and so the icon and the altarpiece are functionally unrelated.[54] Weitzmann may, however, be correct in postulating a formal relationship with the iconostasis of the Eastern Church in some thirteenth-century instances, as for example the altarpiece by the Maestro di San Francesco from San Francesco at Perugia.[55] But the

[50] *Retrotabularium*, 1294, cf. C. Ducange, *Glossarium ad scriptores mediae et infimae Latinitatis*, v (Paris, 1754), 1410, citing a law of Jaime II of Majorca (1294); Braun, *Der Christliche Altar* ii, 280. *Ancona* attested on a panel inscription of 1310, cf. M. Muraro, *Paolo da Venezia* (University Park, Pa., 1970), 141 ff. *Ymago* (1286), cf. G. G. Meersseman, 'La Prédication dominicaine dans les congrégations mariales en Italie au XIIIᵉ siècle', *Archivum Fratrum Praedicatorum*, 18 (1948), 148. *Tabula*, cf. the inscription once on Guido da Siena's panel No. 16 in the Pinacoteca of Siena. See also J. Stubblebine, *Guido da Siena* (Princeton, NJ, 1964), 61. For examples earlier than the 13th c. and for terminology, Braun, *Der Christliche Altar*, ii, 280 ff. Benedictions of images of the Virgin and of the saints are to be found in Andrieu, Durand, 525 ff. but not in earlier pontificals.

[51] Hager, *Die Anfänge des Italienischen Altarbildes*, 59 ff.

[52] *Post Qvadrageno Qvinto Post Mille Trecentos/Dandvlvs Andreas Praeclarvs Honore Dvcabat/Nobilibvsqve Viris Tvnc Procvrantibus Almam/Ecclesiam Marci Venerandam Ivre Beati De Lauredanis Marco Frescoqve Quirino/Tvnc Vetus Haec Pala Gemis Preciosa Novatur*. B. Jestaz, *La Chapelle Zen à Saint Marc de Venise* (Stuttgart, 1986), app. I, 170 ff. which is inconclusive; Berthélé and Valmary, 'Les Instructions', 62, and preceding note.

[53] C. Brandi, *La Regia Pinacoteca di Siena* (Rome, 1933), 20; L. Marcucci, *Gallerie Nazionali di Firenze: I dipinti toscani del secolo XIII* (Rome, 1958), No. 9, 35 ff.; F. Santi, *Galleria Nazionale dell'Umbria: dipinti, sculture e oggetti d'arte di età romanica e gotica* (Rome, 1969), No. 15, 41 ff.; Gardner, 'Fronts and Backs', 298.

[54] H. J. Schulz, *The Byzantine Liturgy* (New York, 1986); Bishop, 23; H. Belting, 'The "Byzantine" Madonnas: New Facts about their Italian Origin and Some Observations on Duccio', *Studies in the History of Art* (National Gallery of Art, Washington, DC), 12 (1982), 7–22. Cf. also the important article by P. Speck, 'Die ENΔYTH. Literarische Quellen zur Bekleidung des Altars in der byzantinischen Kirche', *Jahrbuch der Österreichischen Byzantinischen Gesellschaft*, 15 (1966), 323–75. I am grateful to Dr Robin Cormack for drawing my attention to this article. Speck (p. 361) suggests that the gradual shift towards aniconic textile altar frontals in the Orthodox Church may be connected with ever-increasing closedness of the iconostasis.

[55] K. Weitzmann, 'Crusader Icons and Maniera Greca', in I. Hutter (ed.), *Byzanz und der Westen*, Österreichischische Akademie der Wissenschaften Philosophisch-Historischen Klasse, Sitzungberichte, 432 (Vienna, 1984), 159 ff.; D. Gordon, 'A Perugian Provenance for the Franciscan Double-

development of the altarpiece is a wholly European phenomenon, a point further confirmed by the evident links with northern examples, and especially the European currency of canon laws, as well as the internationality of the religious orders. In 1239 the Franciscan provincial in England was greatly embarrassed by the presence of an elaborate altarpiece at the Order's house at Reading, '*unam tabulam ad altare depictam et auro stellatam*', provided by royal mandate.[56] In Germany there are a number of altarpieces, certainly of the thirteenth century, one of which to all intents and purposes is a fragment of a Dominican polyptych, of a type that would have been readily recognized in Italy (Plate 13).[57] Similarly another Dominican polyptych fragment now in Brussels shows a double-sided panel, the back showing Saint Dominic set against a marble ground, a differentiation between back and front systematically developed in fifteenth-century Netherlandish painting (Plates 11, 12).[58]

Parenthetically, perhaps, the question of mural altarpieces should be raised here. Several significant examples survive in Rome. In Santa Balbina (Plates 14, 15), the peculiar shape of the nave walls, with its rippling series of niche-like chapels, here probably derived from the ancient building it incorporates, rather as Orvieto Duomo later provoked a series of side altars, one of which still has its altar inscription *in situ*.[59] Behind these side altars are a series of mural altarpieces indubitably related to the surviving altars (Plates 14, 15). Unfortunately, insufficient of the series survives for us to establish whether a programme was intended.[60] Of approximately contemporary date is the mural behind the high altar of San Saba. Here the relationship to the

Sided Altarpiece by the Maestro di San Francesco', *Burlington Magazine*, 124 (1982), 70-7.

[56] A. G. Little (ed.), *Tractatus Fr. Thomae vulgo dicti de Eccleston De Adventu Fratrum Minorum in Anglia*, Collection d'Études et de Documents, vii (Paris, 1909), 173; cf. A. G. Little, *Studies in English Franciscan History* (Manchester, 1917), 62.

[57] *Die Zeit der Staufer,* i (Stuttgart, 1977), cat. No. 435, 307 ff. The fragment which measures 40·3 × 86·3 cms. is said to come from the Dominican nunnery of Altenhohenau. The presence of Peter Martyr suggests a *terminus ante quem non* of 1253. Note also the Dominican decree of 1256 at the General Chapter of Paris; B. M. Reichert, *Acta Capitulorum Generalium Ordinis Praedicatorum*, Monumenta Ordinis Fratrum Praedicatorum Historica, 3, 4 (Rome, 1898), 81, '*Item. Apponatur diligencia quod festum beati Dominici et beati Petri ubique celebretur et quod imagines eorum in locis congruentibus depingantur*'. For a recent discussion of the programme of a 13th-c. German altarpiece, cf. R. Haussherr, '*Si tu es Christus, dic nobis palam!* Eine Notiz zum Soester retabel der Berliner Gemäldegalerie', in Per Bjurström *et al.* (eds.), *Florilegium in Honorem Carl Nordenfalk Octogenarii Contextum* (Stockholm, 1987), 81-90.

[58] *Musées Royaux des Beaux-Arts de Belgique, Catalogue inventaire de la peinture ancienne* (Brussels, 1984), Inv. 8733, 137 × 90 cms.

[59] The plaque is now set in the strip of wall separating the fourth and fifth chapels on the left side of the nave. Of white marble it measures 28·5 × 67·5 cms. The inscription reads:

+ ISTUD ALTARE Î HONORE BEATI NICHOLAI
CÔSTRVCTÛ·EST·ET·DOTATÛ·P DÑM·PALÛ·
PAPHENSE·EP̂M· NATIONE· VNGARÛ·QVI ORDINA
VIT· ET· FRÊS· hVIVS·DOMVS· PROMISERV̂T·QVOD
IN·EODÊ·ALTARI·MISSA·QVANDOCV̂QVE·FIERI·
POTERIT·CELEBRABÎT·ET EIVS·MEMORIA·FIET·

For Paul of Paphos see W. Rudt de Collenberg, 'État et origine du haut clergé de Chypre avant le grand schisme d'après les registres des papes du XIIIᶜ et du XIVᶜ siècle', *Mélanges de l'école française de Rome*, 91/3 (1979), 211, 270. Rudt de Collenberg mistakenly assumed Ungaro to be Paul's family name, but the third line of the inscription, which is not, I believe, published, makes it clear that he was Hungarian. More information on Paul of Paphos may be found in I. Herklotz, '*Sepulcra*' e '*monumento*' del Medioevo (Rome, 1985), 169-71.

[60] For the history of the church cf. R. Krautheimer, *Corpus Basilicarum Christianarum Romae*, i, Monumenti di Antichità Christiana, Pontificio Istituto d'Archeologia Christiana, 2nd ser., ii (Vatican City, 1937), 82 ff., 91, suggesting that the niched walls formed part of the Domus Cilonis.

apsidal throne, altar, and ciborium is instructive (Plates 16, 17). It represents a local compromise taking account of Roman liturgical practice, the specific situation at San Saba, and the wish to have a cross above the altar. The survival of all three elements, altar block, ciborium, and mural at San Saba is a particularly valuable piece of early evidence for the existence of altarpieces in Rome.[61]

From why and when we come lastly to which. As has been shown, the Saviour is a special case, and outside Rome direct dedications to the deity are not especially common. In Tuscany the panel dated 1215 from the Badia at Castelnuovo Berardenga (Plate 9) and two panels of the 1270s by Meliore (Plate 10), whose original location is uncertain, are examples.[62] It has been plausibly suggested that the early panels of San Francesco, for which the evidence that they served as altarpieces remains inconclusive, is inextricably connected with the saint's presence in the place, that they served thus as *memoria* (Plate 18).[63] The same is even more true of the panels with *Beati*, where the presence of the revered person in the place was vital. This fact has recently been well exemplified in discussion of the original setting of Simone Martini's Beato Agostino Novello panel.[64] But we have yet to have a systematic investigation of Italian medieval church dedications and the one study known to me, that on Venetian dedications, is somewhat unsatisfactory.[65]

Yet, parish and church dedications are central to any study of altarpiece iconography, and beyond that their archaeology. In France, although admittedly dealing with a substantially later era, there are interesting studies of the penetration of new altarpiece dedications in Provence.[66] It is clear that much work of this kind remains to be begun in Italy. Where for example were altars to Peter Martyr, Louis of Anjou, or Bernardino da Siena inserted in churches already constructed? Did their 'modern' aspect provoke a more general updating of neighbouring altars?[67] None of the early parishes in Florence was dedicated to a 'mystery', the monastery of Santa Trìnita becoming a

[61] I. Hueck, 'Der Maler der Apostelszenen im Atrium von Alt-St. Peter', *Mitteilungen des Kunsthistorischen Institutes in Florenz*, 14 (1969), 140 ff.; H. Belting, *Die Oberkirche von San Francesco in Assisi* (Berlin, 1977), 160; Krautheimer, *Corpus Basilicarum Romae*, 51 ff. For the apse at S. Saba, cf. P. Tempestini, *San Saba*, Le Chiese di Roma Illustrate, 68 (Rome, 1961), 56 ff.

[62] For the Badia at Castelnuovo Berardenga panel, see n. 53 above. For the lost altarpiece of 1270 by Meliore once in San Francesco in Barberino val d'Elsa, see N. Catalano, *Fiume del terrestre Paradiso* (Florence, 1652), 474 ff.

[63] H. W. van Os, 'The Earliest Altarpiece of St. Francis', *I Valori Francescani*, Simposio in occasione dell'VIII centenario della nascita di S. Francesco (Amsterdam, 1985), 9.

[64] See Ch. 2, Plate 35 in this volume. A. Bagnoli, 'Il Beato Agostino Novello e quattro suoi miracoli', in A. Bagnoli and L. Bellosi (eds.), *Simone Martini e 'chompagni'*, exhibition catalogue, Siena 1985 (Florence, 1985), 56 ff.

[65] N. Gockerell, *Kirchen mit alttestamentarischen Patrozinien in Venedig: Materialen zur Geschichte der Kirchen S. Giobbe, S.*

Geremia, S. Moisé, S. Samuele, S. Simeone und S. Zaccaria, Centro Tedesco di Studi Veneziani, Quaderni, 2 (Venice, 1978); cf. also H. C. Peyer, *Stadt und Stadtpatron in mittelalterlichen Italien*, Züricher Studien zur allgemeinen Geschichte, 13 (Zürich, 1955). There are some valuable remarks in M. Meiss, 'A Dugento Altarpiece at Antwerp', *Burlington Magazine*, 71 (1937), 14–25. A bibliography on church dedication is to be found in S. Wilson (ed.), *Saints and Their Cults* (Cambridge, 1983), 356–67, Nos. 542–60.

[66] M. H. Froeschlé-Chopard, 'Univers sacré et iconographie au XVIIIᵉ siècle: Églises et chapelles des diocèses de Vence et de Grasse', *Annales*, 31 (1976), 489–519.

[67] It is uncertain whether Simone Martini's *Saint Louis of Toulouse Crowning Robert of Anjou* was an altarpiece, cf. J. Gardner, 'Saint Louis of Toulouse, Robert of Anjou and Simone Martini', *Zeitschrift für Kunstgeschichte*, 39 (1976), 33; A. Martindale, *Simone Martini* (Oxford, 1988), 192 ff. The same is true of the earliest panels of S. Bernardino; cf. P. Torriti, *La Pinacoteca Nazionale di Siena, I: Dipinti dal XII al XV secolo* (Genoa, 1977), 300 ff.; and also Ch. 3 in this volume.

parish only in the twelfth century. But the need to have a second patron is the likely reason for the choice of the enthroned Virgin as the iconography for Cimabue's altarpiece—only in the subsequent high altarpieces does the Trinity become the primary subject-matter (Plate 19).[68] A more puzzling shift, too often elided in vague generalizations about the popularity of the cult of the Virgin, is why, during the fourteenth century, high altarpieces, such as, for example, Bernardo Daddi's San Pancrazio polyptych, adopt the Virgin as main saint, or why the same artist's high altarpiece for San Giorgio a Ruballa takes the Crucifixion as central image? (Plate 20).[69] Equally it might very well be worth enquiring whether the well-known practice in the early years of the mendicant orders of introducing the liturgical feasts of other orders into their calendars, in the hope that there would be reciprocal acceptance of their saints in the calendar of older, better-established orders, had any effect on altarpiece programmes.[70] That certain conventions of this sort did apply can be seen from the common presence of Peter and Paul in mendicant altarpieces. As exempt orders they were directly under the papacy, and thus Peter was often representative of this linkage, Paul the natural equivalent, with the added advantage of being both preacher and proselytizer. Some important evidence about choice and implementation of altarpiece programmes survives and should be mentioned here. The eminent Bolognese jurist Giovanni d'Andrea single-mindedly championed the cult of St Jerome by erecting altars and causing liturgical offices to be composed, as well as by founding a chapel in the cathedral of Bologna.[71] The programme for the altarpiece of the Compagnia della SS Trinità at Pistoia, begun by Pesellino, is also instructive (Plate 118). There, '*perche era differentia nella Compagnia*' the priest Piero ser Lando cannily interjected his personal favourite, St Mamas, reinforcing his suggestion by the promise of a rent in perpetuity for the confraternity (Plate 118).[72] The passage in the

[68] Marcucci, *Gallerie Nazionali di Firenze*, No. 12, 39 ff.; see also C. De Benedictis, 'La Pittura del Duecento e del Trecento in S. Trinita', in G. Marchini and E. Micheletti (eds.), *La Chiesa di Santa Trìnita a Firenze* (Florence, 1987), ch. ix, 89 ff.

[69] L. Marcucci, *Gallerie Nazionali di Firenze: I dipinti toscani del secolo XIV* (Rome, 1965), No. 13, 33 ff.; R. Offner, *A Corpus of Florentine Painting*, sect. 3: *The Fourteenth Century*, iii (New York, 1930), 80 ff.; v (New York, 1947), 117 ff.; Gardner, 'Fronts and Backs', 302 ff.

[70] e.g. the Franciscans' adoption of the feast of St Bernard in 1260 in recognition of the Cistercians' greater liturgical veneration of St Francis in 1259. See S. J. P. van Dijk, *The Sources of the Modern Roman Liturgy*, Studia et Documenta Franciscana, 1 (Leiden, 1963), 128 ff.

[71] '*Imponi feci nomen ipsius certis pueris in cathecismo et mutari monachus in ingressu. Quandoque solum de ipsius scriptis sermones composui . . . Dictaui formam qua nunc in cathedra sedens pingitur cum capello, quo nunc cardinales utuntur deposito et leone mansueto, sic in locis diuersis ipsius multiplicando picturas. in publico domus proprie plene ipsius historiam feci depingi. In Bononiensi ecclesia cathedrali, cappellam et sacerdotale beneficium dotaui ad ipsius vocabulum et honorem, et ultra Bononiam iuxta stratam piblicam qua itur ad Florentiam una cum nuru mea nunc defuncta pulchram parrochialem ecclesiam cum officinis et dote fundaui. Monasteri Cartusianensis ordinis nuperrime prope Bononiam, infra miliare versus occidentem alienis et meis sumptibus inchoatum ac etiam parrochialem ecclesiam infra idem spatium versus septentrionem intitulari ad ipsius nomen obtinui. In diversis ecclesiis ad ipsius honorem altaria erigi procuraui: singulis prescriptis ecclesiis assignando doctoris ipsius officium speciale: ad mei preces eleganter compositum et notatum.*' *Acta Sanctorum* (Antwerp, 1643), Septembris VIII, 659–60; cf. B. Ridderbos, *Saint and Symbol* (Groningen, 1984), 16 ff.; E. F. Rice, Jr., *St. Jerome in the Renaissance* (Baltimore, 1985), 64 ff.; D. Russo, *Saint Jérome en Italie* (Rome, 1987), 60 ff.

[72] P. Bacci, *Documenti e commenti per la storia dell'arte* (Florence, 1944), 113 ff.; M. Davies, *The Earlier Italian Schools*, 2nd rev. edn. (London, 1961), 414 ff. Cf. also the fuller discussion by Patricia Rubin in Ch. 7 of the present volume.

document is reminiscent of Villard de Honnecourt and Pierre de Corbie designing the ground-plan of a church 'inter se disputandum'.[73]

One last problem must be touched on before our conclusion. Santa Trìnita in Florence, while serving as a parish church, was also a monastic foundation. Thus it differed from say Ognissanti further down the river where the Umiliati had their house, and where Giotto's great enthroned Madonna occupied the high altar (Plate 21). The Ognissanti *Madonna*, although it partially imitates and adapts the old-fashioned shape of the Santa Trìnita *Madonna*, has its programme extended to become a proper 'all-saints' painting. But the painting is not the only panel by Giotto from Ognissanti, for the *Dormition* now in Berlin is as fully documented (Plate 22).[74] It is, however, a narrative subject, and in this it may be compared to Giotto's other early experiment in this direction, the *Stigmatization* once in San Francesco at Pisa (Plate 23).[75] Such scenes are not wholly unprecedented in Florentine painting as a panel of the *Last Supper* from the workshop of the Magdalen Master demonstrates (Plate 24).[76] But the significance for our purpose of the *Dormition* lies in another direction, although the evidence for my proposal is admittedly fragmentary. Like the high altarpiece, it introduces a larger number of participants than could be strictly justified by the textual tradition, and the reason for this surely is to make it into another 'all-saints' picture. If this is admitted, the possibility arises that we are dealing with the remnants of an integrated programme of altarpieces for the church. Such groups of panels can perhaps be traced even earlier, for example at Santa Chiara in Assisi, or San Sisto Vecchio in Rome, but our proposal is perhaps more important in postulating an earlier altarpiece programme than the now well-established one for the Duomo at Siena of about a generation later, where once again it is aspects of the life of the Virgin set off against a central dedication to the *Assunta* (Plates 25, 26).[77]

By way of conclusion I wish to cite two aspects of a single problem. What was lay access to

[73] H. Hahnloser, *Villard de Honnecourt: Kritische Gesamtausgabe des Bauhüttenbuches Ms. fr. 19093 der Pariser Nationalbibliothek* (Vienna, 1935), 69 and pl. 29. The full text reads: '*Istud bresbiteriu(m) inveber(un)t Ulardus d(e) Hunecourt (et) Petrus de Corbeis i(n)t(er) se disputando.*'

[74] Marcucci, *Gallerie Nazionali di Firenze*, No. 1, 11 ff.; M. Boskovits, *Gemäldegalerie Berlin: Katalog der Gemälde Frühe Italienische Malerei* (Berlin, 1988), No. 24, 56 ff. For the church, cf. H. Tiraboschi, *Vetera Humiliatorum Monumenta*, iii (Milan, 1768), 101 ff.; W. and E. Paatz, *Die Kirchen von Florenz*, iv (Frankfurt, 1952), 433. The empty space which is such a striking feature of the composition of the Madonna panel is surely to permit the subject to be unimpededly legible despite the presence of the celebrant in front of it. The kneeling angels are both bringers of gifts to the Virgin and acolytes flanking the priest. A similar point for a later period is made by Dr Patricia Rubin in Ch. 7 below.

[75] J. Gardner, 'The Louvre Stigmatization and the Problem of the Narrative Altarpiece', *Zeitschrift für Kunstgeschichte*, 45 (1982), 217–47.

[76] G. Coor-Achenbach, 'Some Unknown Representations by the Magdalen Master', *Burlington Magazine*, 93 (1951), 74, where it is dated shortly after 1280. See also M. Laclotte and E. Mognetti, *Inventaire des collections publiques françaises*, 21: *Peinture italienne Avignon-Musée du Petit Palais* (Paris, 1976), No. 138; V. J. Koudelka, ' "Le Monasterium Tempuli" et la fondation dominicaine de San Sisto', *Archivum Fratrum Praedicatorum*, 31 (1961), 5–81.

[77] For S. Chiara at Assisi, cf. the paintings listed by E. B. Garrison, *Italian Romanesque Panel Painting: An Illustrated Index* (Florence 1949), Nos. 5, 393, 542. For S. Sisto Vecchio, cf. H. Geertman, 'Ricerche sopra la prima fase di S. Sisto Vecchio in Roma', *Atti della pontificia accademia romana di archeologia*, ser. 3, Rendiconti, 41 (1969), 219–28; Garrison, *Italian Romanesque Panel Painting*, No. 488. For the Lippo Vanni, cf. n. 47 above. For Siena, cf. van Os, *Sienese Altarpieces*. Cf. M. F. Nims, *Poetria Nova of Geoffroy de Visnauf* (Toronto, 1967), 42: 'It is a picture which charms from a distance, but displeases the viewer who stands at close range.'

altarpieces, particularly in nunneries and stricter orders?[78] What do we know of the laity's reaction to the growing custom of having painted panels decorating the altars of churches? In this context it would be interesting to establish more dates for the acts of vandalism which so commonly disfigure the persecutors of Christ and His saints in many paintings of the period.[79] Here access is undeniable. In nunneries there are peculiar problems, never really confronted, of the visibility of the altarpiece to the members of the order, and these problems were solved at times by specific architectural means, notably the raised choir at the liturgical west. But in these communities where the community observed the mass through a grille normally behind the high altar, things must have been different.[80] What for example did the Cistercian nuns of Santa Giuliana at Perugia make of the Vigoroso da Siena polyptych which adorned their high altar in the 1280s?[81] Liturgical literature for laymen is a rather rare branch of medieval book-production and one surviving English book implies an ideal of lay behaviour during mass.[82] But we know relatively little of the reactions of those who saw altarpieces on their more or less frequent visits to church. Did they, indeed could they, read the inscriptions on the altars or, as was becoming more common in the later middle ages, the increasingly frequent signatures of artists on the panels themselves?[83] These problems and much else remain for further investigation.

[78] I plan to treat this problem more fully on another occasion. It is at least noteworthy at the beginning of the period under discussion that Geoffroy de Visnauf's *Poetria Nova*, dedicated incidentally to Innocent III, gives some advice about the proper viewing distance for a picture.

[79] For this topic, most recently see the wide-ranging essay by D. Freedberg, *Iconoclasts and Their Motives* (Maarsen, 1985). For an example of damage to a painting believed to be heretical, albeit placed in a family chapel in a Benedictine monastery, cf. the *Assumption of the Virgin* ascribed to Francesco Botticini in the National Gallery in London. See Davies, *Earlier Italian Schools*, 122 ff.

[80] For discussion of nunnery plans in central Italy in the 13th c., cf. M. A. Filipiak, 'The Plans of the Poor Clares' Convents in Central Italy from the Thirteenth Through the Fifteenth Century', Ph.D. thesis (University of Michigan, 1957). Much remains to be done on the topic.

[81] Gardner, 'Fronts and Backs'; F. Santi, *Galleria Nazionale dell'Umbria*, No. 15, 41 ff.

[82] F. Wormald, 'Some Pictures of the Mass in an English XIVth Century Manuscript', *Walpole Society*, 41 (1966–8), 39–45.

[83] P. C. Claussen, 'Früher Künstlerstolz: Mittelalterliche Signaturen als Quelle der Kunstsoziologie', in K. Clausberg *et al.* (eds.), *Bauwerk und Bildwerk im Hochmittelalter* (Giessen, 1981), 7–34.

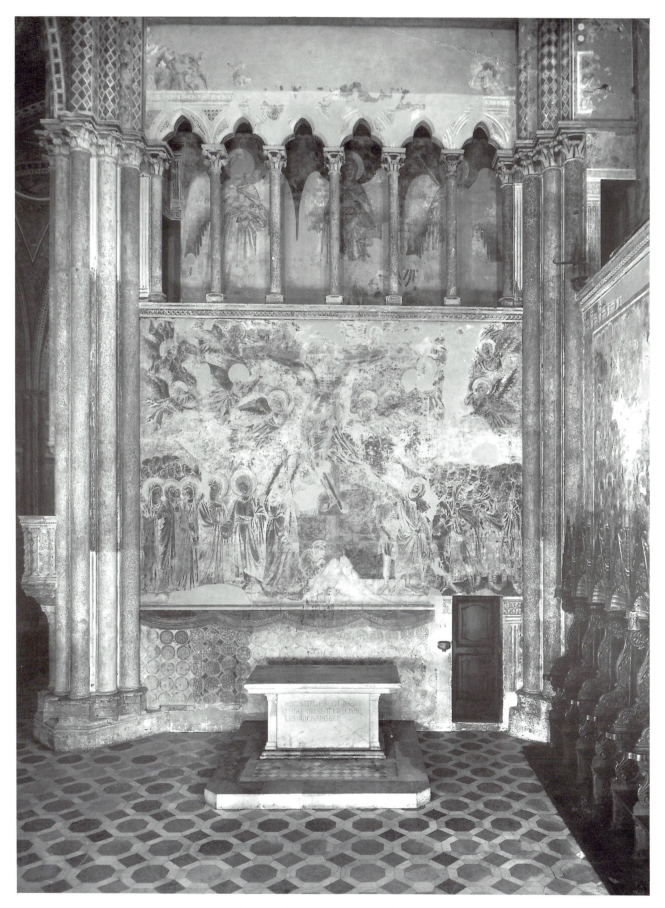

1. Cimabue, *Crucifixion* with altar of St Michael. Assisi, San Francesco, Upper Church, left transept.

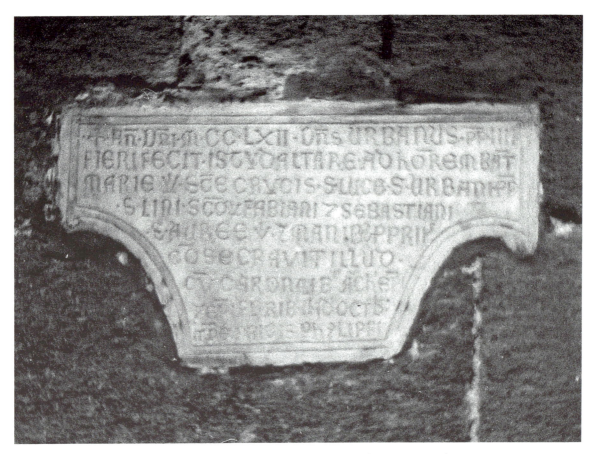

2. Inscription tablet on high altar, 1262. Montefiascone, San Flaviano, Upper Church.

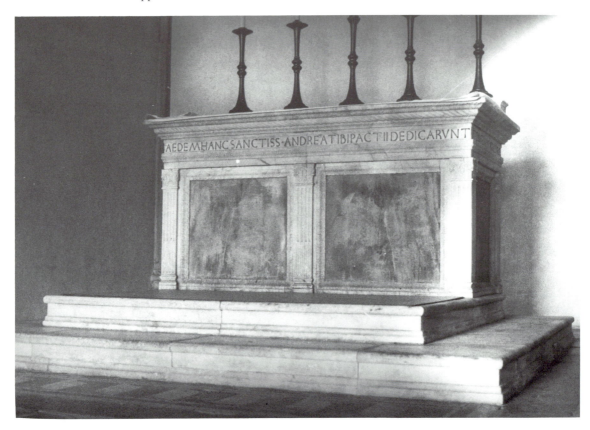

3. Altar. Florence, Santa Croce, Pazzi chapel.

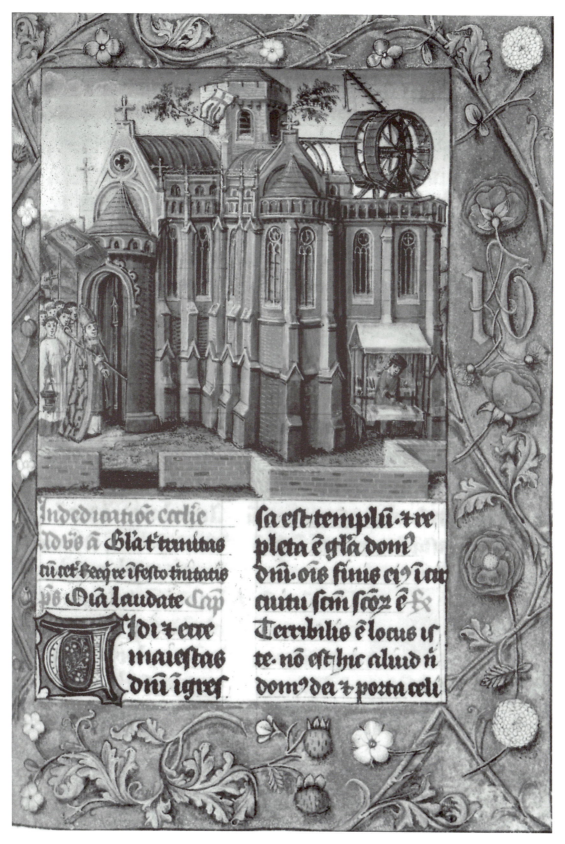

4. Flemish Missal, fifteenth century, *The Consecration of a Church*.
Manchester, John Rylands Library, MS Lat. 39, fo. 146ᵛ.

5. Riminese School, fourteenth century, *The Blessed Reginald Preaching,
Reception of Nicola of Tolentino into the Augustinian Order*, fresco,
Tolentino, Cappellone di San Nicola.

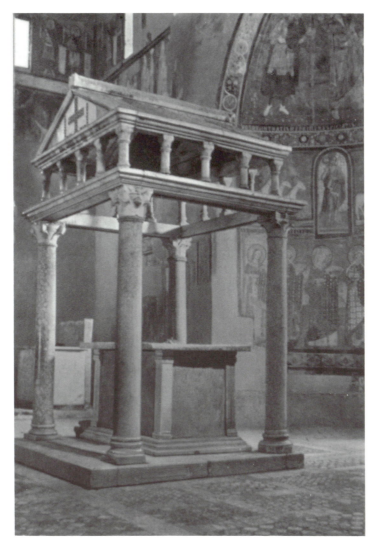

6. High altar. Nepi, Sant' Elia.

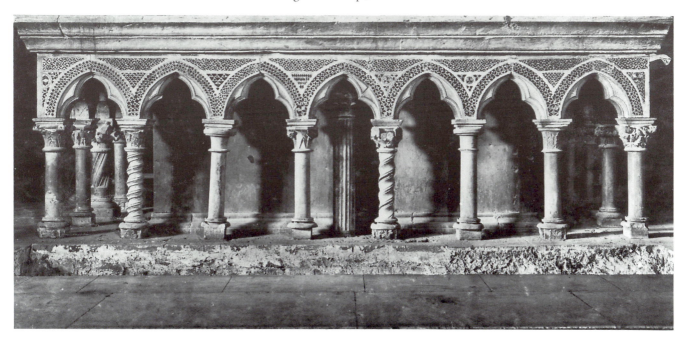

7. High altar. Assisi, San Francesco, Lower Church.

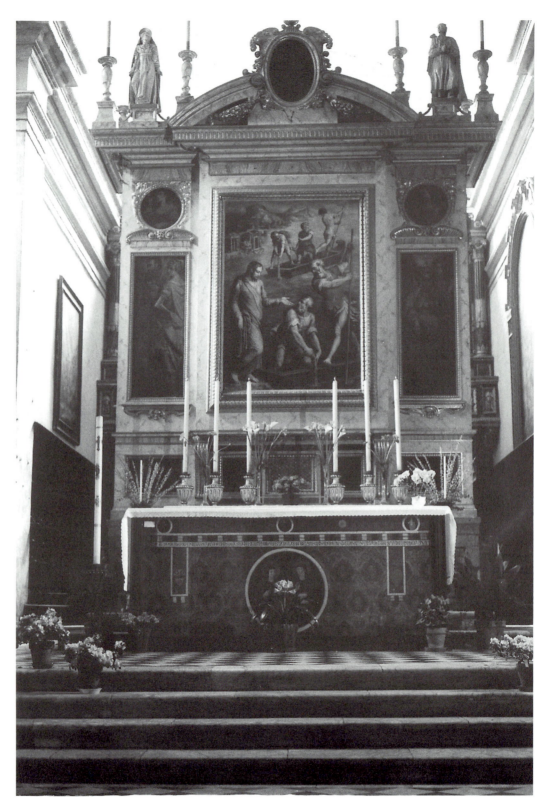

8. Giorgio Vasari, *Calling of Peter and Andrew*, high altar, Arezzo, Sante Fiora e Lucilla (originally in the Pieve).

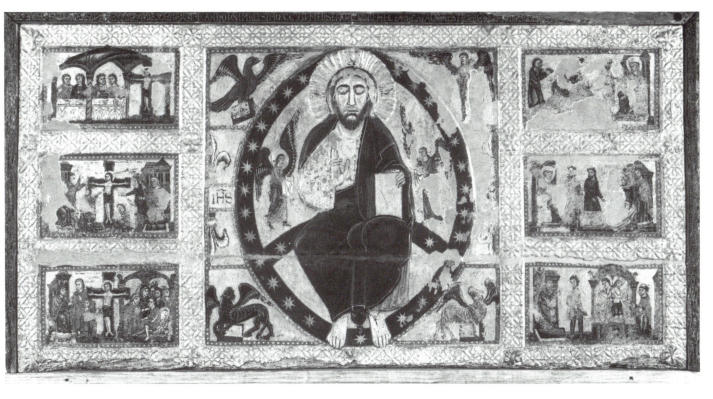

9. Altar dossal from the Abbey of San Salvatore, Castelnuovo Berardenga,
1215. Siena, Pinacoteca, No. 1.

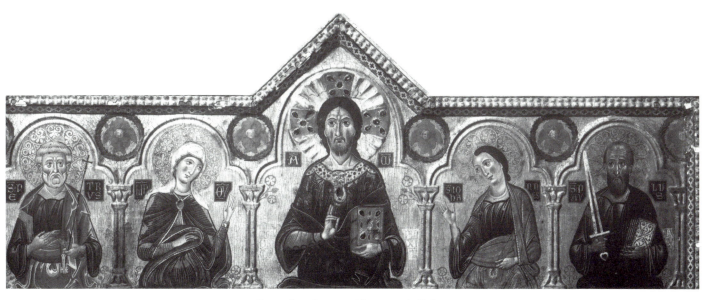

10. Meliore, dossal, 1271. Florence, Uffizi, No. 9153.

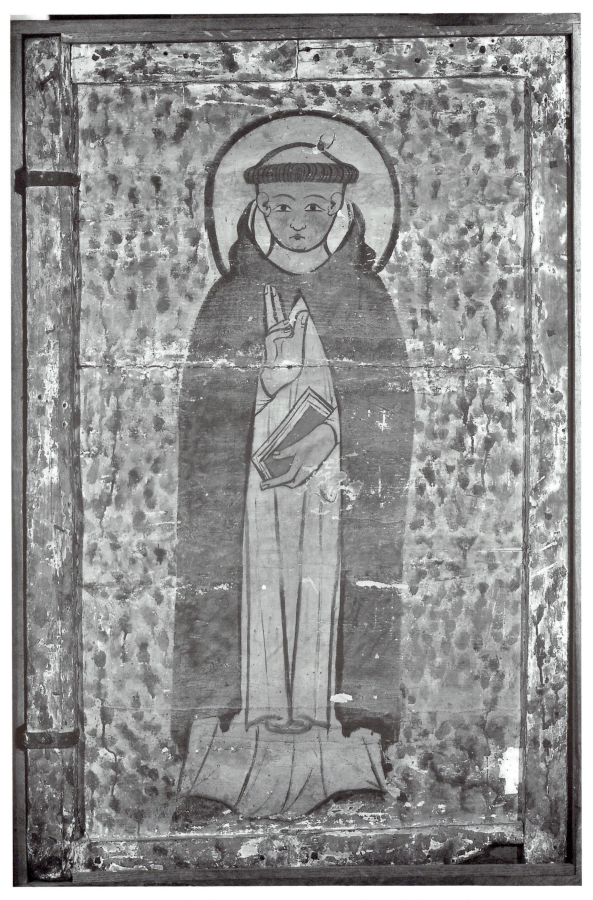

11. Netherlandish (?), *c.*1300. *St Dominic*. Brussels, Musées Royaux des Beaux Arts.

12. *Crucifixion* and *Resurrection* (reverse of Plate 11).

13. Fragment of a Dominican altarpiece from Kloster Altenhohenau, 40·3 × 86·3 cm. Nürnberg, Germanisches Nationalmuseum.

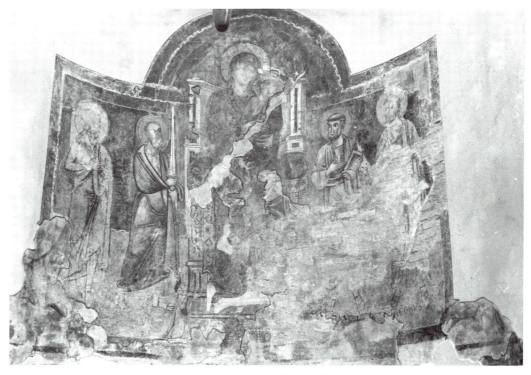

14. *Madonna and Saints* (detail of Plate 15).

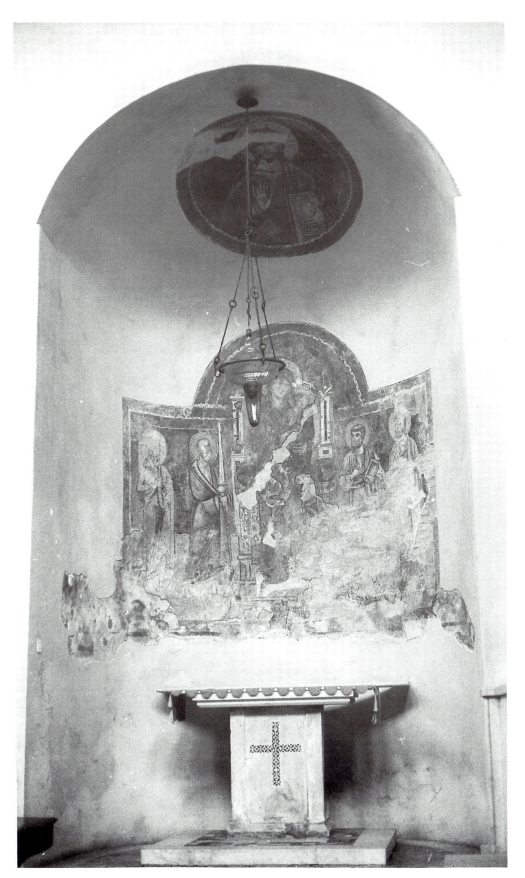

15. Mural altarpiece and altar, *c*.1280. Rome, Santa Balbina.

16. Apse. Rome, San Saba.

17. Ciborium and altar wall. Rome, San Saba.

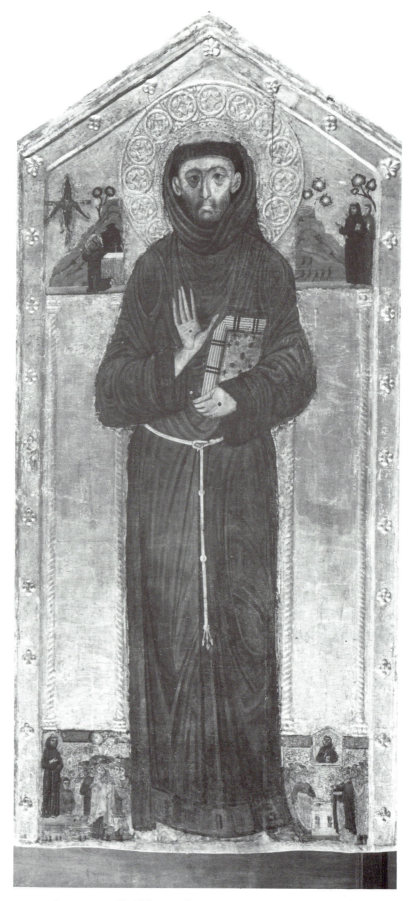

18. Umbrian, second half thirteenth century. *St Francis*, Orte, San Francesco.

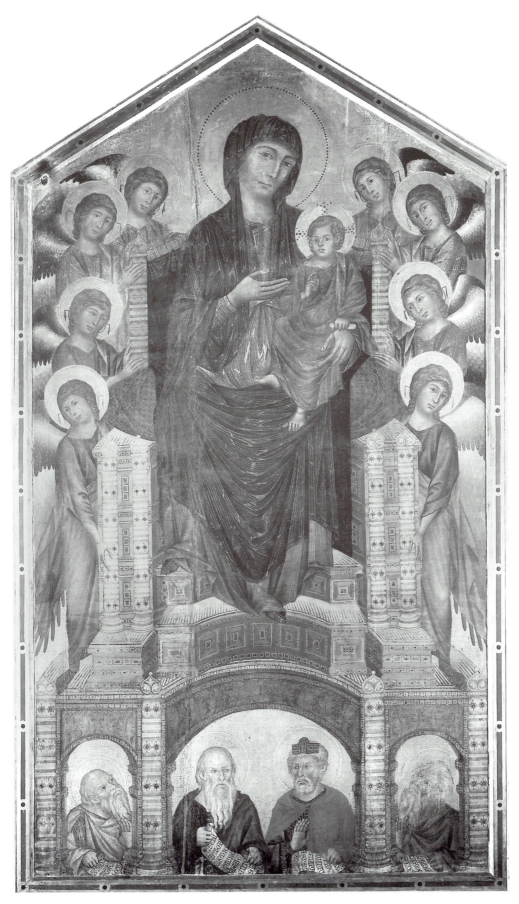

19. Cimabue, *Madonna Enthroned with Angels*. Florence, Uffizi, No. 8343.

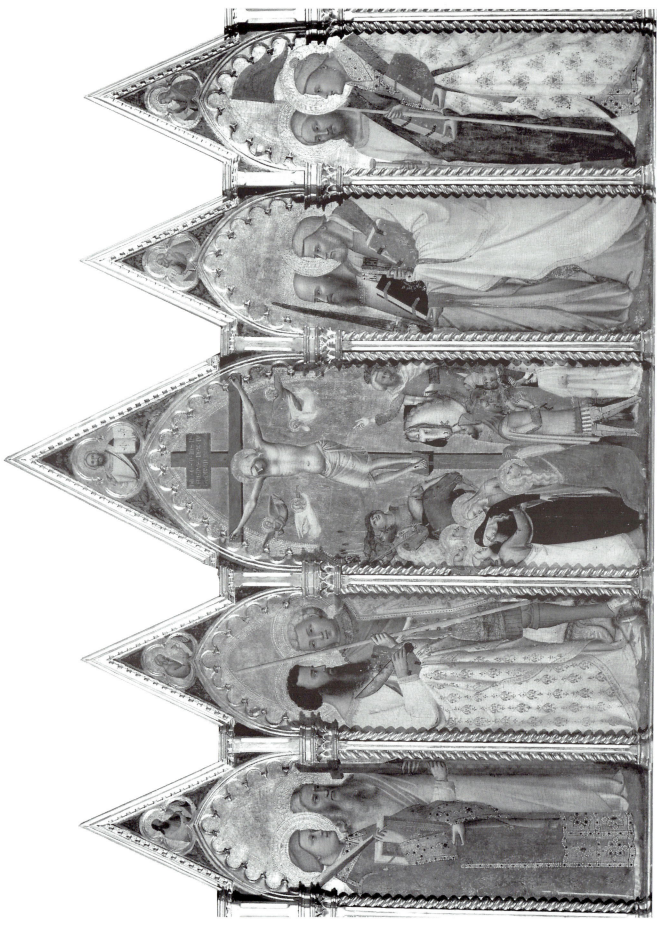

20. Bernardo Daddi, polyptych, 1348. London, Courtauld Institute Galleries.

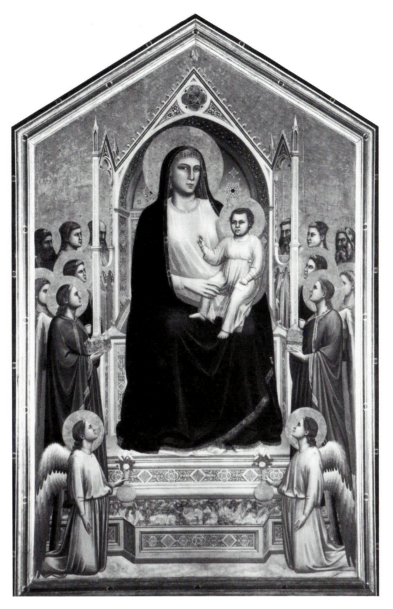

21. Giotto, *Madonna Enthroned*. Florence, Uffizi, No. 8344.

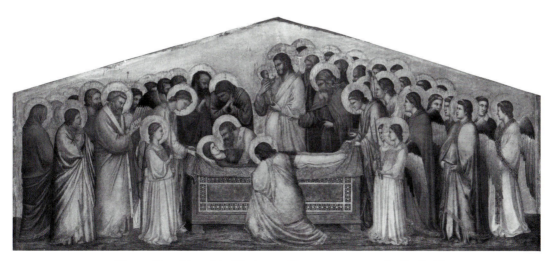

22. Giotto, *Dormition of the Virgin*, panel, 73·7 × 174·8 cm. Berlin-Dahlem,
Gemäldegalerie, No. 1884.

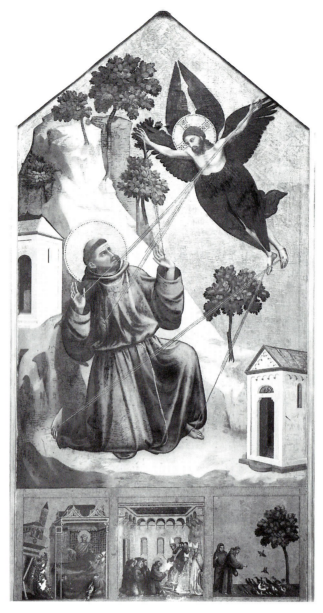

23. Giotto, *Stigmatization*, 31·4 × 16·2 cm. Paris, Louvre, No. 1312.

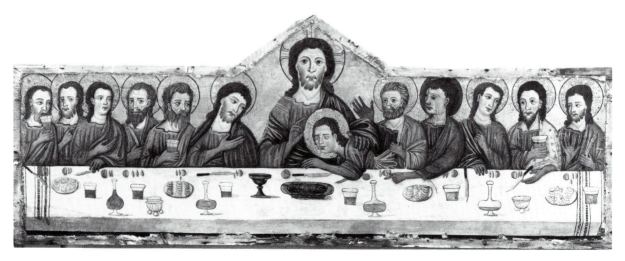

24. Maestro della Maddalena (assisted), *Last Supper*. Avignon, Petit Palais,
No. 138, Inv. 20148.

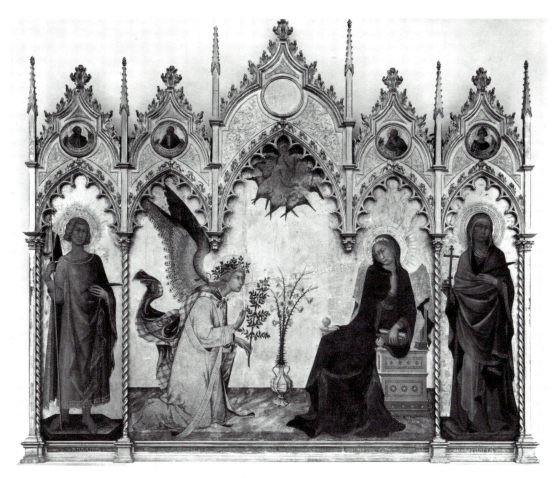

25. Simone Martini and Lippo Memmi, *Annunciation*, 1333.
Florence, Uffizi, No. 452.

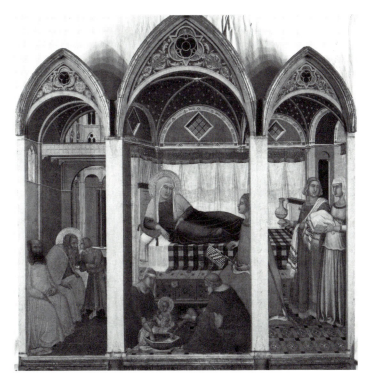

26. Pietro Lorenzetti, *The Birth of the Virgin*, 1342. Siena, Museo
dell'Opera del Duomo.

2

THE CREATION, MEANING, AND AUDIENCE OF THE EARLY SIENESE POLYPTYCH: EVIDENCE FROM THE FRIARS

Joanna Cannon

THE study of polyptychs has traditionally been concerned with questions of attribution and reconstruction. More recently, the physical structure of the polyptych, and, to a lesser extent, the identification of the patron, are issues that have also received close attention. With information from these sources it is now possible to analyse the programmes of certain polyptychs, to ask how the messages which they were intended to convey may have governed their appearance, and to discuss what this new form of altarpiece reveals about those who commissioned and contemplated it. Even when the precise circumstances of the commissioning of a polyptych are obscure, it may still be possible to achieve results by studying works associated with members of the various religious orders.

Considering as a group the polyptychs connected with a single order of friars provides a framework for questions about their creation, meaning, and audience. The present author's article on early Sienese polyptychs connected with the Dominicans,[1] was developed from study of all the forms of art that existed in that Order's central Italian convents before *c.*1325, and the documentary information provided by its legislation and other texts.[2] Little evidence of a policy on art, promulgated by those who governed the Dominicans, was found. But it was argued that

After the I Tatti seminar in preparing this text for publication, I have taken the opportunity to reinstate material and arguments omitted from the talk in the interest of brevity, to consult works available since the paper was originally prepared, and to respond to the discussion which followed. The paper was given again in Spring 1989, at the *Trecento* Seminar held at the University of Warwick. I am most grateful for the stimulating and informative comments made on that occasion by Professor Julian Gardner, Dr Christa Gardner von Teuffel, and Dr Gervase Rosser.

[1] J. Cannon, 'Simone Martini, the Dominicans and the Early Sienese Polyptych', *Journal of the Warburg and Courtauld Institutes*, 45 (1982), 69–93 (and see below n. 63).

[2] Id., 'Dominican Patronage of the Arts in Central Italy: The *Provincia Romana, c.*1220–*c.*1320', Ph.D. thesis (University of London, 1980).

certain friars were instrumental not only in the genesis but also in the design of a series of polyptychs in the first quarter of the fourteenth century. A surprising variety of factors influenced the creation and appearance of these paintings: not only the common training, aims, and mental habits of members of the Order, the cult of saints belonging to the Order, and new canonization processes, but also the financial organization and the administrative grouping of convents; the date and site of chapter meetings; the peripatetic nature of a friar's life; the family from which a friar came; repetition or emulation of admired works, sometimes in a spirit of rivalry; and the resources, tastes, households, and personal devotions of church prelates who were also members of the Order.

I concluded that members of the Dominican Order made a significant contribution to the promotion of the early Sienese polyptych. In a period of artistic experiment and active patronage in many quarters, innovations in both content and form were encouraged by the ambitious requirements of certain Dominican patrons. It might be objected that works such as Siena Pinacoteca polyptych No. 28 (Plate 28), attributed to Duccio, and the Santa Caterina polyptych (Plate 27) by Simone Martini, presumably stood to the east of a substantial screen, visible to all convent members, but less accessible to the laity.[3] But it would be wrong to regard these polyptychs as isolated pieces, known well to only a small number of people, and unlikely to influence the course of art outside the convent walls. The Dominican friar owed his allegiance to the Order as a whole, rather than to the convent in which he had made his profession, and in the course of his career he might travel extensively: first to another *studium* within his province; then, if he was gifted, to a *studium generale* or to Paris; later to different administrative posts in the convents of his province, and, in many cases, to attend annual provincial or general chapter meetings.[4] Thus awareness of an impressive altarpiece could have spread quickly through the Order. In the first quarter of the fourteenth century Sienese artists worked on Dominican-related commissions for Pisa, Perugia, Orvieto, Florence, and Montepulciano, influencing local painters, as well as expanding their own careers.

It was initially intended that this chapter should summarize the state of research concerning the early Sienese polyptych and the friars, comparing studies of other orders with the present author's work on the Dominicans. Despite the work of the last ten years, however, we are still some distance from a broad understanding of art and the friars.[5] At this stage it is possible to begin

[3] For screens, see M. B. Hall, 'The *ponte* in S. Maria Novella: The Problem of the Rood Screen in Italy', *Journal of the Warburg and Courtauld Institutes*, 37 (1974), 157–73; id., 'The Italian Rood Screen: Some Implications for Liturgy and Function', in S. Bertelli and G. Ramakus (eds.), *Essays Presented to Myron P. Gilmore*, ii (Florence, 1978), 213–18. The question of lay access is raised in D. Blume, *Wandmalerei als Ordenspropaganda: Bildprogramme im Chorbereich franziskanischer Konvente Italiens bis zur Mitte des 14. Jahrhunderts* (Worms, 1983), 100–6.

[4] A broad picture of Dominican careers is provided by the surviving obituary lists, discussed in Cannon, 'Dominican Patronage of the Arts', app. 2, 465–79.

[5] Publication of polyptychs connected with the friars have tended to concentrate on a single work. A notable exception is C. Gardner von Teuffel, 'Masaccio and the Pisa Altarpiece: A New Approach', *Jahrbuch der Berliner Museen*, 19 (1977), 23–68, esp. 37, 53–7. See also id., 'The Buttressed Altarpiece: A Forgotten Aspect of Tuscan Fourteenth Century Altarpiece Design', *Jahrbuch der Berliner Museen*, 21 (1979), 21–65, a wide-ranging study which also touches on questions of mendicant patronage. H. W. van Os, *Sienese Altarpieces*, i (Groningen,

formulating enquiries, but much harder to propose answers. It will not be feasible to present here a detailed analysis of major works, but we can outline the range of material for each Order, and give an indication of some of the questions which can be asked.

The Augustinians

It will be convenient to begin with the Augustinians, the only mendicant order whose roots lie partly in the Sienese *contado*,[6] and who placed a *studium generale* in Siena.[7] Seidel, Butzek, and Bagnoli's work on Sant' Agostino in Siena provides a fascinating insight into this convent's use of both panel painting and fresco decoration.[8] For instance, they have shown how Simone Martini's panel of Beato Agostino Novello (Plate 35) not only promoted the new saint's cult, but also expressed a dichotomy within the Order itself. By the time the painting was commissioned, *c.*1324, the Order was principally an urban one, which resembled the Dominicans in its legislation and study organization. But its origins lay in the union of a number of Tuscan eremitical groups in 1244, and the Augustinians looked back before the thirteenth century for their supposed origins. These they traced to St Augustine, as author of their rule, and, on the other hand, to the first hermits in Egypt, St Anthony Abbot and St Paul the Hermit, from whom the communities were thought to descend.[9] Agostino Novello, the well-travelled, well-educated Augustinian, is shown

1984), devotes chapters to 'The Altarpieces of the Urban Religious Orders' (21–38), and 'Early Sienese Polyptychs' (63–75). These are primarily concerned with major works, and provide a résumé of recent work in the field, with some new proposals. Beyond the subject of polyptychs, much useful central Italian Franciscan material is gathered together in the exhibition catalogues *Francesco d'Assisi*, 3 vols. *Chiese e conventi, storia e arte, documenti e archivi, codici e biblioteche, miniature* (Milan, 1982). For the Franciscans see also the valuable Blume, *Wandmalerei als Ordenspropaganda, passim*. For the range of Augustinian patronage in Siena, see the work of Seidel, Butzek, and Bagnoli, cited in n. 8 below.

⁶ For the early history of the Order see esp. K. Elm, 'Neue Beiträge zur Geschichte der Augustiner-Eremitensordens im 13. und 14. Jahrhundert', *Archiv für Kulturgeschichte*, 42 (1960), 357–87; B. Van Luijk, *Le Monde augustinien du XIIIᵉ au XIVᵉ siècle* (Assen, 1972); D. Gutiérrez, *Los Agustinos en la edad media 1256–1356, Historia de la orden de San Agustín*, vol. i, pt. 1 (Rome, 1980). For the central Italian provinces see E. Roth, 'Cardinal Richard Annibaldi: First Protector of the Augustinian Order (1243–1276)', *Augustiniana*, 2 (1952), 26–60, 108–49, 230–47; 3 (1953), 21–34, 283–313; 4 (1954), 5–24; B. Van Luijk, *Gli eremiti Neri nel Dugento con particolare riguardo al territorio Pisano e Toscano: Origine, sviluppo ed unione* (Pisa, 1968); with criticisms in K. Elm, 'Gli eremiti Neri nel Dugento: Ein neuer Beitrag zur Vorgeschichte des Augustiner-Eremitensordens', *Quellen und Forschungen aus italienischen Archiven und Bibliotheken*, 50 (1971), 58–79.

⁷ *Acta cap. gen.*, 'Antiquiores quae extant definitiones Capitulorum Generalium Ordinis', 'Viterbense, 1312', *Analecta Augustiniana*, 3 (1909–10), 152–3; *Acta cap. prov.*, 'Capitula antiqua Provinciae Romanae O.N., Urbeveteri, 1315', *Analecta Augustiniana*, 3 (1909–10), 174–5.

⁸ M. Seidel, 'Die Fresken des Ambrogio Lorenzetti in S. Agostino', *Mitteilungen des Kunsthistorischen Institutes in Florenz*, 22 (1978), 185–252; M. Butzek, 'Altar des sel. Augustinus Novellus', in P. A. Riedl and M. Seidel (eds.), *Die Kirchen von Siena*, i (Munich, 1985), 1–273, esp. 210–12; A. Bagnoli and M. Seidel in the exhibition catalogue *Simone Martini e 'chompagni'* (Florence, 1985), eds. A. Bagnoli and L. Bellosi, 56–61, 68–72; M. Seidel, 'Ikonographie und Historiographie, "Conversatio Angelorum in Silvis", Eremiten-Bilder von Simone Martini und Pietro Lorenzetti', *Städel Jahrbuch*, NS 10 (1985), 77–142; id., 'Condizionamento iconografico e scelta semantica: Simone Martini e la tavola del Beato Agostino Novello', in L. Bellosi (ed.), *Simone Martini: Atti del convegno*, Siena, 1985 (Florence, 1988), 75–80.

⁹ See the bibliography cited by Seidel, 'Ikonographie und Historiographie', esp. 129, 139–40, to which may now be added, K. Elm, 'Elias, Paulus von Theben und Augustinus als Ordensgründer: Ein Beitrag zur Geschichtsschreibung und Geschichtsdeutung der Eremiten- und Bettelorden des 13. Jahrhunderts', in H. Patze (ed.), *Geschichtsschreibung und Geschichtsbewusstsein im späten Mittelalter*, Vorträge und Forschungen, 31 (Sigmaringen, 1987), 371–97.

by Simone Martini in a wooded setting suitable for a hermit, with the figures of two earlier venerated Augustinian hermits in the roundels above.

Both these strands are also illustrated in the polyptychs associated with the Order. The earliest surviving polyptych which can reasonably be connected with the Order is a work attributed to the Maestro di Città di Castello, now divided between the Pinacoteca in Siena (Nos. 29–32)[10] and the Museo dell'Opera del Duomo (Plate 29).[11] The panels came to these collections from the church of Santa Cecilia at Crevole,[12] but Lusini records their earlier provenance as the Eremo di Montespecchio,[13] which joined the Augustinian group of Tuscan hermitages in 1255.[14] In the main panels the artist has used a formula similar to that found in polyptych No. 28 in the Pinacoteca generally attributed to Duccio (Plate 28), which may have come from San Domenico, Siena.[15] A hermit saint, probably St Anthony Abbot,[16] occupies the position taken by St Dominic in the Dominican work. Towards the centre, Sts Peter and Paul are retained. Their inclusion may have an air of inevitability to our eyes, but the canon of figures to be included in a polyptych was only gradually being established in the first two decades of the century, and the two Sts John may well have been more popular at this stage.[17] Presumably this reference to apostolic predecessors and papal power would have been legible to all members of mendicant orders, living the apostolic life and answerable directly to the Pope rather than to the local bishops. For Dominican viewers the figures carried additional meaning: St Dominic had been granted a vision in which St Peter and St Paul presented him with a staff and book, providing both theological and physical support for his mission.[18] St Augustine is another figure who is visually similar on both polyptychs, but was seen with different eyes. In the Dominican altarpiece he forms a pendant to St Dominic, as writer of the rule which Dominic adopted for his own Order. But in the Maestro di Città di Castello's painting for Montespecchio (Plate 29) he is not only the writer of the Rule but also the man for whom the Order was named and thus, in a sense, its founder. Surprisingly, Augustine is the only figure *not* holding a book. Instead he holds his crozier with his left hand and gestures with his right hand in the direction of the hermit saint who is at the far right of the polyptych and who,

[10] Overall dimensions: 96 × 151 cm. P. Torriti, *La Pinacoteca Nazionale di Siena*, i (2nd edn., Genoa, 1980), 66.

[11] 44 × 39 cm. J. H. Stubblebine, *Duccio di Buoninsegna and His School* (Princeton, NJ, 1979), i, 86–7.

[12] Ibid.

[13] V. Lusini, 'Per lo studio della vita e delle opere di Duccio di Buoninsegna', *Rassegna d'arte senese*, 9 (1913), 24. Lusini proposes a date of 1307 for the polyptych, to coincide with the reported date of the reconsecration of the church at Montespecchio.

[14] M. B. Hackett, 'The Medieval Archives of Lecceto', in *Miscellanea Ordinis Sancti Augustini Historica in honorem P. D. Gutiérrez O.S.A.*, i, *Analecta Augustiniana*, 40 (1977), 29.

[15] Cannon, 'Simone Martini', 79.

[16] The joint dedication of Montespecchio to the Virgin and St Anthony supports this identification. Lusini, 'Per lo studio della vita', 21, 31.

[17] e.g. Guido da Siena, Siena, Pinacoteca, No. 7; Vigoroso da Siena, Perugia, Gall. Naz. dell'Umbria, No. 32; Duccio, Siena, Pinacoteca, No. 47; Pietro Lorenzetti, Arezzo, Pieve. The Segna di Bonaventura in New York, Metropolitan Museum (*John the Evangelist*) and at Assisi, S. Francesco, Museo (*John the Baptist*), were part of the same polyptych. The two Sts John were, of course, available as models, nearer to the Virgin and Child than Sts Peter and Paul, on the front of Duccio's *Maestà*.

[18] Constantinus de Urbeveteri, 'Legenda beati Dominici', in *Monumenta Ordinis Praedicatorum Historica*, ed. H. C. Scheeben, 16 (Rome, 1935), 304.

on this occasion, *does* hold a book, and to whom Augustine has apparently entrusted a copy of his Rule.[19]

Is this carefully considered altarpiece an isolated example, perhaps the fruit of one friar's preoccupations and enthusiasm, or is there other early evidence of an interest in Sienese painting in general, and the polyptych in particular, within the Augustinian Order? It appears that the Augustinians, like their fellow mendicants, played a part in welcoming paintings of the Virgin and Child into their churches. A panel which followed the same route from Montespecchio, via Crevole, to the Museo dell'Opera del Duomo in Siena, is the *Virgin and Child* generally attributed to Duccio, known as the *Madonna di Crevole* (Plate 30).[20] If Montespecchio was indeed the panel's original home, the significance of the Augustinian Order for the development of Sienese painting may be considerable.[21]

Firm evidence for a commission is found in the *Giornale del convento di Lecceto*. This account book for the *opera* of the church, noted by Bacci, records in December 1317 a partial payment of 4 florins to Segna '*dipintore, per parte di denari che ha d'havere della tavola che ci fa per l'altare*'.[22] Since this is only a part-payment, it is not possible to gauge the scale and type of the work, but it appears to have been destined for the main altar in the church. Bacci linked this document with a panel of the Virgin and Child now in the Seminario arcivescovile di Montarioso in Siena (Plate 38).[23] This has generally been accepted,[24] and it has recently been argued by Padovani that the Seminario panel once formed the central section of a large polyptych.[25]

Information exists about altarpieces in a third Augustinian hermitage in the Sienese *contado*. Bacci published a versified description of San Leonardo al Lago (a foundation which joined with San Salvatore di Lecceto in 1252).[26] The *cantilena*, written in 1611, includes passages on three altarpieces in the church. The high altarpiece represented the *Virgin and Child* with six full-length saints, and a narrative predella, with four small figures of female saints.[27] Carli says that this work has disappeared without trace.[28] Although none of the subject-matter described precludes a date

[19] For a variation of the visual theme on the codex as Augustinian Rule, see Seidel's discussion of the three volumes held by St Augustine in Ambrogio Lorenzetti's frescoed *Maestà* for S. Agostino in Siena (Plate 36). Seidel, 'Die Fresken des Ambrogio Lorenzetti', 219.

[20] 89 × 60 cm. Lusini, 'Per lo studio della vita', 25–7.

[21] It might even be argued, although I would certainly not press the point, that certain elements in the Maestro di Città di Castello's work—the Child pulling at the Virgin's head-dress, in this case updated as a veil, and the insistently diaphanous nature of that veil—are conscious references to the pose and garments of the Christ Child in the earlier image.

[22] Excerpt printed in P. Bacci, *Fonti e commenti per la storia dell'arte senese* (Siena, 1944), 37–8.

[23] 96·5 × 62·5 cm.

[24] E. Carli, 'Nuovi studi nell'orbita di Duccio di Buoninsegna', *Antichità viva*, 11/6 (1972), 10–12, but with the exception of Stubblebine, *Duccio di Buoninsegna*, i, 141–6, who

created a separate 'Seminary Madonna Master' on stylistic grounds.

[25] S. Padovani, in *Mostra di opere d'arte restaurate nelle provincie di Siena e Grosseto II*, Siena, 1981 (Genoa, 1981), 32.

[26] P. Bacci, 'S. Leonardo al Lago e gli affreschi lorenzettiani in una cantilena del XVII sec.', *Rassegna d'arte senese: La Balzana*, 5, NS I (1927), 35–9. For an outline of the history of Lecceto and its relations (often previously misunderstood) with S. Leonardo al Lago and Montespecchio see Hackett, 'The Medieval Archives of Lecceto', 1–45.

[27] The *Virgin and Child* were accompanied by *Sts Martin, Augustine, John the Baptist, Bartholomew, Leonard*, and *Paul*. The predella represented the *Agony in the Garden*, the *Betrayal*, the *Crucifixion*, the *Deposition* (?), and the *Entombment*, and *Sts Catherine, Agnes, Thecla*, and *Agatha*.

[28] E. Carli, *Lippo Vanni a San Leonardo al Lago* (Florence, 1969), 20 n. 43.

in the first half of the fourteenth century, it is hard to tell from the seventeenth-century text whether the altarpiece was a polyptych of the fourteenth or of the fifteenth century or, indeed, a fifteenth-century *pala*.[29]

Carli also notes the disappearance of the second altarpiece described, but in this case there is some evidence to suggest a work of the fourteenth century. The record of a visitation of San Leonardo al Lago made in 1638, in connection with the examination of the cult of Beato Agostino Novello,[30] has been noted by Seidel.[31] This says that the painting, which was *antiqua*, represented the Virgin and Child flanked by St John the Baptist, St Augustine, St Leonard (dressed as an Augustinian and holding a red book) and B. Agostino Novello, with an angel by his ear. The versified description also tells us that there were half-length figures,[32] and that at the top of each panel was an angel and, at the centre, presumably above the Virgin and Child, the figure of Christ.[33] This description would fit the type of single-storey polyptych produced in the fourteenth century. Moreover, Seidel remarks that trustworthy seventeenth-century sources mentioned a painting with this iconography, executed either by Simone Martini or Lippo Memmi, in San Leonardo al Lago.[34] The polyptych programme described in the sources is carefully planned: in addition to St Augustine, St John the Baptist is chosen, presumably as a reference to the eremitical life, while St Leonard is presented in the guise of an Augustinian, balancing the more recent figure, Agostino Novello, who spent his last days at San Leonardo al Lago.[35]

The third altarpiece is described as a triptych, with the Virgin and Child with two angels, flanked by St Augustine and St Anthony Abbot. In this case there is no room for doubt about the date, for the work still exists in a private collection in Palazzo Gondi in Florence (Plate 32).[36] It is clearly a Ducciesque work of high quality. Boskovits attributed the *Virgin and Child Enthroned* with two half-length angels looking over the throne back[37] to Segna di Bonaventura, and he characterized the two full-length figures of *St Augustine* (with crozier and book) and *St Anthony Abbot* (with tau-headed staff and book) as close to the Master of the Buonconvento Cross.[38] The combination of an enthroned Virgin and Child with full-length saints on separate panels suggests the influence of Pietro Lorenzetti's Carmelite altarpiece of 1329 (Plate 33). The pose and drapery of the *St Augustine* are reminiscent of Lorenzetti's *St Nicholas* in the Carmelite altarpiece, but the

[29] Bacci, 'S. Leonardo al Lago', 38–9, says that a date of 1266 given in the margin of the manuscript has no historical basis. Bacci describes the work as '*di maniera ducciana*', and says that the painting had been moved to Florence, but this appears to be a confusion with the triptych discussed below.
[30] Appended to Agostino Novello's *Vita* in the *Acta Sanctorum*, Maii, iv (Antwerp, 1685), 622.
[31] Seidel, 'Ikonographie und Historiographie', 127.
[32] '*Et son tutti di meza figura*'. Bacci, 'S. Leonardo al Lago', 39.
[33] '*Et a capo di ciascun santo v'é dipinto un Angel santo con un Cristo in mezo di loro*', ibid.
[34] Seidel, 'Ikonographie und Historiographie', 127.

[35] For the representation of St Leonard as an Augustinian, see ibid. 112–29.
[36] 158 × 165 cm., Carli, *Lippo Vanni*, 20 n. 43.
[37] Reproduced in L. Ginori Lisci, *I palazzi di Firenze nella storia e nell'arte* (Florence, 1972), ii, 589, fig. 476; 591.
[38] M. Boskovits, review of J. H. Stubblebine, *Duccio di Buoninsegna and His School*, in *Art Bulletin*, 64 (1982), 501, fig. 11 (side saints) 502. The provenance of the panels has also been mentioned in L. Cateni, 'Appunti sul "Goodhart Master"', *Prospettiva*, 45 (1986), 63–6, where the Virgin and Child are attributed to the Goodhart Master and the side saints are called 'in stretta relazione con Segna di Bonaventura'.

Virgin and Child recall earlier, Ducciesque models. The explanation may be that an independent panel of the Virgin and Child was added to, at some time after 1329, so as to provide a grander altarpiece,[39] making reference to two of the strands in the Order's supposed origins.[40]

The connection between the Augustinians and polyptychs of high quality is further confirmed by the existence of an altarpiece, formerly signed by Simone Martini, from the Augustinian church in San Gimignano, and now dispersed in Cambridge, Cologne, and a private collection (Plate 31).[41] Steinweg and Klesse reconstructed the altarpiece as a heptaptych, with two missing panels. Kreytenberg's proposal that the altarpiece was always a pentaptych has recently been confirmed by Gordon's conclusive study of the technical evidence; she corrects Kreytenberg's arrangement of the panels by establishing that St Augustine and St Geminianus originally formed the outer panels of the altarpiece.[42] As at Montespecchio, the church already seems to have possessed a Sienese panel of the Virgin and Child, in this case a Guidesque painting of the *Virgin and Child Enthroned*, with two kneeling intercessory figures, identified by Carli as St Augustine [?] and Beata Giuliana Corneliense.[43] But, unlike Montespecchio, this convent was an urban foundation, established inside the city walls of San Gimignano in 1280.[44]

The city's patron saint, St Geminianus (Plate 31), makes a rare appearance, inviting the speculation not only that the friars were using Simone's work to make a statement about their position in the town, but also that, as was sometimes the case in Siena, the *Comune* of San Gimignano may have offered some funds towards the cost of the altarpiece.[45]

St Catherine's inclusion on a Sienese polyptych may appear routine, but it is unusual to find her holding a book in addition to her martyr's palm and wheel (Plate 31). This detail calls to mind Seidel's cogent exposition of the reasons for her inclusion in the Lorenzettian frescoed decoration of the chapter house of Sant' Agostino in Siena (Plate 36).[46] Presumably we have here an earlier

[39] Since I have not had the opportunity to examine these panels, I do not know whether the carpentry provides any supporting evidence.

[40] Two inscriptions at the base of the panels, if original, underline this: scs AGVSTINVS DOCTOR; scs ANTONIVS HEREÎT.

[41] *St Michael*: 110 × 38·2 cm., *St Geminianus*: 109·5 × 38 cm., *Virgin and Child*: 79 × 55·6 cm., *St Augustine*: 109·5 × 38 cm., *St Catherine*: 110 × 38·5 cm. For a full account of the discovery of the provenance of the panels and further bibliography, see C. De Benedictis, 'Simone Martini a San Gimignano e una postilla per il possibile Donato', in L. Bellosi (ed.), *Simone Martini: Atti*, 187–91.

[42] D. Gordon, 'Simone Martini's Altar-piece for Sant' Agostino, San Gimignano', *Burlington Magazine*, 133 (1991), 771; G. Kreytenberg, 'Zum gotischen Grabmal des heiligen Bartolus von Tino di Camaino in der Augustinerkirche von San Gimignano', *Pantheon*, 46 (1988), 21–5, with relevant bibliography; fig. 26 on p. 24, is reproduced in reverse. This reconstruction is also used in the photomontage in L. Bellosi (ed.), *Simone Martini: Atti*, 17, pl. v. Kreytenberg also proposes

that the altarpiece, originally approx. 200 cm. wide, stood on the altar '*allato alla porta—del fianco*', as described in 1558 by Borghini, which was dedicated to St Catherine.

[43] 170 × 134 cm. Seen by Brogi in the sacristy of S. Agostino in 1865, now in the Museo Civico, S. Gimignano. E. Carli, *Dipinti senesi del contado e della Maremma* (Milan, 1955), 15–33. Van Os, *Sienese Altarpieces*, 30–1, suggests that the Augustinian patrons specifically commissioned a smaller version of Guido's Palazzo Pubblico *Madonna*, painted for the Dominicans of Siena.

[44] The community began outside the city walls in 1272 and the church inside the walls was consecrated in 1298. Carli, *Dipinti senesi*, i, 19.

[45] For Siena, see below, n. 70. Documents published by Kreytenberg, 'Zum gotischen Grabmal', 25, show that the *comune* of S. Gimignano stepped in, in 1327, to help the friars with the cost of completing the chapels and tomb built in their church for San Bartolo.

[46] Seidel, 'Die Fresken des Ambrogio Lorenzetti', 202–5.

example of her association, in Augustinian perception, with the virtues of learned preaching. In this connection one might interpret her elegant gesture, left thumb touching right little finger, as the preacher's action of counting off the points to be made in a sermon on the fingers of one hand.

The figure of *St Michael* (Plate 31) is also treated in an unusual way. He is not normally seen in a non-narrative context holding the scales of judgement. Perhaps this is, in part, a reference to the eschatological content of Augustinian preaching and teaching.[47] The anonymous saved soul in the scale presumably indicates that the commissioning of this panel was, at least in part, an individual initiative.

Of particular interest is Simone's handling of the problem presented by the inclusion of *St Augustine* (Plate 31). To be immediately recognizable he has to be shown as a bishop saint, dressed in a suitably ornate cope, as in Siena Pinacoteca polyptychs No. 28 and Nos. 29–32 (Plates 28–29). Yet to be similar to all other representations of the saint might diminish his special significance within a painting viewed by members of the Augustinian Order. Several mendicant orders looked to much earlier generations for their supposed founders. Heinrich of Friemar's *Tractatus de origine et progressu ordinis fratrum heremitarum et vero ac proprio titulo eiusdem* of 1334, and John of Cheminot's *Speculum fratrum Ordinis Beatae Mariae de Monte Carmeli* of 1337, presented these claims in detailed form for the Augustinians and Carmelites.[48] In both texts an unbroken tradition was traced from venerated founders to present-day Order, with those supposed founders regarded as members of the Order in question, and thus dressed, with curious logic, in the respective order's current fourteenth-century habit. Heinrich of Friemar noted with satisfaction that his order's roots were thus far older than those of the Dominicans or Franciscans,[49] and the Carmelites made even more far-reaching claims for the antiquity of their foundation.[50]

While the desire to formulate and set down in writing an Order's pre-mendicant history seems to have been in the air in Paris (and among those trained in Paris) in the 1330s,[51] the impulse to give legitimacy to these aspirations by visual means was felt in and around Siena some years earlier. Pietro Lorenzetti's altarpiece for the Carmelites (Plate 33) was completed in 1329.[52] The date of Simone Martini's San Gimignano polyptych (Plate 31) is not known, but proposals range from *c.*1317 to, at the very latest, the middle of the 1330s, with the majority opinion favouring a date in the first half of the 1320s.[53] Thus it is probable that Simone's work precedes Heinrich of

[47] Another image of St Michael which occurs in the church is a large, fragmentary fresco, flanking the Virgin and Child. E. Carli, 'Ancora dei Memmi a San Gimignano', *Paragone*, 159 (1963), 36–7, figs. 29, 30, suggests that it may be Lippo Memmi's earliest work.

[48] For detailed consideration of the Augustinian material and the essential bibliography, see Seidel, 'Ikonographie und Historiographie', esp. 99–116, 126–9. For the Carmelite material and bibliography, see J. Cannon, 'Pietro Lorenzetti and the History of the Carmelite Order', *Journal of the Warburg and Courtauld Institutes*, 50 (1987), 18–28.

[49] R. Arbesmann (ed.), 'Heinrich of Friemar's Treatise on the Origin and Development of the Order of the Hermit Friars and its True and Real Title', *Augustiniana*, 6 (1956), 109, cited by Seidel, 'Ikonographie und Historiographie', 104.

[50] See Cannon, 'Pietro Lorenzetti', 21, 24–6.

[51] Ibid. 26–8; Heinrich of Friemar's treatise is dated 1334, some years after his term as *Magister* in Paris.

[52] See the discussion of this work, below.

[53] For a recent summary of opinions, see C. De Benedictis in the exhibition catalogue, A. Bagnoli and L. Bellosi (eds.), *Simone Martini e 'chompagni'*, Siena, 1985 (Florence, 1985), 47–51. She proposes there, and in De Benedictis, 'Simone Martini a San Gimignano', 188–9, a date of *c.*1317, which is accepted in

Friemar's treatise, and Seidel has argued that the representation of St Augustine in the habit of an Augustinian friar was itself preceded by an image of St Leonard dressed in this manner, in the reconstructed polyptych from Santi Leonardo e Cristoforo in Monticchiello (Plate 34), placed by Seidel and Maginnis in Pietro's earliest known period, c.1315.[54] Heinrich of Friemar tells us that following his baptism St Augustine wore a black cowl and a belt, signs of his links with the followers he was to have in the Augustinian Order.[55] This description accords with the revealingly anachronistic images of St Leonard cited by Seidel, but the representation of St Augustine presented an artist with a more delicate problem. As noted above, the figure had to combine, for the purposes of identification, the dress of both bishop and friar. Simone appears to have been the first to solve this visual dilemma by revealing Augustine's Augustinian habit beneath his parted cope in the San Gimignano polyptych (Plate 31). This solution soon found favour and was often repeated.[56] Simone may have got the idea by simply observing the dress of Augustinian bishops, or perhaps his previous experience of painting the figure of St Louis of Toulouse, who always wore his Franciscan habit beneath his episcopal cope, suggested to the artist a similar treatment for St Augustine. In the context of the present study, it is notable that the supposed founders of both the Augustinian and Carmelite Orders first appear in their new garments in the panels of polyptychs.

There may be less than a decade between the production of the Montespecchio and San Gimignano polyptychs,[57] yet the difference in programme is considerable (Plates 29, 31). The choice of saints in the earlier work reminds the viewer of the eremitical traditions of the Order, while the choice in the later work carries connotations of preaching, study, personal salvation, and civic pride. This may partly reflect a gradual change in the concerns of the Order. For instance, amendments about this time to the legislation concerning election procedures favoured the opinions and votes of those who had been in the Order's Paris *studium*.[58] But the contrast may also reflect contemporary differences of character between an older eremitical community and a more recent, urban foundation.[59]

A. Martindale, *Simone Martini* (Oxford, 1988), 28, 200–1. The much later dating in the mid-1330s, proposed by Boskovits, has recently been supported in J. Pope-Hennessy and L. Kanter, *The Robert Lehman Collection*, New York, The Metropolitan Museum of Art, i, *Italian Paintings* (Princeton, NJ, 1987), 20–1. Seidel, 'Ikonographie und Historiographie', 111–13, favours an early dating, well before Heinrich of Friemar's text.

[54] Seidel, 'Ikonographie und Historiographie', 115, 126–9; H. B. J. Maginnis, 'Pietro Lorenzetti: A Chronology', *Art Bulletin*, 66 (1984), 183–211; 193–4.

[55] Arbesmann, 'Heinrich of Friemar's Treatise', 92–3, cited by Seidel, 'Ikonographie und Historiographie', 112, 140 n. 117.

[56] e.g. in Ambrogio Lorenzetti's *Maestà* for the Augustinians of Massa Marittima (Plate 37), and chapter-house decoration for the Augustinians of Siena (Plate 36), and in the triptych from S. Leonardo al Lago discussed above (where St Anthony Abbot is also dressed as an Augustinian: Plate 32), all probably painted in the 1330s.

[57] Stubblebine, *Duccio di Buoninsegna*, i, 86–7, dates the Montespecchio work c.1305–1310; C. Brandi, *La Regia Pinacoteca di Siena* (Rome, 1933), 169–70, tentatively suggests c.1315–1320; Torriti, *La Pinacoteca Nazionale di Siena*, 66, places his activity between 1315 and 1325.

[58] 1338, *Acta Cap. Gen.*, 'Antiquiores quae extant definitiones capitulorum Generalium Ordinis, Senense, 1338', *Analecta Augustiniana*, 4 (1911–12), 182–3.

[59] The studiousness of the S. Gimignano convent, at least in later years, is indicated in an inventory of conventual libraries made in the town in 1440. The Augustinians possessed 106 items, in comparison with 60 for the Dominicans, and 30 for the Franciscans. D. Gutiérrez, 'De antiquis O.E.S.A. bibliothecis', *Analecta Augustiniana*, 23 (1954), 342.

In the years following the San Gimignano polyptych (Plate 31) the Augustinians seem to have preferred other forms of painting for their most adventurous commissions.[60] The polyptych, especially in its seven-panelled form, suited the Dominicans and Franciscans, allowing for a full and often symmetrical display of canonized members. But Simone's panel of B. Agostino Novello (Plate 35) provided a more potent means of representing and explaining the Augustinians' new *beato*, while Ambrogio Lorenzetti's various works for the Order expressed Augustinian interests in a number of other ways (Plates 36–7, 39).[61]

The Carmelites and the Servites

Like the Augustinians, the Carmelites did not have a pair of recently canonized friars to display on a polyptych. Yet they succeeded, on one occasion, in adapting their foundation legend to that format. Pietro Lorenzetti's altarpiece of 1329 for the Carmelite house in Siena (Plate 33) has been discussed several times in the recent literature, most recently by van Os, by the present author, and by Gilbert.[62] This major, large-format work, with its extensive programme, provides answers to the question of whether, given sufficient funds and an artist of the highest calibre, other mendicant orders could adapt the polyptych form to their needs as thoroughly as the Dominicans of Pisa. A major theme of the altarpiece is the antiquity of the Carmelite Order, and the unbroken succession from Elijah's Carmel to fourteenth-century Siena. Thus in the main panels, Elijah and Elisha are presented in Carmelite dress, and a narrative predella is used to illustrate the Order's foundation legend, in course of composition at this time.

The theme of continuity even affects the treatment of minor areas of the polyptych. In each

[60] A more modest Sienese polyptych for the Augustinians is the partial polyptych (three remaining panels from a pentaptych) from S. Agostino, Montalcino, now in the Museo Diocesano d'Arte Sacra, dated 1346, showing the *Virgin and Child*, with *Sts Augustine*—dressed as an Augustinian bishop—(with *St Paul* in the gable), and *John the Baptist* (with the *Magdalen* in the gable). See E. Carli, *Montalcino: Museo Civico, Museo Diocesano d'Arte Sacra* (Bologna, 1972), 52–3.

[61] Works by Ambrogio Lorenzetti or his followers for Augustinian contexts include: Massa Marittima, Palazzo Comunale, ex Sant' Agostino, *Maestà* (Plate 37) (see B. Santi, in *Mostra di opere d'arte restaurate nelle province di Siena e Grosseto I* [Genoa, 1979], 60–6); Siena, S. Agostino, chapter-house programme (Plate 36) (majority lost) (see Seidel, 'Die Fresken des Ambrogio Lorenzetti'); Florence, S. Spirito, chapter-house, frescoes, including the lost *Crucifixion* (?) (see L. Ghiberti, *I Commentarii*, in J. von Schlosser [ed.], *Lorenzo Ghibertis Denkwürdigkeiten* (Berlin, 1912), i, 42). Attributed by G. Vasari to Simone Martini (*Le vite de più eccellenti pittori, scultori e architettori nelle redazioni del 1550 e 1568*, ed. R. Bettarini and P. Barocchi [Florence, 1967], ii, 194); Siena, Seminario Arcivescovile di Montarioso, ex Lecceto, *Madonna*

del Latte (Plate 39) (see E. Borsook, *Ambrogio Lorenzetti* [Florence, 1966], 29); Eremo di Lecceto, Chiesa del S. Salvatore, fresco of *St Michael*; cloister, fresco of *Resurrected Christ*; portico, fresco of *Redeemer and Two Angels* (ill. N. Fargnoli, 'La chiesa di San Salvatore nel Trecento', in C. Alessi et al., *Lecceto e gli eremi Agostiniani in terra di Siena* [Milan, 1990], 181–209, figs. 10, 16, 17); Montefalco, S. Agostino, fresco of the *Coronation of the Virgin* with four saints, angels, and the reclining Eve (ill. C. Volpe, 'Ambrogio Lorenzetti e le congiunzioni fiorentine-senesi nel quarto decennio del trecento', *Paragone*, 13 [1951], fig. 25, 40–52); Siena, Pinacoteca, polyptych panels Nos. 89, 91, *Sts Anthony Abbot and Maximinus* (dressed as an Augustinian bishop) (Torriti, *La Pinacoteca Nazionale di Siena*, 126, figs. 125, 126).

[62] Van Os, *Sienese Altarpieces*, 91–9; Cannon, 'Pietro Lorenzetti', 18–28. To the bibliography cited, there should now be added, Elm, 'Elias, Paulus von Theben und Augustinus', and the two works cited in n. 65 below. C. Gilbert, 'Some Special Images for Carmelites circa 1330–1430', in T. Verdon and J. Henderson (eds.), *Christianity and the Renaissance* (Syracuse, NY, 1990), 166–80.

pinnacle panel a pair of apostles joins in lively discussion while a prophet, placed in the spandrel above, listens intently. In Simone Martini's Dominican polyptych for Santa Caterina in Pisa (Plate 27) the choice and position of figures appears to have been carefully thought out;[63] here the prophets are not even identified. It is the communication between the Old and New Testaments that matters, rather than the identity of an individual.

Christa Gardner von Teuffel made a pioneering and illuminating study, setting Masaccio's Pisa Polyptych in its Carmelite context.[64] Her discussion included several polyptychs, but in the period preceding Pietro Lorenzetti's altarpiece there hardly appears to have been any interest in this form of panel painting within the Carmelite Order.[65] Instead, there is evidence that they favoured panels of the Virgin and Child, generally half-length rather than enthroned, of Byzantine or Byzantinizing style (Plate 43).[66]

The Carmelites were not alone in this apparent preference for panels of the Virgin and Child. The Servites, as has long been recognized, played an important role in the development of paintings of that subject, especially through their commissions for Coppo di Marcovaldo.[67] Lippo Memmi's *Madonna del Popolo* (Plate 42), also from the Sienese house of the Order, suggests a taste

[63] The question of Caleca's reconstruction of the S. Caterina polyptych (which is used at present in the Museo Nazionale, Pisa) has recently been reopened, with cogent arguments in I. Hueck, 'Simone attorno al 1320', in Bellosi (ed.), *Simone Martini: Atti*, 49–52. My observations concerning the cross-references made through figure position in the polyptych (Cannon, 'Simone Martini', 70–4), in which Caleca's reconstruction was used, hold good in Hueck's reconstruction too, since the order of the predella is certain, and Hueck accepts that the two *Sts John* must flank the central panel. The arrangement of the outer panels is more problematic for, as Hueck notes, the sequence of apostles is disturbed in either arrangement. (Indeed, if following Hueck's reconstruction, it could be argued that *Matthew* and *Bartholomew* are placed unusually far from the centre specifically because they are required to appear above *St Peter Martyr*.) As Hueck shows, the Dominican saints, placed well to the outer edges of their panels, form satisfying visual limits to the altarpiece. But the two female saints are also set well to the outer edges of their panels, with the *Magdalen* contiguous with the side of her panel for more than half its height. Both reconstructions can be shown to have an aesthetic rationale in the varying rhythms of heads, hands, and bodies. This prompts the speculation that the arrangement was itself originally uncertain, and that views on the hierarchical niceties of the programme of an unprecedented work, or its artistic arrangement, were rethought during the course of production.

[64] Gardner von Teuffel, 'Masaccio and the Pisa Altarpiece', 23–68.

[65] In the discussion following this paper, Professor Miklós Boskovits kindly drew my attention to the proposed reattri-

bution of a panel of probable Carmelite origin. The half-length figure of *Elijah* dressed as a Carmelite (77 × 48 cm.) in a private collection in Turin, which probably formed part of a polyptych, was published as Neapolitan, early 14th c. in H. van Os, 'Text and Image: The Case of a Jewish Prophet in Carmelite Disguise', in M. Gosman and H. van Os (eds.), *Non nova, sed nove: Mélanges de civilisation médiévale, dédiés à Willem Noomen* (Groningen, 1984), 163–8. Recently, A. De Marchi in the exhibition catalogue *Umbri e Toscani tra due e trecento*, ed. L. Bellosi (Turin, 1988), 53–8, has reattributed the panel to a Florentine master, working *c*.1300. Van Os, 'Text and Image', 163–4, drew attention to a similarity of form, but not, he argued, of style, with an early 14th-c. Florentine panel of *St Benedict* in the Museo Bardini, now attributed to Bernardo Daddi. In commenting on the present paper, Professor Boskovits cited these two panels as examples of early Florentine activity in the production of polyptychs for the religious orders.

[66] See Cannon, 'Pietro Lorenzetti', 20–1, pls. 4 and 5.

[67] See e.g. G. Coor-Achenbach, 'A Visual Basis for the Documents relating to Coppo di Marcovaldo and His Son Salerno', *Art Bulletin*, 28 (1946), 235; and subsequently, van Os, *Sienese Altarpieces*, 21–5. For a recent detailed and thoughtful re-evaluation of the significance of Coppo's *Virgin and Child* for the Servites of Siena, see R. W. Corrie, 'The Political Meaning of Coppo di Marcovaldo's Madonna and Child in Siena', *Gesta*, 29 (1990), 61–75. Corrie's conclusions are challenged in G. A. Mina, 'Studies in Marian Imagery: Servite Spirituality and the Art of Siena (*c*.1261–*c*.1328)', Ph.D. thesis (University of London, 1993), sect. ii, pt. 1.

for modernity which contrasts markedly with Carmelite preferences. Sienese art connected with the Servites before the Black Death is currently the subject of detailed study by Gianna Mina (a doctoral thesis at the Courtauld Institute) so the situation concerning this Order should soon be clarified. Meanwhile, my brief survey indicates that Servite polyptychs were a rarity.[68]

Serena Padovani has demonstrated, however, that the Siena convent did once receive help in paying for a costly altarpiece. Padovani connects these records of payment with the panel of the *Virgin and Child* still in the Servite church in Siena attributed to Segna di Bonaventura (Plate 40).[69] She argues that the high cost of the commission indicates that the *Virgin and Child* was once the central panel of a large polyptych. The painting is virtually a replica of Segna's *Virgin and Child* for the Augustinians at Lecceto (Plate 38), a striking coincidence which requires further investigation. The Servite altarpiece, which was in course of production in 1319, cost over 300 Sienese *lire*, twice the sum which the Carmelites paid Pietro Lorenzetti ten years later. In both cases the Sienese *comune* footed a third of the bill.[70]

These two examples illustrate the special external circumstances which could influence mendicant polyptych patronage. In the main, neither the Servites nor the Carmelites seem to have been very interested in early polyptychs, but Fredericksen has recently established the existence of one further Servite polyptych. The altarpiece from Simone Martini's shop, now in the Isabella Stewart Gardner Museum in Boston, came from the Order's Orvieto convent (Plate 41).[71] The painting had previously been thought to have a Franciscan provenance, and the interpretation of the eschatalogical content of the polyptych pinnacles, made by Fehm against a Franciscan background, is now being re-evaluated within a Servite context.[72]

The Franciscans

The story of the early Sienese Franciscan polyptych is, as Vasari long ago recognized, dominated by the figure of Ugolino da Siena.[73] Eight polyptychs of possible Franciscan provenance have

[68] One further example may be the *Virgin and Child*, now Montepulciano, S. Maria dei Servi (64 × 52 cm.) which is thought to have formed the central panel for a polyptych, and which has been associated with that church for a long time. See Stubblebine, *Duccio di Buoninsegna*, i, 172; ii, fig. 423. For discussion of the date and attribution of this panel, see Mina, 'Studies in Marian Imagery', sect. ii, pt. 2; for a detailed analysis of Lippo Memmi's *Madonna del Popolo*, ibid., sect. ii, pt. 3.

[69] S. Padovani, 'Una tavola di Castiglione d'Orcia restaurata di recente', *Prospettiva*, 17 (1979), 87 n. 8.

[70] The payment from the *comune* to the Servites was divided into four instalments of 25 *lire* each, the first paid in 1319, and the last in 1321, loc. cit.; for the Carmelites, see Cannon, 'Pietro Lorenzetti', 18.

[71] Central panel: 137·6 × 60·7 cm; side panels: approx.

115·9 × 42·9 cm. B. Fredericksen, 'Documents for the Servite Origin of Simone Martini's Orvieto Polyptych', *Burlington Magazine*, 128 (1986), 592–7. Recently reconstructed as a heptaptych, with the addition of hypothetical panels of St Peter and St John the Evangelist flanking the Virgin and Child, in G. Previtali, 'Introduzione ai problemi della bottega di Simone Martini', in L. Bellosi (ed.), *Simone Martini: Atti*, 156–61, photomontage, fig. 23.

[72] S. A. Fehm, 'Simone and the Franciscan *Zelanti*', *Fenway Court*, 1978 (Boston, 1979), 3–6. An extended reassessment of the Gardner polyptych is presented in G. A. Mina, 'Studies in Marian Imagery', sect. iii.

[73] Vasari, *Le vite de più eccellenti pittori*, ii, 139, 1550 edn., '*Fu felicissima l'età di Giotto per tutti coloro che dipingevano, perché in quella i popoli tirati della novità e della vaghezza dell'arte che già era ridotta dagli artefici in maggior grado, avendo le Religioni di San*

been connected with his style,[74] and Vasari also mentions a panel of the Crucifixion as a former altarpiece for the Bardi chapel in Santa Croce, Florence.[75] The origins and course of this prolonged contact between Order and artist are elusive, since none of these works is securely dated, the majority survive only as fragments, and only one, the great polyptych for the high altar of Santa Croce (Plates 46–7), has a secure provenance.[76]

Despite this lack of information, certain deductions may be made about the adoption of Ugolino's polyptychs within the Franciscan Order. Three works stand out because of their size: the original width of the Santa Croce altarpiece has been estimated at approximately 428 cm. (Plate 47);[77] the Williamstown heptaptych (Plate 44) now measures 341·4 cm. across (max. height 163·7 cm.);[78] the fragmentary predella in the Museo Nazionale di Villa Guinigi in Lucca (Plate 45) comes from a work which must originally have been at least 314 cm. wide.[79] Even the briefest consideration of these three works shows that Ugolino and his patrons were not content with the mere repetition of an established formula. On the contrary, a sequence of variations and elaborations is indicated. Pope-Hennessy and Gardner Von Teuffel have argued convincingly that

Domenico e di San Francesco finito di fabricare le muraglie de' conventi e delle chiese loro et in quelle predicando del continovo, tiravano con le predicazioni a la cristiana fede et a la buona vita i cuori indurati nelle male opere e quegli esortavano ad onorare i Santi di Gesù, di sorte che ogni dì si fabricavano cappelle e dagli idioti si facevano dipignere per desiderio di giugnere in paradiso: e così costoro col muovere gl'intelletti ignoranti degli uomini, acomodavano le chiese loro con bellissimo ornamento. Per questo Ugolino sanese pittore fece moltissime tavole et infinite cappelle per tutta Italia . . .'

[74] As indicated by the choice of saints on some of the remaining panels: Birmingham, Barber Institute, panel from a polyptych: *St Francis* (ill. Stubblebine, *Duccio di Buoninsegna*, ii, pl. 458); Cleveland, Museum of Art, Leonard C. Hanna Jr. Bequest, pentaptych: *St Francis* (ill. ibid. pl. 385); formerly Florence S. Croce heptaptych: *St Francis, St Anthony of Padua, St Louis of Toulouse, St Clare, St Elizabeth of Hungary* (Plates 46, 47); Lucca, Museo Nazionale di Villa Guinigi, No. 300, part of predella: *St Louis of Toulouse* (Plate 45); S. Casciano Val di Pesa, S. Maria del Prato, two panels from a polyptych: *St Francis* and *St Peter* (Plates 50 and 51); San Francisco, Palace of the Legion of Honor, two panels from a polyptych: *St Louis of Toulouse* and *St Mary Magdalen* (ill. ibid., pls. 388–9); Siena, Pinacoteca, No. 39, polyptych: *St Francis, St Clare* (Plate 52); Williamstown, Sterling and Francine Clark Art Institute, heptaptych: *St Francis, St Louis of Toulouse* (Plate 44).

[75] Vasari, *Le vite de più eccellenti pittori*, ii, 140 (1568 edn.) 'nella cappella di messer Ridolfo de' Bardi che è in Santa Croce, dove Giotto dipinse la vita di S. Francesco, fece nella tavola dell'altare a tempera un Crucifisso e una Madalena et un S. Giovanni che piangono, con due frati da ogni banda che gli mettono in mezzo'. For the identification of this panel as the *Crucifixion* now in the Thyssen-Bornemisza Collection, see H. B. J. Maginnis, 'The

Thyssen-Bornemisza Ugolino', *Apollo*, 118, No. 257 (1983), 20–1.

[76] See M. Davies (revised D. Gordon), *The Early Italian Schools Before 1400*, National Gallery Catalogues (London, 1988), 99–116, esp. 108–9. The parts of the S. Croce altarpiece are dispersed thus: (Pinnacles) *Isaiah, David, Moses* (London, National Gallery); *Daniel* (Philadelphia, Johnson Collection); *St Matthew* and *St James Minor* (Berlin-Dahlem, Gemäldegalerie); *St Bartholomew* and *St Andrew* (London, National Gallery); *St James Major* and *St Philip* (Berlin-Dahlem, Gemäldegalerie); *St Simon* and *St Thaddeus* (London, National Gallery); *St Mathias* (?) and *St Elizabeth of Hungary* (?) (Berlin-Dahlem, Gemäldegalerie); (main panels) *St John the Baptist* and *Two Angels* (Berlin-Dahlem, Gemäldegalerie); *St Paul* and *Two Angels* (Berlin-Dahlem, Gemäldegalerie); central spandrels with *Ten Angels* (Los Angeles County Museum of Art); *St Peter* and *Two Angels* (Berlin-Dahlem, Gemäldegalerie); two *Angel* spandrels (London, National Gallery); (predella) *Last Supper* (New York, Metropolitan Museum of Art, Robert Lehman Collection); *Betrayal* (London, National Gallery); *Flagellation* (Berlin-Dahlem, Gemäldegalerie); *Christ carrying the Cross, Deposition* (London, National Gallery); *Entombment* (Berlin-Dahlem, Gemäldegalerie); *Resurrection* (London, National Gallery).

[77] Ibid. 112.

[78] J. Pope-Hennessy, *Heptaptych: Ugolino da Siena* (Williamstown, Mass., 1962), 5.

[79] Present width 200 cm.; G. Monaco *et al.*, *Museo di Villa Guinigi, Lucca: La villa e le collezioni* (Lucca, 1968), 140–1, originally the *Crucified Christ* marked the centre of the predella, with at least four further figures in an arcade to the left accounting for approximately a further 114 cm.

the Williamstown heptaptych (Plate 44) is a less complex forerunner of the Santa Croce altarpiece (Plate 47).[80] The frame design of the Lucca predella (Plate 45) may suggest that it, too, precedes the Santa Croce work,[81] and the figure of *St Louis of Toulouse*, restricted to the predella, without mitre or cope, owes nothing to the Santa Croce type. Meanwhile the content of this predella, which uses individual figures rather than scenes, indicates a quite different programme from that used in the Florence altarpiece (Plate 47). In other words, the situation may parallel that in the Dominican Order, where a rapid development of design in the early Sienese polyptych was apparently facilitated by a series of major commissions. In the case of the Dominicans, the patron houses were substantial foundations, each capable of accommodating the provincial chapter. This may apply to the Franciscans too. The size of these polyptychs implies that they were made for large altars,[82] situated in substantial buildings. By the second decade of the fourteenth century a number of central Italian Franciscan churches could fit this description. Gardner Von Teuffel suggested that the Williamstown heptaptych (Plate 44) may have been made for the Franciscan house in Siena,[83] and it is possible that the Lucca predella (Plate 45) has always been in that town.[84] Florence, Siena, and Lucca were all heads of custodies in the Tuscan province of the Franciscan Order.[85]

Our knowledge of Dominican activities may guide us further in an interpretation of the Franciscan material. Certain major Dominican polyptychs also seem to have created a demand for more modest, imitative reminiscences. The diffusion and dilution of the forms of 'high art' in smaller centres could be assisted by an Order's network of houses. In the Franciscan Order this process may be traced in the case of mural decoration, on the basis of the material provided in Blume's valuable survey.[86] Blume saw the decoration of the Upper Church of San Francesco at Assisi as the dominant model throughout Italy.[87] For example, in the Upper Church of San

[80] Pope-Hennessy, *Heptaptych*, 10–13; Gardner von Teuffel, 'The Buttressed Altarpiece', 48.

[81] Stubblebine, *Duccio di Buoninsegna*, i, 160.

[82] For a discussion of the scale of some contemporary Franciscan high altars in Italy, see J. Gardner, 'Some Franciscan Altars of the 13th and 14th Centuries', in A. Borg and A. Martindale (eds.), *The Vanishing Past: Studies of Medieval Art, Liturgy and Metrology Presented to Christopher Hohler* (Oxford, 1981), 29–38.

[83] Gardner von Teuffel, 'The Buttressed Altarpiece', 48 n. 68. See also J. Gardner, 'The Cult of a Fourteenth-Century Saint: The Iconography of St. Louis of Toulouse', in *I Francescani nel Trecento*, Atti del XIV convegno, società internazionale di studi francescani, Assisi, 1986 (Perugia, 1988), 174 and n. 17.

[84] The recorded provenance goes no further back than 1884, when the work was acquired for the Pinacoteca in Lucca from Pietro Massagli of Lucca (Stubblebine, *Duccio di Buoninsegna*, i, 159–60). A pinnacle panel of the prophet Isaiah, attributed to Ugolino, now in the National Gallery of Ireland,

was acquired in about 1870 by the Dowager Viscountess Galway in Lucca (G. Coor-Achenbach, 'Contributions to the Study of Ugolino di Nerio's Art', *Art Bulletin*, 37 [1955], 162 n. 43). This panel may conceivably have formed part of the same polyptych from a Franciscan church in Lucca.

[85] P. Péano and C. Schmitt, 'Die Ausbreitung der Franziskaner bis 1300', in H. Jedin, K. Latourette, and J. Martin (eds.), *Atlas zur Kirchengeschichte* (Freiburg im Breisgau, 1970), 42*–3*. S. Francesco al Prato, Perugia, head of a custody in the province of St Francis (Umbria), may have obtained an altarpiece to coincide with a general chapter meeting held in that convent in 1322. See D. R. Gordon, 'Art in Umbria, c.1250–c.1350', Ph.D. thesis (University of London, 1979), 164.

[86] Blume, *Wandmalerei als Ordenspropaganda*, figs. 80, 82, 129, 132, 133, 145, 158. For the frescoes in S. Fortunato, Todi, and S. Francesco, Castelfiorentino, discussed below, see also ibid., 54–7, 65–6, 147, 173.

[87] Ibid., esp. pp. 77–80

Francesco at Assisi the scenes of the *Death of St Francis* and the *Funeral of St Francis and Testing of the Wound in the Side* are shown separately. Blume found no example of both scenes being repeated together. The closest copy of Assisi is in the fourteenth-century fresco of the *Funeral of St Francis and Testing of the Wound in the Side* in the St Francis chapel in the church of San Fortunato at Todi, which seems to have depended on a very detailed drawing of the prototype. In the Bardi chapel in Santa Croce, elements from the two Assisi scenes are combined in the scene of the *Death of St Francis and Testing of the Wound in the Side*. The Bardi chapel fresco demonstrates a thorough knowledge of both Assisi scenes, but they are reformulated and new elements are added. In the scene of the *Death of St Francis and Testing of the Wound in the Side* in the choir of San Francesco, Castelfiorentino (attributed to Giovanni del Biondo), we find again an example of a close copy, presumably executed with the help of drawings, but in this case following not Assisi, but the Bardi chapel. Thus we find, on the one hand, that the scene of the *Funeral of St Francis* in San Fortunato at Todi—the monument in the same province of the Order as Assisi—reproduces the Assisi *Funeral* scene closely. On the other hand Santa Croce—head of the Tuscan province—asserts its independence by recasting the Assisi scenes in its Bardi chapel fresco, and then appears to exert its own influence on the *Death of St Francis* scene in San Francesco, Castelfiorentino, which was within the provincial custody of Florence, directly under the leadership of Santa Croce.

The situation for polyptychs is less clear, but in two cases a hypothesis may be advanced. The panel of *St Peter*, now in the church of the Misericordia (or Santa Maria al Prato) in San Casciano in Val di Pesa (Plate 50), attributed to Ugolino, appears to be a careful reminiscence, on a reduced scale, of the equivalent figure on Ugolino's Santa Croce altarpiece (Plate 48).[88] The treatment of features, flesh, and hair is extremely close (with the exception of the direction of Peter's glance and the precise form of the curls above his left ear) and the drapery, while not identical in every detail, uses the same fold pattern.[89] Two other polyptych panels of St Peter, also generally attributed to Ugolino, the Brolio pentaptych and the Williamstown heptaptych (Plate 44) have similar facial types, but the arrangement of drapery, hands, and attributes is further from the Santa Croce *St Peter*.[90] There are a number of possible explanations for such close similarity: a smaller work serving in some sense as a study for the larger one (but the San Casciano *St Peter*, Plate 50, seems too well finished for a trial run); the meticulous repetition by an assistant of a type established by the master (but the equally high quality of both panels makes this unlikely); artistic convenience, especially if the two works were executed in the studio at the same time (although the difference in scale precludes the reuse of a cartoon); or a request from a patron for a copy (*modo et forma*) of an admired exemplar. In this case the last two possibilities seem the most plausible.

[88] *St Peter*: 70 × 41 cm. Stubblebine, *Duccio di Buoninsegna*, i, 169–70. Berlin, *St Peter* (ex S. Croce): picture field approx. 103 × 53 cm.; including frame and angel spandrels, excluding frieze 124·5 × 56·5 cm. M. Boskovits, *Gemäldegalerie Berlin: Katalog der Gemälde Frühe Italienische Malerei*, i (Berlin, 1988), 164.

[89] Boskovits, *Gemäldegalerie*, for excellent reproductions, pls. 249, 264.

[90] Stubblebine, *Duccio di Buoninsegna*, ii, figs, 445, 450.

Before pursuing the question further, it may be helpful to turn to the other San Casciano panel, which represents *St Francis* (Plate 51).[91] The Santa Croce St Francis is lost, and the drawing of the Santa Croce polyptych, made for Séroux d'Agincourt in the eighteenth century (Plate 46),[92] already shows it in a ruined state. But Gardner von Teuffel has published an engraving, prepared by Baccanelli in 1647 for a hagiographical miscellany, which was based, in reversed form, on the Santa Croce *St Francis*.[93] Comparison shows that the main lines of the pose of the Santa Croce *St Francis* also occur at San Casciano.[94] Another figure of St Francis which is closely comparable in composition with the San Casciano work appears in polyptych No. 39 in the Pinacoteca in Siena (Plate 52).[95] The *Virgin and Child* of polyptych No. 39 resemble, as Gordon has pointed out, the pose used in the lost Santa Croce central panel (Plate 46).[96] Only the relationship between the Virgin's right hand and the Christ Child's feet is slightly different, and was in a damaged area which Séroux d'Agincourt's artist might have had difficulty reading. All the other half-length panels of the Virgin and Child associated with Ugolino are variations on a relatively restricted theme, but none precisely repeats the formula found at Santa Croce or in polyptych No. 39 (Plate 52). The resemblance thus seems, for whatever motive, to be the result of a conscious choice.[97] In conclusion, it seems reasonable to propose that the *St Francis* of polyptych No. 39 (Plate 52) in the Siena Pinacoteca and, by extension, the San Casciano *St Francis* (Plate 51), also looked like the lost Florentine panel.

Having linked both San Casciano panels to the Santa Croce altarpiece, we need to decide whether artistic convenience or patronal requirements are more likely to have dictated the similarities. Ugolino was certainly in demand in the first half of the 1320s, and duplicating procedures might have speeded production in his *bottega*. In addition to the great undertaking at Santa Croce, he produced a polyptych for the Dominicans of Santa Maria Novella.[98] It has been proposed that the San Casciano panels (Plates 50–1) are remnants of the Santa Maria Novella altarpiece, a proposal strengthened by the fact that the church of Santa Maria al Prato, in which the panels are now displayed, was founded as an *ospizio* by the friars of Santa Maria Novella before 1301.[99] However, the size of the panels seems surprisingly small for an impressive work

[91] 70 × 39 cm.

[92] First published by H. Loyrette, 'Une source pour la reconstruction du polyptyque d'Ugolino da Siena à Santa Croce', *Paragone*, 343 (1978), 15–23, fig. 21.

[93] Gardner von Teuffel, 'The Buttressed Altarpiece', 48–50, fig. 24.

[94] In reversed form, with the exception of the wound in the side, which is kept on the right, presumably for iconographic reasons.

[95] Overall max. dimensions 84 × 189 cm. Torriti, *La Pinacoteca Nazionale di Siena*, 62.

[96] D. Gordon and A. Reeve, 'Three Newly-Acquired Panels from the Altarpiece for Santa Croce by Ugolino di Nerio', *National Gallery Technical Bulletin*, 8 (1984), 45 n. 24. The poses appear to be a development of those in Siena

Pinacoteca polyptych No. 28, attributed to Duccio (see our Plate 28).

[97] One other polyptych panel of the Virgin and Child associated with Ugolino's style, which may have resembled the S. Croce pose, has also been connected with a Franciscan milieu. See below, n. 118.

[98] Cannon, 'Simone Martini', 87–91.

[99] First suggested in G. De Nicola, 'Ugolino e Simone a San Casciano Val di Pesa', *L'Arte*, 19 (1916), 13–20. De Nicola gives the foundation date as 1335, but the hospice was established by 1301, and permission to build a new hospital and a church was granted in 1304. See S. Orlandi, OP, *Necrologio di S. Maria Novella* (Florence, 1955), i, 23–4, 253–4, 260, 274. The existence of a church is also mentioned in a property transaction of 1335 (ibid. 449).

intended for an altar with a maximum width of 428 cm., and the inclusion of St Francis in such a work, while not unthinkable, is, at that date, unlikely.[100] The early provenance of the panels is unknown, and they may have been handed on, perhaps via the fifteenth century Franciscan foundation in San Casciano itself,[101] from their original location. A fair assumption might be that that location was a Franciscan church, and that the person responsible for handling the commission was so impressed by the Santa Croce altarpiece that he requested its partial replication, perhaps while the great polyptych was still in the workshop.

The relationship between polyptych No. 39 (Plate 52) and the Santa Croce altarpiece (Plate 47) is more problematic, for while the composition and figure types are close to the Florentine work, there is a perceptible difference in quality, and a slight awkwardness in the disposition of features, especially in three-quarter view, which puts a distance between the two works. This has most frequently been explained by placing polyptych No. 39 (Plate 52) earlier in Ugolino's career, before the fluency of Santa Croce.[102] The simpler form of the round-headed arches has been cited as evidence of an early date,[103] but Brandi long ago raised the evidence of frame shape only to discount it, noting the similarity with the San Casciano panels (Plates 50–1), and favouring an attribution close to Ugolino, probably after the Santa Croce altarpiece.[104] In this case the discrepancy in style would indicate that the *Virgin and Child* (and *St Francis*) of polyptych No. 39 (Plate 52) is not a slightly tentative trial run for the Santa Croce *Virgin*, but a cautious repetition of an established type, by an artist closely associated with Ugolino but weaker than his master.[105] This is the solution which Stubblebine favoured in creating the polyptych No. 39 Master and assembling an œuvre for him.[106]

[100] For the appearance of St Francis in Dominican commissions before *c.*1325, see Cannon, 'Dominican Patronage of the Arts', esp. 209–10, 324–6. De Nicola's proposal is rejected in Coor-Achenbach, 'Contributions to the Study of Ugolino', 160 n. 31, and W. and E. Paatz, *Die Kirchen von Florenz*, iii (Frankfurt, 1952), 831 n. 431. Stubblebine, *Duccio di Buoninsegna*, i, 168–70, gives detailed consideration to De Nicola's suggestion, and concludes that the *St Peter* and *St Francis* panels did come from S. Maria Novella, but did not form part of the high altarpiece. For discussion of the probable appearance of the S. Maria Novella high altarpiece, see Cannon, 'Simone Martini', 87–91, and further proposals in Davies and Gordon, *The Early Italian Schools*, 3–5, 115–16, n. 45.

[101] Founded in 1492. See J. R. H. Moorman, *Medieval Franciscan Houses* (New York, 1983), 423.

[102] e.g. H. S. Francis, 'An Altarpiece by Ugolino da Siena', *The Bulletin of the Cleveland Museum of Art*, 48 (1961), 200–1; Torriti, *La Pinacoteca Nazionale di Siena*, 62; Pope-Hennessy, *Heptaptych*, 12, implies that No. 39 is close in date to the Williamstown heptaptych, which he dates well before the S. Croce altarpiece. Pope-Hennessy points convincingly to the similarity between the Siena *St Stephen* and the Williamstown

St Louis, but this may be explained as two pieces executed by the same distinctive assistant, at different times in his career. This artist may also have painted the *St Louis of Toulouse* now in San Francisco for which see below, n. 118. The Siena *St Stephen*, however, is quite unlike the Williamstown *St Stephen*, in pose or facial type.

[103] e.g. Boskovits, *Gemäldegalerie Berlin*, 173–4.

[104] Brandi, *La Regia Pinacoteca di Siena*, 302–4. Pope-Hennessy, *Heptaptych*, 12, points out, in relation to the Cleveland altarpiece, that figure proportion and pose can be more reliable indicators of date. The choice of framing type may have been influenced by a number of factors, including cost, architectural setting, use of a pre-existing panel, patronal taste, or the conservatism of the carpenter.

[105] Torriti, *La Pinacoteca Nazionale di Siena*, 62, briefly proposes, as an alternative to an early dating, an attribution to one of Ugolino's two painter brothers, Guido or Minuccio.

[106] Stubblebine, *Duccio di Buoninsegna*, i, 176–80. In response to Stubblebine's reattributions, E. Carli, *La pittura senese del Trecento* (Milan, 1981), 80, allows that a number of polyptychs, including Siena No. 39, could possibly be attributed to extremely able assistants.

Having established the possibility that polyptych No. 39 (Plate 52) may follow, in some respects, the Santa Croce altarpiece (Plate 47), we can turn, once again, to the question of patronage. Brandi recorded the polyptych's provenance as unknown, but the inclusion of St Clare as a principal figure implies a Clare provenance which is confirmed by Lusini's information that the work came from Santa Chiara in Siena.[107] Since the movements of the nuns were restricted, it was presumably their spiritual adviser who suggested the model, perhaps also the workshop, for their altarpiece.[108] As already noted, the quality of the work differs from that at Santa Croce, and the content of the work differs too. Only two of the Santa Croce figures are repeated on polyptych No. 39 (Plates 46, 52). The nuns' representative may have had more than one Franciscan model in mind when giving the artist his instructions. The Maestro di Città di Castello painted a polyptych, now No. 33 in the Pinacoteca in Siena (Plate 49),[109] which Lusini says came from the former Clare house of San Lorenzo.[110] The inclusion of St Clare in both works substantiates the Clare provenance. In both works her attribute is, unusually, an elegantly shaped vessel.[111] This is not the only parallel between the two programmes: in both cases *Clare* is balanced by *Francis*, while the *Virgin and Child* are flanked by *St John the Evangelist*, shown as the ageing writer of Revelations, and a *Deacon Saint*, generally identified as Stephen but more likely, at least in the case of the San Lorenzo panel (Plate 49), to be St Lawrence.[112]

[107] V. Lusini, ['Mostra ducciana'] 'Catalogo dei dipinti', *Rassegna d'arte senese*, 8 (1912), 123. Lusini reports that the monastery was in existence by 1246, and benefited from a bequest of Cardinal Riccardo Petroni (d. 1314).

[108] For an early 16th-c. example of a representative of a house of Clares commissioning an altarpiece based on an admired earlier work in a Franciscan house which was the head of a neighbouring custody in the same province (paid for partly from private sources), see the documents of 1505 relating to Raphael's *Coronation of the Virgin* for the monastery of Monteluce in Perugia. The painting was to be based on the Ghirlandaio *Coronation* of 1486, painted for S. Girolamo in Narni. V. Golzio, *Raffaello nei documenti . . .* (Vatican City, 1936); repr. with corrections (Farnborough, 1971), 11–14.

[109] 116 × 184 cm. Torriti, *La Pinacoteca Nazionale di Siena*, 67.

[110] Lusini, 'Catalogo dei dipinti', 133. The church was handed over to the Clares in 1257, and the rebuilt church was consecrated in 1298.

[111] In the Maestro di Città di Castello's work this appears to be a transparent glass vessel containing a reddish-brown liquid. No other examples are cited in G. Kaftal, *Iconography of the Saints in Tuscan Painting* (Florence, 1952), 270–4, nor in F. Bisogni, 'Per un census delle rappresentazioni di Santa Chiara nella pittura in Emilia, Romagna e Veneto sino alla fine del Quattrocento', in *Movimento religioso femminile e francescanesimo nel secolo XIII*, Atti del VII convegno, società internazionale di studi francescani, 1979 (Assisi, 1980), 131–65. Bisogni

(ibid. 28, 139–9) points to the use of another attribute with eucharistic significance, in this case an ostensory, in the second half of the 15th c., but apart from the Guidesque panels now Siena, Pinacoteca No. 4 (Torriti, *La Pinacoteca Nazionale di Siena*, 37–8) in which St Clare repels the Saracens by holding the casket with the reserved host in her hands, there do not appear to be other surviving examples of representations of St Clare with an attribute of eucharistic significance, in Siena, before the time of Giovanni di Paolo's altarpiece, Siena, Pinacoteca, No. 191 (ibid. 326–9).

[112] Intriguingly, the order of the protagonists in one panel is the mirror image of the other. If the later work comes from a church dedicated to St Clare, it is reasonable to place her to the right side of Christ and the Virgin. The order of the earlier work is less expected. *St Lawrence*, towards whom the *Christ Child* turns and to whom the church for which the painting was probably intended was dedicated, is placed to the *Christ Child*'s left. It may be that the painting was destined for a side altar, and that the side of favour coincides with the direction of the high altar, but at this date the high altar itself seems a more probable destination. Reversed order can be a feature of the reverse face of double-sided altarpieces. For their connection with nunneries, see J. Gardner, 'Fronts and Backs: Setting and Structure', in H. W. van Os and J. R. J. Van Asperen De Boer (eds.), *La Pittura del XIV e XV secolo: Il contributo dell'analisi tecnica alla storia dell'arte*, Atti del XXIV congresso internazionale di storia dell'arte, Bologna, 1979 (Bologna, 1983), iii, 297–322, esp. 301–3, 307 n. 44.

Regrettably, the pinnacles of polyptych No. 39 (Plate 52) are missing, but those of polyptych No. 33 (Plate 49), the earlier work, confirm the thought with which the Clares and their advisers could plan a polyptych. This is an early example of the use of pinnacles for figures other than angels—a feature which may have been originated, as I have previously argued, by Duccio, for the Dominicans of Perugia. The number of biblical saints is thus increased by including *St Peter* and *St John the Baptist*. *Augustine*, writer of a monastic rule, crowns the image of *St Francis*, who holds the book of his own rule in both hands. *Augustine's* hands are covered by the episcopal gloves, bearing their distinctive discs, signs of ecclesiastical authority. *St Francis's* hands bear the stigmata, signs of divine suffering and approbation. Meanwhile *St Clare's* vessel is paralleled by the *Magdalen's* ointment jar.

The Clares can be associated with a number of earlier Sienese panel paintings.[113] Their patronage of polyptychs can also be seen at an earlier stage, when they appear to have played a seminal role. It was the Clare hospital in Pisa, possibly already the owner of a Pisan panel of the Virgin and Child and a crucifix signed by Ranieri di Ugolino,[114] which gave Cimabue the commission for a polyptych with predella in 1302.[115]

The origins and precise course of Ugolino's artistic contact with the Franciscan Order remain unclear, but the following hypothesis may be advanced. Two large polyptychs were painted for Franciscan churches by Ugolino before he received the Florentine commission. Both are probably based on Ducciesque models in their design.[116] One or two smaller works may also have been executed for the Franciscans at this stage.[117] Ugolino's transfer to Florence may have come through the Dominican commission for Santa Maria Novella, perhaps as a second choice in default of Simone Martini. His admirable work at Santa Maria Novella, combined with his earlier work for the Franciscans, brought him the commission at Santa Croce, his first surviving enterprise in a more Simonesque style and format—although this change may already have occurred at Santa Maria Novella. After Santa Croce, he and his workshop received a second group of Franciscan commissions, for smaller houses whose ideas about altarpieces may partially

[113] e.g. attributed to Guido da Siena or his school: Krakow National Museum, Tabernacle of *Virgin and Child with Sts Francis and Clare, Crucifixion, Entombment* (J. H. Stubblebine, *Guido da Siena* [Princeton, NJ, 1964], 101–2); Siena, Pinacoteca, No. 4, shutters with scenes including *St Clare repelling the Saracens* (Torriti, *La Pinacoteca Nazionale di Siena*, 37–8); Siena, Pinacoteca, No. 136M, ex Siena, S. Chiara, *Virgin and Child* (fragmentary, ibid. 34); Siena, Clarisse, *Christ and Virgin Enthroned* (Stubblebine, *Guido da Siena*, 67–8); Wellesley, Mass., Wellesley College Museum, Tabernacle centre with the *Funeral of St Clare* and the *Mounting of the Cross* (ibid. 102–4).
[114] E. B. Garrison, *Italian Romanesque Panel Painting: An Illustrated Index* (Florence, 1949), 62, No. 110; 214, No. 575.
[115] Documents printed in L. Tanfani Centofanti, *Notizie di artisti tratte dai documenti pisani* (Pisa, 1897), 119–21. See the

discussion in Gardner von Teuffel, 'The Buttressed Altarpiece', 42–4. A puzzling, transitional work, with a Clare donor, from the Clare house in S. Gimignano, attributed to Memmo di Filippuccio, is reproduced in Santi, *Mostra* (see n. 61 above), 41.
[116] The content of the Lucca predella may, however, have been influenced by the S. Caterina polyptych. See Stubblebine, *Duccio di Buoninsegna*, i, 160.
[117] The dating of the Cleveland pentaptych is controversial. See e.g. ibid. i, 160–1 for an early dating; Pope-Hennessy, *Heptaptych*, 12, 15 n. 18, for a post-S. Croce dating. For another pentaptych which the present author would place after S. Croce, but has also been placed before it, see the following note.

have been formed by the magnificent work visible at Santa Croce.[118] Thus the development of Ugolino was initially stimulated by his patrons; his fulfilment of their requirements led to challenging commissions in which the artist was so successful that he, in turn, succeeded in creating a new demand.[119]

Ugolino da Siena's contribution to the Franciscan polyptych did not spring from a void. Some interest in polyptychs existed in the First Order of St Francis, and, perhaps more strongly, in the Second Order, and Ugolino was not unaware of his predecessors.[120] Nor was his dominance complete. A polyptych including *St Francis* and *St Anthony of Padua*, attributed to the Maestro di Città di Castello, has been variously reconstructed by Fehm, Vertova, and Zeri (Plate 53).[121] In this altarpiece it may be possible to detect the influence of Ugolino's work for Santa Croce, but two fine works perhaps executed while Ugolino was occupied with Florentine commissions demonstrate the wider scope of some Franciscan polyptychs. These are the polyptych probably from San Francesco in Colle Val d'Elsa, attributed to Lippo Memmi (Plate 54),[122] and the panel

[118] One further reminiscence of S. Croce may still, in part, exist. The *St Louis of Toulouse* now in San Francisco (83·8 × 44·4 cm., ill. Stubblebine, *Duccio di Buoninsegna*, ii, fig. 388) clearly follows the S. Croce type (our Plates 46–7: crozier in left hand, held diagonally, and right hand raised in gesture of blessing or speech), rather than the Williamstown type (Plate 44: crozier in right hand, left hand holding cord). The panel belongs with one of the same dimensions and style, showing the *Magdalen* (ibid. ii, fig. 389). Coor-Achenbach ('Contributions to the Study of Ugolino', 162 n. 48, 163) linked these panels with the *St Catherine* at Urbana and the Princeton *Madonna* (Stubblebine, *Duccio di Buoninsegna*, ii, fig. 441) which, severely damaged and restored in the lower sections, approaches in the upper sections the drawing of the S. Croce *Virgin and Child*. Stubblebine (ibid. i, 161) rejected this reconstruction, but it has recently been supported in L. N. Amico, 'Reconstructing an Early Fourteenth Century Pentaptych by Ugolino di Nerio: St. Catherine Finds Her Niche', *Bulletin of the Krannert Art Museum*, 5/1 (1979), 12–30, who dates the panel early.

[119] For two recent views of Ugolino's stylistic development, see Boskovits, *Gemäldegalerie Berlin*, 173–4, and L. B. Kanter, 'Ugolino di Nerio: "Saint Anne and the Virgin"', *Annual Bulletin of the National Gallery of Canada*, 5, 1981–2 (1983), 9–28.

[120] An earlier Sienese altarpiece with Franciscan connections which originally included six principal figures flanking the *Virgin and Child* is, of course, Siena, Pinacoteca, No. 7, attributed to Guido da Siena, and once in the possession of S. Francesco, Colle Val d'Elsa (Torriti, *La Pinacoteca Nazionale di Siena*, 26–7).

[121] Reconstruction proposed in S. A. Fehm, 'A Pair of Panels by the Master of Città di Castello and a Reconstruction of

Their Original Altarpiece', *Yale University Art Gallery Bulletin*, 31/2 (1967), 16–27; and L. Vertova (who adds the Lanckoronski *St Francis*), 'What Goes With What?', *Burlington Magazine*, 109 (1967), 668–71. To which Zeri, who does not accept the inclusion of the Copenhagen *Virgin and Child*, has added a panel of *St Anthony of Padua*, now in the Lia Collection, La Spezia; F. Zeri, *Diario di lavoro*, ii (Turin, 1976), 8–10, pl. 2. The measurements which Fehm supplied for the position of the dowel holes on the *St Peter* and *St John the Baptist* panels do not appear to support his argument that *St Peter* must have been placed to the right of the *Baptist*. Thus the reconstruction of this polyptych, and the original number of panels, remain controversial, and the panels have been illustrated here (Plate 53) as individual elements. A further polyptych panel of *St Francis* attributed to the Maestro di Città di Castello (present location not known) is published in Boskovits, review of Stubblebine, 500, fig. 9, 502.

[122] For a summary of Coor-Achenbach and Mallory's reconstructions, and the proposal of the Colle Val d'Elsa provenance, see M. Mallory, 'An Altarpiece by Lippo Memmi Reconsidered', *Metropolitan Museum Journal*, 9 (1974), 187–202. The panels of Lippo Memmi's Colle Val d'Elsa (?) altarpiece have been dispersed thus: (pinnacles) *St Dorothy* (Milan, Museo Poldi Pezzoli); *St Clare* (New York, Metropolitan Museum of Art); *St Anthony of Padua* (Pittsburgh, Frick Art Museum); *St Mary Magdalen* (Providence, Museum of Art, Rhode Island School of Design); *St Agnes* (Pittsburgh Frick Art Museum); (main panels): *St Louis of Toulouse* (Siena, Pinacoteca); *St Paul* and *St John the Baptist* (Washington, DC, National Gallery of Art); *Madonna and Child* (Berlin-Dahlem, Gemäldegalerie); *St John the Evangelist* (New Haven, Conn., Yale University Art Gallery, Bequest of Maitland F. Griggs); *St Peter* (Paris, Louvre); *St Francis* (Siena, Pinacoteca).

from San Francesco, Orvieto, now in the Museo dell'Opera del Duomo in Orvieto (Plate 55), attributed to Simone and his shop.[123] Brink's reconstruction proposes that the Orvieto panel was the centre of a triptych whose principal theme, following the sermons of St Bonaventure, was the journey to God by way of the celestial hierarchies.[124] The choice of this unusual programme for a polyptych is even more striking when seen against the background of Ugolino's works for the Franciscans.[125]

The Dominicans and the Other Orders of Friars

In conclusion, we can ask how these preliminary observations concerning the other mendicants compare with the evidence from the Dominican Order. Of course, all mendicant churches in central Italy did not feel obliged to obtain a Sienese polyptych. The Servites seem to have shown little interest in this form of painting. Both they and the Carmelites were more concerned with independent panels of the Virgin and Child. Both Orders had a major polyptych in their Sienese convents, but this may have been in part the result of an awareness of the abundance of great paintings in other Sienese churches, and in part due to the financial assistance of the *Comune*. The Augustinians of the Sienese *contado* were more active than has previously been recognized in obtaining polyptychs which reflect some of the concerns of their Order. The Franciscans were even more active. Studies of the Franciscans and the arts, which traditionally emphasize that Order's interest in narrative cycles, need also to consider the role of a polyptych as part of the typical furnishing of the Franciscan church interior. Although few definite provenances can be demonstrated, even this short study has listed some dozen examples of polyptychs with Franciscan connections produced by Sienese artists. There are fewer known Dominican polyptychs from the same area, but it must be remembered that there were also far fewer Dominican houses in central Italy.

It seems reasonable to suppose that the parallels between Dominican and Franciscan patterns of patronage spring, in part, from similar circumstances, opportunities, and requirements. But they may, on occasion, indicate a more direct relationship. The *Virgin and Child* in Copenhagen, attributed to the Maestro di Città di Castello, which may form part of a Franciscan polyptych (Plate 53), appears to follow closely the form of Duccio's Virgin and Child for the Dominicans of

[123] *Virgin and Child*: 179·6 × 59·9 cm. The probable provenance is given in G. B. Cavalcaselle and J. A. Crowe, *Storia della pittura in Italia*, iii (Florence, 1885), 54–5.

[124] J. Brink, 'Simone Martini's *St. Catherine of Alexandria*: An Orvietan Altarpiece and the Mystical Theology of St. Bonaventure', *Annual Bulletin of the National Gallery of Canada*, 3 (1979–80), 37–56. For an alternative reconstruction, with the *Virgin and Child* at the centre of a pentaptych, see M. Lonjon, 'Quatre médaillons de Simone Martini: La reconstitu-

tion du retable de l'église San Francesco à Orvieto', *Revue du Louvre*, 33 (1983), 199–211.

[125] The theme of the celestial hierarchies occurs elsewhere in Franciscan painting, e.g. the crossing vault (*vele*) of the Lower Church of S. Francesco at Assisi; panel of the *Virgin and Child with Saints and Angels*, attributed to Lippo Memmi, Metropolitan Museum, New York (ill. K. Christiansen, 'Fourteenth-Century Italian Altarpieces', *Bulletin of the Metropolitan Museum of Art*, 40/1 [1982], 11).

Perugia.[126] The subject-matter of the Franciscan Lucca predella (Plate 45) has been seen as a reworking of the Dominican Pisa polyptych predella (Plate 27),[127] and it can be argued that Ugolino's lost Santa Maria Novella altarpiece preceded, and perhaps also influenced, his work for Santa Croce.[128] There may also be parallels to be drawn between the polyptych from San Francesco in Colle Val d'Elsa (Plate 54), and the Dominican polyptychs in Pisa (Plate 27) and, more strikingly, Orvieto (Plate 56).[129]

Dominican provincial chapter acts and convent obituary lists reveal the role of provincial links in encouraging art patronage, and illuminate the activities and attitudes of certain individual patrons. No comparable information is known to survive for the other orders of friars, although documentary sources may one day yield valuable information. Nevertheless a consideration of the works themselves, with their apparently deliberate repetitions, parallels, and variations, would seem to indicate the attention which certain individuals gave to the preparation of an artist's 'brief'. And how significant was the contribution of the Dominicans? It appears that at certain crucial moments they led, and others followed.

[126] See Cannon, 'Simone Martini', 81 n. 95, pls. 17a and b.

[127] Stubblebine, *Duccio di Buoninsegna*, i, 160.

[128] Cannon, 'Simone Martini', 91.

[129] See Mallory, 'An Altarpiece by Lippo Memmi', 202.

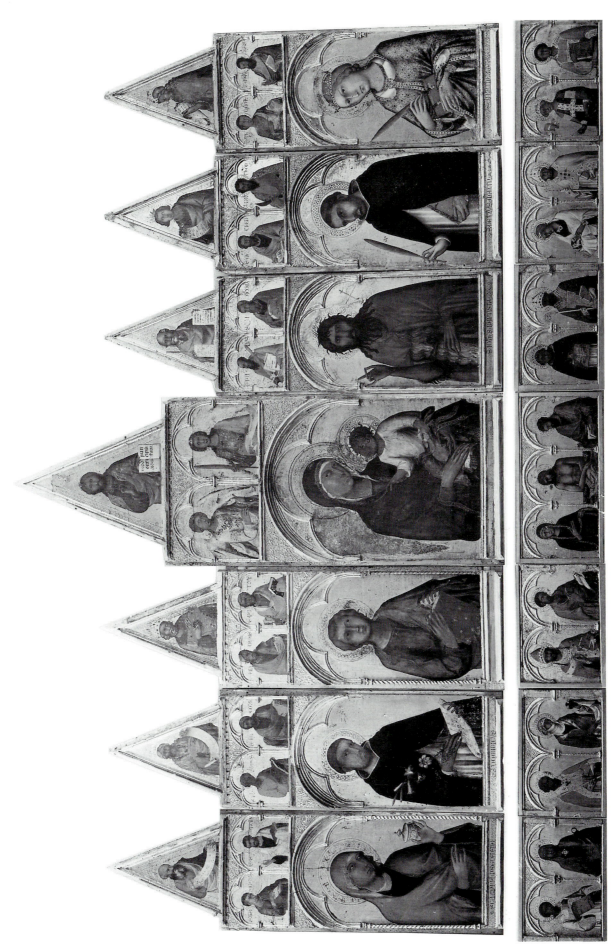

27. Simone Martini, 1320. Polyptych (reconstruction), 195 × 340 cm. Pisa, Museo Nazionale di San Matteo. From Santa Caterina, Pisa.

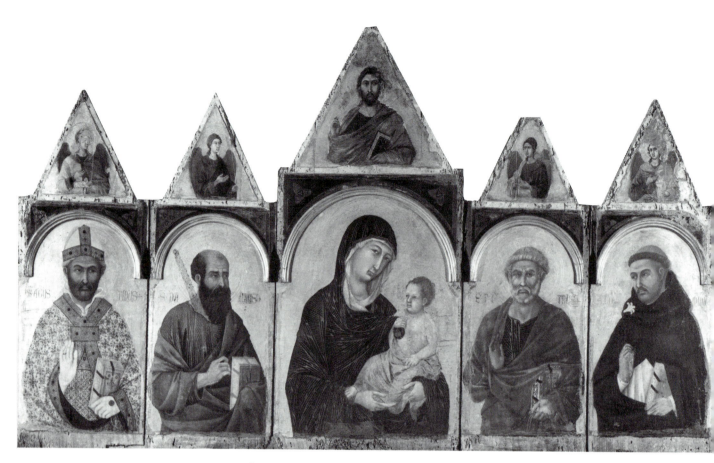

28. Duccio di Buoninsegna (attrib.), polyptych, max. dimensions 143 × 241·6 cm. Siena, Pinacoteca, No. 28. From San Domenico, Siena (?).

29. Maestro di Città di Castello (attrib.), reconstructed polyptych, 96 × 190 cm. *Madonna and Child*. Siena, Museo dell'Opera del Duomo, No. 24; lateral *Saints*, Siena, Pinacoteca, Nos. 29–32. From the Eremo di Montespecchio.

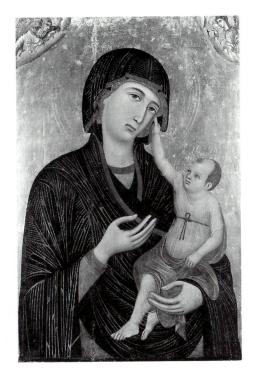

30. Duccio di Buoninsegna (attrib.), *Madonna di Crevole*, panel, 89 × 60 cm. Siena, Museo dell'Opera del Duomo, No. 37. From the Eremo di Montespecchio.

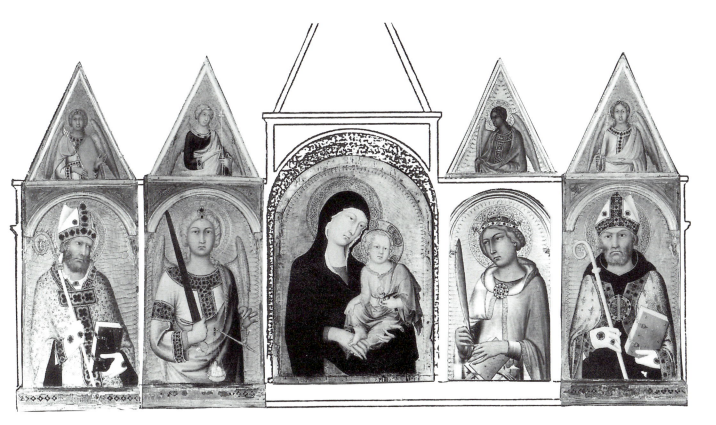

31. Simone Martini, polyptych (reconstruction after Gordon), 110 × 208·3 cm. *St Geminianus, St Michael*, Cambridge, Fitzwilliam Museum; *Madonna and Child*, Cologne, Wallraf-Richartz Museum; *St Catherine*, Florence, private collection; *St Augustine*, Cambridge, Fitzwilliam Museum. From Sant' Agostino, San Gimignano.

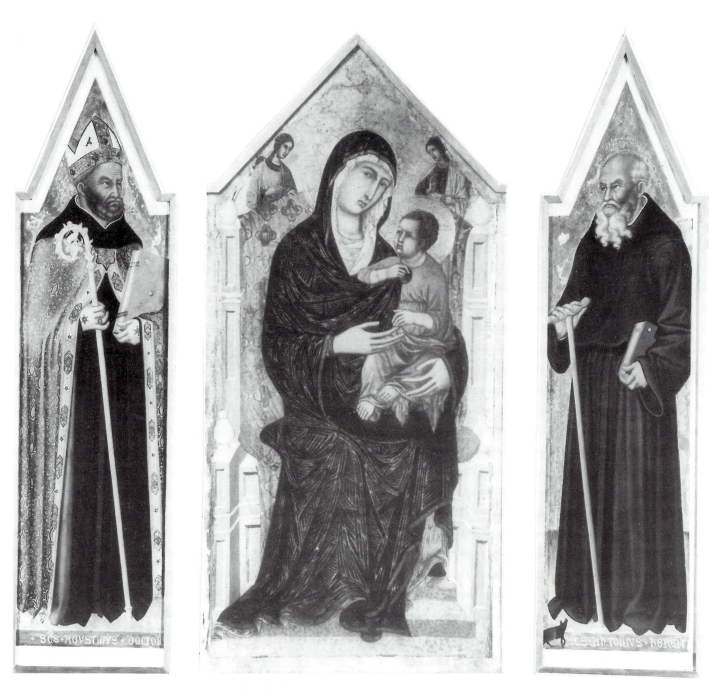

32. Sienese School, fourteenth century. Triptych, 158 × 165 cm. Private
 Collection. *Madonna and Child*, attributed to Segna di Bonaventura or
 the Goodhart Master; *St Augustine* and *St Anthony Abbot*, attributed to
 a painter close to the Master of the Buonconvento Cross. From San
 Leonardo al Lago.

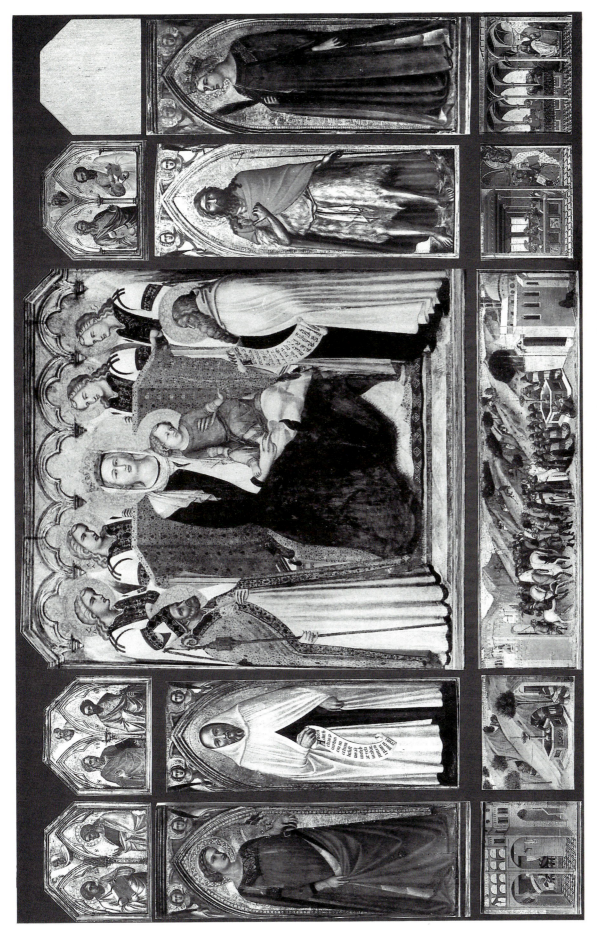

33. Pietro Lorenzetti, 1329, polyptych (based on Zeri and Maginnis reconstructions), not less than 208·5 × 338·8 cm. Siena, Pinacoteca, except for *St Andrew* and *St James Major* (New Haven, Yale University Art Gallery). *Elisha* and *John the Baptist* (Pasadena, Norton Simon Foundation). From San Niccolò del Carmine, Siena.

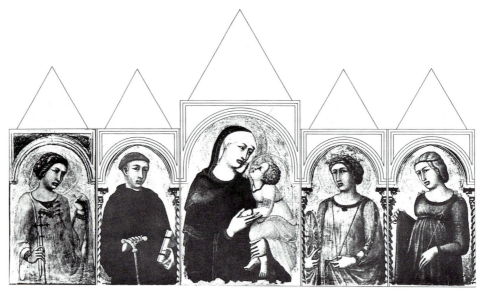

34. Pietro Lorenzetti (attrib.), polyptych (reconstruction after Seidel), approx. 178 cm. wide, *Madonna and Child* (Monticchiello, Santi Leonardo e Cristoforo); *St Margaret* (Le Mans, Musée Tessé); other Saints (Florence, Museo Horne). From Santi Leonardo e Cristoforo, Monticchiello.

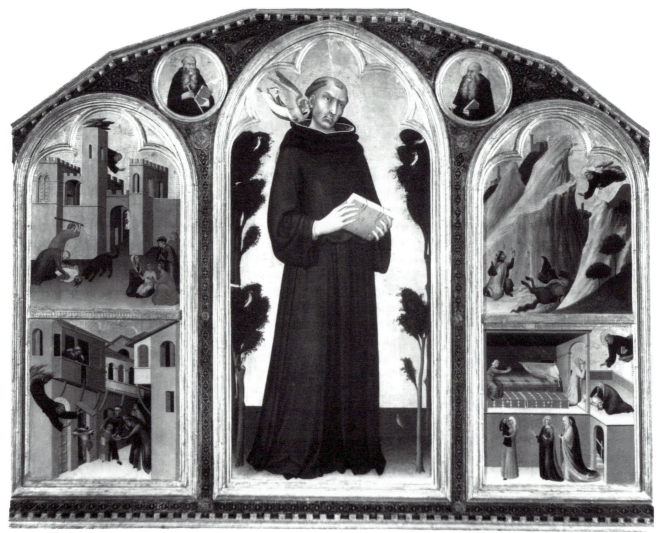

35. Simone Martini (attrib.), *The Blessed Agostino Novello and Four Miracles*, panel, 200 × 256 cm. Siena, Pinacoteca (on deposit). From Sant' Agostino, Siena.

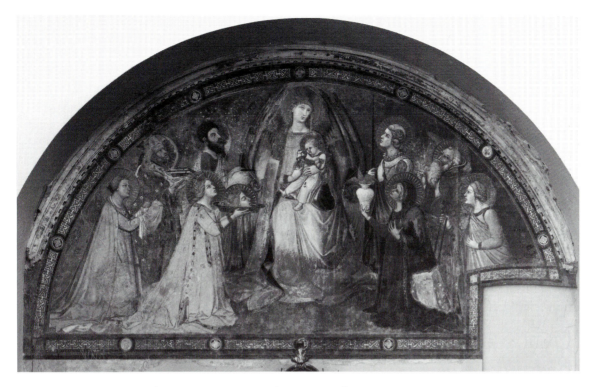

36. Ambrogio Lorenzetti (attrib.), *Maestà*, fresco, 215 × 381 cm. Siena, Sant' Agostino, chapter room.

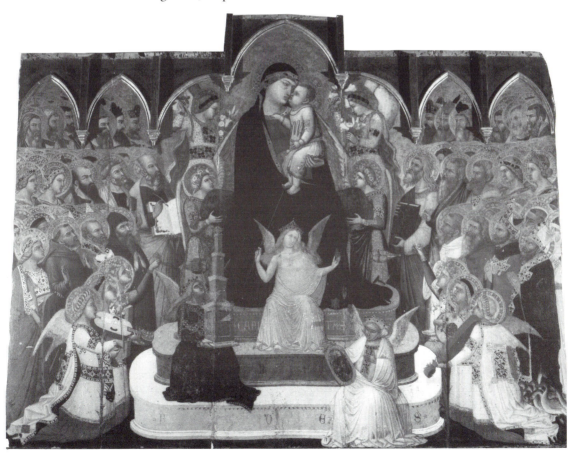

37. Ambrogio Lorenzetti (attrib.), *Maestà*, panel, 161 × 207 cm. Massa Marittima, Palazzo Comunale. From Sant' Agostino, Massa Marittima.

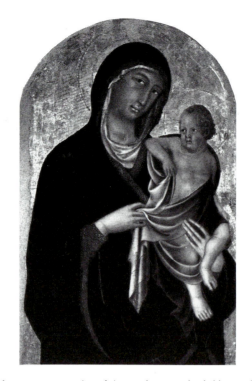

38. Segna di Bonaventura (attrib.), *Madonna and Child*, panel, 96·5 × 62·5 cm. Siena, Seminario Arcivescovile di Montarioso. From the Eremo di Lecceto (?).

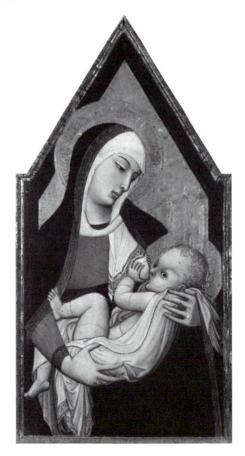

39. Ambrogio Lorenzetti (attrib.), *Madonna and Child* ('Madonna del Latte'), panel, 90 × 48 cm. Siena, Seminario Arcivescovile di Montarioso. From the Eremo di Lecceto.

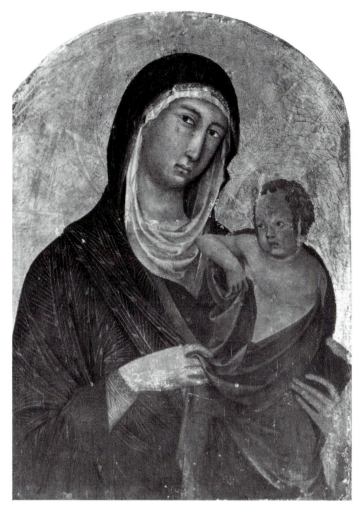

40. Segna di Bonaventura (attrib.), *Madonna and Child*, panel,
85 × 62 cm. Siena, Santa Maria dei Servi.

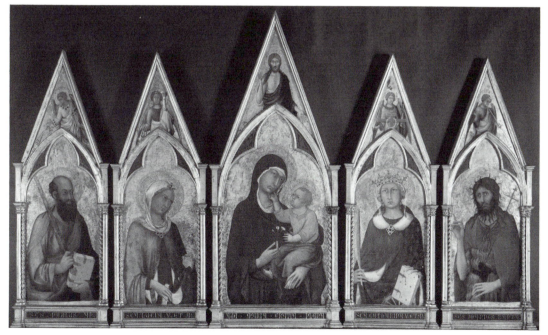

41. Simone Martini (attrib.), polyptych, 137·6 × 232·3 cm. Boston,
Isabella Stewart Gardner Museum. From Santa Maria dei Servi,
Orvieto.

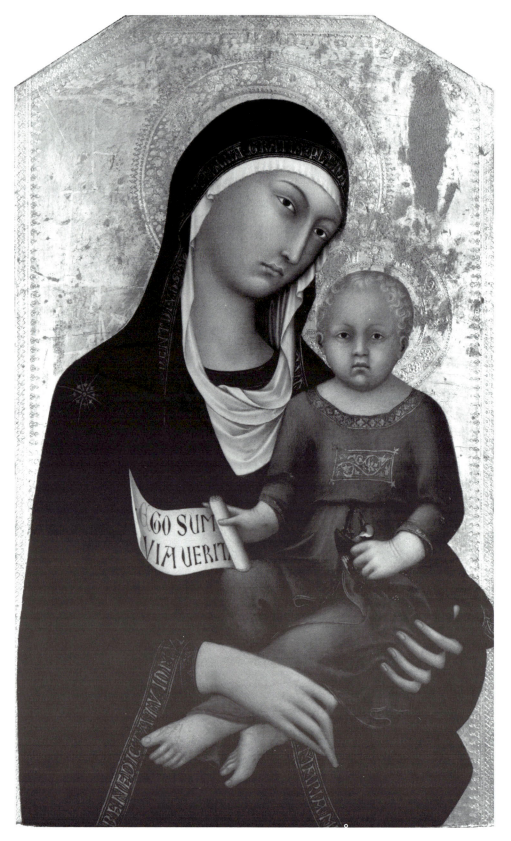

42. Lippo Memmi, *Madonna and Child* ('Madonna del Popolo'), panel, 78 × 51 cm. Siena, Pinacoteca (on deposit). From Santa Maria dei Servi, Siena.

43. Byzantine, fourteenth century (?), *Madonna and Child* ('Mater Decor Carmeli'), panel during restoration, 28 × 22 cm. Siena, San Niccolò del Carmine.

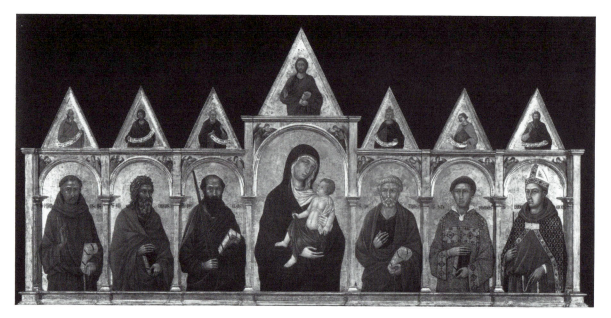

44. Ugolino da Siena (attrib.), polyptych, 163·7 × 341·4 cm. Williams-town, Mass., Sterling and Francine Clark Art Institute.

45. Ugolino da Siena (attrib.), *SS Agnes, Mary Magdalen, Stephen, Louis of Toulouse, the Crucifixion, Michael,* panel 29 × 200 cm. Lucca, Museo Nazionale di Villa Guinigi.

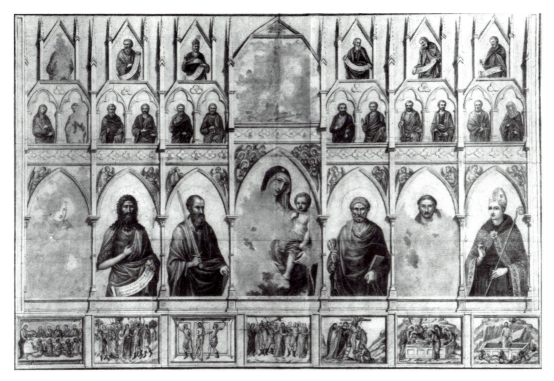

46. Drawing (*c*.1785–89) of Ugolino da Siena's Santa Croce polyptych.
Vatican, Biblioteca Apostolica, Vat. Lat. 9847, fo. 92ʳ.

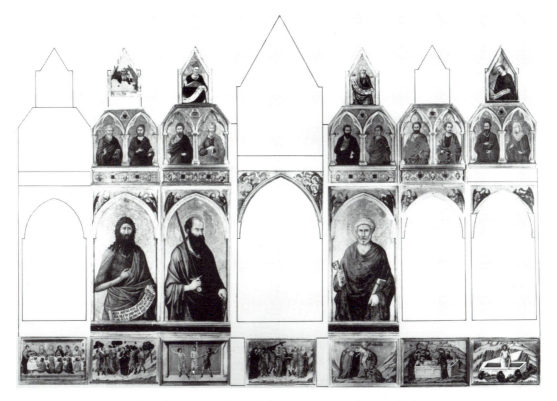

47. Ugolino da Siena, polyptych (reconstruction after Gordon), approx.
428 cm. wide. Berlin-Dahlem, Gemäldegalerie; London, National
Gallery; Los Angeles, County Museum of Art; Milan, Museo Poldi
Pezzoli; New York, Metropolitan Museum of Art, Lehman Collec-
tion; Philadelphia, Museum of Art, Johnson Collection. From Santa
Croce, Florence.

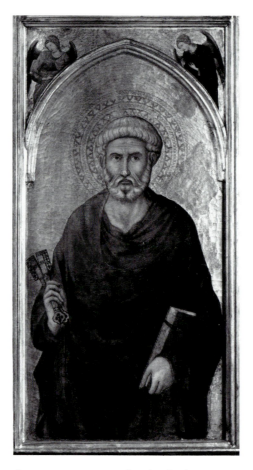

48. Ugolino da Siena, *St Peter*, detail of Plate 47. Berlin-Dahlem, Gemäldegalerie.

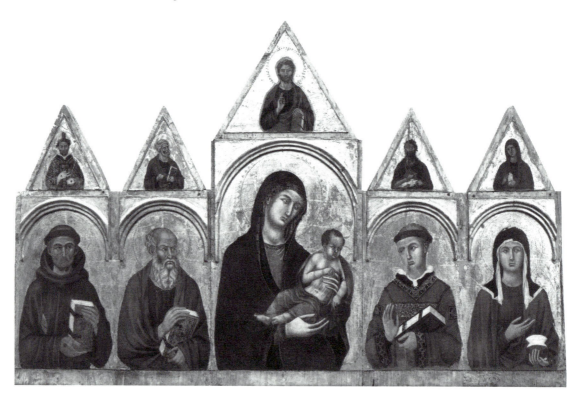

49. Maestro di Città di Castello (attrib.), polyptych, 116 × 184 cm. Siena, Pinacoteca, No. 33. From San Lorenzo, Siena.

50. Ugolino da Siena (attrib.), *St Peter*, panel, 70 × 39 cm. San Casciano Val di Pesa, Misericordia.

51. Ugolino da Siena (attrib.), *St Francis*, panel, 70 × 39 cm. San Casciano Val di Pesa, Misericordia.

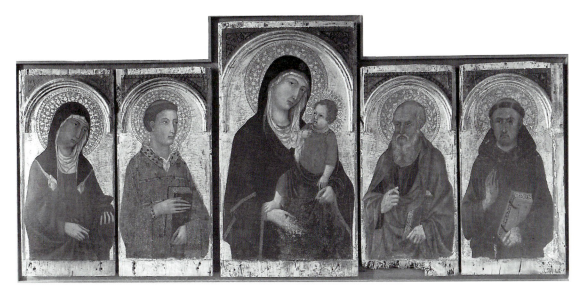

52. Ugolino da Siena, or workshop, polyptych, 84 × 189 cm. Siena, Pinacoteca, No. 39. From Santa Chiara, Siena.

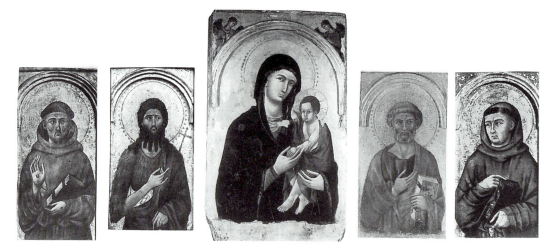

53. Maestro di Città di Castello (attrib.), panels from a polyptych. *St Francis*, dimensions unrecorded, Vienna, formerly Lanckoronski Collection; *John the Baptist*, 72·4 × 35·1 cm., New Haven, Yale University Art Gallery; *Madonna and Child*, 100·6 × 60·9 cm., Copenhagen, Statens Museum for Kunst; *St Peter* (?), 71·2 × 35·6 cm., New Haven, Yale University Art Gallery; *St Anthony of Padua*, 71 × 34 cm., La Spezia, Lia Collection.

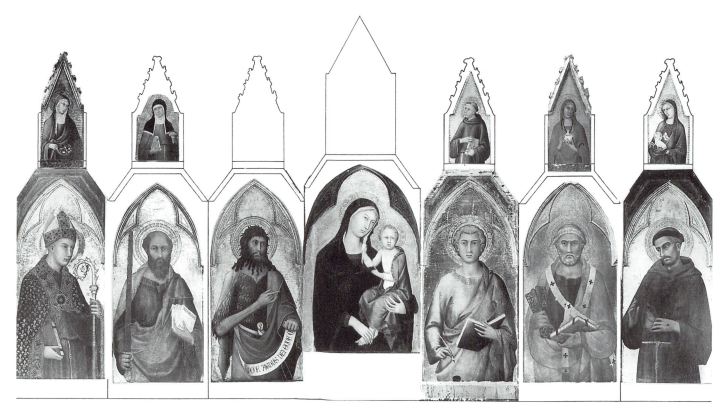

54. Lippo Memmi (attrib.), polyptych (based on Mallory's reconstruction), not less than 319·5 cm. wide. Main panels: (?) Berlin-Dahlem, Gemäldegalerie; New York, Metropolitan Museum of Art; New Haven, Yale University Art Gallery; Paris, Louvre; Siena, Pinacoteca; Washington, National Gallery of Art. Pinnacles: Milan, Museo Poldi Pezzoli; New York, Metropolitan Museum of Art; Pittsburgh, The Frick Art Museum; Providence, Museum of Art, Rhode Island School of Design. From San Francesco, Colle Val d'Elsa (?).

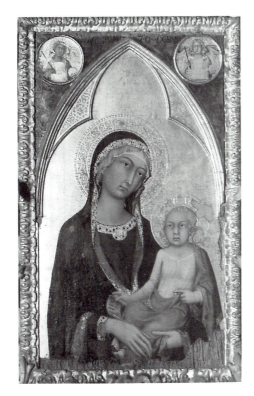

55. Simone Martini and shop (attrib.), *Madonna and Child*, panel,
179·6 × 59·9 cm. Orvieto, Museo dell'Opera del Duomo. From
San Francesco, Orvieto (?).

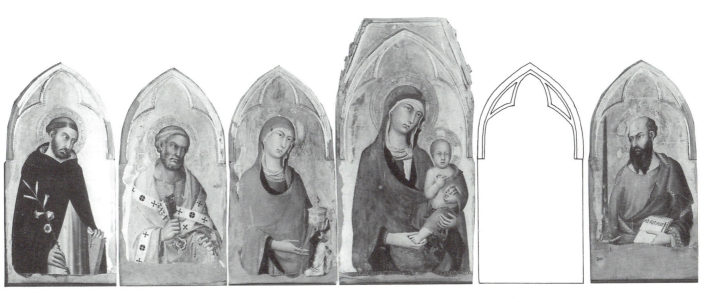

56. Simone Martini, polyptych (current reconstruction), not less than
354 cm. wide. Orvieto, Museo dell'Opera del Duomo. From
San Domenico, Orvieto.

3

SIENESE QUATTROCENTO PAINTING IN THE SERVICE OF SPIRITUAL PROPAGANDA

Gaudenz Freuler

TRADITIONALLY, the visual arts have been instrumental in the diffusion of the cult of saints as, for instance, has been recently demonstrated in the case of St Catherine of Siena.[1] In this study, thanks to new archival discoveries, Sano di Pietro's career will be examined in the light of his connection with a religious confraternity, the *Compagnia della Vergine*, associated with Siena's Ospedale della Scala and also with the new monastic order known as the Gesuati. The spiritual milieu of the Ospedale della Scala with its confraternities and its ties to various orders was of central importance to the canonization proceedings on behalf of Bernardino of Siena.

Let us begin with the Ospedale della Scala where the future saint assisted the plague-stricken and served as a member of the *Compagnia della Vergine*[2] who were the custodians of the carved *Crucifix* responsible for Bernardino's conversion (Plate 57).[3] His canonization was carried out

Abbreviations used in the Notes and Appendix

AAS: Archivio Arcivescovile, Siena

AOMC: Archivio dell'Ospedale di S. Maria della Croce, Montalcino

APD: Archivio della Società di Pie Disposizioni, Siena

ASS: Archivio di Stato, Siena

BCS: Biblioteca Comunale, Siena

The origin of this study comes from a joint research project carried out in the Sienese archives with Michael Mallory, New York. The material presented here forms part of a larger study dedicated to the artistic career of Sano di Pietro seen in the light of Sienese spirituality and civic life. The volume now in preparation will be published by both of us.

[1] G. Freuler, 'Andrea di Bartolo, Fra Tommaso d'Antonio Caffarini, and Sienese Dominicans in Venice', *Art Bulletin*, 69 (1987), 570–86.

[2] In the membership register of the *Compagnia della Vergine* (Siena, APD, MS 47 *bis*), under 30 May 1400 we find S. Bernardino inscribed as a member of the confraternity: '*Messer Bernardino di tolo venne a fare de nostri fratelli a di 30 di maggio 1400 a tempo di maestro franciescho del bertino priore.*' A later addition reads: '*Morto a dì 20 di maggio 1444; fu canonizzato per papa Nicolao V a dì 24 magio era l'an(n)o del jubileo.*' For S. Bernardino see also U. Meattini, *Santi senesi* (Poggibonsi, [1974]), 65 ff.; G. Kaftal, *The Iconography of the Saints in Tuscan Painting* (Florence, 1952), 196–200.

[3] APD, Forteguerri, *Memorie*, fo. 10. For a critical discussion of the miraculous Crucifix and its attribution to the Maestro del Crocifisso dei Disciplinati, see R. Bartalini, 'Maestro del Crocefisso dei Disciplinati', in A. Bagnoli and R. Bartalini (eds.), *La scultura dipinta: Maestri di legname e pittori a Siena 1250–1450*, exhibition catalogue, Siena, 1987 (Florence, 1987), 96–100.

with unusual rapidity and, of course, the hospital and his confraternity basked in the reflected glory of their former associate and, as a result, their sites became hallowed as well. San Bernardino's canonization and the propagation of his cult were far more rapid than St Catherine of Siena's, whose case had taken eighty years while his took only six!

Bernardino died on 20 May 1444.[4] Less than a month afterwards, on 7 June, the members of the *Compagnia della Vergine* together with another of the hospital's confraternities, the *Compagnia dei SS. Girolamo e Francesco*, decided to commemorate his death with masses and other events.[5] In addition, the *Compagnia della Vergine* wanted to give more tangible and durable form to their celebration of Bernardino via an image for which the prior and councillors were authorized to spend as much as they deemed necessary. Its history began on 23 May 1445 when three of the confraternity's members were chosen to supervise the execution of a painting of the Blessed Bernardino.[6] On 28 August of the same year the commission was given to Sano di Pietro.[7] By this date the carpenter, Domenico di Cesare, had already prepared a panel,[8] and probably work on it began soon afterwards. An agreement stipulated that Sano di Pietro would paint an image of the Blessed Bernardino to the confraternity's satisfaction:

El detto maestro Sano s'obligha di dipegniare il detto beato Bernardino a piacimento de sopradetti aloghatori e se a loro non piacesse s'obrigha di guastarlli e rifallo tanto e quante volte e sopradetti siano ben contenti.[9]

[Said master Sano promises to paint the said Blessed Bernardino according to the pleasure of the above-mentioned commissioners and if they are displeased with it he will be obliged to ruin it and do it over and over so often until the above (commissioners) are well pleased.]

Probably such pains were taken so as to guarantee the painting's likeness to the official portrait apparently established soon after his death when Pietro di Giovanni d'Ambrogio painted the panel in the Osservanza (Plate 61)[10] based upon a death mask (Plate 59).[11]

Sano di Pietro must have finished his panel by 1446 because in February 1447 it is mentioned as already done.[12] Furthermore, the same document declares that the *Compagnia della Vergine*, who had commissioned the work, intended either to give it or to lend it to another confraternity known as the *Compagnia di Sopra* that was a branch of the *Compagnia dei SS. Girolamo e*

[4] See n. 2.

[5] See Doc. 1 in Appendix. See also M. Bertagna, 'L'Osservanza di Siena', *Studi storici*, i (Siena, 1963), 11. For the commemorative celebrations in honour of Bernardino performed by the *Compagnia dei SS. Girolamo e Francesco* see Siena, ASS, *Patrimonio Resti*, No. 906, Documenti e memorie, fos. 6–7.

[6] See Doc. 2 in Appendix.

[7] See Doc. 3 in Appendix.

[8] Ibid.

[9] Ibid.

[10] For the most recent literature on Pietro di Giovanni

d'Ambrogio's panel, see the item by A. Cornice, 'Opere d'arte all'Osservanza', in *L'Osservanza di Siena: La basilica e i suoi codici miniati* (Milan, 1948), 78–9.

[11] That the traditional portrait of S. Bernardino was based on the saint's death mask has been argued convincingly by P. Misciatelli, 'Iconografia Bernardiniana', *La Diana*, 7 (1932), 247–52.

[12] See Doc. 4 in Appendix. Various contemporary documents show that 'una tavola' in quattrocento terminology did not simply mean a single panel, but instead signified an actual altarpiece composed of various elements.

Francesco.[13] If this panel was to be set up in the *Compagnia di Sopra*'s oratory, then another panel must have been ordered for the *Compagnia della Vergine*'s chapel. Before considering the possible reasons for the *Compagnia della Vergine* to have ceded their picture to another confraternity, we must find out where it was originally located. A document dated 13 September 1448 supplies the answer and proves that together with two further panels it formed what we suspect to have been an altarpiece. At this date it is recorded that Sano di Pietro had received 200 *lire* for the painting of San Bernardino and

d'una Nostra Dona in uno tondo a chapo del beato Bernardino, e per due storie dipente, una quando el beato Bernardino predicho in sul champo di Siena, e l'altra quando predicho a' frati Minori.[14]

[a Madonna in a roundel above the head of the Blessed Bernardino, two painted scenes, one when the Blessed Bernardino preached in the Campo of Siena, and the other when he preached to the Friars Minor.]

The ensemble, including the two scenes mentioned, was apparently installed not in the oratory of the *Compagnia della Vergine*, but upon the altar of the *Compagnia di Sopra* ('*Queste tavole son poste al altare della cappella della compagnia di sopra*').[15]

The second picture which might have been substituted for the panels given to the *Compagnia di Sopra* and set up in their chapel was apparently already on hand because the amount paid included another panel by Sano di Pietro with San Bernardino alone. This second painting, still unknown, however, again was not destined to go on the *Compagnia della Vergine*'s altar, because we know that, instead, the confraternity gave it to Giovanni da Capestrano, San Bernardino's companion, as a token of gratitude for having celebrated mass and prayers in their oratory a few days earlier.[16]

The altarpiece that was finally installed in the San Bernardino chapel belonging to the *Compagnia della Vergine* was only completed after 1458. According to descriptions, it consisted of four large panels depicting SS Bernardino, Catherine of Siena, the Blessed Giovanni Colombini, and Ansano.[17] One panel of this group is probably to be identified with Sano di Pietro's

[13] The foundation of the *Compagnia di Sopra* began on 22 Mar. 1443 when members of the *Compagnia dei SS. Girolamo e Francesco* decided to organize a congregation that would meet during the day rather than at night. The close alliance with the original group, i.e. the *Compagnia dei SS. Girolamo e Francesco*, emerges from the statutes that established that one of the three governors of the new brotherhood had to be a member of the *Compagnia dei SS. Girolamo e Francesco* (ASS, *Patrimonio Resti*, 906, Documenti e memorie, fo. 7; ASS, *Patrimonio Resti*, 917 *bis*, fos. 5, 14).

[14] See Doc. 5 in Appendix.

[15] See n. 14 above.

[16] See Doc. 6 in Appendix.

[17] The intention finally to furnish the altarpiece for the chapel of S. Bernardino appears in a document of 13 Oct. 1454 in which the *Compagnia della Vergine* decided to have painted four saints, and chief among them, S. Bernardino. See Doc. 7

in Appendix. The coda that one of these saints had to be S. Bernardino ('*e massimo Sancto Bernardino . . .*') indicates that the S. Bernardino chapel was still without appropriate furnishing, such as the altarpiece in question. A second document of 1458 informs us that this commission was awarded to Sano di Pietro. APD, *Deliberazioni 1401–1557*, fo. 73ʳ (16 Apr. 1458): '*Domenicha a di 13 d'ottobre il priore feccie proposstta in chapitollo generale, di fare quattro figure di quele isttatte dela Chompagnia della Vergine Maria, e massime Sancto Bernardino. Fu chonssegliatto e messo a parttito a lupini bianchi e neri, chollto parttito in [nu]maro di vintti di fratteglli, ventto e ottenutto per lupini vintti bianchi, ttutti d'achordo che ffuse rimesso in ser Stefano apreso di lui chi a lui para, ed egllino fare tantto et qua[n]tto a loro para, o in tavole o i' muro et dove meglio para i'nela Chompagnia di sotto.*' The four saints mentioned here are perhaps identifiable with the '*quadri quattro con quattro santi in capitolo i quali di Santo Ansano, Santo Bernardino, Beato Giovanni*

Sant'Ansano from the Ospedale della Scala but now in the Siena Pinacoteca (Plate 58).[18] So much for the historical circumstances concerning the three commissions to Sano di Pietro from the *Compagnia della Vergine*: i.e. the two altarpieces and the single panel with San Bernardino.

But to return to the three large panels donated to the *Compagnia di Sopra*: from the description in the payment of 1448, San Bernardino's image (Plates 60, 62) and the two panels with the saint preaching in the Piazza del Campo and in front of San Francesco (Plates 63–4), one may deduce that they should be identified with the three paintings by Sano di Pietro now in the chapter room (Sala del Capitolo) of Siena Cathedral, which seem to have constituted the main part of an altarpiece (Plate 66).

Our proposal that Sano's three chapter-room panels are the surviving parts of the triptych is, above all, based on the coincidence of their subjects.[19] This is particularly significant in the case of the two preaching scenes, for the chapter-room versions are the only known large-scale representations of these events in Sienese art.[20] By contrast there exist several sizeable portraits of Bernardino including, as mentioned, some attributed to Sano, and so the identification of the chapter-room *Bernardino Ascending to Heaven* (Plate 62) as the documented '*figura del beato Bernardino*' is less self-evident, though there are several arguments in its favour.

Foremost of these is the fact that the three chapter-room panels are among the relatively few representations of Bernardino to portray him with rays of a *beato* rather than the halo of a saint (Plates 60, 62).[21] When we recall that the documents just cited stipulate that the subject of the confraternity's altarpiece was to be the '*beato Bernardino*', that the altar it was placed on had the same dedication, and that the painting was made at just the time we might reasonably expect images of Bernardino as Blessed, the association of the three existing panels with the documented work seems very likely.[22]

Colombini, Santa Caterina' that appear in the inventory of the *Compagnia della Vergine* dated 1610 (APD, *Inventarii*, 155–1677, fo. 53). The likelihood that this identification is correct is strengthened by the fact that the Chapel of S. Bernardino belonging to the *Compagnia della Vergine* had as its patrons, aside from its titular saint, saints Ansano and Catherine, all of whom are represented in this altarpiece (ASS, D. III [G. Macchi], fo. 200).

[18] For this panel, see P. Torriti, *La Pinacoteca Nazionale di Siena: I dipinti dal XII al XV secolo* (Genoa, 1977), 289; and D. Gallavotti Cavallero, *Lo Spedale di Santa Maria della Scala in Siena: vicenda di una committenza artistica* (Pisa, 1985), 238.

[19] For the sake of clarity the following ten paragraphs have been reprinted from an article previously published (M. Mallory and G. Freuler, 'Sano di Pietro's Bernardino Altarpiece for the Compagnia della Vergine in Siena', *Burlington Magazine*, 133 [1991], 186–92, for which we thank the Editor).

[20] Small scenes of Bernardino preaching, including *San Bernardino preaching in the Campo of Siena*, formerly in the Edward Hutton Collection, and attributed to Sano, are

known, but none would be appropriate as parts of the *Compagnia della Vergine*'s triptych.

[21] Our thanks to Keith Christiansen for sharing with us his observation that originally rays barely visible in our reproduction (Plate 60), decorated the head of *Bernardino Ascending to Heaven*. The present halo is a later addition. Pietro di Giovanni d'Ambrogio's portrait of Bernardino (Plate 61), in the church of the Osservanza near Siena, dated 1444, seems to have undergone a similar transformation.

[22] J. Pope-Hennessy, *Sassetta* (London, 1939), 161–3, discusses the representation of Bernardino in 15th-c. art, speculating that images of him without designation either as Blessed or as a saint might have been painted before his death, that images of him as Blessed would have been painted between 1444 (the year of his death) and 1450 (the date of his canonization) and that haloed images would have been made after this event. Without knowledge of the documents published here, a number of dates for the execution of the chapter-room panels have been proposed. Pope-Hennessy, *Sassetta*, follows E. Gaillard, *Un peintre Siennois au XVᵉ siècle:*

In addition, the style of the chapter-room panels supports this supposition. Their execution is of consistently high quality throughout and, indeed, they closely recall Sano's *St George* altarpiece, which recent research has established as originating in the mid-1440s.[23] The resemblance between Bernardino's attentive audience and the entourage of the king in the predella of *St George Preaching to the King of Silena* is particularily striking.

There may even be circumstances to explain how the *Compagnia della Vergine*'s triptych came to be transferred to the chapter room. Antonio Palmieri-Nuti, who is claimed to have been the previous owner of the two preaching scenes, and who donated them to the chapter room, was once an important member of the confraternity. In fact, some years after his gift, he was elected prior.[24] Since the *Bernardino Ascending to Heaven* (Plate 62) seems to have turned up in the chapter room at about the same time as the preaching scenes (Plates 63–4), it too may once have formed part of Palmieri-Nuti's collection.[25] In any case, if the scenes of Bernardino preaching were not already owned by the family, Palmieri-Nuti's high-ranking position in the confraternity might have facilitated their acquisition. There is, in addition, a sound reason as to why he might have donated them to the chapter room. Another member of the Palmieri-Nuti family, Pier Luigi, had quite recently become a canon of the cathedral, so that an association between family and cathedral chapter is known to have existed.[26] It is to be hoped that further research can establish more certainly whether the coincidence of circumstances just outlined was, indeed, relevant to the history of Sano's altarpiece.

Of some importance for the principal argument proposed here is the question of whether the existing paintings can be plausibly reconstructed as a triptych. In our view, their form and style allow for such a reconstruction, although it should be noted that the technical evidence is inconclusive on two important points.

The centre of such an ensemble would logically have been the tall, narrow *Bernardino Ascending to Heaven* (Plate 62). For the reconstruction proposed here (Plate 66), it is noteworthy that this

Sano di Pietro 1406–1481 (Chambéry, 1923), 24–5, and dates the chapter-room preaching scenes before the saint's death. R. L. Mode, 'San Bernardino in Glory', *Art Bulletin*, 55 (1973), 71, believes them to have been made only after the saint's canonization in 1450. J. Trübner, *Die stilistische Entwicklung der Tafelbilder des Sano di Pietro (1405–1481)*, (Strasburg, 1925), 19–20, dates them around 1444. As for *Bernardino Ascending to Heaven* (Plate 62), E. Carli, 'Una mostra Bernardiniana a Siena', *Emporium*, 112 (1950), 167–78, and id., *Il Duomo di Siena* (Genoa, 1979), 116, considers it to have been painted some time after 1450, a date implied but not stated by other critics. D. Arasse, 'Fervebat Pietate Populus: Art, dévotion, et société autour de la glorification de saint Bernardin de Sienne', *Mélanges de l'école française de Rome*, 89/3 (1977), 189–263, claims that an immaterial, flame-like monogram of Christ is a feature of the very earliest of the Bernardino portraits. To our knowledge, only the chapter-room panels and another one in Civita Castellana (S. Pietro) show this sort of monogram.

[23] C. Alessi and P. Scapecchi, 'Il "Maestro dell'Osservanza": Sano di Pietro o Francesco di Bartolomeo?', *Prospettiva*, 42 (1985), 13–37; W. Loseries, 'La pala di San Giorgio nella chiesa di San Cristoforo a Siena: Sano di Pietro o il Maestro dell'Osservanza?', *Prospettiva*, 49 (1987), 61–74; K. Christiansen *et al.* (eds.), in *Painting in Renaissance Siena, 1420–1500* (exhibition catalogue, Metropolitan Museum of Art, New York, 1988), 27–30.

[24] He is listed as a prior for the year 1859 on a roster of members still preserved in the confraternity's former quarters.

[25] One is tempted to think that Antonio might have been especially interested in all these paintings since his father's patron saint was Bernardino (ASS, A. Aurieri, *Battezzati maschi dal 1593*, MS A. 19, 184). For the provenance of the two preaching scenes see Trübner, *Die stilistische Entwicklung*, 19.

[26] Pier Luigi's appointment as canon in 1818–20 is recorded on an inscribed tablet in the entry room of the Siena cathedral chapter room.

panel's otherwise rich gilding is conspicuously absent along its outer edge, indicating that lateral panels and an upper framing device were once attached. Also, it is reasonable to speculate that the lower and broader rectangular preaching scenes were these laterals since their heights are identical to the central one, if measured to the springing of the arch (Plate 66).[27]

To judge from their compositions, it appears that *Bernardino Preaching in the Piazza San Franceso* and *Bernardino Preaching in the Campo* would have been the triptych's left and right wings respectively (Plate 66). In such an arrangement, the emphatic diagonals created by the crowds listening to Bernardino's sermons would have led the viewer's eye to the large portrait in the centre. Other non-stylistic evidence confirms this sequence as well. Nail holes from additional, seemingly substantial frames once attached to the right edge of the *Bernardino Preaching in the Piazza San Francesco* and to the left edge of *Bernardino Preaching in the Campo* demonstrate that these panels flanked some central element in the sequence we propose. The missing outside frames might well have resembled the deep one surrounding the *Bernardino Ascending to Heaven* (Plate 62).[28]

However, there are significant questions that the technical evidence does not clarify. No dowel holes are visible in any of the three panels, nor is there evidence of battens on the backs of the preaching scenes, another common device used to unite separate panels within composite altarpieces of the type here proposed.[29] Recalling that the record of payment states that '*le dette tavole*' had been placed on the altar, there remains the possibility that no single piece of carpentry enclosed Sano's three panels and that they stood independently on the *Compagnia di Sopra*'s altar, though it is likely they would have been arranged in the order we have proposed.[30] We find such a free and, for this date, fragmentary arrangement to be quite unlikely, particularly for a work of such importance. A third possibility might be that Sano's panels were joined, but in a sculpted frame that eliminated the need for any further coupling device. However, the confraternity's relatively complete documentation of the altarpiece makes no mention of a sculptor's participation. We prefer the view that since all three chapter-room panels must long ago have

[27] *Bernardino Ascending to Heaven*: 216·4 × 101 cm. (restored gilding in the triangular pedestal at the bottom, the bases of the colonnettes which may have originally extended into the flanking panels, and the finials); *Bernardino Preaching in the Campo of Siena* and *Bernardino Preaching in the Piazza San Francesco in Siena*: 162 × 101·5 cm (including original frames).

[28] Although it has a triangular gable, Vecchietta's *Assumption of the Virgin* triptych in Pienza Cathedral (Plate 68) includes deep frames between the central panel and its laterals of a type related to those we propose for the *Compagnia della Vergine*'s triptych. Our thanks to Elena Pinzaiuti of the Gabinetto dei restauri of the Pinacoteca of Siena, who agrees that the preaching scenes flanked some central element in this sequence.

[29] Unfortunately, we were unable to inspect the back of the *Bernardino Ascending to Heaven* panel. However, Keith Christiansen, who in 1988 had the opportunity of studying the panels, noted on the back of the S. Bernardino panel traces of two battens one-quarter and two-thirds of the way up from the bottom (K. Christiansen, 'Sano di Pietro's S. Bernardino Panels', *Burlington Magazine*, 133 [1991], 451–2). He states that this reinforcing device does not necessarily imply that the panel was part of a larger complex.

[30] In response to an article by M. Mallory and myself ('Sano di Pietro's Bernardino Altarpiece, 186–92), Keith Christiansen discussed technological issues concerning the S. Bernardino panels in the Sala Capitolare and underlined the manifold technological problems surrounding their plausible reconstruction. At the same time he presented an alternative reading of the documents which we related to these panels (K. Christiansen, 'Sano di Pietro's S. Bernardino Panels', 451–2). For a further discussion of the documents see the introduction to our appendix.

been removed from their original settings, the visible evidence of battens or whatever joining device was employed has vanished in subsequent restorations. We await a more extensive technical examination of all three panels to help resolve this issue.

Assuming the panels were joined in a triptych, the form of the upper frame is impossible to determine from the remaining evidence. Basing ourselves on a triptych type common in fifteenth-century Siena, we hypothesize that the three panels were surmounted by a segmental gable. As for '*una Nostra Dona in uno tondo a chapo del Beato Bernardino*', mentioned in the 1448 record of payment, we have interpreted this reference rather loosely and in our reconstruction have followed the scheme of other, comparable works by Sano (Plate 67) including double roundels depicting the *Annunciation*.[31] A single, circular image of the Madonna and Child situated over the top of the *Bernardino Ascending* panel would be an equally plausible solution.[32]

Having clarified the more recent history of these panels and having perceived how they belonged to the altarpiece commissioned by the *Compagnia della Vergine*, it remains to be seen what factors motivated this confraternity to cede their large new altarpiece to the *Compagnia di Sopra*. I believe this event was directly connected with Giovanni da Capestrano's efforts in the process of canonizing San Bernardino. Siena eagerly awaited Giovanni da Capestrano's arrival so that all the various depositions concerning Bernardino's life and miracles could be examined officially. It is to be noted that on various occasions the Sienese government requested insistently that the pope send Giovanni da Capestrano to Siena.[33] This became reality in the summer of 1448 when he arrived with an escort consisting of a papal commission including Angelo Capranica, bishop of Ascoli, along with a Franciscan delegation among whom was the order's master general and the provincial minister for Tuscany.[34]

Among the important events that took place in the saint's native city was the delegation's two-day visit to the Ospedale di Santa Maria della Scala, the place which occupied such an important role in Bernardino's life.[35] This visitation assumed a special significance because Giovanni da Capestrano and the papal commission paid hommage to the site of the saint's conversion and to the place where his charity and miracles were most keenly felt (Plate 57).[36] Therefore, it was particularly appropriate that Giovanni da Capestrano, together with the papal commission and all the other influential personages, celebrated mass in the Oratorio di Sopra where Bernardino

[31] e.g. Siena, Pinacoteca No. 237.

[32] No work by Sano that might be this missing element from the triptych is known to us.

[33] A. Liberati, 'La Repubblica di Siena e San Giovanni da Capestrano', *Bullettino senese di storia patria*, NS 8 (1937), 375–402; id., 'Le prime manifestazioni di devozione a S. Bernardino dopo la sua morte da parte del comune di Siena', *Bullettino senese di storia patria*, NS 6 (1935), 143–61.

[34] Id., 'La vicenda della canonizzazione di S. Bernardino', *Bullettino di studi Bernardiniani*, 2 (1936), 91–124; M. Bertagna, 'Memorie Bernardiniane I', *Bullettino senese di storia patria*, NS 23 (1964), 5–50.

[35] The hospital's importance in S. Bernardino's life is witnessed by the many miracles he performed there. The compiler of the *Acta Sanctorum* wrote this: '*In ecclesiam S. Mariae de Scala, hospitalis Senensis, S. Bernardinus tot et tantis coruscat miraculis, quod si omnia scripta forent magna librorum volumina compleretur*' (*Acta Sanctorum*, V, Maii 20 [Antwerp, 1685], 259).

[36] For San Bernardino's conversion, see: APD, Forteguerri, *Memorie*, fo. 44ᵛ. See also n. 35 above.

himself had officiated on various occasions.[37] In the interest of a common cause, the two confraternities, the *Compagnia di Sopra* and the more prestigious *Compagnia della Vergine*, joined forces to create a Bernardine sanctuary where Giovanni da Capestrano and the papal commission could gather and celebrate mass. Very probably the series of lauds in honour of San Bernardino published by Lusini[38] were composed for this occasion. Their text includes an image of the saint still represented with the rays of a *beato* (Plate 69) clearly indicating that these songs belong to the time preceding his canonization. Various factors indicate that the verses were composed for the *Compagnia della Vergine* and were probably sung during Giovanni da Capestrano's visit to the oratory of the *Compagnia di Sopra*: their provenance from the Ospedale della Scala, the textual allusions to the *Compagnia della Vergine*, and their emotional nature in the style of the *laudi* of the Gesuati who served as chaplains for the *Compagnia della Vergine*.[39] Some of these verses are particularly revealing because they throw light on Sano di Pietro's San Bernardino altarpiece and upon Siena's identification with this new saint. Bernardino was compared to a lily:

Chanti il popol di Siena, chanti massa e Toscana in ogni lato ch'essi di gratia plena avendo in cielo un tal giglio piantato

[Sing, people of Siena, sing every side of Tuscany who have been graced with such a lily planted in heaven]

In other verses, Bernardino is again seen in a clearly civic light with the faithful praising God for having honoured the Virgin's city of Siena with Bernardino:

noi piangiam tutti cantando laude gloria sia a te dolce signore ch'ai posto in tant'honore la città di Maria.

[we cry all singing songs of glory to you sweet Lord who has placed so much honour on the city of Mary.]

Even though Bernardino's body remained in Aquila, it was openly considered and publicized as Sienese. From this it is clear that his canonization did not touch only the Franciscans or the two confraternities associated with him: it was also a civic act of great importance especially if we keep in mind that as early as 1446 Bernardino was considered by the commune as '*singolarissimo*

[37] M. Bertagna, 'La vicenda della canonizzazione di S. Bernardino', 27. On this solemn occasion Angelo Capranica was elected to membership in the *Compagnia dei SS. Girolamo e Francesco*; see ASS, *Patrimonio Resti*, 917 *bis*, fo. 14ʳ–14ᵛ; *Patrimonio Resti*, 906, fo. 34; and Siena, Biblioteca Comunale (BCS), M.E III *bis 2*, fo. 3 where he is mentioned as 'Misser Agniolo di chapranicho, Veschovo' along with other members of the confraternity. For S. Bernardino's great esteem and devotion to the *Compagnia dei SS. Girolamo e Francesco* and for his orations in the Cappella di Sopra, see document 8 in appendix. The saint's close relationship to the confraternity and its oratory is emphasized by the fact that the *Capitoli* of the *Compagnia dei SS. Girolamo e Francesco* were submitted to his examination and helped in their formulation:

'*1436 fu fatto il libro de' Capitoli i quali furono poi rivisti et in parte riformati nell'anno 1441 colla directione et assistenza di San Bernardino da Siena*' (ASS, *Patrimonio Resti*, 917 *bis*, fo. 4). This oratory, where San Bernardino officiated, was the old oratory of the *Compagnia dei SS. Girolamo e Francesco*, which soon afterwards (1443) was turned over to the *Compagnia di Sopra* (ASS, *Patrimonio Resti*, 917 *bis*, fo. 5) after the construction of a larger chapel.

[38] A. Lusini, 'Un rotulo Bernardiniano', *La Diana*, 4 (1929), 161–70.

[39] APD, *Deliberazioni 1668–1674*, fo. 6ᵛ. This document reveals that the Gesuati officiated in the S. Bernardino Chapel belonging to the *Compagnia della Vergine*.

avvocato del Comune e del popolo' (unique advocate of the city and its people).[40] This explains why all the interested parties joined forces. This significance clearly emerges in the pictorial programme and is reflected in the history of the *Compagnia di Sopra*'s San Bernardino altarpiece. The special civic character of San Bernardino's canonization is directly displayed by the large panel showing the saint praying before Siena's town hall (Plate 64) which is very carefully reproduced. Never before in the visual arts has a saint been so openly promoted as representing a single city—although such a concept had surfaced earlier, if only allusively, in altarpieces devoted to Agostino Novello and Filippino Ciardelli.[41] Another clearly identifiable Sienese site appears on the left-hand panel where the church and piazza of San Francesco are faithfully reproduced (Plate 63). With the representation of *San Bernardino Preaching in Front of San Francesco in Siena*, the Franciscans presented themselves as the city's dominant spiritual force. In conjunction with the other panel of *San Bernardino Preaching in the Piazza del Campo* (Plates 64, 66) the claim of the promoters of San Bernardino's cult appeared to have enjoyed the approval of the Sienese government. This harmonious union and solidarity among the interested parties, civic and religious, displayed here to promote Bernardino's case, is clearly visualized in the pictorial programme of the San Bernardino altarpiece which obviously was devised to impress the papal commission for the canonization when it met on the site and was intended to accelerate the canonization proceedings towards its happy conclusion. That the *Compagnia della Vergine*'s role was so important to the process is probably to be explained not only in its interest of having one of its members canonized. Its solidarity was defined by its cosmopolitan character and its self-definition with the entire city. This confraternity supported not only the case of a single religious order, it also favoured others such as the Dominicans and, above all, as will be seen, the Gesuati. Almost every religious order in the city saw to it that they were represented in this confraternity which also counted among its members Siena's secular élite.[42]

Sano di Pietro's paternity of this important altarpiece installed in its equally important site may explain how he became virtually the official painter of San Bernardino images which, especially after his canonization and the authorization of his cult, were placed in many churches in Siena and the surrounding countryside. An example of the latter is to be found in Montalcino where two pictures were commissioned from Sano di Pietro soon after Bernardino's canonization. Today,

[40] Bernardino appears in this guise in the acts of Siena's *Consiglio generale* during 1446; cf. Bertagna, 'Memorie Bernardiniane I', 23.

[41] For the Agostino Novello altarpiece, see M. Seidel, 'Condizionamento iconografico e scelta semantica: Simone Martini e la tavola del Beato Agostino Novello', in L. Bellosi (ed.), *Simone Martini: Atti del convegno*, Siena, 1985 (Florence, 1988), 75–80; id., 'Ikonografie und Historiographie, Conversatio Angelorum in Silvis, Eremiten-Bilder von Simone Martini und Pietro Lorenzetti', *Städel Jahrbuch*, NS 10 (1985), 77 ff. For the altarpiece of the Blessed Filippino Ciardelli, see

G. Freuler and M. Mallory, 'Der Altar des beato Philippino Ciardelli in S. Francesco in Montalcino, 1382: Malerei im Dienste der franziskanischen Ordenspropaganda', *Pantheon*, 47 (1989), 21 ff.

[42] For this confraternity see G. G. Meersseman and G. P. Pacini, *Ordo Fraternitatis: Confraternite e pietà dei laici nel medioevo*, ii (Rome, 1977), 935; V. Wainwright, 'Andrea Vanni and Bartolo di Fredi', Ph.D. thesis (University College, London, 1978), 84 ff.; and G. Freuler, *Bartolo di Fredi Cini*, in press.

one of them, in the Siena Pinacoteca, No. 253 (Plate 70), was commissioned by Fra Leonardo,[43] a Franciscan friar of San Francesco in Montalcino, for a new chapel built at the behest of a certain Giovanna Angelini.[44] It seems likely that the initiative in this case was assumed by the provincial minister of the Tuscan Franciscans, Fra Scolaio di Ser Lodovico, another Franciscan from Montalcino who was a member of the canonization committee organized for San Bernardino.[45]

While the *Compagnia della Vergine* in Siena promoted Bernardino's cult, it did not forget the followers of another of its *beati*: Giovanni Colombini, founder of the Gesuati, who had also been an important member of this confraternity.[46] According to a deliberation of 1439,[47] the *Compagnia della Vergine* commissioned Sano di Pietro to paint the high altarpiece for San Girolamo, the church of the Gesuati. Thanks to the documentation of Bossio's pastoral visitation, this altarpiece can be identified as the one dated in 1444 now in the Siena Pinacoteca which indeed came from San Girolamo (Plates 71, 74).[48]

This polyptych painted between 1439 and 1444 along with its predella now in the Louvre (Plate 73), is of exceptionally high quality and is undoubtedly Sano's masterpiece. This is not the occasion for a detailed analysis of the work, however it should be noted that its iconography, already discussed by Trübner,[49] is very simple. Among the saints around the Virgin is the founder of the Gesuati, Giovanni Colombini, humbly kneeling at her feet. This composition was a topos common to most of the later altarpieces painted for the Sienese Gesuati—such as the *Santa Bonda* altarpiece today in the Siena Pinacoteca (No. 226, Plate 72).[50] At its sides are to be found St Jerome as the order's protector and patron saint and St Augustine (Plate 71) whose monastic rule served as the model for the Gesuati. The presence of Sts Francis and Dominic can be explained by the fact that the Gesuati sought to emulate the ideas of these great mendicant orders.

Also Sano di Pietro's other great altarpiece for the Gesuati, polyptych No. 233 in the Siena Pinacoteca (Plate 75),[51] was financed by the *Compagnia della Vergine*. In 1446 the confraternity inherited 1,381 florins from one of its members: a doctor, Francesco da Gubbio.[52] In this

[43] This altarpiece is inscribed with: 'F. LEONARDUS FECIT FIERI MCCCCL'; Torriti, *La Pinacoteca Nazionale di Siena*, 268.

[44] That the S. Bernardino chapel was built by Giovanna di Antonio Angelini is found in the 18th-c. résumé of a now lost notarial document; see Doc. 9 in Appendix. That the S. Bernardino commissioned by Fra Leonardo and painted by Sano di Pietro (Siena, Pinacoteca, No. 253) was originally installed in the S. Bernardino Chapel in San Francesco at Montalcino is proved by another document summarized during the 18th c. referring to this church; see Docs. 10–11, in Appendix. For further documents regarding the commissioners of the altarpiece and chapel, see Montalcino, Archivio dell'Ospedale di Santa Maria della Croce, MS *Inv. 100*, fo. 43; Montalcino, Archivio del Seminario Vescovile, perg. ad annum 1453, 1456.

[45] For Fra Scolaio di Ser Lodovico, see Freuler, 'Andrea di Bartolo', 578–80. For Fra Lodovico Scolaio's great admiration of S. Bernardino, see his letter of 1442 to the priors of Siena

urging the holy preacher to come to Florence for the Lenten sermons; G. Focci, 'Il Cembalo di Dio', in *Enciclopedia Bernardiniana*, iv (Salerno, 1985), *Biografia*, ed. Silvio Aloisi, tomo ii, 49. Although Focci refers to Scolaio as Fra Lodovico Scolari, he is none other than Fra Scolaio di Ser Lodovico. This high-ranking Franciscan is so mentioned in all the other documents. Presumably 'Scolari' derives from the latinized form of Scolaio.

[46] In 1359 Giovanni Colombini was the prior of the *Compagnia della Vergine*; Siena, Archivio di Pie Disposizioni, MS 1, ad annum 1359.

[47] See Doc. 12 in Appendix.

[48] See Doc. 13 in Appendix.

[49] Trübner, *Die stilistische Entwicklung*, i, 10 ff.

[50] Torriti, *La Pinacoteca Nazionale di Siena*, 269.

[51] Ibid. 284–6.

[52] See Doc. 14 in Appendix.

document, as well as others in the long series, it is stated that 1,000 florins of this sum had to be used by the Gesuati for the construction and decoration of a new chapel while the remaining sum was given as a loan.[53] This information makes it possible to identify this altarpiece as well as the chapel. The fact that the chapel and presumably its altarpiece as well had been paid for with funds from the doctor, Francesco da Gubbio, who had given them to the *Compagnia della Vergine*,[54] who in turn passed on this legacy to the Gesuati for their oratory, explains several of the painting's iconographical features.

The large amount of space in the pictorial programme occupied by the patron saints of doctors, *Cosmas* and *Damian*, represented on the side panels, together with scenes from their lives in the predella (Plate 75), seem clear allusions to the doctor Francesco da Gubbio, the donor of the funds used for the chapel and its altarpiece. The presence of the *Compagnia della Vergine*'s emblem, the cross flanked by whips, located on the base of the two pilasters (Plate 76) seems definitive proof that this polyptych is to be identified with the one in the chapel built with Francesco da Gubbio's legacy because, as we know, the confraternity transferred the doctor's money to the Gesuati. This act obviously justified the *Compagnia della Vergine*'s commemoration on the altarpiece via the emblem painted in a place traditionally reserved for donors—i.e. at the base of the lateral pilasters.

The correctness of this identification finds further confirmation in Bossio's visitation record which describes a work of this type in the oratory of the Gesuati.[55] Furthermore, the oratory's liturgical function, which we will examine briefly, seems to be reflected in the altarpiece's iconography. From Bossio we know that the saint most venerated at the oratory was Jerome, the Gesuati's patron saint. On his feast-day a solemn liturgy was celebrated there and on this occasion the Gesuati were joined by notaries who also had a special veneration for the saint—not surprisingly since according to the *Golden Legend* Jerome's name signifies sacred law.[56]

This oratory was the liturgical centre for the Gesuati of Siena where they met for daily devotions.[57] Here the brothers listened to mass and the prior read biblical passages and delivered his sermon. At certain times of day 165 Pater Nosters and 165 Ave Marias had to be recited. Even more important, acts of penitence were performed early in the morning, twice during the day and again at night.[58] The obviously penitential character of the daily ceremonies in this oratory is a possible explanation for the change of emphasis in this altarpiece compared to Sano's earlier work designed for a high altar. Whereas in the latter, Jerome is shown as a cardinal in the act of reading, in the later altarpiece he appears together with the Blessed Giovanni Colombini kneeling humbly and penitentially beating his breast with a stone. Here Jerome no longer appears in the guise of a cardinal but as a member of the Order of the Gesuati. The two great saints of the Gesuati are

[53] See Docs. 15–18 in Appendix.

[54] It is most likely that the rest of the funds received in the legacy from Francesco da Gubbio was destined for the financing of the altarpiece and the liturgical instruments of the altar: 'achoncime del detto luogho degli Ingiesuati' (to finish the said site of the Gesuati); see Doc. 14 in Appendix.

[55] See Doc. 19 in Appendix.

[56] Jacobus da Voragine, *Legenda Aurea . . .* ed. Graesse (Osnabrück, 1965), 653: '*Hieronymus dicitur a gerar, quod est sanctum, et nemus, quasi sanctum nemus, vel noma, quod est lex. Unde dicitur legenda sua, quod Hieronymus interpretatur sacra lex.*'

[57] See n. 55 above.

[58] Meattini, *Santi senesi*, 201.

represented as models of penitence to be venerated and imitated by the brothers during their own penitential acts in the oratory.

All of Sano di Pietro's works discussed here document a fascinating chapter in the history of Sienese spirituality which spread throughout the most important charitable institutions of Siena consisting chiefly of the hospital of Santa Maria della Scala and its various confraternities. Sano di Pietro as a member of the prestigious *Compagnia della Vergine*, and omnipresent in many other religious institutions found himself in a privileged position becoming the official painter of the Gesuati as well as of San Bernardino's image.

APPENDIX OF DOCUMENTS FOR SANO DI PIETRO'S ALTARPIECES

After our first discussion of Sano di Pietro's San Bernardino altarpiece for the *Cappella di Sopra*[59] Keith Christiansen responded to our theories in a letter to the editor and presented an alternative reading of the documents which we related to the three Bernardino panels from the *Cappella di Sopra*.[60] While Christiansen agreed with us that documents 2–4 do concern one and the same artistic project, he dissociated document 5 from it. The works cited in this last document he related to another project by Sano di Pietro promoting the cult of San Bernardino. By doing so he dissociated the image of San Bernardino in the Sala Capitolare (which he identifies with the project reported in documents 2–4) from the two panels representing *San Bernardino preaching*. Christiansen's alternative reading of the documents and consequently his conclusions raise some doubts.

A serious objection to his interpretation comes from the fact that a new artistic project of such importance as that one recorded in document 5 (which Christiansen considers to be separate from the project cited in documents 2–4) would necessarily have appeared in the *Compagnia della Vergine*'s book of *Deliberazioni*. This volume records an uninterrupted series of resolutions regarding all the important decisions taken in the confraternity meetings from 1400 to 1557. The first project, the '*tavola del Santo Bernardino*'[61] appears in this book no less than three times (documents 2–4) and the same is true for the panel donated to Giovanni da Capestrano (document 6) cited again later in the final reckoning (document 5). There is, however, no sign in this book of a further artistic project which coincides with the one recorded in the accounts (i.e. document 5). This strongly suggests that the items cited in the final reckoning (document 5) for works executed by Sano di Pietro, are indeed part of the artistic projects recorded in the *Deliberazioni*.

A further element in favour of our interpretation is the fact that in document 4 the *Compagnia della Vergine* planned to have Sano di Pietro's '*tavola del Santo Bernardino*'—whatever it was—placed not on the altar of their own chapel but on that of the *Compagnia di Sopra*, who were also engaged in the propagation

[59] Mallory and Freuler, 'Sano di Pietro's Bernardino Altarpiece', 186–92.

[60] Christiansen, 'Sano di Pietro's S. Bernardino Panels', 451–2. Documents 1, 2, 3, 4 discussed by Christiansen correspond to documents 2, 3, 4, 5 in our Appendix.

[61] In medieval terminology '*tavola*' does not necessarily mean a single panel but was commonly used for an ensemble, such as a triptych or polyptych.

of San Bernardino's cult. This concern, as a matter of fact the main object of document 4, emerges also from the accounts (document 5), because after the initial list of works by Sano di Pietro we find the unusual specification of their location, that is, their placement on the altar of the *Compagnia di Sopra*. This is a further element which links documents 2–4 with document 5.

That the account of Sano's artistic performance explicitly states the materials ('*oro e azuro*') used by the artist is not surprising nor is this unusual in the present context. At any rate, there are insufficient grounds for Christiansen's proposal that this document refers to materials used by Sano for a polychromed wooden statue of San Bernardino. The item simply specifies that these two precious materials were recorded in the payments to Sano di Pietro. As a matter of fact, many painters' contracts specify that the artist was obliged to use precious colours and materials such as lapis lazuli and gold which were included in the fee.

Therefore, document 5 is the final reckoning with Sano di Pietro for his decoration of the San Bernardino altar which, as we learned from the documents, was turned over to the *Cappella di Sopra*. The *Compagnia della Vergine* ordered the substitute for their own San Bernardino chapel only in 1454 and Sano di Pietro completed it in 1458.

If we agree that document 5 concerns the final balance for Sano di Pietro's three-year service (1446–8) to the *Compagnia della Vergine*, then also the sequence of the various sums paid out to him gains significance. Apparently the sums are listed chronologically and taken from another now lost account book (*Libro d'Uscita*) referred to as *Giornale A*. At the beginning there is a payment of '*Lire LXXXVII s. VIII d. II*' corresponding to an entry in the lost account book on fo. 112, other items correspond to items on fos. 220, 230, 251 while the last two came from fo. 351. Bearing in mind that Sano worked for about three years on this project, there is a plausible explanation for the big gap of 239 pages in the lost account book between the first payment recorded on fo. 112 and the final one of '*L. XXVII s. XII d. VIII*' on fo. 351. The first payment is clearly an advance paid to Sano when he was hired on 28 August 1445. This is confirmed by the fact that this payment amounts to about a third of the total sum. Somewhere in the middle of the lost *Giornale A* (fos. 220–56) there are four more payments amounting to approximately *Lire LX*. They could have been recorded in the winter of 1446/7, when Sano seems to have finished the panels for the altar of the *Cappella di Sopra*. The last two payments taken from fo. 351 include the final settlement with Sano, and logically would date from the time of the final reckoning recorded in document 5 (13 September 1448). This would roughly coincide with the period of August–September 1448 when the *Compagnia della Vergine* decided to give a panel representing San Bernardino by Sano di Pietro to Giovanni da Capestrano recorded on 4 August 1448 (document 6). The approximately *Lire LX* which Sano received in the last two payments during the summer of 1448 might, therefore, actually have included this panel.

Doc. 1. Siena, APD, MS Forteguerri, *Memorie*, fo. 44$^{\text{v}}$

Domenicha adi 7 di giugnio [1444] nel gienerale chapitolo de' fretegli dela chompagnia dela Vergine Maria solennemente chongregato nela chompagnia predetta. ett [*sic*] fatta in esso chapitolo solenne proposta sopra a honorare i'esecuio dela buona memoria del venerabile padre, frate Bernardino, fu solennemente proveduto e diliberato che sia rimesso nel priore e nel chonseglio e quagli possino fare cielebrare uno hofitio devoto a [o]nore di dio e di frate Be[r]nardino, nel quale possino ispendare quello che piacara a loro dela pechunia dela detta chonpagnia.

Doc. 2. Siena, APD, *Delib. 1401–1557*, fo. 44 (23 maggio 1445)

Adi 23 di Magio i dilibaro nel chapitolo gienerale per vintiuno huomo, che si dovesse chiamare tre huomini dela chompagnia a fare dipegniare il beato Berna[r]dino in chel modo che para a loro. Fu venta per quindici lupini bianchi per lo si, none istante sei lupini per lo no e fu venta. E quagli huomini sarano iscr[i]tti qui di sotto, in prima ci[o]e al tempo del'onorevole prior ser Istefano di Ser Nicholaio e Nerocio di Ghoro. Et questi sono egli [sic] huomini chiamati messer Marco di Mateo, Sali[m]beni di Petro, Mariano di Petro.

Doc. 3. APD, *Delib. 1401–1557*, fo. 45 (28 agosto 1445)

Memoria chome a di 28 aghosto [1445] chome Mariano di Petro e messer Marcho di Mateio e Sali[m]bene di Petro alogharono a dipegniare una tavola del beato Bernardino. La quale tavola l'a fatta maestro Domenicho di Cesari, cioe de'legname, e la detta tavola l'ano aloghata a dipegniare e sopradetti [sic] a maestro Sano di Pietro dipentore con questi patti e modi apreso di diraremo. In prima che 'l detto maestro Sano la deba dipegniare a tute sue spese. El detto maestro Sano s' obligha di dipegniare il detto beato Bernardino a piacimento a piacimento [sic] de' sopradetti aloghatori, e se a loro non piacese, s' obriglia [sic] di guasta[r]lo e rifallo tanto e quante volte e sopradetti siano bene contenti. E fatta la detta tavola a loro piacimento, el detto maestro Sano si rimette nele mani de' sopradetti dela fatura e d'ogni altre ispese v'avese fatte in detta tavola. E quagli sopradetti ano altruita di poter fare le dette chose, come apare per una deliberazione fatta per chapitolo gienerale, chome in questo a foglio 44.

Doc. 4. APD, *Delib. 1401–1557*, fo. 48ᵛ (2 febbraio 1446/47)

Memoria come oggi, questo di ciovedi, el di di Sancta Maria Candeloro, che fumo adi 2 ferraio, anno sopradecto, fu solepnemente vento, deliberato et obtenuto per lupini 29 bianchi del si e neri nove in contrario [non] obstanti prima facta proposta per ser Stefano, honorabile priore, nel capitolo generale della Compagnia di socto della Vergine Maria, che sia pienamente et esser s'intenda rimesse e data piena auctorita quanto a tucto el decto capitolo, allo honorabile priore insieme co' suoi consegl[i]eri di disporre, convenire e terminarese la presente tavola del beato Bernardino, facta per maestro Sano dipentore, si deghi [sic debba] collocare e pore piu in uno luogho che in un altro, et in quello luogo che sara deputata per esso priore e suoi consegl[i]eri s'intenda e sia bene posta e deputata, intendono pero non si possa thrare della Compagnia della Vergine Maria excepto che nella Chompagnia di sopra, con questa limitatione che in quanto essa tavala [sic] fusse deputata e collocata nella Compagnia di sopra, si deghi allora et in quel caso farne pe' lla Compagnia di secto, bella e suffitiente.

Doc. 5. APD, MS 4, fo. 124 left and right (13 settembre 1448)

Maestro Sano di Pietro, dipentore, de' avere per insino a questo di, a di 13 di Setembre 1448, lire dugento soldi O, so' per queste chose qui sotto scrivaremo. E prima. Per oro, azuro e per dipintura dela figura del beato Bernardino e d'una Nostra Dona in uno tondo a chapo del be[a]to Bernardino, e per due storie dipente, una quando el beato Bernardino predicho in sul Champo di Siena, e l'altra quando predicho a' frati Minori. Le dete tavole so' poste al' altare dela chapela dela chompagnia di sopra, a lato alo Spedale di Monna Agniesa. E per adonare el armario di deta chapela. E per una tavola dipenta la fighura del beato Berna[r]dino, la qu[a]le si de a frate Giovani da Chapestrano [sic], frate del' Oservanza di Sancto

Franciesco. E di tuto fero achordo insieme maestro Sano deti chori [choram *sic*] Iachomo d' Andreucio, orafo, Salimbene di Petro Benasai e Marino di Petro Menghini e noi Marcho di Mateio di Marcho ligntieri e chomesari a deto opera ———————————————————— L. CC sod. O
Maestro Sano di Pietro, dipentore, de' dare adi lire ottantotto soldi otto d. due, sonno per tanti avuti chontanti in piu volte chome partitamente si vede a libro giornale A a fo. 112
———————————————————————————— L. LXXXVIII s. VIII d. II
E die dare lire undici s due d. oto s'e a uscita d' Ambru[o]gio di Ser Pietro chamarlengho, di sotto a fo 220
———————————————————— L. XI s. II d. VII
E die dare lire trenta, so' uscita di Giovanni di Pietro Panilini a fo. 230 ———————— L. XXX s.- d.-
E die dare lire sei, so' a uscita a Iachomo di Boncio, chamarlengho, di sotto a fo. 251 —— L. VI s.- d.-
E die dare lire quattro, s. quindici, e so' a uscita a Duccio d' Agniolo di Lando, chamarlengo, di soto a fo. 256 ———————————————————— L. III s. XV d.-
E die dare lire trentadue s. due, e quali denari gli fiece dare Salimbene di Petro, retore dela Compagnia, a Giovanni Savini, camarlengo del Monte, e per Giovanni gliel de contanti Matteio d'Antogno di Ghuido, per parte dela provisione che la compagnia ricie[ve] all' anno dal Chomuno di Siena che debba dare n'abbi dati in questo indietro a ffo. 117 e sso' a uscita di sue Ambruogio camarlengo, a ffo 351 ———————————————————— L. XXXII s. II d.-
E die dare lire adi XV ferraio lire vintisette, s. dodici, d. otto, e quali denari ebbe contanti in suo mano da me Ambruogio di ser Pietro, camarlengo per detto Salimbene di Petro, rettore dela Compagnia, per resto dela tavola del beato Bernardino e d'ogni lavorio avesse fatto del' alogagione gli fu fatta, chome apare qui di risconta nel' altra faccia a ffo. 124; e' sso a uscita di me Ambruogio a libro grosso a ff 351 ———————————————————— L. XXVII, s. XII, d. VIII
Somma lire 200, s. 0, d. 6.

Doc. 6. APD, *Delib. 1401–1557*, fo. 51 (4 agosto 1448)

Queso di IIII d'aghosto, nel capitolo gienerale, fu detto per ser Stefano priore che per parte del venerabile padre frate Giovanni da Chapestrano, frate del' Oservanza di Santo Francesco, lui volontieri richied[e]rebe per limosina ala compagnia una tavola che ci e dela figura del beato Bernardino. E pero el detto ser Stefano in chapitolo detto fecie proposta se detta limosina si dovese fare o no. Di che fu consegliato per Salinbene che se gli dovese conciedare per limosina con questo che una mattina a venire il detto frate Giovanni dovese venire a dire una mesa nella chompagnia, e detta la mesa, alora gli fuse data e presentata la detta tavola. E cosi fu per altri afermato il detto consiglio; e meso il partito a lupini bianchi e neri, tutti d'acordo furono XXV lupini bianchi, non alcuno scordiante che chosi faciesse.

Doc. 7. APD, *Delib. 1401–1557*, fo. 62 (13 ottobre 1454)

Domenicha a di 13 d'ottobre il priore feccie proposstta in chapittollo generale, di fare quattro figure di quele isttatte dela Chompagnia della Vergine Maria, e massime Sancto Bernardino. Fu chonssegliatto e messo a parttito a lupini bianchi e neri, chollto parttitto in [nu]maro di vintti di fratteglli, ventto e ottenutto per lupini vintti bianchi, ttutti d'achordo che ffuse rimesso in ser Stefano apreso di lui chi a lui para, ed egllino fare tantto et qua[n]tto a loro para, o in tavole o i' muro et dove meglio para i'nela Chompagnia di sotto.

Doc. 8. Siena, ASS, *Patrimonio Resti 917 bis*, fo. 4

. . . Haveva il detto Bernardino molto affetto e divozione alla nostra Compania [*sic* SS. Girolamo e Francesco] alla quale molte volte intervenne e vi celebrò la Santa Messa, e una volta fra l'altre che fu a di Nov. 1439 venne alla nostra Compania col P. Generale del Osservanza e col ministro Provinciale di Toscana e col rettore dello Spedale e quali assiterono la sera alle nostri preci e la mattina seguente ritornarono al nostro oratorio dove udirono la santa messa celebrata del detto Bernardino. E percio pochi mesi dopo la sua morte fu aggiunto per Beato Protettore della Nostra Compagnia.

Doc. 9. Montalcino, AOMC, MS *Inv. 100* (*Memoriale del Padre Bovini*, 1750), fo. 50

1453 al tempo di Niccolo V sommo Pontefice e di Federigo Imperadore, Domina Giovanna figlia d'Antonio Angelini, e moglie di Giovanni Dominici, detto l'Orbo di Montalcino s'elegge la sepoltura in chiesa nostra [*sic* S. Francesco di Montalcino] ov' era sepolta la sua figliola Domina Andrea avanti la Cappella di S. Bernardino da se edificata ove presente e l'altare di S. Maria Maddalena, quali vestite ambedue dell'abito religioso di S. Francesco furono quivi sepolte e lascito detta Giovanna cento fiorini alla sagrestia per ordine di sua figlia gia nominata accio i religiosi facessero un Uffizio alla detta Cappella di S. Bernardino, annuo, e in perpetuo oltre a quelli che fecero nel di 3. 7. a 30.
Rogato Ser Giovanni di Barna Tinelli.

Doc. 10. AOMC, Ms *Inv. 100* (*Memoriale del Padre Bovini*, 1750), fo. 177

. . . da quest' oratorio si passa nella Cappella di S. Bernardino destinata per celebrarvi la S. Messa da sacerdoti convalescenti nella quale si fa festa solenne il 20 Maggio, e due volte il mese vi si dice la S. Messa per soddisfare agl'obblighi dell'altare di detto santo come in questa a fol e il suo quadro e quello che fu fatto fare da Fra Leonardo figliolo di Donna Caterina del Riccio famoso pittore che dipinse la Vergine del Presepio, che ora si venera all'altare delle Reliquie. Detta pittura fu fatto l'anno stesso che il santo passo all'eterna felicita (la medesima Signora Caterina lascio al convento un pezzo de Tiratoi).

Doc. 11. AOMC, MS *Inv. 100*, fo. 42 (1424)

Domina Caterina del Riccio da Montalcino, maritata al magnifico Andrea Ambrosi da Siena, lascia alla sagrestia, e convento e chiesa un pezzo di terreno ne tiratoi, e per detta chiesa lo riceve Fra Leonardo suo figlio al tempo di Martino V.
Rog. Ser Donato da Montalcino.

Doc. 12. APD, *Delib. 1401–1557*, fo. 38 (1439)

Memoria chome a di 17 di gienaio fu diliberato nel chapitolo dela cho[m]pagnia, tutti d'achordo che si facci una tavola all'altare maggiore dela chiesa delli ingiesuati e che rettore dela cho[m]pagnia vi [s]pe[n]da fiorini vintici[n]que ora per prencipiare la detta tavola e paghili in quelle chose che per l'Ingiesuati li sara detto per fare essa tavola. E la detta diliberazione fu fatta al tempo di Zacomo d'Andreuccio priore.

Doc. 13. Siena, AAS, MS 21 (Bossio, 1575), fo. 697, S. Girolamo

Visitavit altare maius lapideum, lignea tabula coopertum et auctum supre pro altare aderat pietra sacra tela

coperta et affixa et mandavit accomodari iuxta eius longitudinem, munitum erat altare tribus tobaleis decentibus et supra dictam mensam aderat tela rubra et duo candelabra actonea ac duo angeli lignei et pallium habebat ex serico damasci predellam ligneam congruam et Iconam decentem cum Imagine Beatae Virginis, sancti Hieronimi et aliorum sanctorum perpulcram, quod altare nullum habet onus, sed aliquando in eo missa parva celebratur et presertim in diebus festis prout idem sacrista asservit.

Doc. 14. APD, *Delib. 1401–1557*, fo. 46[v]

Memoria chome a di II di ferraio (1446), nel chapitolo del chonpagnia fu fatto diliberazione solennemente deliberato per vintinove lupini bianchi del si, nonostante tre lupini neri del no, che sia pienamente rimesso ne' rettore e nel priore che si facci un sindacho insieme cho'loro che abino tanta altruita quanto tutta la chonpagnia a questo fare, cioe di fiorini milletreciento ottanta uno e se piu fussero o si trovassero di quelli dela redita di maestro Francesco d' Aghobio, medicho. I quali denari il detto sinddacho de' sopradetti insieme possino dare e donare a poveri ingiesuati chon questo inteso che tutti e denari cierti si debano restituire e fiorini mille si debin stribuire inn una chapella ad detto luogho degl' Ingiesuati, e tutto e resto de' denari incierti li possino stribuire ne' loro achoncime del detto luogho degl'Ingiesutai. chon questo inteso che sopradetti poveri debino avere da Sancto papa la dispen[sa]zione che sopradetti denari la chonpagnia lor possino dare e donare senza niuno progiuditio o danno, e che loro gli possino istribuire chome lo' piacara inn achoncime del detto lu[o]gho sichondo la dispensazione del papa, ciche la chonpagnia sie disbrighata del sopradetto testamento.

Doc. 15. APD, *Delib. 1401–1557*, fo. 47

Nota sia e manifesto come questo di, a di VIII di magg[i]o 1446 nel capito[lo] dela chompagn[i]a della Vergine. . . Nel simile capitolo a di detto, fu vinto [e] solenneme[nte] ottenuto per vintotto lupini bianchi del si nonostante tre lupini del no, che sia pienamente rimesso e chomesso nel camarle[ng]ho della Chonpagnia di sbattere il Chomune, fusse debitore alla Compagnia della Vergine Maria per chagione di fiorini quatromiglia doveva dare per i danari di maestro Francesco da Ghubbio, e fu chonsigliato per Giovanni di Tofano.

Doc. 16. APD, *Delib. 1401–1557*, fo. 49

Memoria chome a di XVIIII di ferraio, el di della sancta domenicha, anno sopradecto [1447], fu solempnemente deliberato e constituto nel capitolo generale della Compagnia della Vergine Maria, per lupini bianchi del si XXVI, uno nero in contrarrio [non]obstante, primo proposta facta per priore e facte tucte le solepnita da farsi, che sia pienamente et essar s' intenda rimesso e piena auctorita abbi il priore che al presente e insieme co' rectore e consegl[i]eri d'esso priore con quelli piu insieme con esso loro e per loro da eleggiarsi d' essa Compagnia, buoni e suffitienti huomini ydeoney che parra e piacara al decto priore, rectore e suoy consegl[i]eri, di provedere, ordinare dichiarare e stabilire circha alla addomanda et suplicatione facta per don Antonio ingiesuato, mandatario e in nome de' povari e capitolo Ingiesuati di Siena, di certa prorogatione di tempo de' residui dell'usure da ristituirsi alle proprie persone de' denari e beni che furo di maestro Francesco dal Gobbio, e quali residui e usure pervennono et ultimamente pervenuto sonno et anche stanno nelle mani d'essi povari Ingiesuati. Et tucto quello che pel decto priore, rectore, consegl[i]eri et altri per loro electi sara deliberato e proveduto, stia di piena auctorita e valore

quancto fusse deliberato per tutti e fratelli della casa, et essa deliberatione vagl[i]a et tengha senza alcuna contradictione.

Doc. 17. APD, *Delib. 1401–1557*, fo. 49

Memoria chome oggi questo di 24 di ferraio et anno predetto [1447], fu solepnemente deliberato, proveduto et obtenuto nel capitolo generale della Compagnia della Vergine Maria, per li infrascripti huomini, chiascuno rendente il suo lupino bianco del si, alla infrascripta delibearatione infra loro solepnemente obtenuta di chomune concordia senza alcuno lupino nero overo contradictione da farsi, facta proposta e le solepnita da farsi per vigore, arbitrio et auctorita a lloro in questa parte concesso et atribuito, chome appare in questa faccia e deliberatione precedente e proxima a questa fu finalmente deliberato che la Compagnia della Vergine Maria predecta sia e essar si intenda spogl[i]ata, privata et absoluta dalla heredita e beni che funno della buona memoria di maestro Franciescho del Gobio, pervenuti nelle mani de' povari Ingiesuati da Siena, volendo per infino a uno la decta Compagnia interponarsi ad alcuna prorogatione di termine addimandata per dono Antonio in nome d'essi povari Ingesuati. In modo che el male et el merito, comodo et incomodo sia loro senza alcuno preguidicio d'essa casa e Compagnia della Vergine Maria e detrimento dell' anime loro e ciaschuno d'essi; ma essi povari solamente sieno tenuti a restituire le decte usure, come parra e piaciara a lloro e sopra la loro cuscientia. Et alle predecte cose e deliberatione fu presente, consentiente, volente et expontaneamente acceptatnte, come di sopra e dichiarato, el sopra decto don Antonio, in nome e vice d' essi povari Ingesuati.

Doc. 18. APD, *Delib. 1401–1557*, fo. 49ᵛ (1447)

Similmente nel decto capitolo e colloquio, in medesimo tempo fu deliberato per boci e lupini bianchi del si 13, uno in contrario non obstante che el libro dell'usure che fu d'esso maestro Franciescho, pervenga nelle mani di Giovanni di Pietro Pannilini e a llui per lo rectore della Compagnia sia assegnato e conceduto, e sia et esser s' intenda camarlengho e scriptore, determinato nientedimeno per essi povari Ingiesuati. Nel quale libro debbi chiaramente scrivare e denotare tucto e ciaschuno dispendio e spese si faranno de' decti denari d' esso maestro Francesco per le mura e nelle mura da edificarsi e farsi per descti povari nella casa loro et luogo. Et similmente scrivare debbi ogni quantita di denari, cioè di fiorini 381 si ristituiranno pe' decti povari Ingiesuati, et achonciarli alle poste de receventi e quali sono acesi creditori in decto libro d' esse soprosure intendendo nientedimeno tucte le quantita di denari si trovaranno in sul li[b]ro del decto maestro Franciescho, da restituirsi.

Doc. 19. AAS, MS 21 (Bossio, 1575), fo. 698ᵛ

Visitavit oratorium dictorum fratrum quod est intra Claustra dicti monasterii in quo erat altare lateritium cum mensa lignea et cum petra Sacra quam mandat equari mensam, munitum erat unica tobalea, et dixit apponi quando celebratur, ornatum erat pallio ex tela alba et predella decenti crucie Imaginis Crucifixi parva. Icona erat cum Imagine Gloriosissime Virginis perpulcra et aliorum sanctorum et tela dicebatur ante ipsam celebrari dixerunt in dicto altare semel in anno in die Sancti Hieronimi, in quo etiam solent convenire Notari omnis Civitis et altare est absque aliqua dote e onere. In dicto oratorio adsunt hinc inde sedilia et in eo orare solent fratres quotidie et dicere eorum officium, quia non psallent horas Canonicas, sicut aliae religiones, et totum oratorium est destudinatam cum finestris.

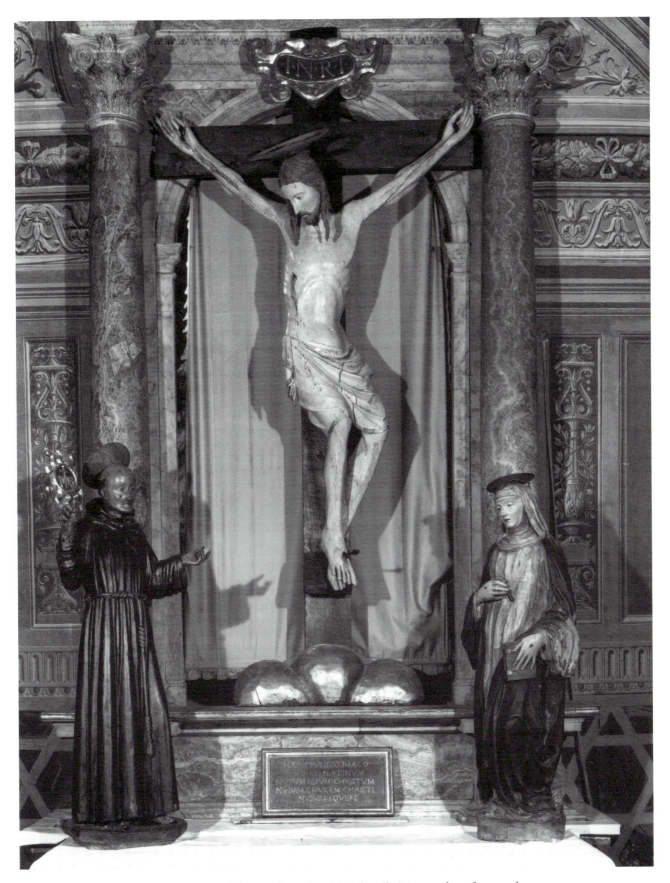

57. 'Maestro del Crocifisso dei Disciplinati' (Sienese, late fourteenth
century), *Crucifix of San Bernardino's Conversion*. Siena, Oratorio dei
Disciplinati.

59. Death mask of San Bernardino. Aquila, Museo Nazionale (after Pavone and Pacelli).

58. Sano di Pietro, *St Ansanus*, panel, 148×55 cm. Siena, Pinacoteca, No. 235.

60. Sano di Pietro, *San Bernardino*, detail of Plate 62.

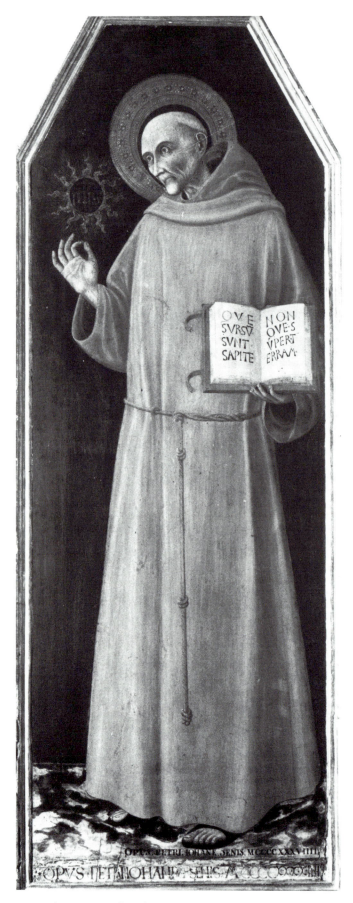

61. Pietro di Giovanni d'Ambrogio, *San Bernardino*, 1444, panel. Siena, Osservanza.

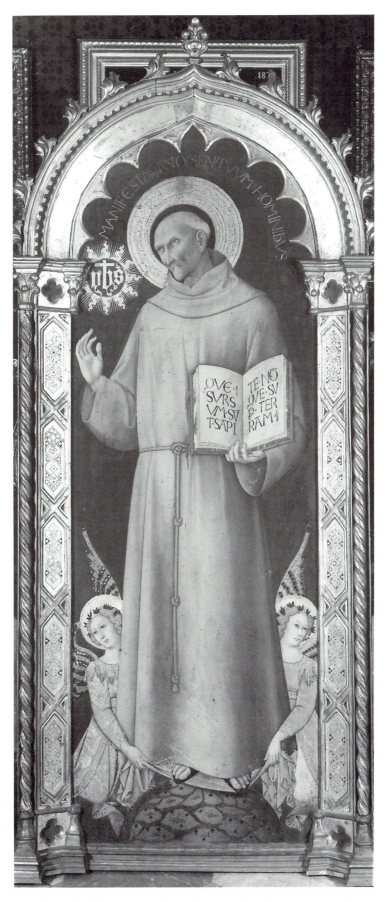

62. Sano di Pietro, *San Bernardino*, panel 216·4 × 101 cm. Siena
Cathedral, chapter room.

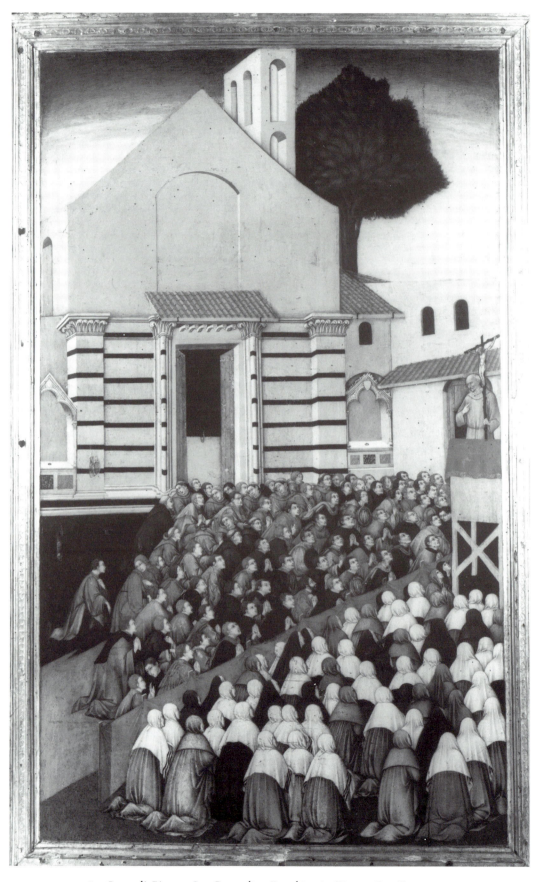

63. Sano di Pietro, *San Bernardino Preaching in Piazza San Francesco at Siena*, panel, 162 × 101·5 cm. (including original frame). Siena Cathedral, chapter room.

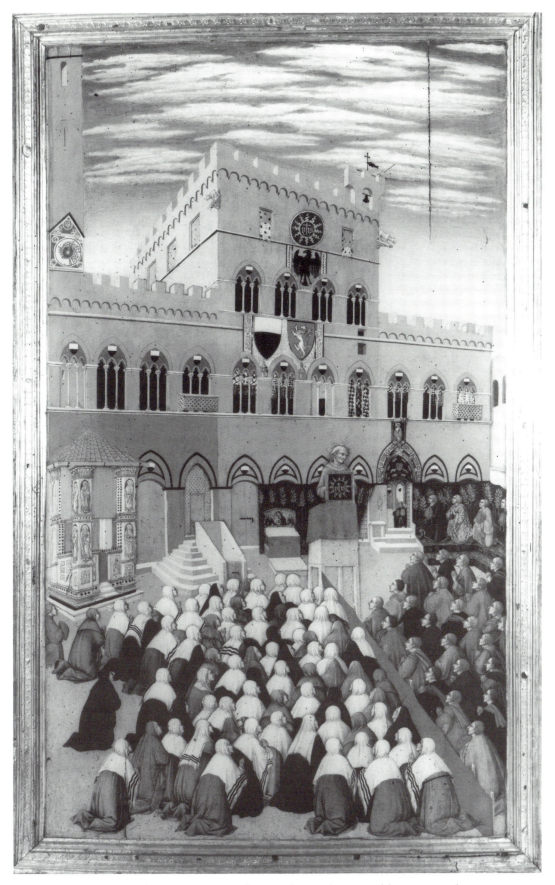

64. Sano di Pietro, *San Bernardino Preaching in the Piazza del Campo*, panel,
162 × 101·5 cm. (including original frame). Siena Cathedral, chapter
room.

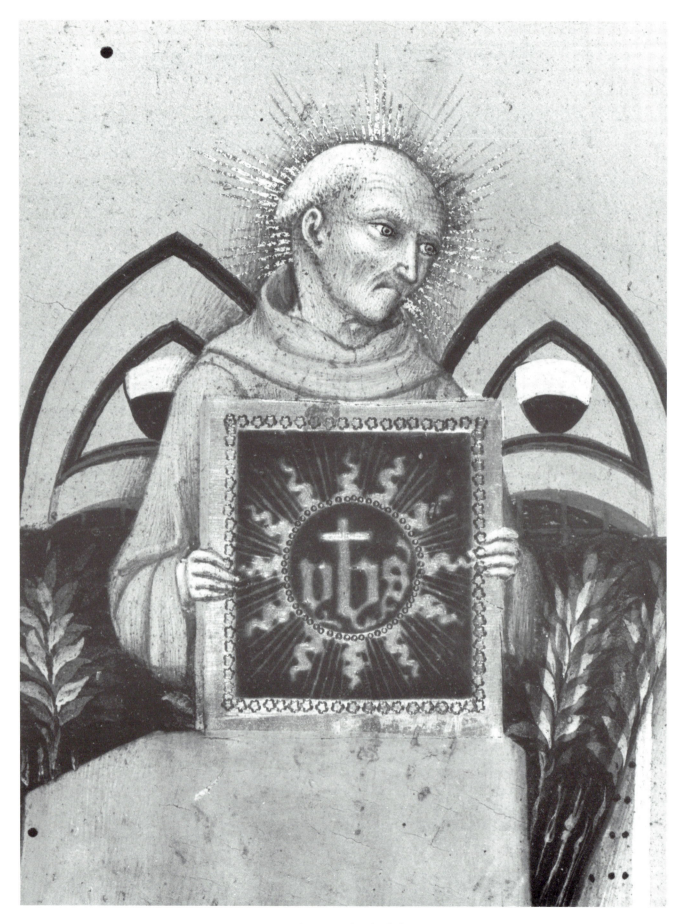

65. Sano di Pietro, detail of Plate 64.

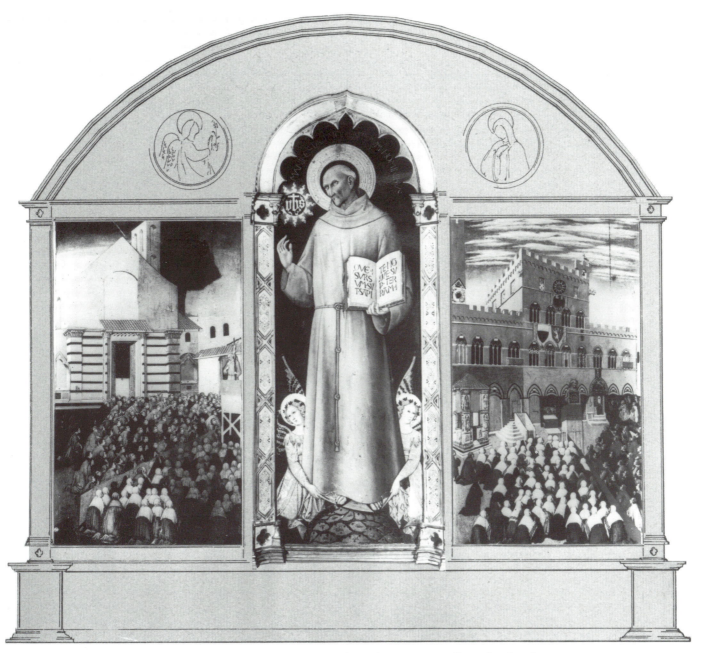

66. Sano di Pietro, *The San Bernardino Altarpiece*, originally in the chapel of the Compagnia di Sopra (reconstruction by G. Freuler and M. Mallory).

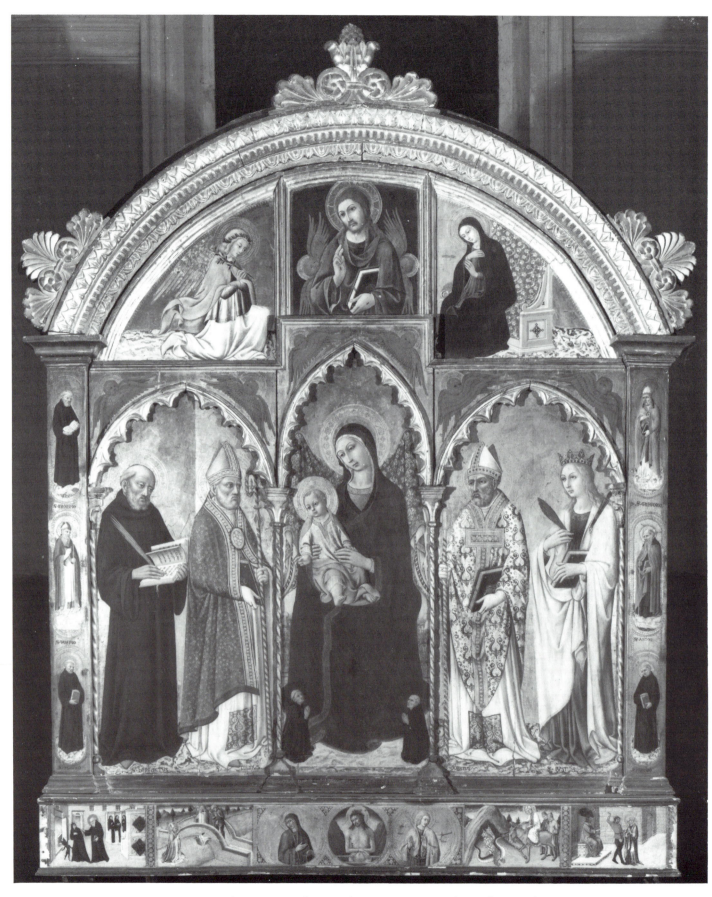

67. Sano di Pietro, *Madonna and Saints*, 1471, panels. Badia a Isola,
SS Salvatore e Cirino, high altar.

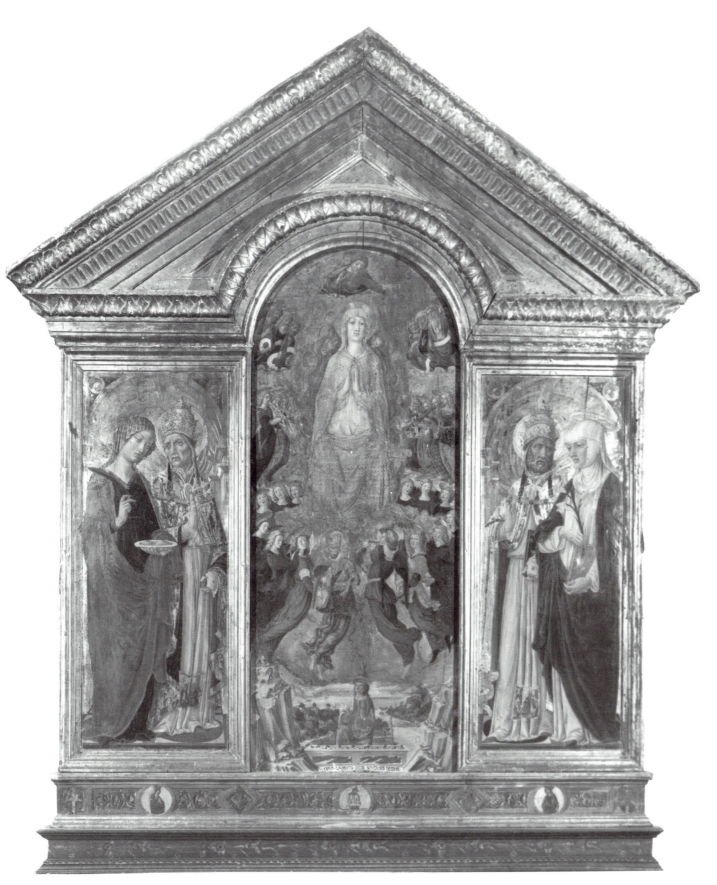

68. Vecchietta, *The Assumption of the Virgin with SS Agatha, Pius, Calixtus, and Catherine of Siena*, panel, 280 × 225 cm. Pienza Cathedral.

69. Anonymous Sienese, fifteenth century, rotulus of *San Bernardino* (detail), parchment. Private collection (after Lusini, 1929).

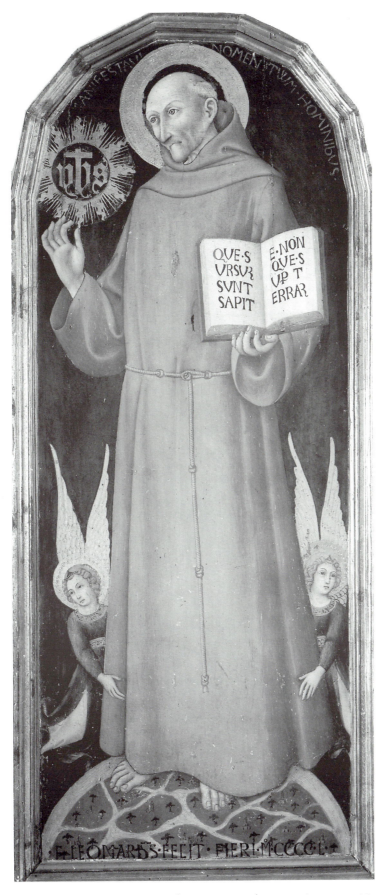

70. Sano di Pietro, *San Bernardino*, 1450, panel. Siena, Pinacoteca, No. 253.

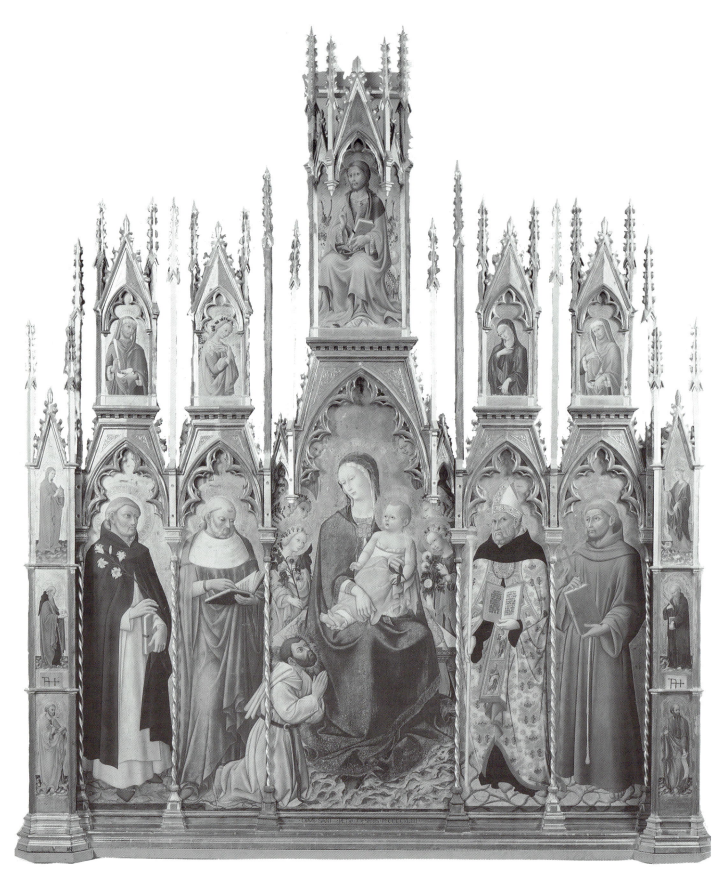

71. Sano di Pietro, polyptych of the Gesuati from S. Girolamo, 1444,
panel, 320 × 282 cm. (without predella). Siena, Pinacoteca, No. 246.

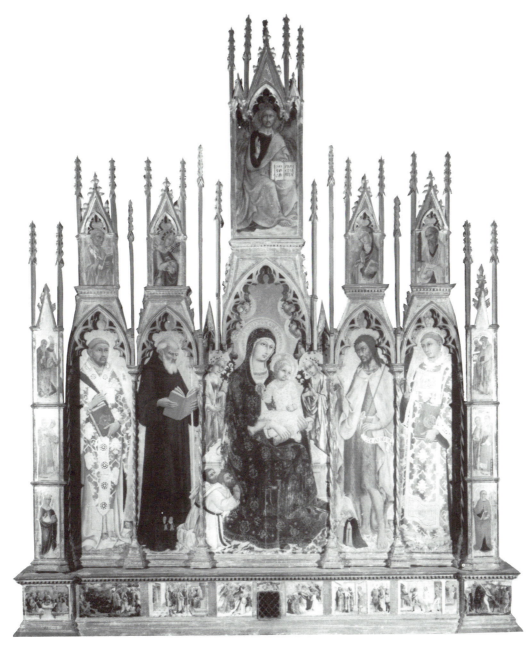

72. Sano di Pietro, polyptych of Santa Bonda, panel, 320 × 287 cm. Siena, Pinacoteca, No. 226.

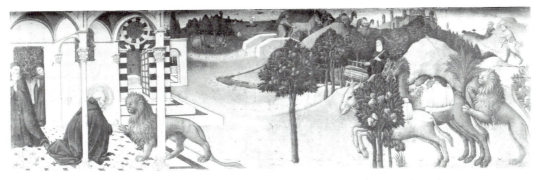

73. Sano di Pietro, part of the predella of the Gesuati altarpiece (see Plate 71), with scenes from the life of St Jerome, panel. Paris, Louvre, No. 1130.

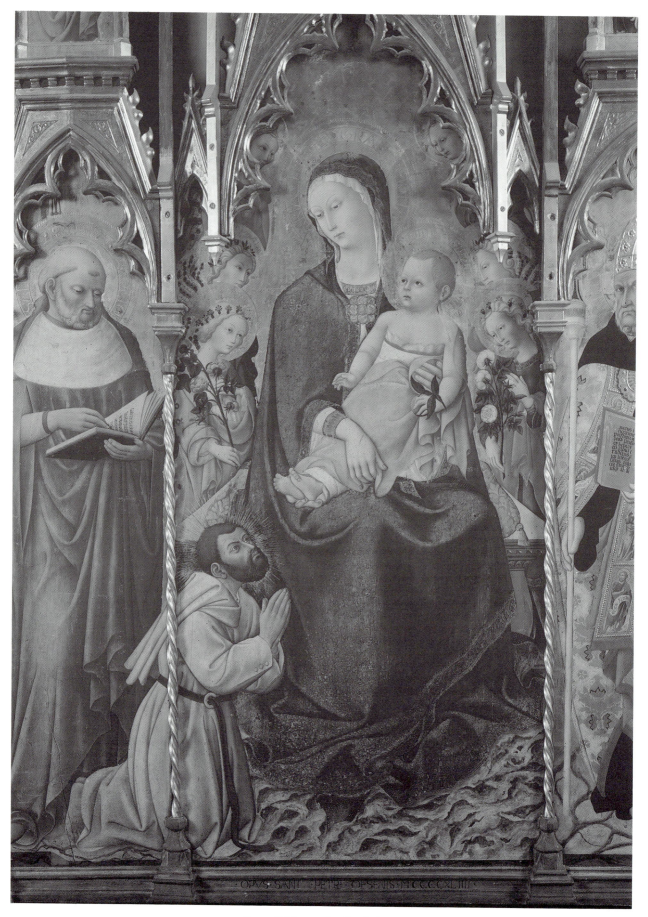

74. Sano di Pietro, detail of Plate 71.

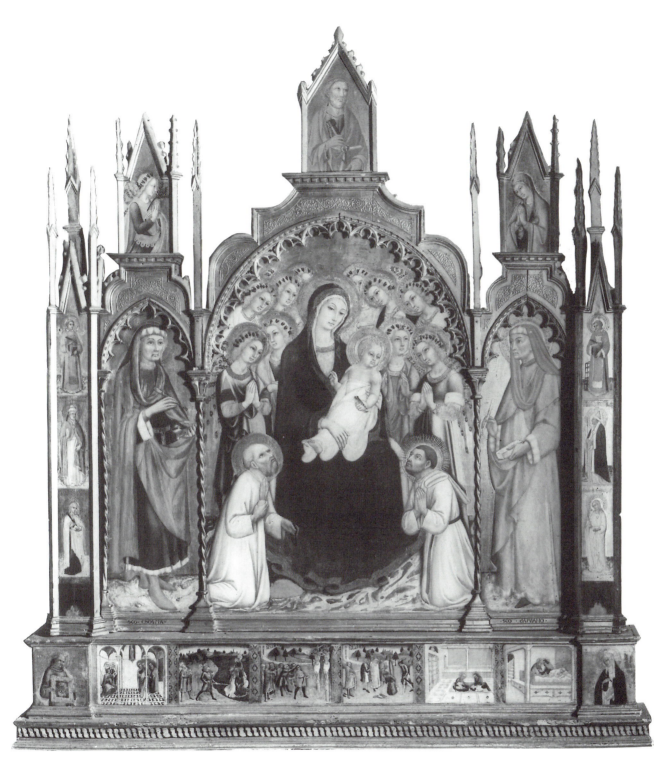

75. Sano di Pietro, polyptych from the Convent of the Gesuati, Oratory of
St Jerome, panel, 216 × 247 cm. Siena, Pinacoteca, No. 233.

76. Detail of Plate 75, left pilaster with emblem of the *Compagnia della Vergine*.

4

THE SOCIAL STATUS OF PATRONAGE AND ITS IMPACT ON PICTORIAL LANGUAGE IN FIFTEENTH-CENTURY SIENA

Max Seidel

THIS essay is part of a broader study devoted to the social history of Renaissance Siena, developed in tandem with the research programme known as the *Corpus delle Chiese di Siena*.[1] I shall concentrate on the following questions: What was the nature of the patron's requests? To what extent could the patron influence the artist's aesthetic and iconographic choices? Beyond the picture's function as a cult object, how far did it constitute a social expression?

Owing to the limitation of space available, I shall concentrate upon a single picture—but I hope that an analysis of its origins will nevertheless demonstrate the importance of socio-historical factors for the development of Sienese Renaissance art in general.

The possession of a chapel in one of the great Sienese churches belonging to the mendicant orders was a sought-after honour usually limited to the most affluent and influential families. In addition to their primary religious significance these chapels were monuments built to celebrate the political and social rank of these families. The acquisition of rights of patronage to a chapel could, for instance, be a sign of political prominence regained after a family's return from exile— as was the case with the Bichi's foundation in Sant' Agostino;[2] or, the celebration of an extraordinary period of economic prosperity that in 1471 permitted Ambrogio Spannocchi to shift his right of patronage from a side chapel in San Domenico to that of the main chapel (Plate 77).

[1] P. A. Riedl and M. Seidel (eds.), *Die Kirchen von Siena* (Munich, 1985), i. The present study is the version based on the text of my lecture delivered on 30 June 1988. I thank Dr Ingeborg Bähr for help and advice. I owe the transcription of the documents cited to Professor Gino Corti and Dr Stefano Moscadelli.

[2] M. Seidel, 'Die Fresken des Francesco di Giorgio in S. Agostino in Siena', *Mitteilungen des Kunsthistorischen Institutes in Florenz*, 23 (1979), 23.

However, other social groups could, in special cases, also aspire to this sort of self-celebration accompanying a chapel's patronage. This is what happened in 1478, when a community of German artisans, the Confraternity of Santa Barbara, acquired rights of patronage to a chapel immediately adjoining that belonging to the Borghesi and Piccolomini families in the choir of San Domenico. In fact, on the occasion when the patronage rights were conferred, the contract's terms stipulated the exact location of the chapel acquired by the Germans as '*in medium inter cappellam heredum olim Mariani de Burgesis et cappellam heredum olim domini Bindocii de Piccolominibus de Senis*'.[3]

In the adornment of their chapel, the artisans hoped to emulate the great Sienese merchants' foundations. Their altarpiece (Plate 78) was supposed to be just as rich and to shimmer with the same precious colours used by Benvenuto di Giovanni for the Borghesi (Plates 80, 81).[4] The agreement made with the painter, Matteo di Giovanni, contains stipulations for the picture's size and iconography that reveal the ambitions of these German artisans. The contract specified that the St Barbara panel (Plate 78) had to be higher than the altarpiece in the Borghesi chapel (Plates 80, 81) and that it use German iconography hitherto unseen in Siena.[5]

It goes without saying that the term *artigiani tedeschi* did not at that time signify a particular national entity. In the language of the time, '*huomini et persone della natione oltremontana di lingua tedesca*',[6] applied as much to a baker from Cologne as to a Flemish tapestry weaver. There is no collection of documents from this confraternity preserved in the State Archives of Siena and, so far, no historical research has been devoted to the group. This leaves only notarial deeds as a possible source for further investigation from which evidence may emerge to give us an idea of the social consistency of these transalpine craftsmen. Study of such documents shows that these artisans formed a homogeneous group united by economic interests and family ties. It turns out that the members were largely textile workers, but there were also taverners, sword-makers, bakers, cooks, carpenters, hosiers, servants of high officials, tanners, and rope-makers. Those who supported the foundation of the Santa Barbara chapel in San Domenico were all of modest social standing. There was *Domina Margarita*, daughter of a German, whose first husband was a German sword-maker and whose second was a German baker;[7] or *Matteus de Alamania*, a bachelor, who was a cook '*in domo Sapientie civitatis Senarum*';[8] or the baker '*Petrus olim Pauli de Alamania*',[9] who

[3] Archivio di Stato, Siena, Notarile ante-Cosimiano, No. 655, fo. 167.

[4] Concerning the arguments supporting the reconstruction illustrated here for Benvenuto di Giovanni's altarpiece, see my contribution in the second volume of the Corpus (*Die Kirchen von Siena*) now in press.

[5] G. Milanesi, *Documenti per la storia dell'arte senese*, ii (Siena, 1854), 364–5. The theme dealt with in our study has until now been misunderstood in art–historical research, due to Milanesi's erroneous belief that the Confraternity of St Barbara's picture had been commissioned by the Sienese bakers' guild. The correction made in the exhibition catalogue, Keith Christiansen *et al.* (eds.), *Painting in Renaissance*

Siena, 1420–1500 (Metropolitan Museum of Art, New York, 1988, 21, 31 n. 22) already refers to my study.

[6] M. Battistini, *La confrérie de Sainte-Barbe des Flamands à Florence: Documents relatifs aux tisserands et aux tapissiers* (Brussels, 1931), 69, citing from a document of the Florentine confraternity of St Barbara dated 1 Apr. 1448.

[7] Archivio di Stato, Siena, Notarile ante-Cosimiano, No. 655, fo. 159 (5 Nov. 1478).

[8] Ibid., fo. 166 (23 Nov. 1478).

[9] Milanesi, *Documenti*. Archivio di Stato, Siena, Notarile ante-Cosimiano, No. 655, fo. 182 (8 Jan. 1478, Sienese style); No. 657, fo. 14 (10 Apr. 1481).

lived in Via delle Donzelle; or the master embroiderer '*Johannes olim Georgii de Alamania*';[10] or the weaver *Arrigus Raymugni*, and *Vaiantes Vaiantis de Alamania*.[11]

The foundation of the Santa Barbara chapel in San Domenico and its furnishing is relatively well documented. A document of 23 November 1478 established the conditions governing the handing over of the chapel: this informs us of the rights and duties assumed by the contracting parties as well as the privileges conceded to the confraternity.[12] What is more, hardly a week after the confraternity had taken possession of the chapel, a contract was drawn up on 30 November with the painter Matteo di Giovanni and this contract supplies a series of revealing details concerning discussion between patron and artist—a subject for which there is hardly better documentation anywhere else in Quattrocento Siena.[13]

What emerges from the contract of 30 November is the importance for both patron and artist of the *modellum*, the particular aesthetic requirements of the patron and the manner in which iconographic matters were briefly defined. From the artist's contract it also becomes clear to what extent the proportions of a Renaissance picture were determined by the patron's iconographic conception.

This transalpine confraternity was not without business acumen. Agreement was made with the artist for a schedule of regular payments but in return he was obliged to work at an exceptional speed while at the same time maintaining clearly defined levels of quality. All foreseeable difficulties of a practical nature were disposed of in advance. Thus, Matteo di Giovanni assumed the duties of a general manager for the entire project, including all the practical responsibilities and financial details for the various phases and aspects of production: from the acquisition of the wooden planks, pigments, gold, and silver to the picture's final installation on the chapel altar in San Domenico.

A third document, which attests to the payment of a prebend on 10 April 1481, allows us to discern the source of the funds this confraternity had at its disposal.[14] But before going into these matters further, it will be helpful to deal with the preliminary circumstances which made it possible for these foreign artisans to compete with Sienese families who otherwise had greater influence in the sensitive area of artistic patronage. If the contract for the Santa Barbara chapel[15] is compared to similar contemporary documents—such as the transfer of the adjacent chapel to the Borghesi family[16]—one cannot help noticing the extreme courtesy with which the Dominican convent greeted the confraternity's initiative. Unlike the Borghesi who, on taking possession of their chapel, were required to supply 150 florins for the endowment of a prebend immediately, the German artisans were authorized to deposit a still undetermined amount at a still unspecified future date (*infra discretum tempus*, according to the text).

[10] Milanesi, *Documenti*, 365.

[11] Archivio di Stato, Siena, Notarile ante-Cosimiano, No. 657, fo. 14 (11 Apr. 1481).

[12] Archivio di Stato, Siena, Notarile ante-Cosimiano, No. 655, fo. 167.

[13] Milanesi, *Documenti*, 364–5.

[14] Archivio di Stato, Siena, Notarile ante-Cosimiano, No. 657, fo. 14.

[15] Archivio di Stato, Siena, Notarile ante-Cosimiano, No. 655, fo. 167 (23 Nov. 1478).

[16] Archivio di Stato, Siena, P.R., No. 2144, C. 57r–59r (31 Mar. 1468).

As far as the chapel's furnishings were concerned, the friars of San Domenico allowed the confraternity complete freedom. I translate:

That the said members of said confraternity are required to make a worthy panel [*unam tabulam honoratam*] for the altar of their own chapel with those figures and paintings and in such manner and form that to them are seemly and pleasing. And in like manner they are bound and obliged to make a glass window . . . and this within a time convenient according to the pleasure of these confraternity members with whom the realization of these things have been placed.[17]

Furthermore, the convent gave these artisans a legal guarantee, which as far as I know has no counterpart in any contract stipulated with Sienese families. The Dominicans promised to protect the confraternity's rights of patronage against anyone, without any time limit—an obligation which had to to be enacted, be it noted, 'at the expense and cost of their own brothers of the chapter and convent'.[18]

Behind this preferential treatment there was probably a 'German faction' within this convent. Of the fourteen friars who participated at the chapter meeting of 23 November 1478, when it was decided to give patronage rights to the Confraternity of Santa Barbara, four turn out to have had German origins.[19] The national solidarity of the German friars with the German artisans resident in Siena is openly proclaimed in the document registering the last will of the cook, *Matteus de Alamania*. From the moment when the cook was stricken with plague and no Sienese notary was willing to come to the dying man's bedside, it was the Dominican, *Nicolaus de Saxonia* who, ignoring the peril of contagion, listened to his countryman's final wishes in September 1478. It is surely not coincidental, that frate *Nicolaus de Saxonia* chose 23 November 1478 to have this will certified by a Sienese lawyer—this was the very day when the German artisans obtained patronage rights for the Santa Barbara chapel in San Domenico. Evidently the cook's testament, apart from some minor legacies, named the Confraternity of Santa Barbara as its main heir and the funds were used to finance the decoration of the chapel it had just acquired.[20]

[17] Archivio di Stato, Siena, Notarile ante-Cosimiano, No. 655, fo. 167.

[18] Archivio di Stato, Siena, Notarile ante-Cosimiano, No. 655, fo. 167:

> Inprimis quod dicti fratres capitulum et conventus tenean-tur et obligati sint in perpetuum eisdem sociis dicte societatis presentibus et futuris, eorum fratrum capituli et conventus propriis sumptiis et expensis, ipsam cappellam defendere auctorizare et disbrigare, si quo unquam tempore ab aliquo quoquo modo tolleretur contenderetur vel molestaretur aliqua ratione iure modo vel causa.

[19] Ibid. The presence of four German friars in this chapter meeting was not exceptional; they are found again among the list of participants in other chapter meetings. For example, in a list of convent members at S. Domenico written on 22 Aug. 1481 containing 21 names, 4 friars of German origin are also

included (Archivio di Stato, Siena, Notarile ante-Cosimiano, No. 657, fo. 67).

[20] Archivio di Stato, Siena, Notarile ante-Cosimiano, No. 655, fo. 166:

> Pro societate Sancte Barbare. Anno Domini 1478, inditione XII, die vero XXIII novembris. Reverendus in Christo patre frater Nicolaus de Saxonio ordinis predicatorum inpresentiarum habitator in conventu Sancti Dominici de Camporegio civitatis Senarum, coram me notario et testibus infrascriptis personaliter constitutus ad exgrava-tionem sue conscientie in verbo veritatis, dixit, asseruit et affirmavit quod, cum Matteus olim alterius Mattei de Alamania, quondam coquus in domo Sapientie civitatis Senarum, de anno presenti et mense septembris proxime decursi egrotaret peste et appropinquaret se ad ultimum sue vite finem et vellet de bonis suis per nuncupativum

Only in one other case have I been able to discover the source of funds donated to the foundation of the Santa Barbara chapel. On 5 November 1478, i.e. eighteen days before the confraternity obtained rights of patronage to the chapel, a *domina Margarita*, daughter of a German, donated to the confraternity the estate of her dead husband *Johannes Antonii de Alamania*.[21] Margherita's condition conforms to the observations made earlier regarding the confraternity's social make-up. The husband had been a sword-maker. At the time the contract we have been discussing was drawn up, Margherita was married to a German baker with whom she lived '*in furno sub ecclesia Sancti Vigilii de Senis*', which implies a rather modest lodging.

By chance, it is possible to determine how this legacy was used. The property consisted primarily of a house situated '*in tercerio Kamollie in contrata vocata Provençano*'. In fact, two and a half years later, when the confraternity's financial obligations to the convent of San Domenico finally fell due, it was this house that served as the capital to fund the annual prebend.[22]

testamentum disponere, nec posset ad hunc effectum aliquem habere notarium qui se illuc conferret propter metum contagionis sui morbi, rogavit suprascriptum fratrem Nicolaum, ibidem presentem in domo dicte Sapientie et in camera ubi ipse iacebat infirmus, ad hoc ne decederet intestatus et sine dispositione suorum bonorum . . . Qui frater Nicolaus volens ipsius Mathei annuere voluntati, coram et presentibus fratre Nicolaio de pulcro campo, fratre Simone Saxon ordinis predicatorum, Petro de Traietto et Katerina de Prucia testibus ibidem ad id spetialiter adhibitis et rogatis, suprascriptum testamentum et ultimam voluntatem ipsius Mattei condidit et scripsit atque rogavit prout et sicut sibi ordinavit et dictatvit . . . videlicet: In primis quod gloriose Virginis Marie apud fontem iustum civitatis Senarum de bonis suis, iure legati, reliquit et legavit ducatos duos auri pro anima ipsius testatoris. Item societati Sancte Barbare que congregatur in dicta ecclesia Sancti Dominici de dictis suis bonis iure legati reliquit et legavit alios ducatos duos auri pro uno officio fiendo pro anima ipsius testatoris. Item fratri Nicolao de pulcro campo ordinis predicatorum eius Mattei confexori dicto iure legati reliquit et legavit ducatos quinque auri pro anima ipsius testatoris. Item de dictis suis bonis iure legati reliquit et legavit Caterine Iacobi de Prucia eius testatoris gubernatrici ducatos XVI auri largos de quibus valeat disponere et eos expendere ut sibi placuerit. Item Petro de Traiecto dicto iure legati reliquit et legavit de dictis suis bonis ducatos duos auri largos pro anima ipsius testatoris. Item fratri Simoni Saxon ordinis predicatorum de dictis suis bonis reliquit et legavit iure legati unum ducatum auri pro anima ipsius testatoris. Et in omnibus aliis suis bonis mobilibus et immobilibus, iuribus et actionibus . . . suam heredem universalem instituit et esse voluit suprascriptam societatem Sancte Barbare . . . Actum Senis in claustro dicte ecclesie Sancti Dominici, coram et presentibus magistro Iohanne Iacobi carpentario de Senis et Mariano Franci del

Tondo de Castro novo Berardinghe comitatus Senarum testibus. Ego Benedictus Biliocti notarius rogatus scripsi.

21 Archivio di Stato, Siena, Notarile ante-Cosimiano, No. 655, fo. 159:

Pro societate Sancte Barbare. Anno Domini 1478, inditione XII, die vero quinto novembris. Domini Margarita filia olim [vacat] de Alamania, uxor relicta olim magistri Iohannis Antonii de Alamania coltellinarii habitatoris civitatis Senarum et inpresentiarum uxor Gerardi Pauli de Alamania predicta fornarii habitatoris in civitate Senarum in furno sub ecclesia Sancti Vigilii de Senis . . . causa donationis inter vivos ecc. dedit et donavit, cessit et concessit Bartholomeo Gulielmi de Alamania habitatori civitatis Senarum, uni ex quatuor prioribus societatis Sancte Barbare, que congregatur in ecclesia Sancti Dominici de Senis, presenti et recipienti vice et nomine dicte societatis . . . omnia et singula iura et actiones . . . quas ipsa habet et habere videtur et potest . . . vigore testamenti conditi per dictum olim magistrum Iohannem eius primum maritum et vigore cuiusdam legati sibi facti in dicto testamento de quo constare asseruit manu . . . Ser Pauli Pietri Pauli notarii publici et civis Senarum, in et super quadam domo Senis in tercerio Kamollie et in contrada vocata Provençano . . ., cum hac inde conditione . . .: quod ipsa societas et disciplinati ipsius teneantur et obligati sint ad satisfactionem et solutionem illorum debitorum in supradicto legato facto . . . Actum Senis in domo suprascripti furni sita sub ecclesia Sancti Vigilii coram et presentibus Pierfrancisco Bartolomei Iohannis de Lutis et Bartolomeo Ristori barbitonsoris de Senis testibus. Ego Benedictus Biliocti notarius rogavi.

22 Archivio di Stato, Siena, Notarile ante-Cosimiano, No. 657, fo. 14 (10 Apr. 1481). The identity of the house with the building mentioned in the document of 5 Nov. 1478 (see the transcription in our n. 21) is based on the following phrases: '*unam ipsius societatis domum, sitam Senis in terzerio Kamollie et*

The documentary material here permits a glimpse into the confraternity's assets and particularly into how the patronage rights to the chapel were paid for. Apparently, the available funds came solely from people of modest means. Larger donations, such as *domina Margarita*'s house, reached the confraternity only just before the chapel came into its possession.

A particularly interesting aspect of this episode in the history of Sienese patronage is the order of priorities adopted by the German artisans in the fulfilment of their obligations connected with the chapel in San Domenico. It turns out that the confraternity's chief concern does not seem to have been the financing of the prebend in order to guarantee the chapel's regular liturgical function but, rather, the appointment of a painter and the manner of his remuneration. By 30 November 1478, we find our artisans already busy with the signing of the contract with Matteo di Giovanni for the execution of the large altarpiece (Plate 78).[23] This took place only seven days after the rights of patronage had been officially ceded to the confraternity. The interval of time seems extraordinarily brief for a group of foreign artisans to have discussed and resolved a series of problems ranging from the choice of the artist, the size of the work to be commissioned, and its iconography, to the artist's fee and terms of payment. The choice of the unusual iconography alone must have required, as we shall see, prolonged deliberation.

The execution of the Santa Barbara altarpiece (Plate 78) coincided with the admission of the faithful to the recently completed transept of San Domenico. The demolition of the wall separating the nave from the transept permitted for the first time a view of the choir chapels (Plate 77). Clearly, the German artisans wanted to take advantage of this fresh focus of public interest to present their new altarpiece. The painter had to complete the imposing work in the record time of eight months! The contract was formulated in a way to preclude any possible extension of time for the work's completion. In fact, it stipulated '*che decto maestro Matteo debbi far fare essa tavola . . . et haverla messa in sull'altare di sancta Barbara . . . per tempo di mesi octo proximi advenire, remossa ogni exceptione*' ['that said Master Matteo must execute this panel . . . and have it placed on the altar of Santa Barbara . . . within the next eight months without fail'].[24] To ensure this tempo of labour, the German artisans promised to observe a prearranged schedule of four payments. The first 25 florins were to be paid to the painter upon the signing of the contract on 30 November 1478. A further sum of 25 florins was promised at Easter, while a third instalment, this time of 20 florins, was set aside for Whitsuntide. The final payment of 20 florins was to go to the artist not on completion of the painting, but only when it was finally in place on the altar of the chapel in San Domenico.

For a group of foreign artisans who aspired to rival the most influential Sienese families in the sector of public esteem, an altarpiece was probably the only possible area of competition (Plate 78). The contract specifically obliged Matteo di Giovanni to do this:

populo S. Petri ad Ovile desubtus, in contrata vocata di Provenzano, [23] Milanesi, *Documenti*, 364–5.
que fuit olim magistri Iohannis Antonii coltellinarii, habitatoris [24] Ibid. 365.
civitatis Senarum.'

La detta tavola da farsi sia . . . richa e grande, e largha per ogni verso tanto quanto è la tavola che fece fare Jacomo di Mariano Borghesi . . . Maestro Matteo debbi far fare essa tavola . . . dipenta e adornata d'oro fino, et di tutti i colori richamente ad giuditio d'ogni buon maestro, come sta quella di Jacomo Borghesi.[25]

[said panel to be made . . . rich and large, as wide on all sides as that made for Jacomo di Mariano Borghesi . . . Master Matteo must make this panel . . . completely painted and richly decorated in finest gold and pigments according to the standard of all good masters just like that commissioned by Jacomo Borghesi.]

Although the work's size was supposed to correspond to the *modellum* (Plate 81), the decision to have a lunette added conspicuously to its height and thereby made it larger than Benvenuto di Giovanni's altarpiece for the Borghesi. In fact, it was decided:

che el colmo di decta tavola debbi essere . . . più alto che quella che fe' fare decto Jacomo, un quarro, per lo meno.[26]

[that the top of said panel must be . . . higher by at least a *quarro* than that ordered by Jacomo.]

Plate 81 is a reconstruction of the Borghesi family's altarpiece that served as the model for the German artisans. Space does not permit here an examination of the problems involved with this reconstruction.[27] Suffice it to say that the most important feature of our altarpiece was that originally it must have had a very similar structure, including a predella of five panels and a framework with two lateral pilasters.

Because of the rivalry with the chapels of Sienese patricians, the German artisans naturally attached great importance to the quality of the colours and precious metals to be used. In the contract, Matteo di Giovanni promised to use colours (Plate 78) at least as precious as those in the Borghesi altarpiece (Plate 80). In concrete terms this meant that the artist had to dress St Barbara in a mantle of crimson brocade and enthrone her upon a seat of gold: '*Sia dipenta la figura di sancta Barbara sedente in sur una sedia d'oro e lei sia vestita d'uno mantello di brochato cremisi.*'[28]

Matteo di Giovanni painted the saint's figure on an entirely golden ground (Plate 78). This technique is also to be observed in the representation of the Magi kneeling before Mary, where the loss of the rose paint on the lower area of the young king's mantle has exposed the gold preparation. The tower supported by St Barbara's left arm today appears in the reddish brown tones of the bole, but originally the painter rendered it in luminous silver. The strange shadows visible in St Catherine's golden gown, caused by the efflorescence of the preparation, do not correspond to the original colouring either.

Clearly, Matteo di Giovanni wanted to fulfil his patrons' expectations; unhesitatingly he adopted the aesthetic criteria of these German artisans, who were really seeking a goldsmith rather than a painter. Whereas yellow paint sufficed for the bases and capitals of the balustrade in the background of the Borghesi altarpiece (Plate 80), for the confraternity Matteo used pure gold

[25] Ibid. 364–5.

[26] Ibid. 364.

[27] See above, n. 4. For the difficulties in the reconstruction of the Confraternity's St Barbara altarpiece, see E. Trimpi, 'Matteo di Giovanni: Documents and a Critical Catalogue of his Panel Paintings', Ph.D. thesis (University of Michigan, 1987), University Microfilms International (Ann Arbor, Mich.), 130–1, 157–8, 214–15, 231–3, 264–6.

[28] Milanesi, *Documenti*, 364.

(Plate 78). For the lighter colours, he mixed in darker tones so as to enhance the brilliance of gold beside an opaque white. Compared to his Borghesi model, the haloes are not only larger, but also more ornate so that the light glitters preciously—an effect increased by candlelight (Plate 78).

Compared to the Borghesi altarpiece (Plate 80), the gold ground in the St Barbara panel extends to exactly half the picture's height (Plate 78). In the eyes of the commissioning artisans, the charm of the sparkling surface was evidently of greater importance than the laws of perspective, which in Benvenuto di Giovanni's panel proved to be an ideal occasion for a virtuoso performance in the representation of the polychromed marble pavement with its geometrical patterns. Here it is not inappropriate to recall Michael Baxandall's fascinating analogy between classic models of perspective (of the type found in the Borghesi altarpiece) and the 'geometric proportions' of contemporary commercial accounting systems[29] familiar at the time to every merchant including, certainly, Giacomo Borghesi but which would have been something quite extraneous to an artisan's training.

I should like to suggest that even in their choice of artist the Confraternity of Santa Barbara was influenced by their ideal of a painter-goldsmith. Very probably the German artisans knew the picture Matteo di Giovanni had painted a few years earlier for the Della Ciaia altar in the church of the Servites in Siena,[30] where Mary is seated upon a golden bench similar to the one later used to enthrone the confraternity's protectress, St Barbara.

This picture in San Domenico belonging to the 'transalpine nation of German tongue' ('*natione oltramontana di lingua tedesca*'), openly competing with the foundations of the most important Sienese families, was also supposed to distinguish itself by the 'national' character of its iconography. The Confraternity of Santa Barbara saw to it that the convent allowed them complete freedom of iconographical expression. As already noted, the contract of 23 November 1478 stated explicitly that the Germans could adorn their altarpiece 'with those figures and paintings and in such manner and form that to them are seemly and pleasing' ('*cum illis figuris et picturis et eo modo et forma prout eis videbitur et placuit*').[31]

Many contemporary observers must have been aware then that all the confraternities of German artisans resident in Italy venerated St Barbara as their patron saint. On the frame of Cosimo Rosselli's Santa Barbara altarpiece (Plate 82), installed in 1469 in the church of the Santissima Annunziata in Florence, is inscribed: '*Barbara diva tibi tabulam sanctissima cetus theutonicus posuit qui tua festa colit*'.[32] The similarity of these two pictures, the one Florentine and the other Sienese (Plates 78, 82), both representing the patron saint flanked by two other saints, allude to a specific canon of 'national iconography'.

[29] M. Baxandall, *Painting and Experience in Fifteenth Century Italy* (Oxford, 1972), 96–101.

[30] P. Torriti, *La Pinacoteca Nazionale di Siena: I dipinti dal XII al XV secolo* (Genoa, 1977), 364–5.

[31] Archivio di Stato, Siena, Notarile ante-Cosimiano, No. 655, fo. 16.

[32] Florence, Museo dell'Accademia, Inventory No. 8635. P.

Nuttall, '"Le tavele Sinte Barberen": New Documents for Cosimo Rosselli and Giuliano da Maiano', *Burlington Magazine*, 127, No. 987 (1985), 367–72; A. Padoa Rizzo, 'La cappella della Compagnia di Santa Barbara della nazione tedesca alla Santissima Annunziata di Firenze nel secolo XV: Cosimo Rosselli e la sua impresa artistica', *Antichità viva*, 26, No. 3 (1987), 3–18.

Furthermore, in the choice of the two subsidiary saints, the Sienese confraternity allowed itself to be influenced by national criteria to a greater extent than their Florentine counterpart, whose homage to the host city was declared by reserving the place of honour on St Barbara's right to John the Baptist (Plate 82). For the corresponding place in the Sienese altarpiece, Matteo di Giovanni had the specific instruction to paint, in the contract's words[33] '*la figura di sancta Caterina tedesca*' (Plate 78).

The attempt to introduce Siena to an iconographical language oriented towards a national type is even more evident in the composition of the lunette (Plates 78, 79). In the contract drawn up with Matteo di Giovanni at the end of 1478 it is clear that the patrons had a particularly keen interest in the scene of the three Magi. The contract is so formulated that reference to the *modellum* is used to replace the listing of many iconographic details. The main figures are listed in the briefest manner; the identification of the secondary figures, such as the eight saints to appear on the lateral pilasters, had to be established verbally in a subsequent agreement. Only in one matter did the German artisans give the notary a fully detailed script. Their zeal was not directed towards any of the main groups in the picture, but towards a secondary scene in the background (Plate 79). Here is their rather pedantic description of how the Magi were to meet at the crossroads near the gates of Jerusalem:

che nel colmo de la decta tavola debbi essere, e sia dipenta la storia de' tre Magi, li quali venghino per tre diverse vie, e che in chapo d'esse tre vie, si riscontrino, essi Magi insieme, e vadino a offerire a la Natività.[34]

[that at the top of said panel there must be present and be painted the scene of the three Magi; who appeared from three different roads and who meet where the three roads end and go to make their offering to the Nativity.]

As far as I know there is no earlier Sienese picture and not even a Tuscan example that represents the scene in this way (see, for instance, the typically Italian interpretation of the voyage of the Magi in the panel by Sassetta in the Metropolitan Museum,[35] in Sano di Pietro's predella in the Yale University Art Gallery,[36] in Gentile da Fabriano's Strozzi altarpiece in the Uffizi, and in the pictures by Filippo Lippi, Botticelli, Benozzo Gozzoli, Cosimo Rosselli, and Domenico Ghirlandaio).

Although one can imagine that members of the Confraternity of Santa Barbara furnished Matteo di Giovanni with a German pictorial interpretation of this scene, I think it more likely that he received guidance in written form.

In fact, there is an exact correspondence between the Sienese picture (Plate 79) and a description of the Magi's journey in a text written between 1364 and 1375 by John of Hildesheim, already translated into German in 1389. The similarity is so exact, not only in the details but in the basic

[33] Milanesi, *Documenti*, 364.

[34] Ibid. 365.

[35] Exhibition catalogue; Christiansen *et al.* (eds), *Painting in Renaissance Siena 1420–1500*, 81.

[36] C. Seymour Jr., *Early Italian Painting in the Yale University Art Gallery* (New Haven, Conn., and London, 1970), 200–2 (Inv. No. 1871.61).

concept, to make me think that John of Hildesheim's famous treatise was circulated from hand to hand, at least in excerpts, not necessarily among the artisans but at least among the German friars in Siena.[37]

In fact, Matteo di Giovanni placed the meeting of the Magi in a setting that perfectly corresponds to John of Hildesheim's account:

Calvary is a high rock . . . near it three roads met. It was at the crossing of these three roads that the Magi met. They had never seen each other before and they did not know one another.[38]

The artist's perspicacious reading of the text is materialized in exemplary fashion by Calvary, which is frequently absent in German renderings of the subject. The significance of Calvary's location in the middle of the scene (Plates 78, 79) only becomes clear within the context of the original arrangement of the entire altarpiece. Originally there was a central axis extending from the Passion scene in the central predella panel[39] upwards to the top of the lunette where, in a scene depicting the *Adoration of the Magi, Calvary*—in the background—presages the Saviour's Passion.

The fact that the German artisans attributed great importance to the congruity between words and imagery, thereby making it possible to identify the textual source for the representation, emerges clearly from several significant details. For instance, the topographical description corresponds exactly to John of Hildesheim's account (Plate 79); Jerusalem is set half-way between Calvary and Bethlehem just as the text explains that the distance between these places was two miles on either side of the city.[40]

The decisive factor in the choice of text on which to base the picture's iconography is in line with previous considerations, namely, the national character of John of Hildesheim's work. Praise for the city of Cologne vibrates throughout the text and the conclusion intones:

No other city is honoured so much by an equally noble populace and by such likewise devout servants of God as is the city of Cologne. Thus God in his wisdom so disposed that the Magi found their last and final home in this city[41] . . . because of them you, happy Cologne, are revered and held in high esteem throughout the world; your name is oftener on the lips of peoples, princes and lords than all the other cities of the world.[42]

The German elements of the picture's iconography, however, should not be overemphasized for they are counterbalanced by the patrons' clear intention to assimilate themselves into the pictorial conventions of Siena. In several fundamental respects the St Barbara picture belongs to a type of Sienese confraternity banner exemplified by the standard of St Catherine painted by

[37] Iohannes von Hildesheim, *Die Legende von den Heiligen Königen*, trans. E. Christern (Munich, 1963); H. Hofmann, *Die Heiligen Drei Könige* (Bonn, 1975), 111–13. The 1st edn. in Cologne of John of Hildesheim's book is dated 1477.

[38] Johannes von Hildesheim, *Die Legende von den Heiligen Königen*, 29–30.

[39] Milanesi, *Documenti*, 365: 'che nel mezo de la predella debbi

essere dipento un Crocifisso con la figura della Nostra Donna dall'uno lato, et san Giovanni dall'altro.'

[40] Johannes von Hildesheim, *Die Legende von den Heiligen Königen*, 29–34.

[41] Ibid. 118.

[42] Ibid. 121.

Pietro di Giovanni d'Ambrogio in 1444, now in Paris in the Musée Jacquemart-André (Plate 83). This composition is also dominated by the patron saint, who is larger in scale than the other figures and also wears a precious brocade mantle. Two angels in flight hold a crown above her head—an iconographical feature appropriated by the Confraternity of Santa Barbara, who obliged the painter 'to paint in this panel two flying angels showing them with a crown held above St Barbara's head'.[43] There is also a general similarity in the hieratic nature of the composition where the figures are not situated in a three-dimensional space, but are lined up in the foreground together with the flying angels (Plates 78, 83).

In conclusion, I would like to emphasize one result of this study which seems worthy of note: namely that the relatively well-documented case discussed here shows to what extent the patrons' specific iconographic needs could determine both the proportions and style of a Renaissance altarpiece. The decision to extend the lunette (Plate 78) upwards in order to accommodate the picture-book landscape full of figures (Plate 79) was taken so that a scene of central importance to the confraternity could be incorporated into the picture. This requirement could only be carried out by substantially altering the proportions of the Borghesi *modellum* (Plate 81) so as to create the necessary space for all the story's episodes and details. Neither the artist nor the patron objected to such a 'distortion', which was the unbalanced result of enlarging only one part of the entire altarpiece.

[43] Milanesi, *Documenti*, 364.

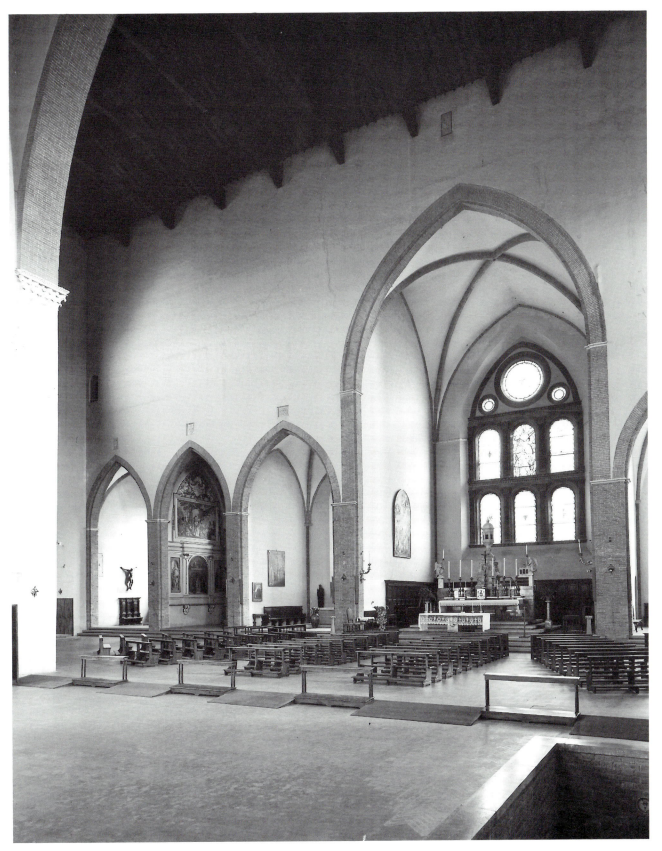

77. View of left transept and main chapel of San Domenico, Siena.

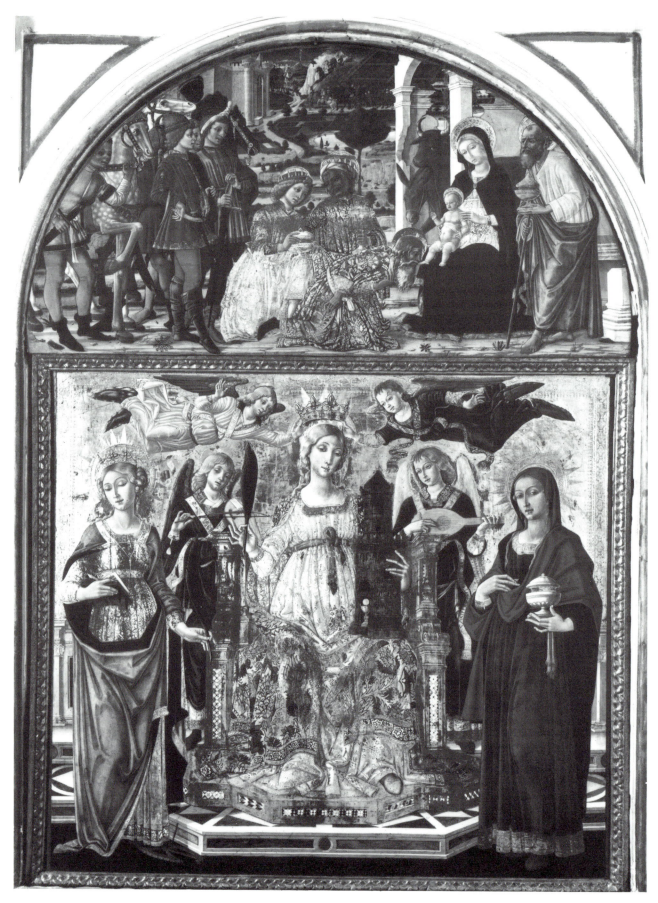

78. Matteo di Giovanni, altarpiece of the Confraternity of Santa Barbara,
282 × 202 cm. Siena, San Domenico.

79. Matteo di Giovanni, detail of Plate 78.

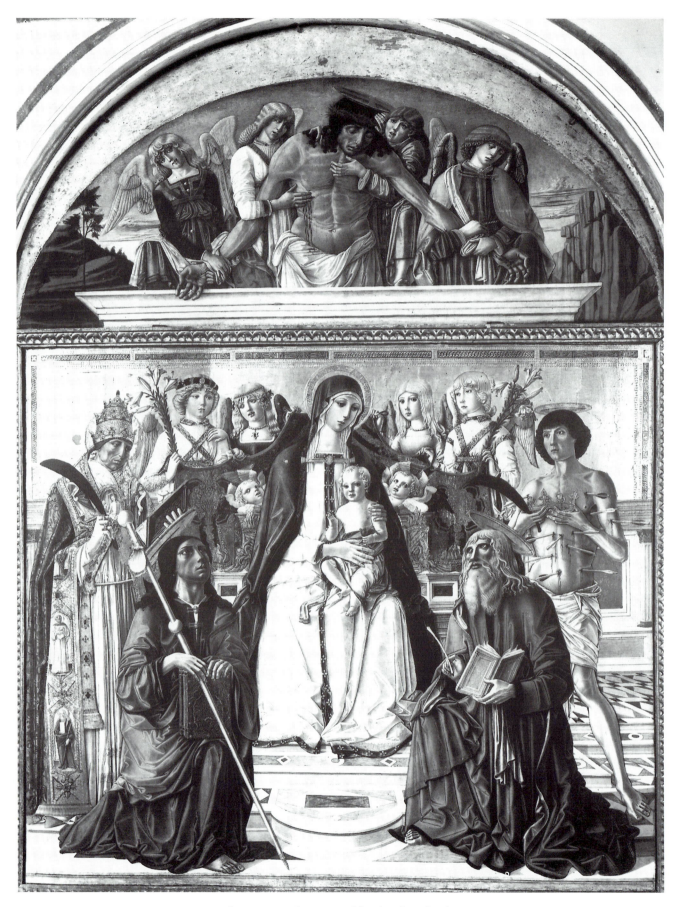

80. Benvenuto di Giovanni, altarpiece of the Borghesi family, 263 × 202 cm.
Siena, San Domenico.

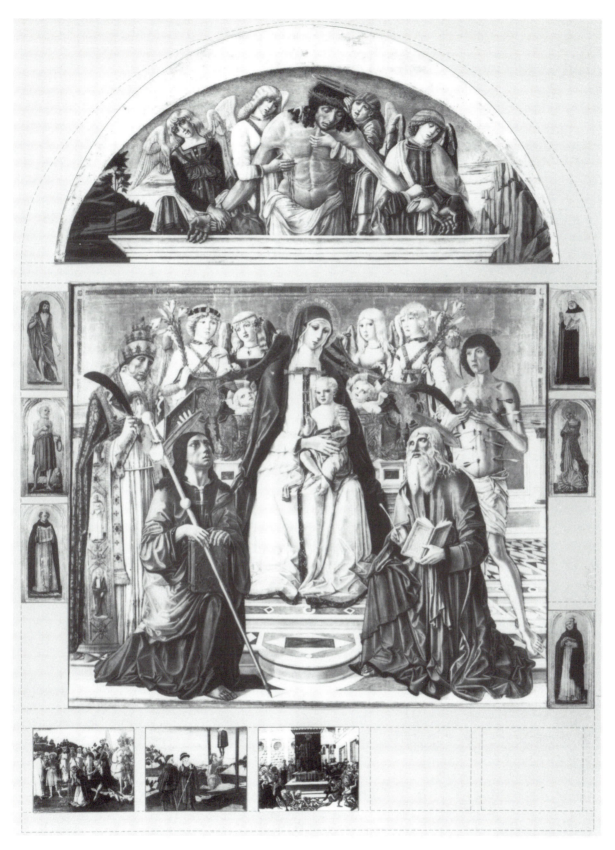

81. Reconstruction of the Borghesi altarpiece.

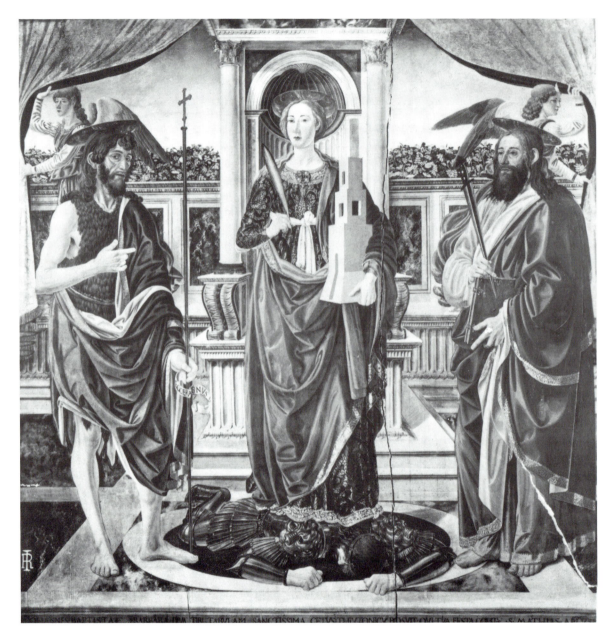

82. Cosimo Rosselli, altarpiece of the Confraternity of Santa Barbara.
Florence, Accademia, No. 8635.

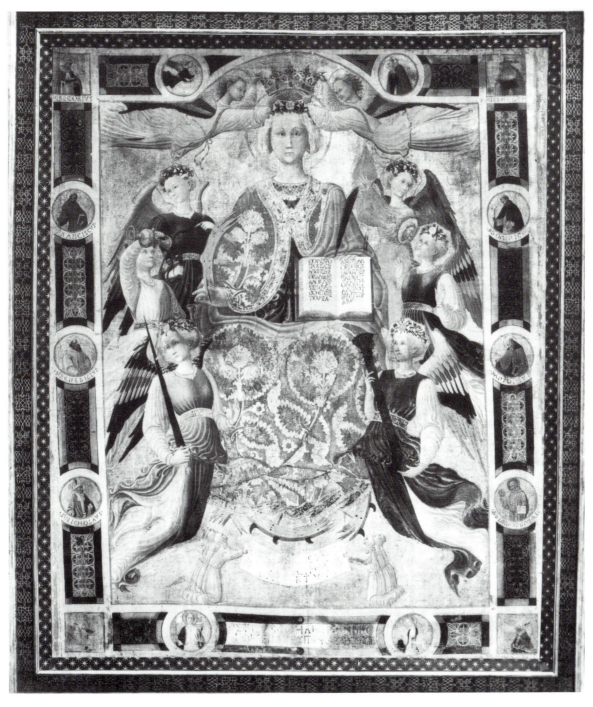

83. Pietro di Giovanni d'Ambrogio, Banner of the Confraternity of
St Catherine of Alexandria, 1444. Paris, Musée Jacquemart-André,
No. 908.

5

THE BELLINI, THE VIVARINI, AND THE BEGINNINGS OF THE RENAISSANCE ALTARPIECE IN VENICE

Peter Humfrey

IN the small but steadily growing art-historical literature dedicated to the Gothic and Renaissance altarpiece, considerable emphasis has rightly been placed on its character as a *Gesamtkunstwerk*. In other words, the altarpiece was conceived not as a mere picture (or set of pictures), but together with its frame as a closely integrated unity of painting and carving, which was normally closely related in turn to its wider architectural environment. This point has generally been made with reference to individual altarpieces, and especially to those comparatively rare examples that happen to be preserved in their original frames and architectural settings. In well-known cases such as Titian's *Assunta* in the Frari, for instance, or Pontormo's *Entombment* in Santa Felìcita, we have learnt to appreciate the essential role played by the frame in giving clearer articulation to the pictorial composition, in enhancing the effect of pictorial illusion, and in creating a visual link between the painting and its surroundings.[1] A certain amount of critical attention has also been paid to the difficult question of identifying which artist—painter, sculptor, or even architect— normally took responsibility for the overall design of a collaborative project such as an altarpiece, and to the various different business procedures that such collaboration involved.[2] But perhaps we

[1] For these examples, see respectively D. Rosand, 'Titian in the Frari', *Art Bulletin*, 53 (1971), 196–213, repr. in id., *Painting in Cinquecento Venice: Titian, Veronese, Tintoretto* (New Haven, Conn., and London, 1982), 51–8; and J. Shearman, *Pontormo's Altarpiece in S. Felìcita* (Newcastle-upon-Tyne, 1971).

[2] See C. Gilbert, 'Peintres et menuisiers au début de la Renaissance en Italie', *Revue de l'art*, 37 (1977), 9–28; C. Gardner von Teuffel, 'From Polyptych to Pala: Some Structural Considerations', in H. W. van Os and J. R. J. Van Asperen De Boer (eds.), *La pittura nel XIV e XV secolo: il contributo dell'analisi tecnica alla storia dell'arte*, Atti del XXIV Congresso internazionale di storia dell'arte, 1979, iii (Bologna, 1983), 323–30; P. Humfrey, 'The Venetian Altarpiece of the Early Renaissance in the Light of Contemporary Business Practice', *Saggi e memorie di storia dell'arte*, 15 (1986), 65–82 (esp. 70–5); id., 'Il dipinto d'altare nel Quattrocento', in F. Zeri (ed.), *La Pittura in Italia: il Quattrocento* (Milan, 1987), ii, 538–50.

have not yet paid sufficient attention to the character of the altarpiece as a *Gesamtkunstwerk* in our consideration of broader questions of stylistic innovation and stylistic interchange. The importance of doing so has been underlined by the work of Christa Gardner von Teuffel, who has stressed the degree to which the form and structure of the fourteenth-century Tuscan polyptych was shaped by the pre-existing Gothic style of the church building.[3] Similarly, in her account of the origins of the Renaissance *pala* in Florence, she makes a strong case for supposing that the spatially unified Renaissance altarpiece, enclosed in a classicizing frame, was the invention not of the painter Masaccio but of the architect Brunelleschi.[4] According to Christa Gardner's analysis, the standard Florentine early Renaissance format consisting of a squarish, unified field, flanked by pilasters and supporting an entablature, resulted directly from Brunelleschi's concern for the harmonious, orderly interrelationship of every architectural and decorative element in his churches; while Masaccio, for all his interest in creating an effect of solid, three-dimensional forms in a coherent, three-dimensional pictorial space, could not have invented the Renaissance altarpiece because he was working in an architectural environment that was still Gothic.[5] It is significant, therefore, that the first fully-fledged (as opposed to transitional) Renaissance *pale* were Fra Filippo Lippi's *Annunciation*, commissioned for San Lorenzo within the architect's lifetime, and Fra Angelico's San Marco altarpiece, designed to be seen against the backdrop of a new choir by Michelozzo.[6] In other artistic centres, however, where Renaissance forms by no means necessarily appeared in architecture before painting, the Renaissance altarpiece emerged in a correspondingly different manner. In Venice, for example, the first work to show all the essential features of the Renaissance *pala*—the unified field, the convincing evocation of space and volume, the classicizing frame—may be identified as Giovanni Bellini's *St Catherine of Siena* altarpiece (destroyed in 1867) of *c.*1470 (Plate 84).[7] Yet this was painted for a Gothic church, Santi Giovanni e Paolo, before any Renaissance-style church or chapel had actually been built in the city; and it was to be another decade before a new stylistic synthesis between the altarpiece and its architectural surroundings was created in Bellini's own San Giobbe altarpiece (Venice, Accademia), painted in about 1480 for a church recently reconstructed in the new style by Pietro Lombardo.[8] The purpose of the present study is to discuss how this came about, and especially how the differing pace of development between the three major arts affected the evolution of the Venetian altarpiece in the transitional period of about thirty years before 1470.

[3] C. Gardner von Teuffel, 'The Buttressed Altarpiece: A Forgotten Aspect of Tuscan Fourteenth-Century Altarpiece Design', *Jahrbuch der Berliner Museen*, 21 (1979), 21–65, esp. 40 ff.

[4] Id., 'Lorenzo Monaco, Filippo Lippi und Filippo Brunelleschi: die Erfindung der Renaissance', *Zeitschrift für Kunstgeschichte*, 45 (1982), 1–30.

[5] Id., 'From Polyptych to Pala'; id., 'Masaccio and the Pisa Polyptych: A New Approach', *Jahrbuch der Berliner Museen*, 19 (1977), 23–68.

[6] Gardner von Teuffel, 'Lorenzo Monaco'; Gilbert,

'Peintres et menuisiers'. It should be noted, however, that at the I Tatti conference John Shearman stuck to his previously stated opinion (quoted by Gardner von Teuffel, 'Lorenzo Monaco', 18) that Lippi's *Annunciation* was originally painted not as an altarpiece but as a pair of organ shutters.

[7] For this work, see G. Robertson, *Giovanni Bellini* (Oxford, 1968), 58–60, 65–6.

[8] Ibid. 85–6; E. Hubala, *Giovanni Bellini: Madonna mit Kind, die Pala di San Giobbe* (Stuttgart, 1969). For the church of S. Giobbe, see J. McAndrew, *Venetian Architecture of the Early Renaissance* (Cambridge, Mass., 1980), 134–43.

As is generally recognized, the first signs of a response among Venetian artists to the early Renaissance in Florence occur in the work of the painters Jacopo Bellini and Antonio Vivarini in the first half of the 1440s. Antonio's early interest in solid volumes and heavy, vertical draperies, perhaps stimulated by a knowledge of Filippo Lippi's work in Padua in the mid-1430s, marks a definite departure from the late Gothic style of Venetian contemporaries such as Giambono. Of particular interest to us here is Antonio's *Investiture of St Peter Martyr*, now in Berlin (Plate 85), one of a series of small panels datable to *c*.1443 and depicting scenes from the saint's life.[9] In this work not only does the artist attempt to generate a coherent three-dimensional space by means of receding orthogonals and an (admittedly naïve) classicizing architecture, but he also includes a representation of an altarpiece, framed with pseudo-classical members (the flanking strips lack capitals, but they do have bases), and depicting a unified *Sacra Conversazione*. The contrast with the probably only slightly earlier *St Benedict Exorcising a Monk* in the Uffizi (Plate 86), by an anonymous north-east Italian painter sometimes identified as Giambono,[10] is a telling one; but it is also important to realize that it was to be another three decades before the first *Sacra Conversazione* was actually realized in Venice: in Giovanni Bellini's *St Catherine of Siena* altarpiece. Evidently it was the small scale of the panel, and hence its informal character, that led Antonio to make so bold an innovation because his own large-scale altarpieces are considerably more conservative. His closely contemporary *St Sabina* polyptych, for example (Plate 87), executed in collaboration with Giovanni d'Alemagna for the newly rebuilt church of San Zaccaria (later to become the chapel of San Tarasio) is not lacking in innovative elements: thus the bell-like doublet of St Achilleus echoes the shape of his cylindrical base, while his left foot projects illusionistically forwards. But any spatial and volumetric effect is then countered by the rich *pastiglia* of the belt, the pattern of the brocades, and the curling outlines, all of which harmonize perfectly with a frame that is no less luxuriantly Gothic than the one depicted in the background of the anonymous *St Benedict* panel.[11] Whatever the relative roles of the painters or the frame-carver in the design as a whole, it is clear that all three worked in close collaboration and together effected a closely integrated artistic unity. So while we may conclude that Antonio was obliged to subordinate any incipient Renaissance interests to the demands of his Gothic context, there is no evidence that he found the obligation irksome. The production of altarpieces remained the central activity of his career, throughout which Gothic remained the prevalent style of architecture and decorative carving in Venice; and in a relatively late work such as the Pesaro polyptych of 1464 (Vatican, Pinacoteca), Antonio's figures remain just as closely attuned to their Gothic frame as those of the *St Sabina* polyptych of twenty years earlier. With two main exceptions, to which I shall return shortly, all of the many altarpieces by Antonio Vivarini and his two painter-collaborators

[9] See R. Pallucchini, *I Vivarini* (Venice, 1962), 97–8.

[10] The problems of attribution are discussed by K. Christiansen, *Gentile da Fabriano* (London, 1982), 119–21.

[11] This is normally and justifiably attributed to the carver

Lodovico da Forlì, who signed the frame of the main Vivarini altarpiece in the S. Tarasio chapel. See Pallucchini, *I Vivarini*, 99–100.

(Giovanni d'Alemagna and Antonio's younger brother Bartolomeo) are essentially of this traditional Gothic type.

Jacopo Bellini, too, may be credited with having anticipated the concept of the Renaissance *pala* some two decades before its actual realization. His Louvre Book of Drawings, which I would accept as dating mainly from the 1430s and 1440s,[12] contains a drawing (fo. 32[r]) of a *St John the Baptist in a Niche* (Plate 88), which resembles an ideal design for an altarpiece (with predella) of a type that was not to be realized until Antonio Rizzo's pair of marble altars for San Marco in the later 1460s (Plate 89).[13] The drawing may be interpreted, in fact, as a simultaneous homage to, and critique of, Donatello's *St John the Baptist*, completed in Florence in 1438, and installed in the church of the Frari in the same year or shortly afterwards. We have no information about the figure's original framing, but to judge from analogous cases of sculptured altarpieces sent from Florence to Venice,[14] the frame would have been supplied by local Venetian rather than by Florentine wood-carvers. In other words, Donatello's figure was almost certainly enclosed within a traditional Gothic type of framing. Only slightly less precocious, because apparently dating from the mid-1450s, is another drawing by Jacopo (fo. 7[v]) of an ambitiously classicizing altarpiece frame, enclosing a single rectangular field (Plate 90). Although the scene represented here is a half-length *Lamentation*, of a type associated with the intimacy of private devotion, the boldly architectonic character of the frame, with its surmounting pediment, is more appropriate to the grander and more formal setting of a church. But, as with Antonio, the continuingly Gothic style practised by Venetian frame-carvers, promoted by the continuingly Gothic taste of altarpiece donors, made it impossible for Jacopo to put his ideal into practice at an early date. Hence it is hardly surprising to find that Jacopo's major surviving work of the 1440s, the *Annunciation* altarpiece completed in 1444 for Sant' Alessandro, Brescia (Plate 91), is enclosed in a frame as undilutedly Gothic as that of Antonio Vivarini's *St Sabina* polyptych (Plate 87). Indeed, it is clear that no less than Antonio, Jacopo worked in close co-operation with his Gothic frame-maker. The frame must have undergone its obvious alterations and mutilations at the very end of the eighteenth century, when the church was rebuilt and the new altars were provided with standardized neo-classical tabernacles.[15] For instance, it is clear that in order to accommodate it to its new stone tabernacle, the original frame had to be considerably increased in height and slightly reduced in width. Thus the intermediate arcade, between the main panels and the upper cresting,

[12] For a recent authoritative discussion of the date of the Louvre Book of Drawings, see B. Degenhart and A. Schmitt, *Jacopo Bellini: Der Zeichnungsband des Louvre* (Munich, 1984), with facsimiles. In their detailed study of the Book, the authors date the two drawings mentioned here (fos. 32[r], 7[v]) to *c*.1440 and to *c*.1455 respectively; B. Degenhart and A. Schmitt, *Corpus der Italienischen Zeichnungen 1300–1450. Teil II. Venedig: Jacopo Bellini*, v, text (Berlin, 1990), 37–49, 74, 77, 103 ff. I am most grateful to Annegrit Schmitt for discussing this matter with me on the occasion of the I Tatti conference.

[13] See Anne Markham Schulz, *Antonio Rizzo, Sculptor and Architect* (Princeton, NJ, 1983), 19–20.

[14] e.g. the altarpiece for the Mascoli chapel in S. Marco of 1430. See W. Wolters, *La scultura veneziana gotica 1300–1460* (Venice, 1976), i, 109–10.

[15] See R. Prestini, *La chiesa di Sant' Alessandro in Brescia: storia ed arte* (Brescia, 1986), 239–40.

is a neo-Gothic addition; while the original flanking piers have been removed, and the lateral foliage has (absurdly) been inverted. The bases of the flanking piers have been badly mutilated and some of the bands of decoration have been completely remade: for instance, that immediately below the main figures. Yet despite these alterations, one need look no further than the original red, blue, and gold polychromy, which so closely repeats the colours of the painting, and the carved figure of God the Father, which provides an essential complement to the painted iconography, to appreciate how far painted panels and decorative carvings were conceived as a unity. As usual, we know nothing of the carver, but I think it may be safely assumed that following normal business practice,[16] the work as a whole was executed in Venice, and was then transported overland and by water to Brescia upon completion.[17] Nor do we know for certain whether or not Jacopo visited Brescia at the time of undertaking the commission. But again, any such visit would have conformed with normal business practice, and would have enabled him to experience at first hand the chapel for which his work was intended. Although our only visual record of this chapel shows no more than a part of the entrance arch, even this provides us with a very strong hint of the Gothic richness of the interior (Plate 92).[18]

Yet if the Brescia *Annunciation* (Plate 91) shows that Jacopo was still producing altarpieces of a previously Gothic character in the 1440s, the work nevertheless retains a particular interest for us in the present context. Despite the Gothic repertory of ornament on the frame, in structure it bears no resemblance to the standard Venetian polyptych of the period, and the number of main panels has been drastically reduced to two. Furthermore, the two main figures are set within a box-space that appears continuous behind the dividing pier of the frame—an effect of continuity that would have appeared even more pronounced before the panels were covered by glass, and the present inner gilt fillets were inserted to hold the panes in place (Plates 91, 93).[19] The illusion of space is then made particularly convincing by Jacopo's display of geometric perspective, with the orthogonals—perhaps for the very first time in Venetian painting—correctly receding to a single vanishing point.[20]

[16] See Humfrey, 'The Venetian Altarpiece', 75–9. Brescia did not have a strong local tradition of altarpiece design at this date.

[17] According to the documents, the panels were shipped to Vicenza, whence they were accompanied to their final destination by two friars from Sant' Alessandro. The documents make no mention of the frame (the *cassa dell'ancona* probably refers to some sort of casing for protecting the work during its carriage overland); but they are known only from 17th-c. transcriptions, and are very incomplete. See L. Testi, *La storia della pittura veneziana*, ii (Bergamo, 1915), 264–5 (where, however, the author is incorrect in supposing that the date of delivery, Jan. 1444, is given *more veneto* and should be read as 1445 New Style; in Brescia, unlike Venice, the new year began at Christmas); Prestini, *La chiesa di Sant' Alessandro*, 229.

[18] A drawing of the exterior of the chapel of the Annunziata from a document in the parish archive is published by Prestini, *La chiesa di Sant' Alessandro*, 35.

[19] A pair of photographs in the Fototeca Berenson of the main panels outside their frame show how much is covered up by the gold fillets. Thus on the *Virgin* panel (Plates 91, 93) the lectern is placed several inches from the left-hand edge of the picture, allowing the patterns of the tiled floor and of the brocade hanging to continue uninterruptedly from the *Angel* panel. Further, a pier, apparently contiguous with that of the frame, is visible at the extreme right-hand edge of the *Virgin* panel. When uncovered this would have contributed to the effect of a three-dimensional stage-space by clearly establishing the position of the proscenium.

[20] See K. Christiansen, 'Venetian Painting of the Early Quattrocento', *Apollo*, 125 (1987), 170.

But if only Jacopo was capable of introducing such innovations into the Venetian altarpiece at this date, the immediate stimulus for them may be attributed to the exceptional circumstances of this particular commission. The *Annunciation* was apparently the very first altarpiece to be ordered for the newly rebuilt church of Sant' Alessandro, which had been ceded to a small group of Servites by Pope Eugenius IV in 1431 as part of his programme of ecclesiastical reform.[21] We know that the prior came from the mother church of the order, Santissima Annunziata in Florence, and also that in the following year, a picture representing the Annunciation and imitating the celebrated miraculous image of the *Annunziata* was commissioned for the new foundation from Fra Angelico.[22] This work, which is now lost, has sometimes been supposed to have been a full-scale altarpiece;[23] but given its early date (before the rebuilding of the church) and the modest payment made to the artist, it is much more likely to have consisted of a small-scale panel for private use in the monastery.[24] Jacopo's altarpiece would then have been commissioned by the friars as a large-scale version for the new church, perhaps with the conscious intention of providing a local counterpart to the famous fresco at Santissima Annunziata. Significantly the new church was rededicated, in addition to St Alexander, to 'Mary the Virgin and Mother of God'; and significantly, too, Jacopo's altarpiece was soon to acquire miraculous properties, and his Virgin was to be decked out by her devotees with a real crown and jewelled necklace.[25] Hence it seems reasonable to suppose that Jacopo was shown Fra Angelico's panel as a desirable compositional prototype. Jacopo's work certainly has a number of features in common with the various surviving Annunciations by Fra Angelico and his school. It shares with the

[21] A. Giani, *Annales Sacri Ordinis Fratrum Servorum B. Mariae Virginis*, i (Florence, 1618), 174ᵛ; Testi, *Storia della pittura veneziana*, 262; Prestini, *La chiesa di Sant' Alessandro*, 95.

[22] The testimony of Giani, *Annales Sacri Ordinis Fratrum*, 146ᵛ, runs as follows: '*His quoque accesit, quod F. Franciscus tantae devotionis Annunciatae de Florentia, ubi et sanguinis, et religionis suae exordia acceperat nequaquam immemor, ut ad maiorem B. M. V. fervorem quotidie magis gentem illam Brixianam excitat et praeclaram Sacratissimae Virginis Annunciatae imaginem ad Ecclesiam S. Alexandri transmitti curavit. Hanc spectatae formae, et conspicuae magnitudinis Florentiae delinearat Vir religiosissimus, et in arte Pictoria nulli secundus F. Ioannes de Fesulis Ord. Praedic. in quo pari discrimine decertabant Sanctitas Vitae, et miritici Pennicilli industria. Hanc igitur P. Franciscus venerandam imaginem Florentia advectam speciali B. Virginis sacello Ecclesiae S. Alexandri, non sine maximo Brixiensium fructu locavit, quemadmodum de ea deq; Cenobio illo suis locis posthac addendum superest.*' For the miraculous image at SS Annunziata generally, see E. Casalini, 'La Santissima Annunziata nella storia e nella civiltà fiorentina', in E. Casalini *et al.* (eds.), *Tesori d'arte dell'Annunziata di Firenze* (Florence, 1987), 75–95. The image was virtually a symbol of the Servite order, and 'copies' (in other words, more or less free variants) were frequently made for the Servite houses, or sent abroad as pious souvenirs. See Z.

Wazbinski, 'L'*Annunciazione della Vergine* nella chiesa della SS. Annunziata a Firenze: Un contributo al moderno culto dei quadri', in A. Morrogh *et al.* (eds.), *Renaissance Studies in Honor of Craig Hugh Smyth*, ii (Florence, 1985), 533–49.

[23] See J. Pope-Hennessy, *Fra Angelico*, 2nd edn. (London, 1974), 193, who tentatively associates the work with the *Annunciation* in the Museo Diocesano, Cortona; see also ibid. 237.

[24] Fra Angelico was paid a mere 11 ducats (including 2 for gold) for his *taola della Nonziata* (Testi, *La storia della pittura veneziana*). It is true that the words '*conspicuae magnitudinis*' (see n. 22 above) imply that Fra Angelico's picture was larger than a small-scale devotional panel; but we know that local tradition in later centuries, and perhaps already Giani, mistook Jacopo's altarpiece for the documented Fra Angelico. There are several extant examples of small-scale versions of the miraculous image; see e.g. the *Annunciation* attributed to the school of Gentile da Fabriano in the Vatican Pinacoteca (Christiansen, *Gentile da Fabriano*, 113).

[25] Prestini, *La chiesa di Sant' Alessandro*, 98, 120, 238. The occasion for commissioning an *Annunciation* altarpiece at S. Alessandro may well have been prompted by knowledge of the work currently being undertaken by Michelozzo in the chapel of the miraculous image at SS Annunziata.

Annunciation in San Francesco at Montecarlo, for example (Plate 94), the general compositional layout, with the two panels set above the predella, the roundel at the centre with God the Father, and the box-space, as well as individual motifs such as the position of the Virgin's hands and the coloured stripes on the Angel's wings, while these same features are rare or unprecedented in Venetian painting. Full-length Annunciations are in any case not particularly common in Venetian altarpieces up to this date, and when they do appear, as in Lorenzo Veneziano's Lion polyptych of 1357–9 (Venice, Accademia), the two main figures characteristically occupy the same panel at the centre of the polyptych. Of course, Jacopo articulates his Florentine Renaissance borrowings with a strong Venetian Gothic accent—so much so, in fact, that some critics have chosen to ignore the documents, and have dated the panels a decade earlier on stylistic grounds.[26] But, as we have seen, a certain archaism of pictorial style may have been quite deliberate on Jacopo's part here, given the need to harmonize his painting with its entirely un-Renaissance frame and architectural setting.

As a response to the needs of a particular commission, the innovation of the continuous box-space in Jacopo's Brescia *Annunciation* was not generally imitated, and polyptychs of the Vivarini type continued to be the norm in Venetian altarpieces for another two decades. But two further exceptions, to which I have already briefly referred, were produced in the mid-1440s by Antonio Vivarini and Giovanni d'Alemagna themselves. In the same year that Jacopo's *Annunciation* was delivered to Brescia, the two painter-collaborators signed an altarpiece of an almost equally innovatory design, under circumstances that are in some ways comparable. Unlike any of their other altarpieces, the *Coronation of the Virgin*, still in the church of San Pantalon (Plate 95), is painted on a single field; and the reason for this is that the composition—probably as with Jacopo, by special request—is loosely based on that of a venerable prototype, the fresco by Guariento on the throne-wall of the Sala del Maggior Consiglio in the Doge's Palace.[27] A single field had already been adopted by Jacobello del Fiore a few years earlier for his own *Coronation* altarpiece,[28] no doubt for the same reason; but unlike Jacobello, Giovanni and Antonio have exploited the continuity of the field to create a relatively deep pictorial space, with an effect of architectonic concavity (and even a use of a mild *di sotto in sù* viewpoint for the main figures) that was not to be developed further until the apse of Giovanni Bellini's San Giobbe altarpiece of nearly forty years later. But I do not want to exaggerate the historical importance of the *Coronation* (Plate 95). Although we know nothing for certain of the original frame, we may probably take our cue from the frame of the Madonna image held by the figure of St Luke in the right foreground, and guess

[26] See C. Boselli and G. Panazza, *Pitture in Brescia dal Duecento all'Ottocento*, exhibition catalogue (Brescia, 1946), 22–3; F. Zeri, 'Quattro tempere di Jacopo Bellini', in id., *Quaderni di Emblema*, i (Bergamo, 1971), 42–9; M. Boskovits, 'Per Jacopo Bellini pittore', *Paragone*, 419–23 (1985), 116.

[27] For this work, largely destroyed by fire in 1577 but surviving in fragments, see F. Flores D'Arcais, *Guariento* (Venice, 1965), 39–41. For the formal and iconographic relationship between Guariento's fresco and later Venetian altarpieces, see S. Sinding-Larsen, *Christ in the Council Hall: Studies in the Religious Iconography of the Venetian Republic*, Acta ad archaeologiam et artium historiam pertinentia, 5 (Rome, 1974), 45–6.

[28] Dated 1438; see S. Moschini Marconi, *Le gallerie dell'Accademia di Venezia: opere d'arte dei secoli XIV e XV* (Rome, 1955), 30–1.

that the real frame consisted of richly gilt Gothic piers supporting an ogival arch, with Gothic foliage sprouting from the sides (as in Jacopo Bellini's frame) and from the top. In any case, there can be little doubt that as in the *St Sabina* polyptych, the forms of the frame combined with the pictorial composition to create an overall effect of rhythmical surface undulation rather than of concave space, and that the gilding of the frame would further have emphasized the extensive areas of gilding in the picture. Thus for all the unity of its field, the work would originally have resembled a prototype of the Renaissance *pala* even less than it does today in its gallery frame. And although the work won sufficient contemporary admiration for a direct copy to be ordered from Giambono in 1447,[29] there was no immediate move to extend the use of the unified field to altarpieces representing any subject other than the Coronation.

More important than the *Coronation* (Plate 95) for the long-term development of Venetian altarpiece design is another major work executed by Antonio and Giovanni in the mid-1440s: the *Four Fathers of the Church* triptych (Plate 96), painted in 1446 for the room in which it still hangs, then the *albergo* of the Scuola Grande della Carità, but since 1811 part of the Gallerie dell'Accademia. Although the work comprises three separate fields, the implication that the figures are contained within a unified precinct enclosed by the crenellated wall has often struck critics as remarkably innovative, especially since it precedes Mantegna's analogous solution in the San Zeno triptych (Plate 104) by more than a decade. To account for this, it has been suggested that the composition reflects the influence of Donatello's high altar for the Santo in Padua, which the painters perhaps knew while it was still in the design stage.[30] To me, however, this suggestion is unconvincing, not only because of the tightness of the chronology, but also because there is no other evidence to indicate that the painters had any interest in or understanding of Donatello. It is generally admitted, on the other hand, that Antonio was impressed by the Paduan work of Filippo Lippi; and if, as has plausibly been suggested, the triptych now divided between New York and Turin was painted for a church in Padua (Plate 97), this may be identified as a major source of inspiration for the Carità triptych (Plate 96).[31] Despite the obvious contrasts of decorative taste

[29] Now Accademia; see Moschini Marconi, *Le gallerie dell'Accademia di Venezia*, 26–7. The frame of Giambono's copy, now lost, was by the Gothic carver Francesco Moranzone. E. Merkel, 'Il *S. Crisogono* di San Trovaso, fiore tardivo di Michele Giambono', *Quaderni della Soprintendenza ai beni artistici e storici di Venezia*, 8 (1979), 38, suggests that a drawing in the British Museum may be identified as a preliminary study for this work, and that the *Annunciation* group shown in the spandrels refers to carvings on the frame. In any case, the presence of the *Annunciation* group reinforces the connection with the prototype by Guariento, where the Angel and the Virgin similarly appeared to either side of the *Coronation*.

[30] Robertson, *Giovanni Bellini*, 6. By contrast, Donatello's altarpiece clearly did constitute a major source for Mantegna's S. Zeno triptych; and the attempt by R. Lightbown, *Mantegna* (Oxford, 1986), 66, to play down this influence, and to emphasize rather the importance for Mantegna of the Vivarini *Four Fathers* triptych, is hardly convincing.

[31] For these works, see F. Zeri, *Italian Paintings: The Florentine School* (A Catalogue of the Collection of the Metropolitan Museum of Art, New York, 1971), 83–5 (accepting them as a triptych); and G. Marchini, *Filippo Lippi* (Milan, 1975), 200, No. 10, 205, No. 24 (denying any connection). E. Rowlands, 'Filippo Lippi's Stay in Padua and its Impact on His Art', Ph.D. thesis (Rutgers University, New Brunswick, NJ, 1983; published by University Microfilms International [Ann Arbor, Mich., 1984]), 38–40, accepts the connection, and suggests that they were painted for a Paduan destination in the early 1440s, after Lippi's return from Padua to Florence. He points out that the triptych is reflected in two works by artists who although quite different from each other, are known to have been in Padua in the 1440s: Giovanni

apparent in the two works, common to both are the high wall that runs across all three fields creating a three-sided enclosure, and the Virgin's niche-like throne attended by standing angels. The comparatively unusual *dramatis personae* of the two triptychs is also identical; indeed, it may have been the identical iconographical requirement that drew the painters (and/or their employers) to Lippi's work as a model. In the case of the Vivarini, the choice of saints is clearly related to the interests of the clergy in the neighbouring church of the Carità, a group of Augustinian canons of the reformed Lateran congregation. We know that the figures of *Augustine* and *Jerome* were originally placed in tabernacles at either side on the roofline of the church façade;[32] and significantly, it is these two saints who appear in the foreground of the triptych, with the other two doctors displayed rather less prominently. Since the same Lateran congregation had recently acquired the church of San Giovanni in Verdara in Padua as recently as 1436,[33] it is perhaps worth investigating whether this now deconsecrated church might not have been the original site of Lippi's triptych (in which *Augustine* and *Jerome* are again more prominent than their companions).

Whatever the precise nature of its debt to earlier Florentine altarpieces, the Vivarini triptych clearly constitutes an important precedent for spatially unified Venetian altarpieces of the 1470s such as Bartolomeo Vivarini's *pala* for San Nicola, Bari, of 1476, which similarly portrays the Virgin, Child, and saints within a walled precinct. In the present context, however, it is important to emphasize that—in contrast to common belief—the *Four Fathers of the Church* was never itself an altarpiece. Painted for the short wall of the *albergo* opposite the entrance—adjacent and at right angles to its present position—it is recorded by Ridolfi (1648) not above an altar, but above the *banca* where the governors of the confraternity sat in committee.[34] Seen in this light, the image may be compared not so much with *Sacra Conversazione* altarpieces, as with the decorations of secular council chambers, such as Simone Martini's *Maestà* in the Palazzo Pubblico in Siena. Consistent with its character as a wall-painting as opposed to an altarpiece is the fact that, unlike any other Venetian triptych or polyptych of this date, it is painted on canvas rather than panel; and

Boccati's *Madonna del Pergolato* (Perugia, Galleria Nazionale dell'Umbria); and the Vivarini *Four Fathers of the Church*. Further, the fact that Lippi's work is a triptych, unlike his Florentine altarpieces suggests a non-Florentine destination. For further comments on the probable direct relationship between Lippi's triptych and that of the Vivarini, see B. Delaney, 'Antonio Vivarini and the Florentine Tradition', *Commentari*, 29 (1978), 87–8. I am grateful to Eliot Rowlands for kindly lending me his reconstruction photograph.

[32] See G. Fogolari, 'La chiesa di S. Maria della Carità di Venezia', *Archivio Veneto tridentino*, 5–6 (1924), 71.

[33] C.-D. Fonseca, 'Frigionaia', in *Dictionnaire d'histoire et de géographie ecclésiastiques*, xix (Paris, 1981), col. 98.

[34] See C. Ridolfi, *Le maraviglie dell'arte* (1648), ed. D. von Hadeln, i (Berlin, 1914), 34: 'E opera ... nel albergo della Confraternità della Charità sopra la banca, oue siedono i Contrati: In quadro assai capace è la figura della Vergine sedente in ricca e

sontuosa sede ...' etc. For references to other early Venetian sources, none of which mention any altar, see Moschini Marconi, *Le gallerie dell'Accademia di Venezia*, 37–8. Recent writers who have assumed that the triptych originally stood above an altar have included Rosand, *Painting in Cinquecento Venice*, 90, 141; and E. Merkel and E. Martinelli, 'Catalogo delle opere', in *Le Scuole di Venezia*, ed. T. Pignatti (Milan, 1981), 34. The latter quotes a reference by Moschini Marconi, xi, to the destruction of an altar in the Scuola at the time of the conversion of the building into the Gallerie dell'Accademia in 1811; but this altar was in the adjoining Sala Capitolare, not the *albergo*. There was no absolute rule governing the existence or otherwise of an altar in the *albergo* of the meeting-houses of the Venetian Scuole Grandi: thus while the *albergo* of the Scuola di S. Giovanni Evangelista did have an altar, that of the Scuola di S. Marco did not.

of particular significance for the effect of continuous box-space is the fact that the picture field is severely rectangular rather than arched. The original frame was presumably destroyed in 1811 when the triptych was moved to its present position, and we have no record of its appearance;[35] but the fact that the work still exactly fits the space between the height of the dado and the cornice of the carved wooden ceiling indicates that the frame cannot have been of the elaborately carved type normal for Vivarini altarpieces, complete with gables and pinnacles, but must have consisted of simple gilt mouldings.

As with Jacopo Bellini's *Annunciation* (Plate 91) and the Vivarini *Coronation* (Plate 95), therefore, the special circumstances surrounding the commission of the *Four Fathers of the Church* (Plate 96) triptych meant that it had little immediate impact on local altarpiece design. The formal solution it offered was difficult to reconcile with the continuing taste for a type of altarpiece in which Gothic woodwork played a major visual role; and it was to be another fourteen years before a comparable effect of unified space was created in a Venetian altarpiece. The innovator was once again Jacopo, and once again there is evidence that external circumstances provided a powerful stimulus for his innovation. This time, however, he created the work that marks the true beginning of the Venetian Renaissance altarpiece (although not yet of the *pala*): the triptych he painted in collaboration with his two sons in 1459 (or 1460) for the Gattamelata chapel in the Santo in Padua.[36]

Until very recently, this famous work was thought lost, and nothing was known of its appearance or subject. But I am convinced by the identification of Miklós Boskovits and others of a panel in a New York private collection representing *Sts Anthony Abbot and Bernardino* as the left wing of the Gattamelata altarpiece (Plate 98).[37] There is no need to repeat the arguments in favour of the identification here, but it is perhaps worth introducing an additional one in the form of Giorgio Schiavone's now dismembered triptych for San Francesco Grande in Padua, the left wing of which seems to me closely to reflect that of Jacopo (Plate 99).[38] Boskovits also proposed that Jacopo's small panels in Ferrara (Galleria Nazionale), Venice (Museo Correr), and Padua (Museo Civico) constituted the predella of the Gattamelata altarpiece. Although one should perhaps be cautious about accepting this suggestion—Jacopo is known, after all, to have painted other altarpieces now lost, including one for the *albergo* of the Scuola di San Giovanni Evangelista in

[35] Merkel and Martinelli, 'Catalogo delle opere', assume that the lost frame was of the characteristic Vivarini type, consisting of elaborate decorative carving; but the surviving physical evidence does not bear out this assumption.

[36] V. Polidoro, *Le religiose memorie . . .* (Venice, 1590), 25ʳ, gives the date as MCCCCLIX; this has reasonably been interpreted as a misprint for either MCCCCLIX or MCCCCLX.

[37] M. Boskovits, 'Giovanni Bellini: quelques suggestions sur ses débuts', *Revue du Louvre et des musées de France*, 36 (1986), 386–93; C. Eisler, 'Saints Anthony Abbot and Bernardino of Siena designed by Jacopo and painted by

Gentile Bellini', *Arte Veneta*, 39 (1985), 32–40; Christiansen, 'Venetian Painting of the Early Quattrocento', 32–40. See also P. Humfrey, 'Jacopo Bellini: Sts. Anthony Abbot and Bernardine of Siena', in D. Garstang (ed.), *Gothic to Renaissance: European Painting 1300–1600*, exhibition catalogue, Colnaghi (London and New York, 1988), 18–26.

[38] For this work, now divided between Berlin-Dahlem (central *Virgin and Child*) and Padua (Duomo, Sagrestia dei Canonici), see most recently A. De Nicolò Salmazo, 'La pittura rinascimentale a Padova', in Zeri, *La pittura in Italia*, i, 179–80. Schiavone was in Padua between 1456 and 1460.

Venice[39]—Colin Eisler's reconstruction drawing of the Gattamelata altarpiece still gives a plausible general idea of the ensemble (Plate 102). The missing right wing clearly showed another pair of saints, one of which must have been St Francis, the co-titular with Bernardino of the Gattamelata chapel. The subject of the main central panel remains uncertain, but since the pink marble object in the lower right-hand corner of the New York panel appears to be the lid of a sarcophagus, I think the two most likely alternatives are either a Resurrection or—more probably, given the downcast mien of the saints—a Lamentation. A comparable sarcophagus lid actually appears in the *Lamentation* on fos. 52[v]–53[r] of the Louvre Book of Drawings (Plate 100). Both subjects would accord well with the funerary function of the chapel, and the placing of the altarpiece between the tombs of the celebrated *condottiere* and of his son Gian Antonio. At the same time, it may be noted that if the figures of the main panel were represented on the same scale as the flanking saints, they must have been severely restricted in number; and hence the main panel may well have shown an abbreviated version of the corresponding narrative scene, such as a *Resurrected Christ* or a *Pietà with Angels*. The latter was, in fact, the main subject of Jacopo's Scuola di San Giovanni Evangelista altarpiece; and it is interesting to note that a *Pietà with Angels* also appears at the centre of a triptych, again with saints *Francis* and *Bernardino* at the sides, carved around this time by an anonymous, but probably Paduan sculptor for the oratory of San Bernardino at San Lorenzo in Vicenza (Plate 101).[40]

All this raises a host of new questions, not the least important of which relates to Giovanni Bellini's birth-date. But I would like to concentrate here on just three main aspects of the work, of direct relevance to assessing its place in the history of the Venetian altarpiece. First, whatever the precise subject of the missing central panel, it seems clear that its narrative connotations prompted Jacopo to introduce a continuous landscape background across the three main panels. Indeed, the walled town glimpsed to the right of *St Bernardino* may represent just a small part of an urban panorama with the city of Jerusalem set against a mountainous backdrop, of a kind seen hitherto only in the informal context of the artist's Books of Drawings. Continuous landscape backgrounds had not previously appeared in north Italian triptychs, although it is significant that the idea was immediately taken up by Schiavone in his San Francesco triptych, despite the fact that his central panel showed the traditional timeless subject of the Virgin and Child enthroned. It is true that in Jacopo's residually Gothic pictorial style there remains a dichotomy between flat decoration (represented by Bernardino's monogram and the originally gold haloes) and the

[39] See P. F. Brown, *Venetian Narrative Painting in the Age of Carpaccio* (New Haven, Conn., and London, 1988), 46, 282. For reasons of internal chronology, Degenhart and Schmitt (*Corpus*, v, text, 147–57) associate Jacopo's three predella panels with this Venetian work rather than with the Gattamelata altarpiece.

[40] The triptych was moved to its present position at the centre of the Pojana altarpiece in S. Lorenzo only in 1731–2. According to A. Sartori, *La chiesa di San Lorenzo in Vicenza* (Vicenza, 1953) the work was carved for the oratory in 1456, in which case it would have pre-dated the Gattamelata altarpiece by three years. But this date seems improbably early for the sculpture, and until Sartori's archival reference can be checked, it is worth raising the possibility that this date refers to the building of the oratory rather than to the carving of the triptych. The early date is accepted by F. Barbieri, *Pittori di Vicenza 1480–1520*, 2nd edn. (Vicenza, 1982), 15.

evocation of deep space. Yet it is also true that with at least the implication of a deep and unified space, the artist has provided the essential germ for numerous subsequent Venetian open-air *Sacre Conversazioni* and narrative altarpieces.

My second point is that unlike the earlier Brescia *Annunciation* (Plate 91), the arched tops of the main panels were evidently rounded rather than pointed, and the predella panels are rectangular rather than trilobal—in other words, the Gattamelata triptych (Plate 102) was the first Venetian altarpiece to have a Renaissance-style frame. This time it is perhaps more likely that the frame was carved by a craftsman based not in Venice but locally in Padua, where under the influence of Donatello and his assistants, architectural decoration *all'antica* was becoming increasingly fashionable. My third point is closely related to the first two: as is apparent from Eisler's reconstruction, in its overall design the Gattamelata triptych followed not Venetian tradition, but the latest and most prestigious altarpieces executed in Padua, beginning with Donatello's high altar for the Santo,[41] and continuing with Pizzolo's terracotta altarpiece of 1449–53 for the Ovetari chapel (Plate 103),[42] and with Mantegna's altarpiece of 1456–9 for San Zeno in Verona (Plate 104). All three consisted of a classical order resting on a tall base and supporting a weighty entablature, so that it resembled the frontispiece of a continuous, three-dimensional space occupied by the saints. All three were also surmounted by a lunette, which in at least two cases contained a figure of God the Father; it seems reasonable to wonder whether the Gattamelata triptych, too, was completed in the same way.[43] Indeed, one might go further, and suggest that Jacopo was specifically required by the terms of his commission to adopt the same general design as these predecessors. The work was, after all, painted for a brand-new chapel in the very same church as Donatello's recently completed and overwhelmingly impressive high altarpiece.[44] Furthermore, his employer would have been none other than Gattamelata's widow, Giacoma da Leonessa, who was naturally closely associated with the commission of Donatello's great equestrian monument, and who is elsewhere recorded as a patron of Mantegna. She was a person, in other words, directly involved with the creation of some of the most advanced examples of Renaissance art in north-eastern Italy, and who is likely to have required her altarpiece to be equally up to date. It has been plausibly suggested that Mantegna was her first choice as author of

[41] The most plausible reconstruction is that by J. White, 'Donatello's High Altar in the Santo at Padua', *Art Bulletin*, 51 (1969), 1–14, 119–41, 412.

[42] See G. Mariani Canova, 'Alle origini del Rinascimento padovano: Nicolò Pizolo', in *Da Giotto a Mantegna*, exhibition catalogue, Padua, 1974, (Milan, 1974), 75–80.

[43] For Donatello's lost *God the Father*, see White, 'Donatello's High Altar'; for the possibility of a God the Father once in the lunette of Mantegna's S. Zeno triptych, see V. Herzner in review of L. Puppi: *Il Trittico di Andrea Mantegna per la Basilica di San Zeno Maggiore in Verona* (Verona, 1972), *Art Bulletin*, 56 (1974), 442. Eisler, 'Saints Anthony Abbot and Bernardino of Siena', 38, also supposes that the Gattamelata altarpiece was

capped by a lunette, but suggests that it contained a Throne of Grace rather than a simple God the Father.

[44] For an account of the construction of the Gattamelata chapel, see V. Lazzarini, 'Gli autori della cappella e dei monumenti Gattamelata al Santo', *Il Santo*, 4 (1932), 228–33; G. B. Alvarez, 'La Basilica del Santo nei restauri e ampliamenti dal Quattrocento al Tardo Barocco', in *L'edificio del Santo di Padova* (Vicenza, 1981), 108–10. In 1651 it was made into the chapel of the Sacrament, and it was physically transformed at this time, and then again in this century. See A. Sartori, 'La cappella del Sacramento al Santo decorata da Ludovico Pogliaghi', *Il Santo*, 10 (1970), 182–204.

the altarpiece, and that she was forced to turn to his father-in-law Jacopo when Mantegna forsook Padua to take up his court appointment in Mantua.[45] But it is also worth noting in this context that Giacoma must already have been well acquainted with Jacopo as a painter of altarpieces, since we know that she had particularly close associations with the church of Sant' Alessandro in Brescia, where she was to found another chapel dedicated to St Bernardino in 1460.[46]

If the innovatory format of the Gattamelata triptych may be interpreted as a direct response to its Paduan destination, Jacopo still deserves recognition as the only Venetian painter of his generation capable of realizing such an innovation. He also deserves credit for then introducing it into Venice itself. It is now increasingly accepted that it was he, rather than his son Giovanni, who had overall responsibility for the series of four triptychs (now Accademia) painted between 1460 and 1464 for the church of the Carità;[47] and it may be noted that in design these are essentially simpler versions of the Gattamelata triptych, omitting the predella but including a lunette. The *St Sebastian* triptych (Plate 105) also includes the continuous landscape across all three main panels. With the loss of the original, evidently Renaissance frames, it is impossible to speculate whether the frame-maker was a locally based craftsman. But it is worth noting that although painted for a Gothic church, the four triptychs were placed in front of a rood-screen that seems from a recorded payment to its mason to have been one of the earliest examples of Renaissance architecture in Venice.[48] In other words, the setting *all'antica* must have made Jacopo's novel altarpiece design particularly appropriate and acceptable in a cultural context where Gothic was still the norm.

The mid-1460s also saw a further development of the unified picture field of the Vivarini *Coronation* (Plate 95) in San Pantalon (and implicitly in the *Four Fathers of the Church* [Plate 96]), in what that seems at first sight to mark the arrival of the *Sacra Conversazione* in Venice. Bartlomeo Vivarini's *Virgin and Child with Saints* in Naples (Plate 106) is dated 1465—a good five years earlier than Giovanni Bellini's *St Catherine of Siena* altarpiece—and already the figures are no longer separated from one another by any subdivisions of the frame. But despite the ostentatious use of Paduan decorative trimmings, the treatment of space and of relative scale is actually more archaic than in the two works of the 1440s by Giovanni d'Alemagna and Antonio Vivarini; and the half-length saints hovering on clouds all too clearly betray their origins in the upper tier of polyptychs. And although one might be tempted to suppose that the form of the original frame, now lost, is reflected in that of the Virgin's throne-back, photographs of the panel outside its present frame show an undulating edge that implies rather a border of Gothic cusps. The little we know of the work's origin—an unnamed church in Bari[49]—is in fact consistent with the assumption that the frame was of a conservative rather than an innovatory type. Conversely, a

[45] Lightbown, *Mantegna*, 78.

[46] See Prestini, *La chiesa di Sant' Alessandro*, 97–8. Giacoma's brother, Gentile da Leonessa, was buried in the chancel of S. Alessandro after his death in battle in 1453.

[47] First suggested by Robertson, *Giovanni Bellini*, 40–2; see also Boskovits, 'Giovanni Bellini', 2.

[48] This work does not survive, but a payment of 1462 to one 'Mº iacomo da milan' refers to 'li colonelli 60 et 10 colomelli et larchitravio cum lo fuso et cornise tuto a lantiga'. See Fogolari, 'La chiesa di S. Maria della Carità', 115.

[49] See C. Aru, 'Un quadro di Bartolomeo Vivarini', *L'Arte*, 8 (1905), 205–7. The presence of two Dominican saints suggests that the church in question may have been the main Dominican church in Bari, S. Domenico.

work of 1463 by Jacopo's nephew Leonardo Bellini (Plate 107) portrays the *Enthroned Virgin and Child with Saints* (including Bernardino, who seems to derive directly from his Gattamelata counterpart [Plate 102]) in a space constructed with a quite remarkable logic and consistency, in a way that must reflect knowledge of Florentine *Sacre Conversazioni*.[50] But although this type of composition was to become popular for Venetian domestic altarpieces some forty years later, Leonardo's painting is, of course, not an altarpiece but a manuscript illumination, which could be designed without any need to take account of the stylistic habits of Venetian *intagliatori*.

Yet it was about this time, and above all as a result of the patronage of Leonardo Bellini's employer Doge Cristoforo Moro, that a gradually increasing number of carvers in wood and stone practising a Renaissance repertory of decoration took up residence in Venice; and gradually Renaissance forms replaced Gothic ones in the frames of altarpieces. This did not in itself necessarily lead directly to the creation of the unified *pala*: in Giovanni Bellini's *St Vincent Ferrer* polyptych, for example (Plate 108), probably the most advanced Venetian altarpiece of the 1460s in terms of its pictorial style, Renaissance ornament merely replaces Gothic on the frame, while the traditional separateness of the individual panels is maintained. Since Renaissance architectural forms entered Venice as a novel repertory of ornament, rather than as a revolutionary intellectual and structural system as in Florence, polyptychs and triptychs were able to survive in Venice in their new Renaissance dress well into the sixteenth century. Well-known examples include Titian's Brescia polyptych of 1522 (Plate 111) and Palma Vecchio's Santa Maria Formosa polyptych of about the same time. This is not, however, to deny any relevance for Venice of Christa Gardner's analysis of the creation of the *pala* in Florence. On the contrary, it is surely indicative of the close relationship between the new style of architecture and the unified *pala* even in Venice that the work that we have identified as the first true Venetian example—Giovanni Bellini's *St Catherine of Siena* altarpiece of *c*.1470 (Plate 84)—not only shows the saints gathered beneath a classicizing loggia (as Mantegna had already done in the San Zeno triptych), but is also enclosed in a stone frame that itself resembles a monumental archway. In other words, although no complete building in the Renaissance style had yet been constructed in the city, the frame in its scale, design, and material resembles truly structural features such as arches and portals, rather than mere furniture or architectural decoration. It is difficult to imagine, in fact, how Bellini's *pala*, which provided a standard of continuing relevance for Venetian altarpieces for the next three hundred years, could have been created without the prior presence in the city of major architect-sculptors such as Pietro Lombardo and Antonio Rizzo. Even without going into the complicated question of the respective contributions of painter and frame-maker to the design of this true *Gesamtkunstwerk*, I think it is clear that the creation of the Renaissance *pala* in Venice, as elsewhere, was not, nor could have been, the achievement of any painter independent of his colleagues and collaborators in the sister arts of architecture and sculpture.

[50] For the dating of the *Promissione dogale di Cristoforo Moro* (London, British Library, Add. MS 15816) to 1463, see L. Moretti, 'Di Leonardo Bellini, pittore e miniatore', *Paragone*, 99 (1958), 58–66.

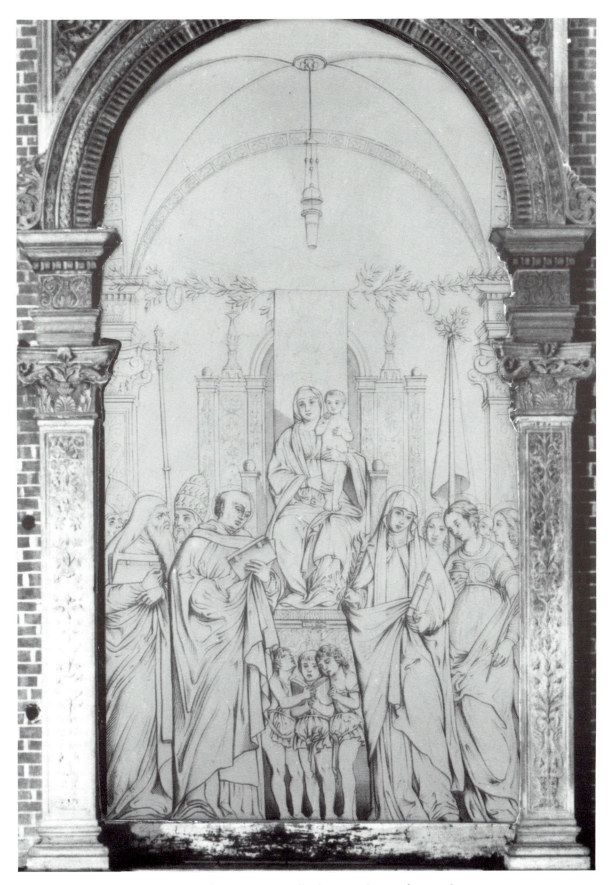

84. Engraving after Giovanni Bellini's *St Catherine of Siena* altarpiece
(destroyed 1867) in Venice, Santi Giovanni e Paolo (photomontage of
the work in its original frame).

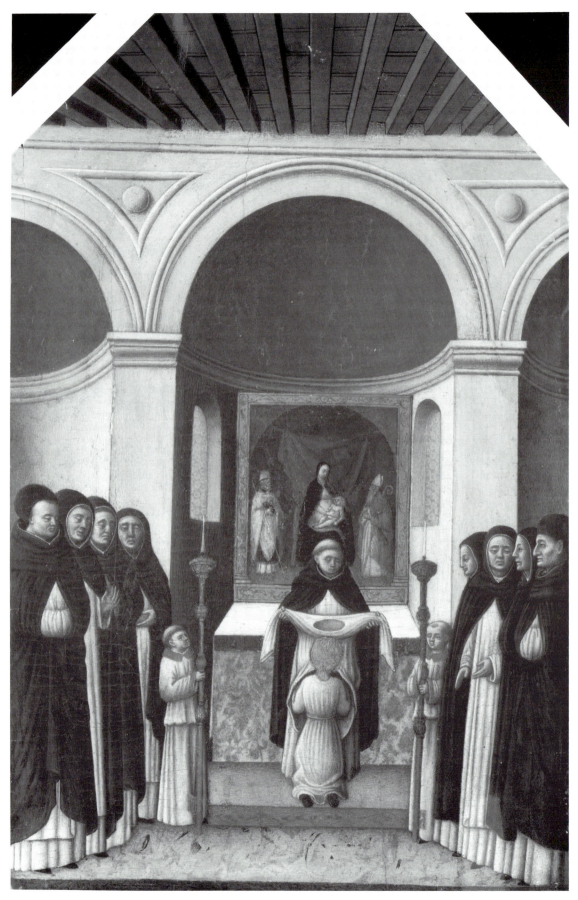

85. Antonio Vivarini, *Investiture of St Peter Martyr*, panel, 53 × 35 cm.
Berlin-Dahlem, Gemäldegalerie.

86. Anonymous North Italian (Giambono?), *St Benedict Exorcizing a Monk*, panel, 106 × 66 cm. Florence, Uffizi, No. 9403.

87. Giovanni d'Alemagna and Antonio Vivarini, *St Sabina* altarpiece, 1443, panel, 347 × 185 cm. (including frame). Venice, San Zaccaria, San Tarasio chapel.

88. Jacopo Bellini, *St John the Baptist in a Niche*. Paris, Louvre, Book of Drawings, fo. 32ʳ (after Degenhart-Schmitt).

89. Antonio Rizzo, *St James* altarpiece. Venice, San Marco.

90. Jacopo Bellini, *Lamentation*. Paris, Louvre, Book of Drawings, fo. 7ᵛ
(after Degenhart-Schmitt).

91. Jacopo Bellini, *Annunciation* altarpiece, panel. Brescia, Sant' Alessandro.

92. Drawing (1645) of entrance to chapels of the *Addolorata* (*left*) and
Annunziata (*right*) in Sant' Alessandro, Brescia. Brescia, Archivio di
Sant' Alessandro, parchment.

93. Jacopo Bellini, *Virgin Annunciate*, right wing (without frame) of
Annunciation altarpiece, panel, 219 × 98 cm. Brescia, Sant' Alessandro.

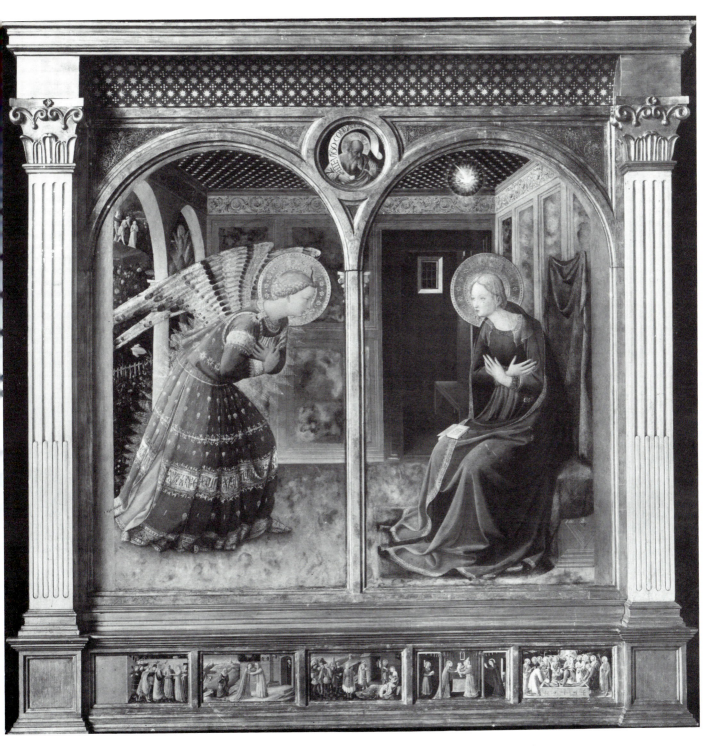

94. Fra Angelico School, *Annunciation*, panel, 195 × 158 cm. Montecarlo
(San Giovanni Valdarno, environs), San Francesco.

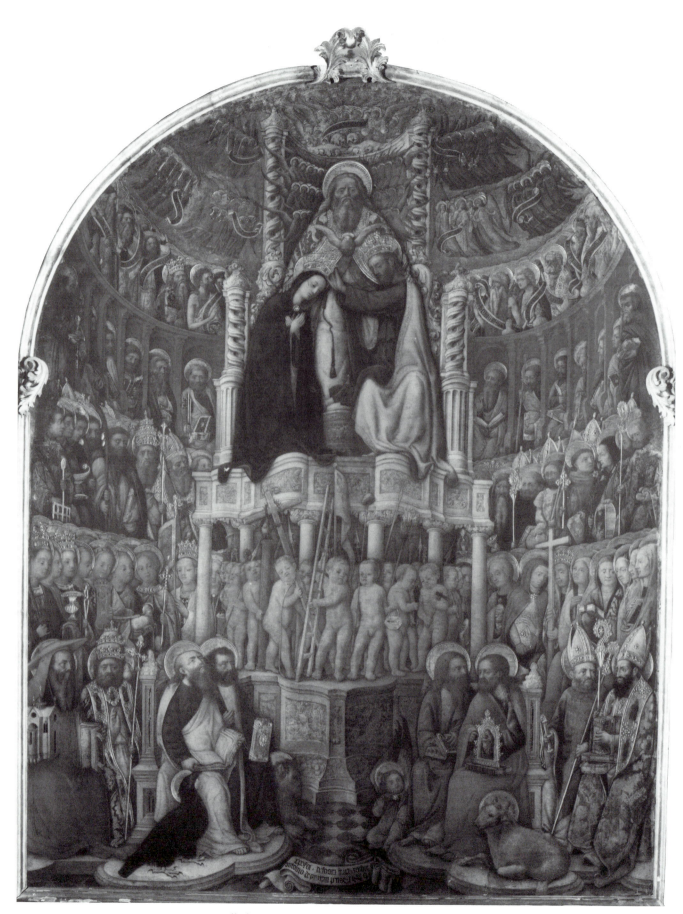

95. Giovanni d'Alemagna and Antonio Vivarini, *Coronation of the Virgin*,
1444, panel, 208 × 112 cm. Venice, San Pantalon.

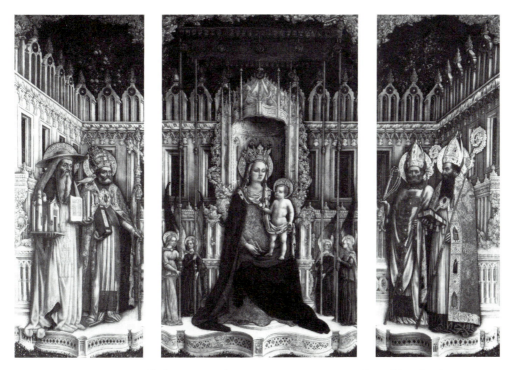

96. Giovanni d'Alemagna and Antonio Vivarini, *Four Fathers of the Church* triptych, 1446, canvas, 103·2 × 203 cm. Venice, Accademia, No. 36.

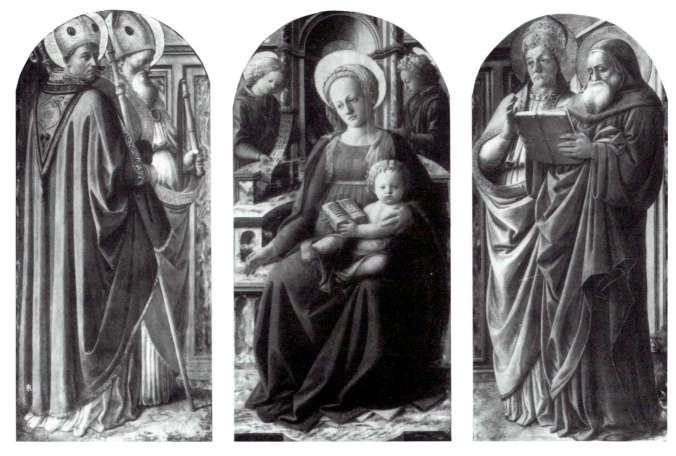

97. Fra Filippo Lippi, *Madonna and Child with Four Fathers of the Church* (reconstruction by Eliot Rowlands). New York, Metropolitan Museum of Art, and Turin, Accademia Albertina.

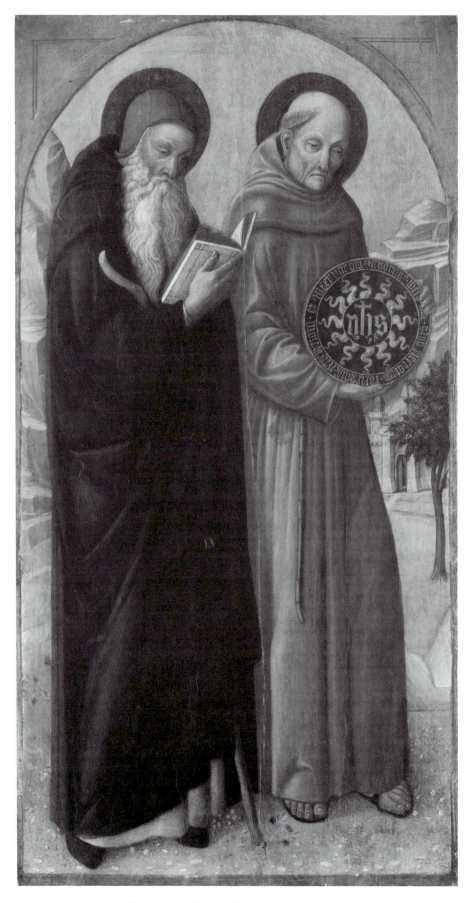

98. Jacopo Bellini, *SS Anthony Abbot and Bernardino da Siena*, panel,
110 × 57 cm. New York, private collection.

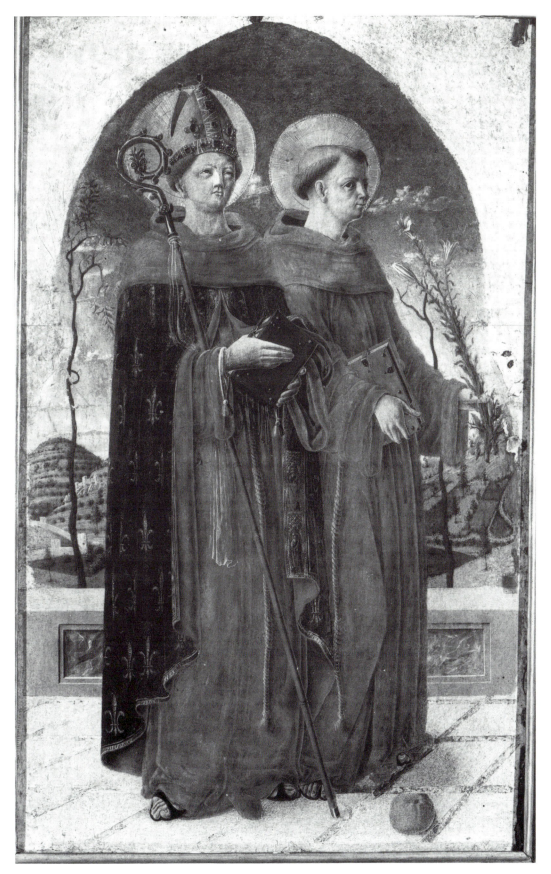

99. Giorgio Schiavone, *SS Louis of Toulouse and Anthony of Padua*. Padua Cathedral, Sagrestia dei Canonici.

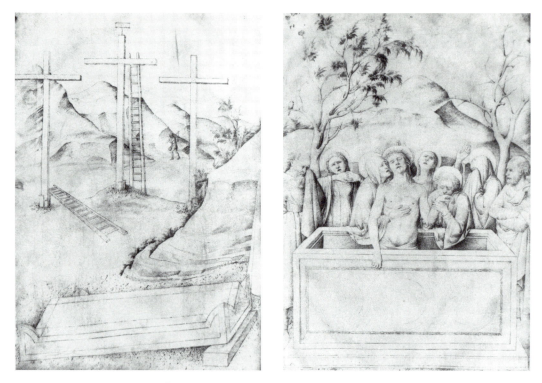

100. Jacopo Bellini, *Lamentation in a Landscape*. Paris, Louvre, Book of
Drawings, fos. 32^v–33^r (after Degenhart–Schmitt).

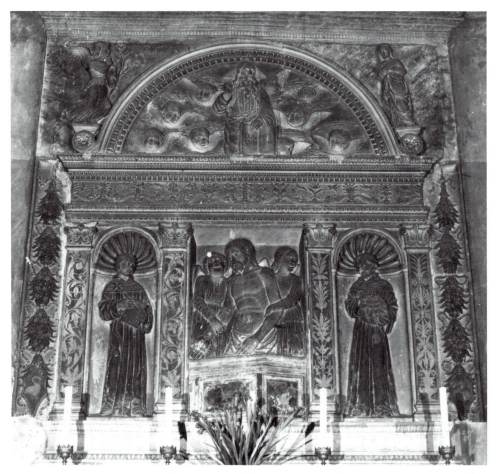

101. Anonymous Paduan sculptor, fifteenth century, altarpiece. Vicenza,
San Lorenzo.

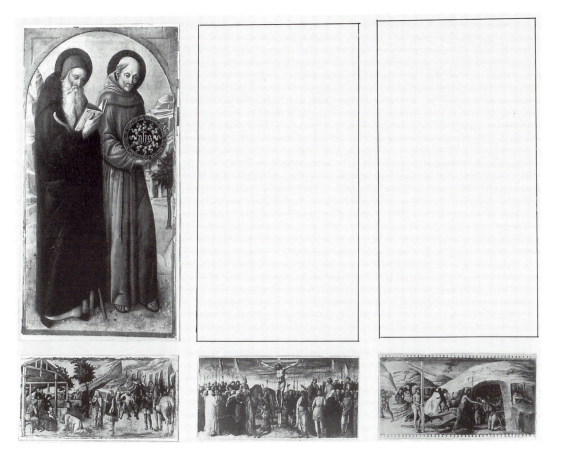

102. Jacopo Bellini, Gattamelata altarpiece (reconstruction by Colin Eisler).

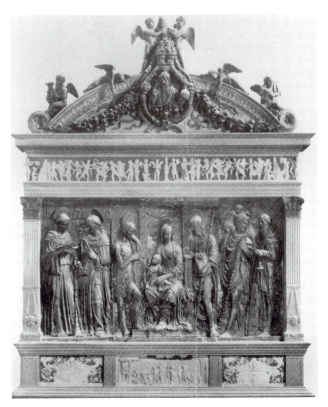

103. Niccolò Pizzolo, altarpiece, terracotta. Padua, Eremitani, Ovetari chapel (after Fiocco).

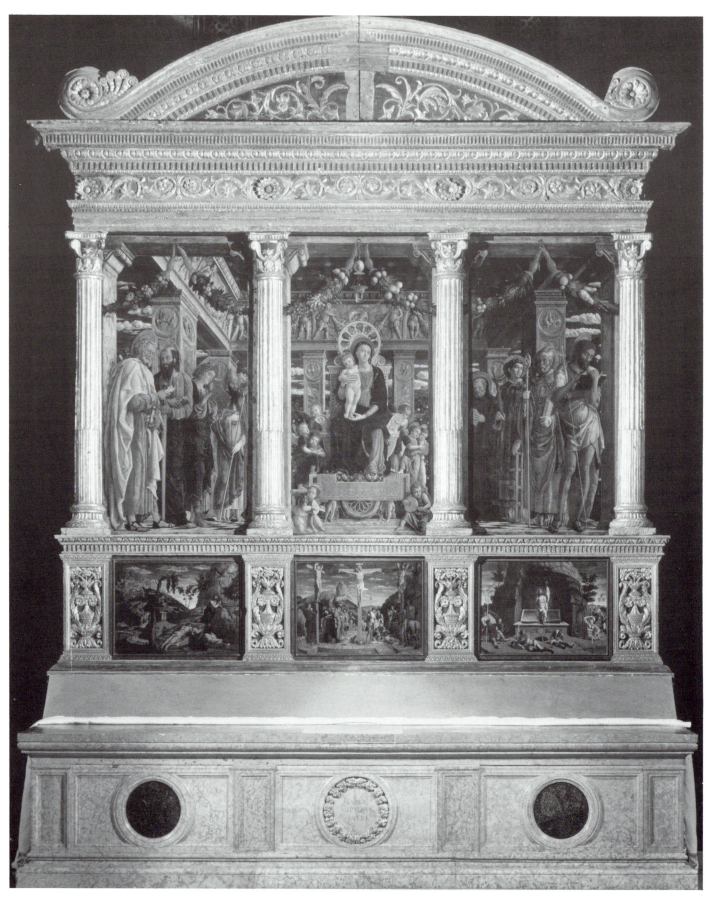

104. Andrea Mantegna, altarpiece, 1457–9, panel, 480 × 450 cm. Verona,
San Zeno.

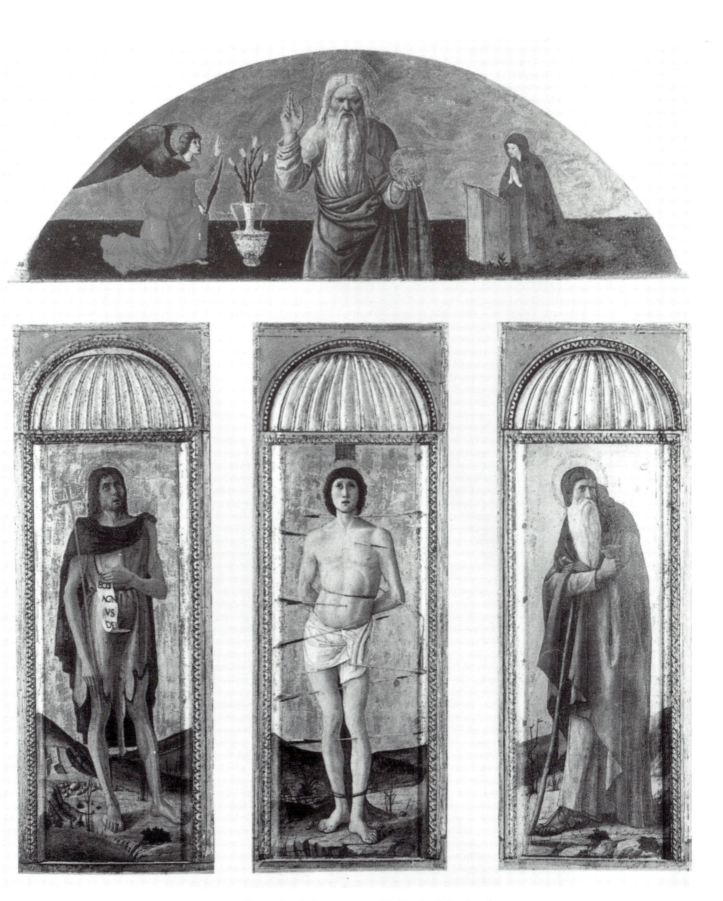

105. Jacopo Bellini School (Giovanni Bellini?), *St Sebastian* altarpiece, main panels each 127×45 cm; lunette 57×151 cm. Venice, Accademia, No. 621*a*.

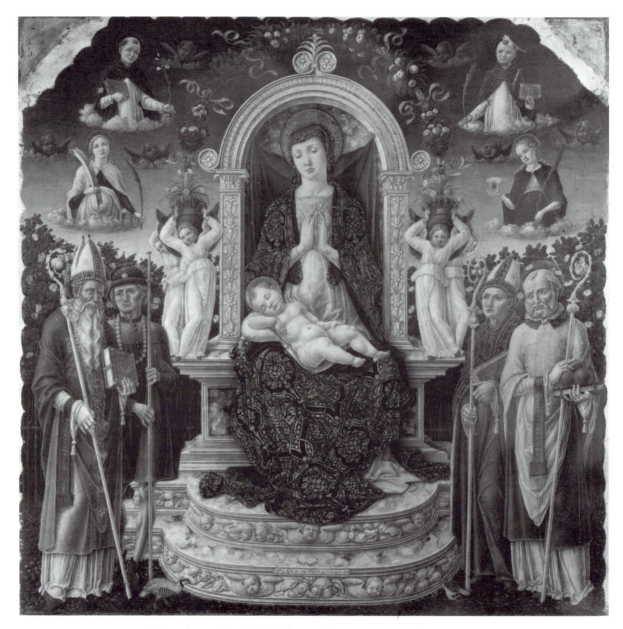

106. Bartolomeo Vivarini, *Madonna and Saints*, 1465, panel, 121 × 121 cm.
Naples, Galleria Nazionale di Capodimonte, No. 66.

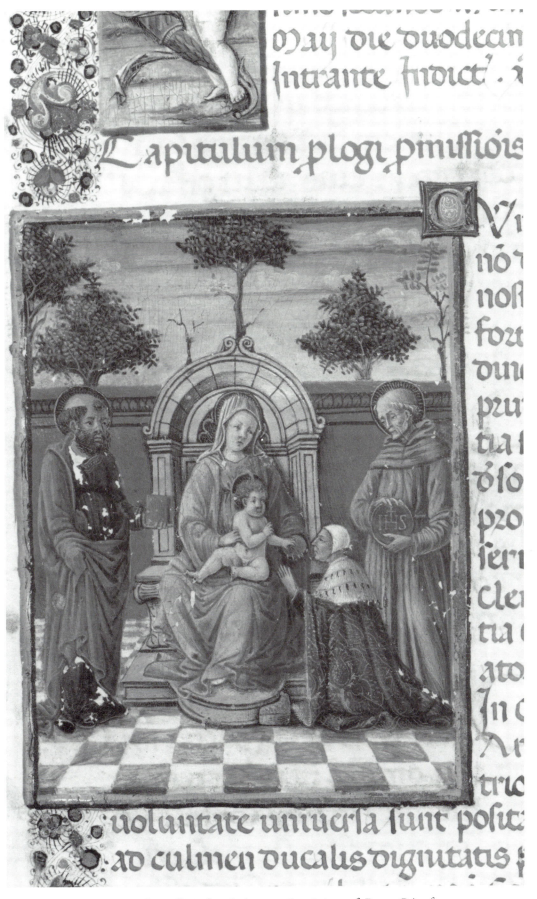

107. Leonardo Bellini, frontispiece to *Promissione* of Doge Cristoforo Moro. London, British Library, Add. MS 15816, fo. 5ʳ.

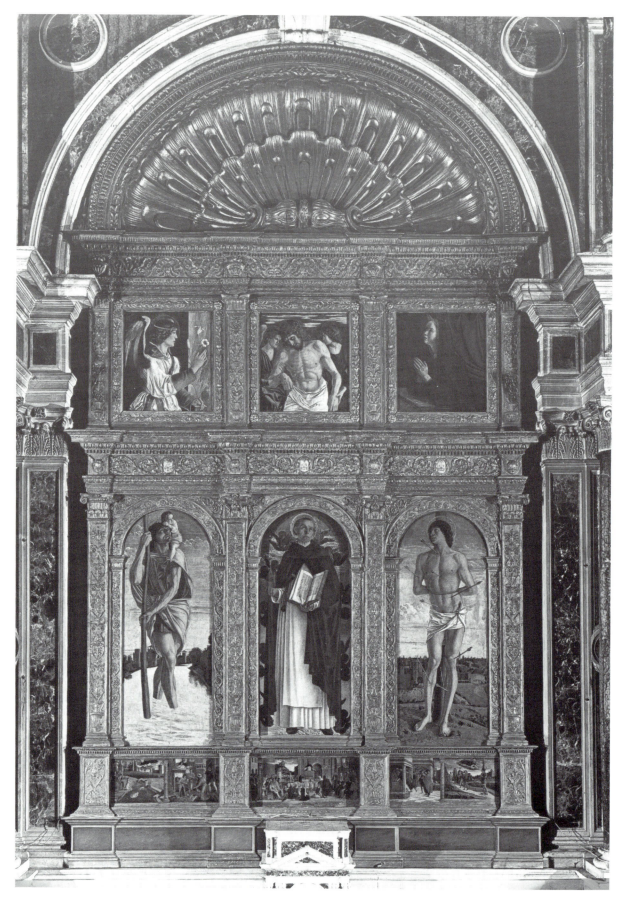

108. Giovanni Bellini, *St Vincent Ferrer* altarpiece, panel. Venice, Santi
Giovanni e Paolo.

6

HANGINGS, CURTAINS, AND SHUTTERS OF SIXTEENTH-CENTURY LOMBARD ALTARPIECES

Alessandro Nova

THE purpose of this study requires a definition of terms to be used as well as the limits of the area to be considered. Although the fact that many Renaissance altarpieces were covered with curtains, covers, and shutters is well known to art historians, this aspect still lacks a specific bibliography. During the course of my research, it immediately became clear that one must understand the various ways that were devised to cover and protect altarpieces. Take, for example, the principal type considered here: the case of shutters. These paintings were carried out on rigid supports using tempera low in fat content (known as *tempera magra* or by the older term *a guazzo*). During the Renaissance, such canvases were used to cover pictures on the high altars of several churches in the dioceses of Brescia and Cremona. In an earlier study devoted to sixteenth-century Brescian painting, I tried to clarify the origins and use of these shutters which at one time, according to the oldest guidebooks of the city, as well as Carlo Ridolfi's *Maraviglie dell'arte*, covered altarpieces painted by Titian, Romanino, and Moretto.[1] As we shall see, these shutters assumed an important role in liturgical ceremonies and at the same time protected paintings from dust, light, and moisture. However, other aspects are not so clearly understood: when they first appeared and their geographical diffusion.

In the attempt to answer these questions I turned for advice to friends and colleagues, but misunderstandings mainly of a lexicographical nature immediately arose. While I was specifically interested in shutters and the related phenomenon of covers (i.e. *cortine*) consisting of painted

I would like to thank Eve Borsook, David Ekserdjian, Suzanne Lewis, Robert Miller, Mauro Natale, John O'Malley, and John Shearman for having discussed with me various problems dealt with here.

[1] A. Nova, 'Girolamo Romanino: Introduzione a un catalogo ragionato', research doctorate in history and criticism of the *Beni artistici e ambientali*, Ph.D. thesis (University of Milan, 1986), 72–4.

cloths that were raised and lowered to protect an altarpiece, many of the people I questioned provided me instead with valuable information on the widespread custom of covering altarpieces with curtains or hangings which were drawn apart from either side. In brief, the misunderstanding derived from the term *cortina*, or curtain, and the confusion is entirely justified because in modern parlance a curtain is understood as a loosely hung cloth. In any Italian dictionary today one reads that the *cortina* was the hanging that enclosed the bed or was placed at the entrances to rooms. However, the term sometimes had a different meaning in Vasari and other Renaissance sources where it refers to a painted linen cloth, always done *a guazzo* and, most of the time, in monochrome, which was installed on the front of altarpieces for their protection. Of course, also in the sixteenth century the word *cortina* could be used to describe a loosely hung curtain. Therefore, for the term's correct interpretation the context in which it appears always has to be taken into account.

Having clarified these terms, but before examining a few documented examples of painted covers (*cortine*) and shutters that protected some Lombard altarpieces, it seems appropriate to explain what led me at this point to present the first results of a problematic study as yet not entirely resolved. The initial stimulus was to add a few marginal notes to Joseph Braun's authoritative study on altarpieces. According to this Jesuit scholar, the shuttered altar (*Flügelaltar*) was typical of Germany, Flanders, Austria, Switzerland, and Scandinavia while it had scarce reception in Spain and southern France and was totally unknown in Italy.[2] The same belief is reiterated in Michael Baxandall's important volume on German Renaissance sculptors: 'winged retables were a north European preference not found in Italy and only rarely in Spain.'[3] However, we will see that this type of altarpiece was, in fact, rather widespread in sixteenth-century Lombardy even though the wings or shutters of these structures have long since been lost, dismembered, or simply separated from their original sites.

Another stimulus for this study arose from several problems encountered in the preliminaries for a study on the function of sacred images and how they were experienced by their Lombard public during the fifteenth and sixteenth centuries. Although this type of enquiry is familiar to literary research, aside from a few exceptions, it is still relatively rare in the field of Italian Renaissance studies notwithstanding the appearance of new methodological approaches.[4] My intent is to approach the problem from four different aspects: the experience of the *Sacri Monti*, the mnemonic aspect of the great fresco cycles on the rood-screens (*pareti diaframma*) of churches

[2] J. Braun, *Der Christliche Altar in seiner geschichtlichen Entwicklung* (Munich, 1924), ii, 345, 348, 357. See also the review by H. Dannenberg, in *Repertorium für Kunstwissenschaft*, 49 (1928), 48–50.

[3] M. Baxandall, *The Limewood Sculptors of Renaissance Germany* (New Haven, Conn., and London, 1980), 66.

[4] Besides the fundamental essay by E. Castelnuovo ('Per una storia sociale dell'arte', *Paragone*, 313 [1976], 3–30); id., *Paragone*, 323 (1977), 3–34 repr. in id., *Arte, industria,*

rivoluzione: Temi di storia sociale dell'arte (Turin, 1985), 3–64, and particularly 45–50; see, among others, A. M. Mura, 'Il pubblico e la fruizione', in *Storia dell'arte italiana Einaudi*, pt. 1, vol. ii, *L'artista e il pubblico* (Turin, 1979), 265–315 esp. 287–9; H. Belting, *Das Bild und sein Publikum im Mittelalter* (Berlin, 1981); H. van Os, *Sienese Altarpieces 1215–1460: Form, Content, Function*, i (Groningen, 1984; paperback edn., Groningen, 1988).

founded by the Franciscan Observants, the chapel decorations executed for eucharistic confraternities, and, finally, the liturgical use of high altarpieces. It is the last theme upon which the present study focuses.

Before taking a closer look at some Lombard examples of shuttered altarpieces (*Flügelaltäre*) that can be at least partly reconstructed as far as their iconography is concerned, the use of hangings and curtains should be briefly considered in order to explain the liturgical function of the shutters that once covered altarpieces by Titian, Romanino, and Moretto. For altarpieces of a certain prestige, hangings were an integral part of their furnishing—and not only during the Renaissance. The bibliography on this particular aspect of the Christian altar is quite vast and has grown from the debate concerning their possible functional, symbolic, or liturgical significance. For instance, Braun believed that at least in the West hangings had above all an ornamental function, thereby helping to maintain the priest's concentration during his performance of the mass (Plate 109). Of course, Braun did not allude to the hangings that covered an altarpiece, but to the cloths hung on either side which were drawn by accolytes so as to conceal the miracle of transubstantiation: the conversion of bread and wine into the body and blood of Christ.[5] This problem is mentioned for two reasons: first of all to emphasize the necessity of distinguishing the various kinds of hangings with which an altar was furnished—and, especially, the distinction between the cloths that covered the picture and those that hung on either side; and secondly, because in several inventories of the fourteenth, fifteenth, and sixteenth centuries these lateral hangings were referred to as *Alae* or *Vleugel*, recalling shuttered altars, or *Flügelaltäre*, as well as Vasari's phrase '*tavola con le sue ale*' used in connection with a painting by the Flemish artist, Pieter Aertsen.[6]

But to return to our main subject: it is Durandus' *Rationale divinorum officiorum* that provides the symbolic liturgical meaning of the veils or hangings used to cover altarpieces during Lent. A famous passage in the text of this medieval liturgist describes the ceremony celebrating Passion Sunday when, after a reading from the Gospel of St John, the *Sancta Sanctorum* (the eucharistic tabernacle) was concealed by a hanging. This rite is described in greater detail in the ceremonial of the pontifical court:

When, at the conclusion of the Gospel reading is said: 'but, Jesus hid himself and left the temple,' the veil prepared on top of the altar table is pulled up by the clergy of the papal chapel on ropes that pass from grooves fixed on high and thereby this veil covers up all the painted images.[7]

[5] Braun, *Der Christliche Altar*, ii, 133–47, 166–71. It is not fortuitous that the paintings that illustrate these curtains hanging at either side of the altar all belong to northern Europe: see, for instance, the *Mass of St Giles* by the anonymous painter named after the picture today in the London National Gallery (Plate 109) or the *Mass of St Gregory* by Bosch painted on the outer shutters of the *Epiphany* triptych now in the Prado, Madrid.

[6] Braun, *Der Christliche Altar*, ii, 140, 142–360; Giorgio

Vasari, *Le vite de' più eccellenti pittori scultori e architettori nelle redazioni del 1550 e 1568*, ed. R. Bettarini and P. Barocchi, text vol. vi (Florence, 1987), 226.

[7] *Cerimoniale*, libro 2, ch. 35: '*Cum in fine evangelii dicitur: Jesus autem abscondit se, et exivit de templo, clerici cappellae [papae] super altare velum paratum cordulis in rotis supra in altum confixis euntibus sursum trahunt et eo imagines omnes ibidem depictae cooperiuntur*' (G. Moroni, *Dizionario di erudizione storico-ecclesiastica*, xxxiv [Venice, 1845], 15).

Obviously, the text does not refer here to the cloths hanging to the side of the altar, but rather to the veil or hanging used to cover sacred images. But it is Durandus' *Rationale* which explains the symbolic significance of the ceremony. The veil symbolized the piece of precious cloth that was hung between the columns of Solomon's temple to separate the sanctuary where the Ark of the Covenant was kept from the rest of the sacred enclosure. The veil alluded to the darkness that overshadowed the human mind before Christ's Passion; before his sacrifice, the significance of holy scripture was veiled, hidden and obscure. However, just as the veil of Jerusalem's temple was torn asunder at the moment Jesus died, so were the altar hangings lowered and reopened on Holy Saturday to manifest God's Word. When the '*Gloria in excelsis*' was intoned during the mass of Holy Saturday, the veils covering the altars were removed (a practice in use until the Second Vatican Council) and hangings moved aside so that through Christ's sacrifice the truth of the Law stood revealed to human sight.[8] This is what is so eloquently represented by Raphael in his *Sistine Madonna* where the rod for the rings used to open and close the curtains is in clear view.

As is well known, the bibliography on this single detail is almost endless: sometimes it is interpreted as a purely ornamental embellishment, as a theatrical device for bringing the supernatural vision closer to the everyday world of the faithful, or even as a *Himmelsvelum* (or celestial curtain-hanging).[9] In any case, for some time, theologians have suggested that the *Sistine Madonna*'s curtains symbolize the veil hung between the columns of Solomon's temple brought into the context of Catholic ritual. According to an allegorical interpretation offered by theologians, the tear, or opening in the temple veil, formed the basis of the complex idea of *Revelatio*. Thanks to Johann Konrad Eberlein we have a history of the motive in its many phases throughout the centuries.[10]

Briefly summarizing the results of this study, the earliest datable examples were the royal hangings of imperial images (what St Ambrose called *cortinae regiae*) reproduced in the calendar illustrations of AD 354 known to us through copies. According to Eberlein, the motive of the hanging was the formal expression of ceremonial concealment by late antique and Byzantine rulers who, imitating models going back to the great asiatic monarchs of antiquity, were hidden from the view of their subjects by veils and draperies of symbolic value. This was also its meaning when the motive of the hanging appeared in the figurative art of the West and, as frequently happens with regalia and other symbols of authority, it was soon adopted as an attribute by high-ranking officials, consuls, bishops, archbishops, and saints.[11]

In the Carolingian period the motive was used in the representation of enthroned evangelists

[8] W. Durandus, *The Symbolism of Churches and Church Ornaments*, trans. of bk. 1 of *Rationale divinorum officiorum* (Leeds, 1843), 72–5.

[9] J. K. Eberlein, 'The Curtain in Raphael's Sistine "Madonna"', *Art Bulletin*, 65 (1983), 61–6.

[10] Id., *Apparitio regis-revelatio veritatis: Studien zur Darstellung des Vorhangs in der bildenden Kunst von der spät Antike bis zum Ende des Mittelalters* (Wiesbaden, 1982).

[11] Eberlein, 'The Curtain in Raphael's Sistine "Madonna"', 66, and see also P. L. De Vecchi, 'Ritratto di una apparizione: Appunti in margine alla Madonna Sistina', in P. Ceschi-Lavagetto (ed.), *La Madonna per San Sisto di Raffaello e la cultura piacentina della prima metà del Cinquecento*, Atti del Convegno, Piacenza, 1983 (Parma, 1985), 34–42.

presented to the faithful with curtains drawn aside so that the figure could unveil and proclaim the veracity of the holy scripture. But around the eleventh century, with the intensification of the Marian cult, the hanging became the Virgin's special attribute. Indeed, the motive of the curtain on either side of the evangelists, still in use during the twelfth century, wanes with the increasing popularity of Marian iconography. At first it appears in narrative scenes of the Annunciation, Visitation, and Nativity but subsequently the motive of the hanging was also used for the isolated figure of the Virgin and Child.[12]

Eberlein's analysis concludes with the symbolic meaning of the hanging, as the veil of the *Sancta Sanctorum* from its mention in the Old Testament to its revelation of the new faith to Christians. Whoever had a certain familiarity with patristic thought would have associated the hanging, either real or painted, with the concept of *Revelatio*.[13]

There is no doubt that Raphael was thoroughly aware of the extraordinary opportunity offered by the curtain motif, but it is equally true that the *Revelatio* idea must always have been associated with all the hangings that preceded or imitated Raphael's spectacular solution.

Indeed, the custom of covering the picture on the high altar with hangings was widespread and is a familiar detail to anyone who has consulted church inventories or who looks attentively at Renaissance paintings. It is a phenomenon found throughout Italy and among painted examples it suffices to mention Fra Angelico's San Marco altarpiece (Plate 123), the Sistine Madonna originally in Piacenza, and the altarpiece by Moretto in San Giovanni Evangelista in Brescia to which we will return further on. According to Eberlein, the painted curtain is supposed to be characteristic of northern Italy and its appearance in Raphael's work is exceptional.[14] However, if the point of using royal hangings was to suggest the idea of *Revelatio*, it should also be kept in mind that the custom of covering high altars with textiles was common throughout Italy. In this regard, mention of a few examples will suffice. The fifteenth-century inventories of Siena Cathedral record that Duccio's *Maestà* was once covered with a vermillion hanging.[15] Filippino Lippi's altarpiece for the Florentine Otto di Pratica in which the enthroned Madonna appears with four saints was protected by a blue hanging that when open was held back by white and red silk bows.[16] An important fresco by Sodoma at Monteoliveto Maggiore (Plate 110) represents a church interior where a hanging gathered to the left side of the apse allows us to admire the picture on the high altar revealed to bystanders.[17] In Lombardy the painting by Civerchio, commissioned by the municipality of Crema in 1507, was covered by a coloured linen cloth '*pro conservatione*

[12] Eberlein, 'The Curtain in Raphael's Sistine "Madonna"', 66–8.

[13] Ibid. 68–75.

[14] Ibid. 75.

[15] Van Os, *Sienese Altarpieces*, i, 55.

[16] Giorgio Vasari, *Le vite de' più eccellenti pittori scultori ed architettori*, ed. G. Milanesi, iii (Florence, 1878), 474 n. 2.

[17] The inscription beneath the fresco reads: '*Come Benedetto scomunica due religiose e le assolve poi che furono morte.*' The triptych on the high altar consists of a Madonna and Child flanked by a female saint and a bishop saint; see E. Carli, *L'Abbazia di Monteoliveto* (Milan, 1961), 44–5, pls. 70–2 and id., *Le storie di San Benedetto a Monteoliveto Maggiore* (Milan, 1980), 144, pl. 33. For an interesting illuminated miniature pointed out to me by John Shearman in which two angels draw aside curtains used to protect an altarpiece, see F. Avril (ed.), *Dix siècles d'enluminure italienne (VIᵉ–XVᵉ siècles)*, exhibition catalogue, Bibliothéque Nationale, Paris (Paris, 1984), 178 n. 158 (The Book of Hours of Frederick III of Aragon).

picture'. For the latter, the civic ordinance providing for it does not omit mention of the rod and iron rings necessary for '*ipsius cortine*' to function.[18]

The Civerchio document again reopens the problem of terminology. In this case, there is no doubt that the curtain cited was a coloured hanging, yet the same word was used to describe those monochrome tempera paintings that functioned as protective covers for altarpieces. Since their function was similar to that of the hangings, the semantic confusion is revelatory.

Although Cennino Cennini's treatise discloses the secrets of painting on wool and velvet, and his chapter devoted to work 'on black or blue cloth like those used for curtains' even mentions the term, from the fifteenth century onwards the word *cortina* suggests a much more complex object than a mere hanging.[19] These covers or *cortine* are frequently mentioned in documents from at least the fifteenth century onwards and here too one is confronted with a phenomenon found throughout Italy. When Neri di Bicci records in his diary the numerous 'curtains' painted for his patrons, these are to be understood as inexpensive cloths that covered the main image.[20] In northern Italy their use was just as widespread in Liguria and Lombardy. For instance, the splendid panel by Foppa and his associates in the Castle of Pavia was protected in a similar way.[21]

Sometimes the documents record rather complicated iconographies for these 'curtains'. For example, Neri di Bicci records a Tobias with the Archangel Raphael, a Mary Magdalen, a figure of Christ and 'a large Jesus' ('*uno Giesus grande*').[22] Indeed, Bicci informs us that a *cortina* could be quite large: the cover for the *Coronation of the Virgin* belonging to the Abbey of Valdambra measured approximately 2·90 × 2·50 metres.[23] Inevitably, the question arises as to how these large cloths painted *a guazzo* were removed to expose the main image.

Actually the mechanism was quite simple and is clearly illustrated in the contract published by Robert Miller in his fundamental list of documents contained in the appendix to the exhibition catalogue devoted to the Campi and artistic culture of the Cremona region during the sixteenth century. In 1572 Bernardino Campi agreed to paint in oil a picture of the *Mourning of the Dead Christ* for the monks of the Monastery of San Bartolomeo and also to buy cloth '*di far la quartina*', a

[18] The painting, *St Mark between Justice and Temperance*, was commissioned from Civerchio on 1 Oct. 1507 but the communal *Provvisione* is dated 3 Jan. 1509: '*una tela di panno lino colorato per una cortina ponenda ante dictam picturam cum virgo et annullia fereis alisque rebus necessariis pro aptatione ipsius cortine*'; see M. Marubbi, *Vincenzo Civerchio: Contributo alla cultura figurativa cremasca nel primo Cinquecento* (Milan, 1986), 149, 166.

[19] Cennino Cennini, *Il libro dell'arte*, ed. F. Brunello with a preface by L. Magagnato (Vicenza, 1971), 170–6. Cennino, besides recording the vast market and cheap price of these curtains, offers indirect testimony for the iconographic complexity of these paintings: '*poi campeggia quanto più poi, e colorisci vestimenti, visi, montagne, casamenti, e quello che a te pare . . .*' (p. 172).

[20] Neri di Bicci, *Le Ricordanze (10 marzo 1453–24 aprile 1475)*, ed. B. Santi (Pisa, 1976), p. xix.

[21] C. J. Ffoulkes and R. Maiocchi, *Vincenzo Foppa of Brescia, Founder of the Lombard School: His Life and Work* (London, 1909), 300: '*Nel antedicta spexa non è computata la copertina che anderà a torno a dicta anchona, che coprirà le figure e le reliquie. Ma ho ordinato a dicti depinctori [Foppa, Zanetto Bugatti, Bonifacio Bembo, Jacopo Vismara, and Costantino da Vaprio] debiano vedere la spexa andarà a fare la dicta copertina senza la depinctura, et però intendano da quella quello vole se li dipinga suxo, et vedano quanto potrà montare in tutto*' (Milan, 8 June 1474). In the same year, Gottardo Scotto was paid about 50 ducats, '*più di quanto contasse un polittico di misure medie*', for a '*copertinam unam magnam*' with a Crucifixion for the high altar of Milan Cathedral (see G. Romano, in *Zenale e Leonardo* [Milan, 1982], 82).

[22] Neri di Bicci, *Le Ricordanze*, 68 n. 134, 119 n. 231, 382–3 n. 717, 398 n. 745.

[23] Ibid. 371 n. 696, 399 n. 747.

lapsus or spurious rendering of the word for curtain (*cortina*). On this covering, Campi painted a crucified Christ with Mary, St John, the Magdalen, and a kneeling monk—all done 'in light and dark with a punched border around the edges and he also promises to have the beam and iron that goes at the bottom of the cloth made as well as the cord and strings to raise and lower said covering' ('*di chiaro et scuro con il suo friso stampato a torno el ornamento e più promette di far far il subio et il ferro che va a basso alla tela et corde et cidrella da levar et bassar detta coperta. . .*').[24]

The beam (*subio*) is a wooden cylinder around which the cloth was wrapped; clearly this painted linen cover was raised up and down via the roller, which was set into action by the strings connected to it; while the iron bar held the cloth straight as the curtain was lowered to cover the altarpiece. In short, this was a system not unlike modern 'roller-blinds'.

As far as I know, it is impossible to illustrate this mechanism with Renaissance examples; however there exists a comparable arrangement used to raise and lower the *Transfiguration* by Titian and his workshop, covering the fourteenth-century silver altarpiece in the church of San Salvatore in Venice. In this case, the canvas is not wrapped around the roller but is raised and lowered vertically by a system of counter weights.[25] Although the mechanism differs from that described in the Cremonese document of 1572, its importance for revealing sacred imagery has not been lost.

At this point we can finally consider some Lombard examples of *Flügelaltäre* taking as a point of departure Titian's Averoldi polyptych (Plate 111). Although rarely mentioned in Titian studies, old guide-books of Brescia relate that the work was covered by two *ante dipinte* upon which appeared the titular saints of the church: Nazarus and Celsus. The sources assigned these painted shutters to Moretto, an attribution partly accepted by modern scholars, although they are almost certainly works by Paolo da Caylina the younger.[26]

For specialists of Venetian art I would like to point out that the oldest Brescian guide, the manuscript by Bernardino Faino entitled *Catalogo delle Chiese di Brescia* states that Titian's *Resurrection* was arched in shape. This means that when the neo-classic architect Antonio Vigliani designed the new marble frame for the Averoldi polyptych, the *Resurrection* was probably cut down at the top and that the two painted shutters (*le ante*) were separated from Titian's original arrangement.[27]

[24] R. Miller 'Regesto dei documenti', in *I Campi e la cultura artistica cremonese del Cinquecento*, exhibition catalogue (Milan, 1985), 468 n. 217 (9 Oct. 1572).

[25] R. Pallucchini, *Tiziano* (Florence, 1969), i, 310.

[26] L. Anelli, *La chiesa dei santi Nazaro e Celso in Brescia* (Brescia, 1977), 19. The two covers were rightly rejected from the general catalogue of Moretto's works (P. V. Begni Redona, *Alessandro Bonvicino: Il Moretto da Brescia* [Brescia, 1988], 528–9) published after the I Tatti symposium.

[27] B. Faino, *Catalogo delle chiese di Brescia*, (Manoscritti Queriniani E. VII. 6. and E.I.10), ed. C. Boselli (Brescia, 1961), 24: '*laltar maggiore è in isola et apeso al muro nel mezo ui è la pala grande Con adornamento di legno adorato nel quali ui è nel*

mezo un quadro grande in archiuolto Con quatro altri quadri, di mano di Titian.' That the expression '*in archiuolto*' means curved is confirmed by the S. Carlo altarpiece by Francesco Giugno still *in situ* in the chapel of the same name in the church of S. Lorenzo at Brescia described by Faino as '*in archiuolto*' (ibid., 28) and which is, in fact, curved (*centinata*). According to recent technical analyses, the central panel of the Averoldi polyptych was not reduced in size at a later date: it seems that an examination of the pigments found on the top of the panel confirms that its original shape was rectangular (see E. Lucchesi Ragni, 'La vicenda del polittico' in B. Passamani (ed.), *Il polittico Averoldi di Tiziano restaurato* [Brescia, 1991], 93).

Therefore Romanino's Sant' Alessandro polyptych (Plate 113), painted three years later, faithfully records the original shape of the Averoldi altarpiece. Also the Sant' Alessandro polyptych was once a *Flügelaltar* with an Annunciation on its exterior and an Adoration of the Magi visible when the shutters were open.[28] Although this Annunciation is lost, the two temperas attributed by Cavalcaselle to Callisto Piazza and today in the Brescian church of San Clemente (Plate 112) testify to the popularity of this subject on the outer faces of altar shutters. These paintings (each measuring 197×90 cm.) would have been too small to function as organ shutters.[29]

Regarding the shutters of the altarpiece formerly in Sant' Alessandro, it is interesting to point out the so-called typological rapport between the iconography of the external paintings and the subject of the main panel within. The painting of the Annunciation on the outside with either the Nativity or the Adoration of the Magi within was very widespread in northern European painting. Among the typical examples are Lochner's altarpiece in Cologne Cathedral, Roger van der Weyden's Bladelin altarpiece in Berlin, and Hugo van der Goes' Portinari triptych in the Uffizi.

In Brescia shutters were used to cover not only polyptychs but also large altarpieces consisting of a single unit. According to Ridolfi, Romanino's San Francesco altarpiece (Plate 114) painted between 1516 and 1517 was covered by two movable tempera paintings:

ne' due portelli, che la ricoprono appare il Serafico Santo, che si sposa alla povertà, e sotto il Vescovo d'Assisi, che predica al popolo l'indulgenza della Madonna degli Angeli, & il Pontefice dormiente à cui il Santo stilla dal costato il sangue in un calice, & in altra parte discaccia dalla Città d'Arezzo molti Demoni sotto mostruose forme, significando le discordie, che vertivano in que' tempi trà la fattione Guelfa e Gibellina . . .[30]

[on the two shutters that cover it appear the seraphic saint marrying Poverty and, beneath, the bishop of Assisi preaching to the people imploring indulgence of the Madonna of the Angels, and the dreaming pope holding a vial into which the saint drops blood from his rib, and on the other side the expulsion of monstrous demons from Arezzo signifying the discord of those times between the Guelph and Ghibelline factions . . .]

In this case, the two lost shutters represented the titular of the church instead of an Annunciation.

The final Brescian example (Plate 115), the painting for the high altar of San Giovanni Evangelista by Moretto, again uses the motive of the painted curtains used in Raphael's *Sistine Madonna*. But here I am more interested in pointing out how difficult it is to attempt a reconstruction of these dismembered ensembles.

One reads in two eighteenth-century Brescian guidebooks that this altarpiece was originally

[28] F. Maccarinelli, *Le glorie di Brescia, 1747–1751*, ed. C. Boselli (Brescia, 1959), 154.

[29] G. Panazza in collaboration with A. Damiani and B. Passamani, *Mostra di Girolamo Romanino* (Brescia, 1965), 204.

[30] C. Ridolfi, *Le maraviglie dell'arte ovvero le vite degli illustri pittori veneti e dello stato*, ed. D. von Hadeln, i (Berlin, 1914), 268.

covered by two tempera paintings (Plate 116) representing the two Sts John that still hang on the walls of the presbytery of this church.[31] However, modern scholars have preferred to identify these with the external coverings of the organ that was originally adorned by two enormous tempera paintings by Moretto illustrating episodes from the life of the Baptist and that today also are kept in the presbytery of the same church.[32] However, it has not been noticed before that these outer shutters representing the two Sts John are distinctly smaller in size than that of the organ shutters: each shutter of the two saints is 43 cm. shorter and 71 cm. narrower than the organ cover of San Giovanni Evangelista. In short, this pair of paintings comprise an all-over width of 1·42 m. less than the organ and therefore they originally may very well have constituted the shutters for the altarpiece just as the eighteenth-century guidebooks claim. In any case, it is not my intention to strain the meaning of the evidence: in fact, the two shutters consisting of the two saints are notably larger in size than the San Giovanni altarpiece and could therefore have been intended for a different destination than that proposed here.[33] It is, however, important to draw attention to two problems. First of all, the need to establish credible measurements because a difference of 10 or 15 cm. more or less could either invalidate or confirm any proposed reconstruction of such ensembles.[34] Secondly, the possibility must be considered either of a switch

[31] Maccarinelli, *Le glorie di Brescia*, 116, and F. Paglia, *Il giardino della pittura*, ed. C. Boselli, i (Brescia, 1967), 250.

[32] Begni Redona, *Alessandro Bonvicino*, 300–3, catalogue No. 61.

[33] The S. Giovanni Evangelista altarpiece measures 308 × 205 cm., while the two covers with the Baptist and John the Evangelist each measure 400 × 160 cm.; G. Gombosi, *Moretto da Brescia* (Basle, 1943), 95. Clearly, the two covers are much larger than the altarpiece, however it cannot be ruled out that they were also supposed to cover part of the magnificent frame. According to Faino (*Catalogo delle chiese di Brescia*, fo. 158ᵛ) the organ of S. Giovanni was protected by covers painted by Bonvicino: 'Cose stupende, di dentro vi è dipinto in una Sto Giovanni Evangelista sedendo che scrive, nelaltra S. Gio Batta pur sedendo con un libro. Al di fuori da una parte è sto Giov. Battista nel deserto con gli farisei, nelaltra quanto il detto sto di età di sette anni prese la benedizione dal padre.' This explains how the two pairs of covers were associated with the organ of S. Giovanni. However, Faino's account is confused since the covers he described as being on the inside should be on the outside and vice versa. Furthermore, as indicated by the text, the dimensions do not correspond because the two inside covers (the *Baptist Taking Leave of his Parents* and the *Saint Preaching on the Banks of the River Jordan*) measure 443 × 231 cm. each (Begni Redona, *Alessandro Bonvicino*, 113). My doubts concerning the original function of the two Sts John is based on the measurements given in Gombosi's monograph cited above: according to the new monograph by Begni Redona (*Alessandro Bonvicino*, 300) published after my lecture at I Tatti, the dimensions would really be 432 × 203 cm. each.

In this case, the difference in size between these covers and the organ shutters would come to only 11 cm. in height and 28 cm. in width for each cover. But this only confirms what I have said in the text and in n. 34 below, i.e. the need for absolutely reliable measurements.

[34] In this regard, it is worth pointing out the two shutters by Moretto now in the Escorial representing the *Eritrean Sibyl* and the *Prophet Isaiah*. According to V. Guazzoni (*Moretto: Il tema sacro*, [Brescia, 1981], 34 n. 11) originally the two shutters could have flanked the *Massacre of the Innocents* painted by the same artist for one of the side altars of S. Giovanni Evangelista in Brescia because the inscriptions on the tablets shown by the Sibyl ('Morte proprio mortuos suscitabit') and by the prophet ('Livore eius sanati sumus') would be well suited to the theme of the picture in which the *Massacre* is dominated by the Christ Child holding the Cross. It seems that this scholar conceived of a sort of triptych 'a Serliana' since the height of these panels corresponds to that of the *Massacre* excluding the curved top. Actually, besides the different supports (the *Massacre* is a panel transferred to canvas, while both Escorial shutters were painted directly on to canvas), it seems to me that the two inscriptions, and especially that of the prophet with its allusion to the bruises on Christ's body, are more suitable to a *Lamentation* such as that in Washington (see also the doubts expressed by Begni Redona, *Alessandro Bonvicino*, 259). The difference in height between the Escorial shutters (163 cm.) and the Washington picture (175·8 cm.) is only 13 cm. Also in this case, however, I do not want to force the evidence available: because the measurements given by the catalogues for the Escorial shutters renders it impossible that they ever

or of a confusion between organ and altar shutters. The two categories are very alike: one is dealing with very large canvases carried out *a guazzo*, painted with the same subjects because usually organ shutters were also decorated either with the church's titular saints or with the Annunciation.

However, when confronted with shutters smaller in size, such as those with the beautiful saints in monochrome by Civerchio now in the Museo Civico of Crema (Plate 117), there can be no doubt of how these were originally used.[35] Therefore, it seems clear that the subjects used on outer faces of some Lombard altar shutters must have been consistent and repetitious: sometimes there was a preference for the Annunciation and sometimes for one or more saints to whom the church was dedicated. If we keep in mind that such paintings could also have been monochrome or coloured with a pale range of tones, one is forcibly reminded of the liturgical significance of the great Flemish prototypes.

In Baldinucci's *Vocabolario toscano dell'arte del disegno* one reads:

Diconsi quasi sportelli, propriamente tra' Pittori, gli sportelli delle tavole e quadri, fatti per coprire esse tavole e quadri, ad effetto di difender le pitture dalla polvere, e tanto più dall'arie umide: che però furono sempre usati assai ne' Paesi bassi; ornandogli con belle pitture, non solo di figure appartenenti alle storie dipinte ne' quadri o tavole; ma ancora d'armi, d'imprese, e simili. Il Vasari nella edizione seconda, P. 3. a carta 859, gli chiama anche alie, & ale.[36]

[Among painters, these shutters for panels and pictures are almost always called shutters made to cover these panels and pictures so as to protect the paintings from dust and, even more, from moist air: these, however, were always much used in the Netherlands [and] were adorned with beautiful paintings not only of figures belonging to scenes on pictures or panels, but also with coat of arms, devices, and the like. Vasari in the second edition calls them shutters or wings.]

Of course these shutters were supposed to protect the painting from dust, light, and moisture, but their choice of subject-matter also reveals their liturgical use. As in the transalpine lands, in Lombardy the organs and altarpieces furnished with shutters were closed during the week or in periods of penance; the images were revealed to the congregation only on feast-days and special celebrations. The choice of the Annunciation does not need elaborate justification since its day always occurs during Lent and is the only feast celebrated during this period of penance. Also figures of saints were appropriate subjects as demonstrated not only by the Flemish examples but also by Moretto's two covers (see above; Plate 116) whether they were shutters for an organ or for an altarpiece. The mystic lamb stresses a penitential message and function: as an attribute of the evangelist it assumes an apocalyptic guise as a symbol of redemption; while in hands of the Baptist, it alludes to Christ's sacrifice. However, during the solemnities of Holy Saturday the

belonged to the same complex as the Washington *Lamentation*. Here again, one needs to be able to rely on a rigorous and consistent system of measurement. Unfortunately, it is well known that such systems vary according to institution.

[35] *SS Pantaleon and Roch*, Crema, Museo Civico, inv. 212–

13, tempera on canvas, 192 × 100 cm.; Marubbi, *Vincenzo Civerchio*, 104–5.

[36] F. Baldinucci, *Vocabolario toscano dell'arte del disegno* (Florence, 1681), anastatic reprint, ed. S. Parodi (Florence, 1976), 127.

shutters revealed either the *Virgin in Majesty*, also painted by Moretto, or the organ pipes at the moment when the congregation sang out the '*Gloria in excelsis Deo*'.

Once the existence of shuttered altarpieces in Lombardy has been demonstrated, many problems still remain to be solved. Above all, the possible prototypes need identification. Granted that the portable triptych was quite diffused and belonged to a different category, the shuttered altarpiece was not unknown in Italy: it suffices to consult Garrison's catalogue of Romanesque painting or to mention Margaritone's panel at Santa Maria delle Vertighe at Monte San Savino, or even the later archaistic revival of an Antonio da Viterbo or Fra Angelico's tabernacle for the linen drapers.[37] Yet one cannot help seeing the greater affinity to transalpine models which is partly due to the rather imposing size of the Lombard examples that often exceeded 3 m. in height and 4 m. in width. Perhaps it is not fortuitous that the period of its greatest diffusion in Lombard territory coincides or, better, follows in the wake of the great season enjoyed by the folding altar (*Wandelaltar*) in Germanic lands: from Pacher at Sankt Wolfgang to the elder Holbein at Augsburg, from Baldung Grien at Freiburg and to Grünewald at Colmar.

Another open question concerns the exact time and place of the phenomenon's origin, as well as its diffusion in the region. The answer to this must without doubt be sought in the synodal decrees of the single dioceses starting with Brescia, where the phenomenon is most visible. However, this is an area of research not without pitfalls because, as is well known, there existed then considerable liberty in liturgical usage. Local traditions were defended, as in the case of the small city of Monza. Although only 15 km. from Milan, this town tenaciously refused to adopt the Ambrosian rite, preferring their own based on that of the patriarchate of Aquileia. Even such a determined man as St Carlo Borromeo had to give up here as far as his proposed reforms were concerned.[38] As if this was not enough, certain religious orders and even some monasteries enjoyed specific privileges and exemptions in the liturgical field.[39]

Another line of enquiry consists of identifying the few surviving shutters and the more numerous examples cited in the sources. However, it is not easy to decide, for example, if Correggio's shutters in Naples were the covers for a tabernacle or for a small altarpiece.[40] On the

[37] E. B. Garrison, *Italian Romanesque Panel Painting* (Florence, 1949), 96, 109, 132 n. 348. For Margaritone, see H. Hager, *Die Anfänge des italienischen Altarbildes* (Munich, 1962), 103–8. For Antonio da Viterbo and other Viterbo painters, see I. Faldi, *Pittori viterbesi di cinque secoli* (Rome, 1970), ill. 40–4, 142–3.

[38] A. A. King, *Liturgies of the Primatial Sees* (London, New York, Toronto, 1957), 309.

[39] Ibid. 325, 340.

[40] On Correggio's shutters, see F. Bologna, 'Ritrovamenti di due tele del Correggio', *Paragone*, 91 (1957), 9–25; and C. Gould, *The Paintings of Correggio* (London, 1976), 231–2. Altarpiece shutters are also documented in Friuli and the Veneto. At Venzone, Pordenone painted the now lost shutters for a wooden altar in the church of S. Maria dell'Ospedale

commissioned in 1527 and finished in 1534; C. Furlan, *Il Pordenone* (Milan, 1988), 330. In addition, there is the following passage from the Bassano text, kindly transcribed for me by Professor Michelangelo Muraro from the manuscript in his collection (34ʳ):

Adì 7 otobrio 1546
Recevé mio fradel Zuanbatista da sier Jacopo di Andriati da Paderno lire quindese et soldi sei in oro, cioè un fiorin et un ongaro, per conto et parte de il depenzer le portelle che sara la sua palla che li ò fatto, ditto oro val L. 15 s.6

Adì ultimo marzo 1547
Recevì io Jacomo da sier Ieronimo Vesentin lire tredese et soldi dui conto de ditte portelle, videlicet L. 13 s.2

basis of written sources and misled by Tommaseo's dictionary, for a time I toyed with the idea
that the lost *Annunciation* and *Lamentation* by Franciabigio and Andrea del Sarto were painted to
protect altarpieces in the Santissima Annunziata in Florence and that they might have been
shutters resembling those used in Lombardy because according to Vasari:

Avendo essi addunque tolta una stanza alla piazza del Grano, condussero molte opere di compagnia, una
delle quali furono le cortine che cuoprono le tavole dell'altar maggiore de' Servi . . . nella quali tele
dipinsero, in quella che è volta verso il coro una Nostra Donna annunziata, e nell'altra che è dinanzi, un
Cristo diposto di croce, simile a quello che è nella tavola che quivi era di mano di Filippo e di Pietro
Perugino.[41]

[having then taken a room on the piazza del Grano, they collaborated in numerous works, among which
were the curtains that covered the panels on the high altar of the Servites . . . on these canvases they painted
an Our Lady on the one facing the choir, and on the other one, opposite, a Christ deposed from the Cross,
similar to that on the panel painted here by the hand of Filippo [Filippino Lippi] and of Pietro Perugino.]

According to Tommaseo and Bellini, curtain (*cortina*) meant not merely the hanging of veils set in
front of temple sanctuaries, but also those objects: 'that cover the panels of the high altar, or
shutters'.[42] The source cited by the dictionary is Vasari, and the words literally derive from the
passage concerning the curtains of the Santissima Annunziata. In other words, for Tommaseo and
Bellini, the *Annunciation* and *Lamentation* painted by Sarto and Franciabigio were shutters; an
interpretation also rendered feasible by Baldinucci's *Vocabolario Toscano* where *cortina* is cross-
referenced with *Alia* and from the latter to *Portelli*.[43] None the less, Vasari's phrase can probably
be interpreted in a different way and the payments published by Shearman in his monograph on
Andrea del Sarto speak, with a significant lexicographical distinction, of 'veils and curtains' ('*vele e
cortine*').[44] The amount disbursed for a work of this kind was really quite considerable: 17 *fiorini
d'oro larghi* equal to 119 *lire* and the payments confirm that both panels were protected by
hangings (the *vele* of the document) as well as covers (*cortine*) possibly painted in monochrome
that were lowered and raised to protect and reveal the altarpiece by Filippino and Perugino. This
is an interpretation confirmed by the *Vocabolario della Crusca* which does not commit Tommaseo's
error.

 The phenomenon of shutters painted in *tempera magra* used for the protection of altarpieces
seems to have been limited, or at least was more widespread, within the area of northern Italy.
However, it remains to be seen why this kind of picture was eventually abandoned. Also here we

Adì primo setembre 1547
Recevì io Jacomo da reverendo missier pre' Francesco
capellan in Paderno lire tredese per conto di ditte portelle,
quali mi mandò sier Jacomo de Canil, videlicet L. 13 s.0

Adì 26 zenaro 1548
Recevì io Jacomo dal Ponte adì ditto lire tredese et soldi otto
per conto de ditte portelle da sier Liberal Moresin, quando
le fu a tor L. 13 s.8

For above, see now: M. Muraro, *Il Libro Secondo di Francesco e
Jacopo dal Ponte* (Bassano, 1992), 111.
[41] Vasari, *Le vite*, text vol. iv (Florence, 1976), 344–5.
[42] N. Tommaseo and B. Bellini, *Nuovo dizionario della
lingua italiana*, i, pt. 2 (Turin, 1865), 1770.
[43] Baldinucci, *Vocabolario toscano*, 41, 7, 127.
[44] J. Shearman, *Andrea del Sarto*, ii (Oxford, 1965), 316, 388.

remain in the field of hypotheses. However, the solution probably rests with diocesan statutes of a Giberti in Verona, whose example was followed by St Carlo Borromeo in his celebrated *Instructiones*. According to these dispositions, the tabernacle housing the Holy Sacrament must always be located on the high altar according to Roman custom ('*more romano*'). Apparently before the Council of Trent, it was possible to reserve the eucharist on the side of the Gospel ('*in pariete more germanico*'), but once it was moved to the high altar, the increasing richness and complexity of the tabernacle would probably have impeded the opening of large shutters.[45]

Preserved in those churches protected by liturgical privileges such as San Francesco in Brescia was, shutters finally disappeared with the Napoleonic suppression and once their ritual function had ceased the restoration did not make the effort of seeing to their return. Probably most of these canvases, considered of little value, were left to rot away in attics. Yet with their disappearance we have lost an important element of the original altarpieces as well as an aspect of religious experience familiar to Renaissance public life.

[45] Braun, *Der Christliche Altar*, 590–1, 639.

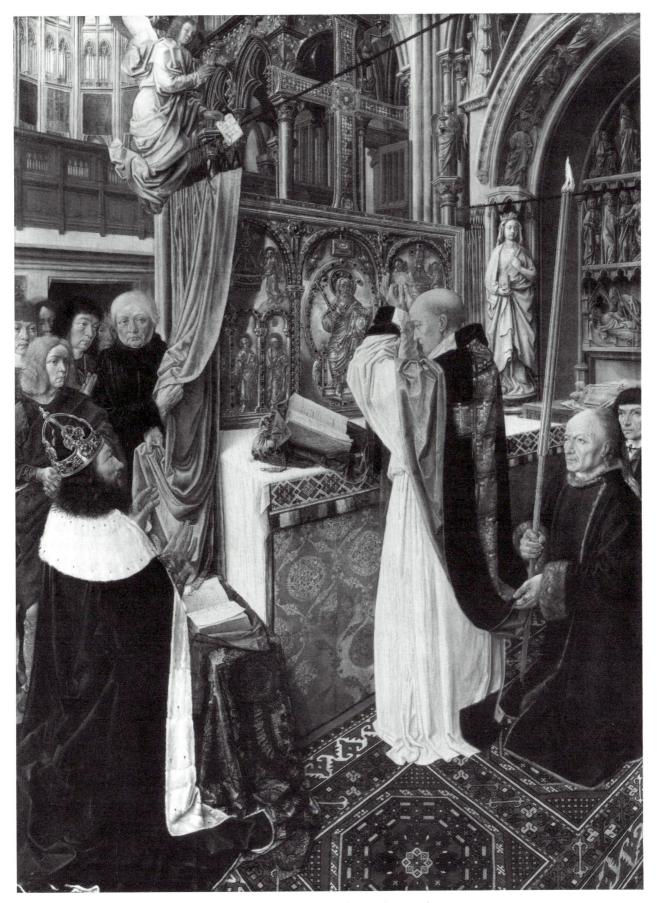

109. Master of St Giles, *The Mass of St Giles*, panel, 61·6 × 45·7 cm.
London, National Gallery, No. 4681.

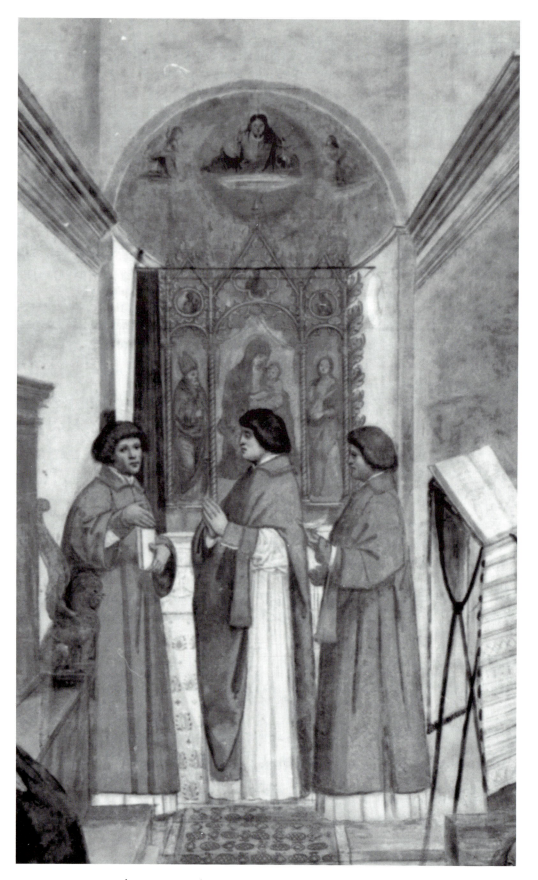

110. Sodoma, *St Benedict Excommunicates Two Monks and Posthumously Absolves Them* (detail), 1505–8, fresco. Monteoliveto Maggiore, Chiostro Grande.

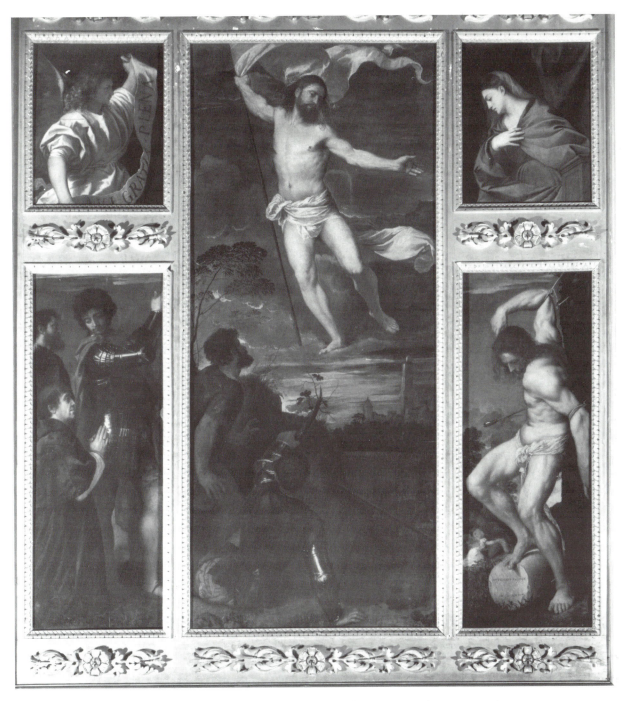

111. Titian, Averoldi altarpiece, 1522, panel, *Resurrection* (278 × 122 cm.)
upper side panels (79 × 65 cm. each), lower side panels (170 × 65 cm.
each). Brescia, Santi Nazaro e Celso.

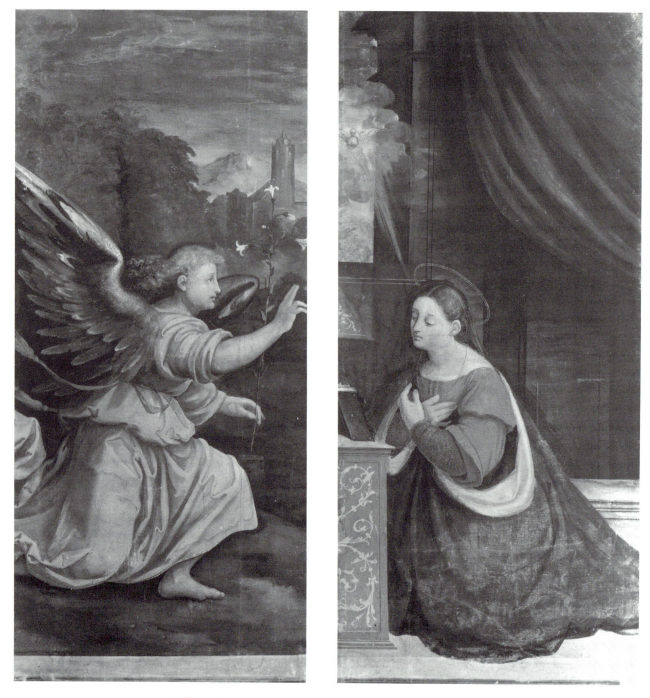

112. Callisto Piazza, *Annunciation*, canvas, 197×90 cm. each section.
Brescia, San Clemente.

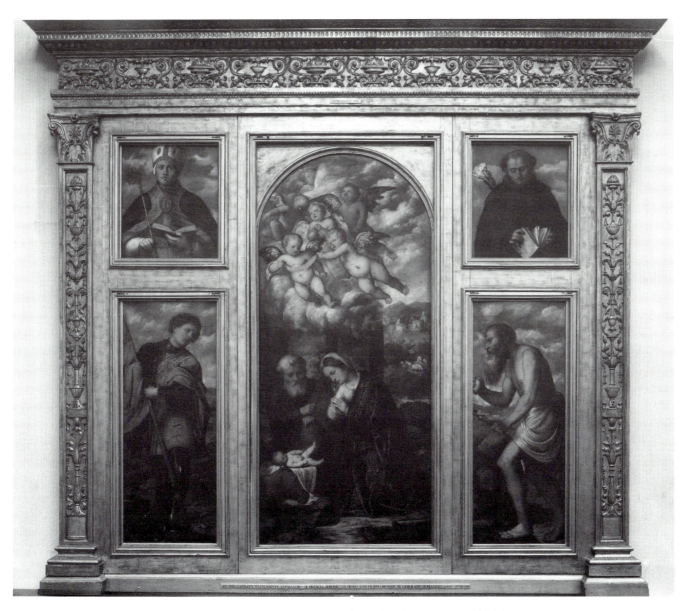

113. Girolamo Romanino, *Sant' Alessandro* altarpiece, panel, *Nativity*
(260·8 × 115·6 cm.), upper side panels (74·3 × 64·8 cm. each), lower
side panels (158·8 × 64·8 cm.). London, National Gallery, No. 297.

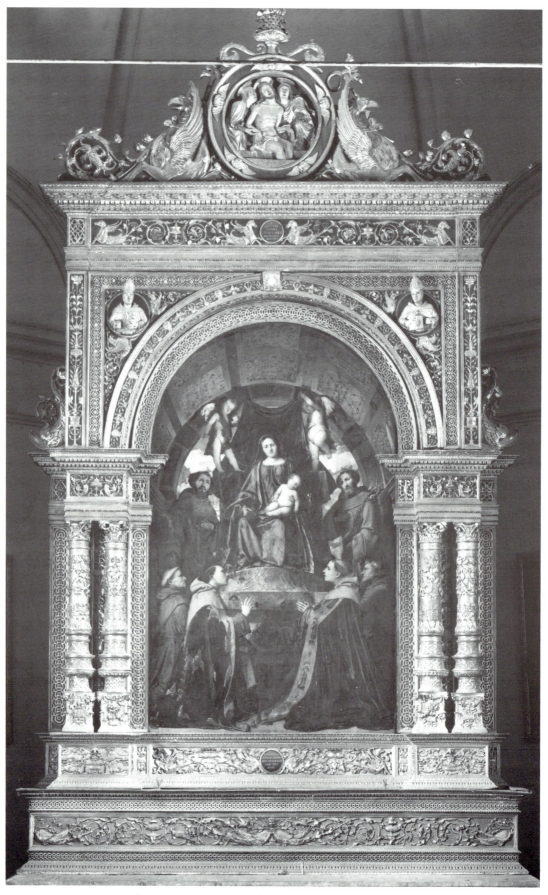

114. Girolamo Romanino, *Madonna and Child with Saints*, panel,
324 × 191·5 cm. Brescia, San Francesco.

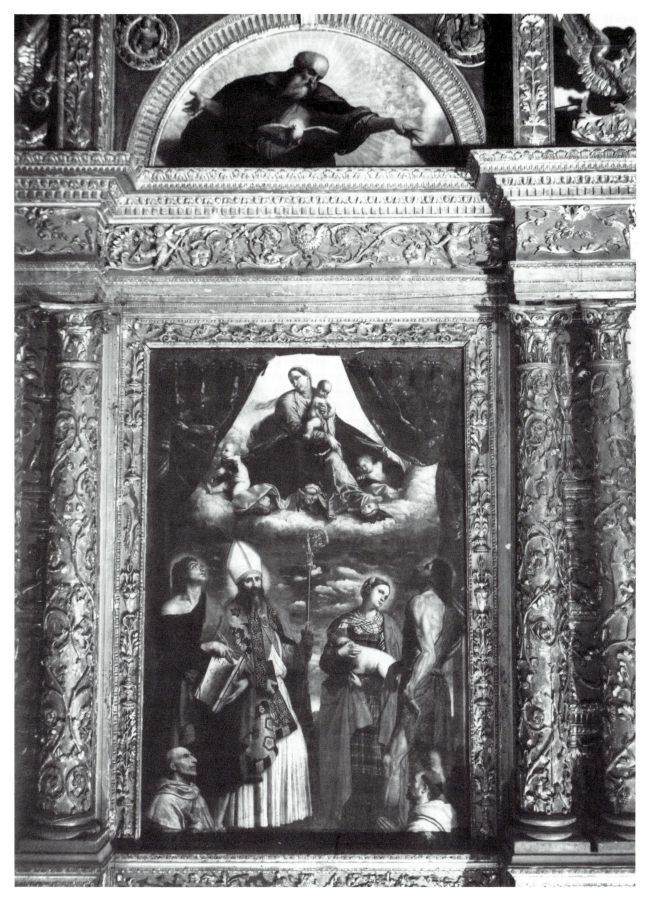

115. Alessandro Moretto, *Madonna and Child in Glory with Saints*, panel, 313 × 209 cm. Brescia, San Giovanni Evangelista.

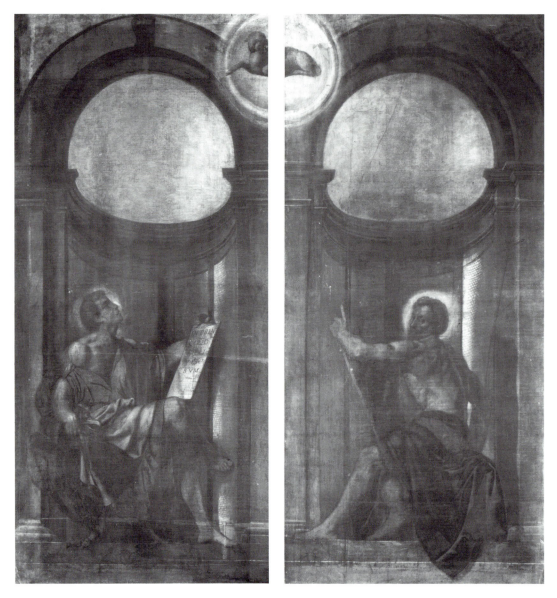

116. Alessandro Moretto, *SS John the Evangelist and John the Baptist*, canvas, 432 × 231 cm. Brescia, San Giovanni Evangelista, presbytery.

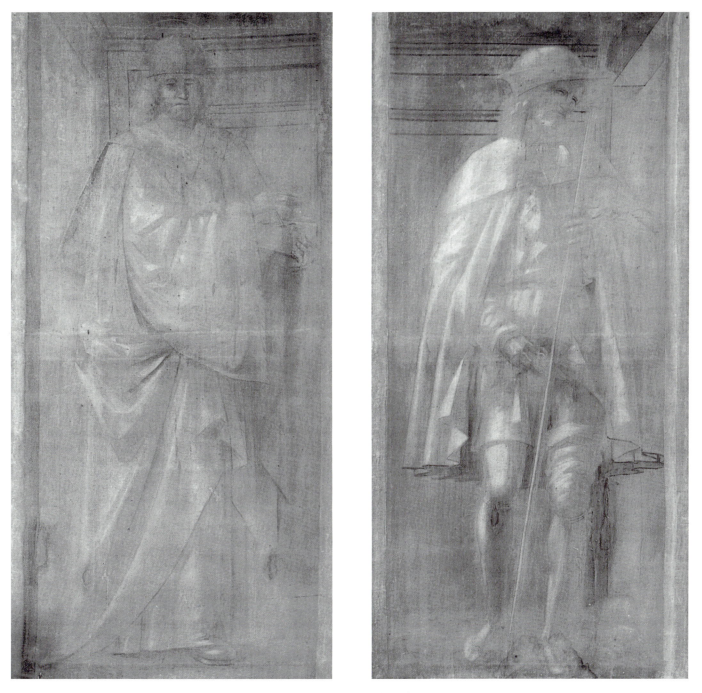

117. Vincenzo Civerchio, *SS Pantaleon and Roch*, canvas, 192 × 100 cm.
each. Crema, Museo Civico (after Marubbi).

7

COMMISSION AND DESIGN IN CENTRAL ITALIAN ALTARPIECES *c.*1450–1550

Patricia Rubin

ON 10 September 1455 the Company of Priests of the Trinity at Pistoia voted to provide the one thing lacking to its honour and glory—an altarpiece (Plate 118).[1] Things did not go smoothly. The chosen artist, Pesellino, died on 29 July 1457. There was litigation over the half-finished painting, which was ultimately given to Fra Filippo Lippi. Final payments date from June 1460. Despite its disturbed and dual creation, the composition is exactly that specified in the Confraternity's original deliberations. By contrast, in 1549 when Giorgio Vasari undertook to paint an altarpiece for the Martelli family chapel in San Lorenzo (Florence) he did so on the condition that he be allowed to use his imagination (*capriccio*) to paint a subject from the life of Saint Sigismund.[2] The painting no longer exists. A drawing in Lille records Vasari's invention (Plate 119).[3]

In both cases reputations were at stake: but in the first, it was the purchaser's. The honour of the Confraternity and its members was predominant, to be expressed in a work whose value matched that of its site. In the other, the subject and scale of the work were largely determined by the artist, 'thinking more of honour than of the slight gain to be made from a small picture with a few figures'.[4] This difference might be credited to the nature of the records I am quoting—the minutes of the Pistoiese Confraternity, the autobiography of the artist from Arezzo—but Vasari's correspondence and his record book show that in the case of the Martelli altar, his choice was decisive and part of the commission. He refers to a formal, countersigned, written agreement

[1] P. Bacci, *Documenti e commenti per la storia dell'arte* (Florence, 1944), 113–15.

[2] G. Vasari, *Le vite de' più eccellenti pittori scultori e architettori*, ed. P. della Pergola, L. Grassi, and G. Previtali, viii (Milan, 1966), 247: '*fui contento di farla, ma con facultà di potervi fare a mio capriccio alcuna cosa di S. Gismondo.*'

[3] Inv. 549. The Martelli chapel is the fourth on the right, Vasari's altar was destroyed in 1711, see W. and E. Paatz, *Die Kirchen von Florenz*, ii (Frankfurt am Main, 1940), 511.

[4] Vasari, *Le vite*, viii, 247: '*piu guardando all'onore che al picciol guadagno che di quell'opera destinata a far una tavola piccola e con poche figure potea trarre*'.

containing that stipulation.[5] Apparently the Martelli family, executing their cousin Sigismund's will, wanted a panel with the Virgin and some saints and meant to pay for a small painting, which Vasari felt would yield little honour to himself.[6] In this case Vasari was willing to pay for what the patrons were not—his own glory. He wanted to impress Florence. So the modest Madonna was dismissed in favour of a grandiose depiction of what he called a 'horrifying scene' ('*orrendo spettacolo*'), filled with special effects of terror and pathos, a demonstration of what he could achieve.[7] Nor was this ambition confined to a single altarpiece. Similar motivation and similar freedom characterized other commissions Vasari used as showcases for his artistry such as the *Immaculate Conception* painted for Bindo Altoviti's chapel in Santi Apostoli in 1540.[8] Vasari was well aware of 'common usage' ('*uso comune*') in religious subjects, and was also aware of the need to inspire devout sentiments, but this recognition was combined with an equal desire to excite admiration for each work's artistic qualities.

The difference between these cases is that between an altarpiece—a commissioned product of artistry (the Pistoia *Trinity*)—and an altarpiece conceived of as a work of art (Vasari's Martelli altar). It is the latter that justifies art-historical poaching on what was originally ecclesiastical ground. Given this fundamental transformation it is worth while examining broadly the practices of commission and design over a period when the priorities of representation shifted so that the subject of the altarpiece *could be* the fantasy (*capriccio*) of its author. Such an overtly and explicitly personal function challenged accepted definitions of the primary institutional (that is liturgical, devotional, and theological) purposes that traditionally constituted an altar painting's suitability to its site.

Whenever possible, Vasari tried to do something outside 'common usage' ('*fuor dell'uso comune*').[9] What this could mean is indicated by a letter from Vincenzo Borghini to Vasari (dating from January 1567), about the design of an altarpiece for Santa Maria Novella (Plate 120). Borghini had spoken with the donor about Vasari's submitted design; both were satisfied, but

[5] K. Frey, *Der literarische Nachlass Giorgio Vasaris* (Munich, 1930), ii, 868–9, Ricordo No. 196: '*Ricordo, come a di 14 di Ottobre 1549 Pandolfo di Piero Martelli . . . mj alloga in Fiorenza una tavola da farsi in tela . . . drentovj a mja eletione una storja de fattj di San Gisimondo re per la capella della casa de Martellj in San Lorenzo . . . cosi rimisse in me ogni afare si dornamento come daltra cosa secondo il ljbero voler mjo; come apare in una scritta, fatta di mano di messer Cosimo Bartolj per tuttadua le partj, soscritta di mano di Pandolfo et mja.*'

[6] Vasari, *Le vite*, viii, 247. When his friend and agent in the matter, Cosimo Bartoli, wrote to Vasari urging him to get on with the work, he spoke of the '*satisfazione del honor uostro*' and of his friends and supporters; Frey, *Der literarische Nachlass Giorgio Vasaris*, i, No. CXXX, p. 269 (8 Mar. 1550). Similar terms occur in Bartoli's letter of 5 Apr. 1550, No. CXXXVII, p. 281, and Vasari to Sforza Almeni (14 Oct. 1553), No. CXCVIII, p. 372.

[7] The painting measured 10 × 13 *braccia* (approx. 550 × 717 cm.) and was surrounded by an elaborate architectural frame, designed by Vasari; see Vasari, *Le vite*, viii, 248.

[8] Ibid. 219: '*E perché aveva a dare saggio di me a Fiorenza . . . aveva molti concorrenti e desiderio di acquistare nome, mi disposi a volere in quell'opera far il mio sforzo e mettervi quanta diligenza mi fusse mai possibile.*'

[9] Ibid. 242, of the *Marriage Feast of Esther and Ahasuerus* for the refectory of the Badia of Arezzo (commissioned in July 1548). Similarly a *Decollation of the Baptist*, 251: '*fatta una tavola all'altar maggiore della compagnia della Misericordia di un San Giovanni decollato, assai diverso dagl'altri che si fanno comunemente*' (finished in 1553, still *in situ* in the Oratory of the Decollato, Rome).

Borghini advised that he should put Sts Cosmas and Damian on the right side, as it was common usage to place the titular saints of a chapel in that position.[10] He suggested that another drawing be made, paying attention to the problem of how to place the soldiers who must necessarily go in the middle, a disturbing view when the host was raised during the mass. It had occurred to Borghini that an angel bathed in light might do the trick, but left it to Vasari to judge what might be the best invention, reminding him, however, 'to dress the doctors richly' (they were the patron saints of both Doctor Pasquali and of Duke Cosimo who had helped to fund the altar).

Uso comune dictated composition in the arrangement of figures. Liturgical demands had to be accommodated in invention. Vasari had apparently jeopardized this in his proposed design. A woodcut illustration to Savonarola's treatise on the mass showing the elevation of the host also shows the problematic moment for both the artist and the celebrants (Plate 121). The concern to keep a clear view of the principal devotional figures is a likely explanation for the spaces reserved at the centre of compositions such as Perugino's *Resurrection* painted around 1500 for the church of San Francesco al Prato, Perugia (Plate 122). Such a scheme ensured that the altar's image did not interfere with its function, or its important (and required) furniture, the altar cross and candles.[11] In the case of the Santa Maria Novella altarpiece, Borghini offered advice, but he deferred to the artist. This three-way consultation between Pasquali, Borghini, and Vasari can be viewed as a logical (biographical) consequence of their relative positions: Pasquali, a functionary at Duke Cosimo's court; Borghini, prior of the Spedale degli Innocenti, frequent adviser to the duke on artistic projects, and also consultant and close friend of Vasari; and Vasari, court artist. But this triangle followed a pattern, itself common usage, discernible in contracts and records of altarpiece commissions going back to the thirteenth century: a discussion of subject between patron/donor, church official, and painter, using drawings as a basis of negotiation and agreement in order to visualize and finalize the deal.[12] The exception that proves the rule is Fra Bartolommeo. His drawings show that frequently he decided what figures to include in a composition in the course of designing it, as in the drawings for the *Salvator Mundi* commissioned by Salvatore Billi in 1516 for Santissima Annunziata (now in the Pitti) where angels become evangelists (Plates 125, 126).[13] He is also documented as being able to make the final decision of figures to include in a

[10] Frey, *Der literarische Nachlass Giorgio Vasaris*, ii, 291, No. DLXII (28 Jan. 1567): '*Darei bene la man ritta à San Cosimo et San Damiano, poi che per uso comune è introdotto, che questo luogo si dia à chi ha il titolo della cappella.*' For the painting and the commission, see M. B. Hall, *Renovation and Counter-Reformation: Vasari and Duke Cosimo in Sta Maria Novella and Sta Croce 1565–1577* (Oxford, 1979), 111–14.

[11] The importance of altar crosses to altarpiece design was discussed by Charles Robertson in a seminar held at University College, London, in Mar. 1985.

[12] This conventional arrangement is discussed by H. Glasser, *Artists' Contracts of the Early Renaissance* (Garland publ., New York and London, 1977), and M. Baxandall,

Painting and Experience in Fifteenth Century Italy (Oxford, 1972), 3–14.

[13] N. Turner, *Florentine Drawings of the Sixteenth Century*, exhibition catalogue, British Museum (London, 1986), Nos. 45 (1895-9-15-528) and 46 (1910-2-12-11). See also C. Fischer, *Disegni di Fra Bartolommeo e della sua scuola*, exhibition catalogue, Uffizi (Florence, 1986), No. 86. For other such cases of change, see ibid., No. 49 compositional study for the *Marriage of St Catherine*, now in the Louvre, and No. 42 about the painter's elaboration of the figures and iconography for the altarpiece showing *God the Father with Saints Mary Magdalen and Catherine* now in the Museo Nazionale di Villa Guinigi at Lucca.

commission for a Virgin and saints for San Domenico, Pistoia (1512, not executed).[14] The reason is clear: as a Dominican, Fra Bartolommeo had theological as well as artistic training, so that he could serve as his own adviser and, occasionally, patron. This selection of subject is different in kind from the inventive evolution of design that occurs in drawings by artists such as Leonardo and Raphael.

The usual practice of decision is well documented in the 1455 Pistoia *Trinity* (Plate 118) commission. The subject was certainly not left to the artist. In fact it was decided upon before the artist was chosen. The deliberations of the Confraternity show that its members 'imagined' an altar appropriate to their needs and budget. It was clear to all that the Trinity should be in the middle because it was their symbol and that there should be two saints on either side. Three were easily decided: the patron of Pistoia (St James Major), the patron of the clergy (St Zeno), the Church Father, St Jerome. An immediate suggestion for a fourth saint was lacking. The treasurer of the order, the priest Piero ser Landi, humbly begged the company to allow him to include St Mamas among the principal figures. He had a special devotion to the saint. He pledged an endowment for part of the devotional maintenance of the altar, that is annual masses for the saint's feast in the Company's church and in the cathedral of Pistoia.[15] This bit of bargaining shows that there was a form of set pattern present in the minds of the commissioning clerics. A standard symmetry was to be observed, a preconception that became problematic when they ran out of patron saints. It also serves as a reminder that the implementation of piety was a practical matter. Buying an altarpiece was buying into eternity, and spiritual upkeep was demanded in the form of masses to be said or sung, candles burnt, and feasts observed.

The degree to which the language and practice of commission remains constant during this period is quite striking. As expressed, the demands for a work in 1450 are quite close to those for one in 1350 or 1550. Vasari's negotiations with the Martelli heirs or Pasquali followed long-established procedures. The price of 150 florins settled upon for Vasari's Martelli altar was the same as that for the Pistoia *Trinity*. What changed was not the terms, but the use of those terms, and one might say the control of them. In 1450, beauty, honour, devotion, and ornament constituted a vocabulary constellated around the commissioner and the commission. It was used by the patron or with reference to the work. By 1550 these terms had been appropriated by the artist. In the fifteenth century the drawing (*disegno*) served as a guarantee of the subject and referred to the execution more than the conception of the composition. By the mid-sixteenth century *disegno* both as concept and as practice was at the centre of learned debate and was granted academic status.[16] In 1450 judgement belonged to appraisal, to commercial valuation by members

[14] Fischer, *Disegni di fra Bartolommeo*, 117, commissioned by Jacopo Panciatichi, 17 Feb. 1512: '*una Vergine col Bambino, San Paolo, San Gio. Battista e San Bastiano e quelli più piaceranno al sud.o Fra. Gio. Maria Canigiani [prior] e Frate Bartolomeo dipintore*'. The contract was annulled after the dissolution of his partnership with Mariotto Albertinelli in Jan. 1513.

[15] Bacci, *Documenti e commenti*, 113–14.

[16] *Disegno* featured in the artists' answers to Benedetto Varchi's question about the relative merits of painting and sculpture, which then formed the basis of his lecture to the Florentine Academy in 1547, published in 1549. For the text, see B. V., 'Lezzione . . . della Maggioranza della arti e qual sia

of the profession, the *arte*, and so it remained as a contractual term. But by 1550 it had also come to be a shared appreciation of the aesthetic value of their art. In order to examine this change, I want to consider the use and understanding of two terms applied to the manufacture of altarpieces during this time: invention and beauty.

The painter was paid for his professional services, his mastery of his craft, his *arte*.[17] It was common, logical, for patrons to seek a famous master, an excellent or skilled one. Wills, bequests, and donations were made saying that altarpieces were to be executed 'by the hand' of a famous or skilled master.[18] That expertise was executive, however, not inventive. The Pistoia *Trinity* (Plate 118) altarpiece is a standard instance of the division of responsibility in commission that gave the choice and composition of subject to the patron (donor) or receiving body (church, monastery, hospital). A drawing by Leonardo da Vinci (Plate 124), in a notebook dating from 1497, with a ground plan of saints' names grouped around the Virgin, is likely to be the artist's record of a client's instructions. It notes the programme in the names, order, and attributes of the saints for an altarpiece for the church of San Francesco in Brescia. It shows the strength of formula as an intermediary between expectation and execution. Both artist and client could visualize an altarpiece from this description. Either Leonardo was busy or the request was perhaps too common to engage the interests of Leonardo who regarded painters as 'inventors and interpreters between Nature and Man'; the altarpiece was eventually supplied by Romanino.[19]

The painter might be allowed to embellish the work as 'necessary' or as 'he saw fit'. Perugino, for example, contracted to add angels, ornaments, and even extra heads as space and subject

più nobile, la scultura o la pittura', in P. Barocchi (ed.), *Trattati d'arte del Cinquecento fra Manierismo e Controriforma*, i (Bari, 1960), 1–82. The Accademia del Disegno was founded in Florence in 1563, for its origins, activities, and history, see K. Barzman, 'The Università, Compagnia, ed Accademia del Disegno', Ph.D. thesis (The Johns Hopkins University, Baltimore, 1985).

[17] For example Neri di Bicci recorded that he was owed '*per oro e metitura e per cholori e mio maestero in tuto 1. quatrocento-otanta*' for an altar for the Spini chapel in S. Trìnita, see Neri di Bicci, *Le Ricordanze*, ed. B. Santi (Pisa, 1976), Ricordo No. 50 (28 Feb. 1455), 25–6.

[18] Typically, F. Canuti, *Il Perugino* (Siena, 1931), ii, No. 279, p. 197 with reference to a donation for an altar and altarpiece for Santa Maria degli Angeli (13 May 1492): '*manu alicuius experti magistri*'. Similarly Ludovico Sforza wrote to Florence in 1499 about the choice of artists to provide altarpieces for the Certosa at Pavia: '*noi avemo exhortato el venerabile messer lo priore et frati a che ne le picture se ne havevano a fare per devotione et ornamento de la Chiesa cercassino de havere persone elette e prestante ad farle per la qual cosa avendo proposto uno certo Perusino et uno Magistro Philippo como pictori prestanti et optimi nel mestero loro . . . a ciò che usassino de lopra loro in la pictura dele ancone così de voluntà nostra veneno con loro a*

conventione,' see B. Fabjan *et al.*, *Perugino, Lippi e la bottega di San Marco alla Certosa di Pavia*, exhibition catalogue, Pinacoteca di Brera, Milan (Florence, 1986), 27. On 6 June 1516 Carlo Ginori specified in his will that the altarpiece for his chapel be 'by the hand of a good master' ('*di mano di buon maestro*'), see D. Franklin, 'Rosso Fiorentino's *Betrothal of the Virgin*: Patronage and Meaning', *Journal of the Warburg and Courtauld Institutes* (forthcoming). Sassetta's contract for the high altar of the Franciscan church of Borgo San Sepolcro (5 Sept. 1437) gives some explanation of what was expected of a master, that he use: '*ad aurum et azurrum finum et colores alios finos, cum ornamentis et aliis secundum subtile ingenium sue artis pictorie, et quanto plus venustius sciet et poterit et omni suo conatu . . .*', in James R. Banker, 'The Program of the Sassetta Altarpiece in the Church of S. Francesco in Borgo S. Sepolcro', *I Tatti Studies*, 4 (1991), 51–2.

[19] J. P. Richter, *The Literary Works of Leonardo da Vinci*, i (3rd edn., London, 1970), 116. For the drawing, see E. Möller, 'Leonardo da Vincis Entwurf eines Madonnenbildes für S. Francesco in Brescia (1497)', *Repertorium für Kunstwissenschaft*, 35 (1912), 241–61, and for the painting, G. Panazza *et al.* (eds.), *Mostra di Girolamo Romanino*, exhibition catalogue, Comune di Brescia (Brescia, 1965), 47–9, as *c.*1516.

required in altarpieces for San Pietro, Perugia (an *Ascension*, now in Lyons)[20] and San Francesco al Monte, Perugia (the *Coronation of the Virgin*, now Galleria Nazionale dell'Umbria, Perugia).[21] And Perugino's design practice was based on a very efficient understanding of such requirements. His mastery of 'common usage' explains the trust of his clients.[22]

A painter's recognized ability to ornament or fill in the blanks must be differentiated from invention, understood as the finding of subjects, which was a skill associated with literary knowledge, *lettere*.[23] And when invention came to play a decisive part in altarpiece design in the third quarter of the fifteenth century the initiative came from gentlemen and scholars. A notable case is the *Assumption of the Virgin with Nine Orders of Angels and Saints* that Matteo Palmieri ordered for his chapel in San Pier Maggiore in Florence (attributed to Botticini, now in the National Gallery, London). According to Vasari, Palmieri provided the *disegno*. Its iconography was based on Palmieri's religious tract, the *Città di Vita*, which was later suspected of heresy and the altarpiece was covered by a curtain.[24] There seems to have been a fashion for having new ideas about altarpieces in Florence at this time. One of the most spectacular was that proposed in 1483 by Tommaso Portinari with the importation of the monumental *Nativity* by the Flemish painter, Hugo van der Goes. This proposal was acknowledged by another Medici bank manager, Francesco Sassetti, in the altarpiece of his burial chapel in Santa Trìnita. His *Nativity*, painted by Domenico Ghirlandaio, included the rough shepherds of the Portinari altar and then 'improved' upon it with the addition of antiquarian references, monuments, and inscriptions, all expressions of Sassetti's cultural and political interests as well as his devotional aims.[25] The family emblem, a stone, is placed in the centre foreground. These conspicuous exercises in personal taste fit well into a phenomenon chronicled by the contemporary biographer Vespasiano da Bisticci, who included the topic of appreciation of artists among his descriptions of the qualities of great men.[26]

[20] Canuti, *Il Perugino*, ii, No. 224, p. 177 (8 Mar. 1495): '*In campo sive quadro ipsius Tabulae Ascentionem D.N. J.C. cum figura et Imagine gloriosissimae Virginis Mariae et XII Apostolorum cum aliquibus angelis et aliis ornamentis, secundum quod in facto cognoverit opportunum.*'

[21] Ibid. ii, No. 379, p. 237 (10 Sept. 1502): '*Item pengere in decta tavola, dall'altro lato verso la Chiesa delle donne, in mezzo di essa fare uno thruono cioè el Segnore et la Madonna, et da piej de essa tavola depengere 4 Apostoli et altre teste secondo remanerà el spazio.*'

[22] Ibid. ii, No. 430, p. 258 for the *Assumption of the Virgin* for Corciano (18 Dec. 1512): '*In qua quidem tabula debeat depingi Immago Gloriosae Virginis Mariae in coelum ascendentis, cum duodecim Apostolis et Angelis et aliis, quae in simili actu Ascentionis B. Virginis requiruntur, ut ispa artis et tabulae capacitas exigit et requirit. Circum et intus ornamentum frigiis et festiis aureis, prout opus fuerit ad usum boni et legalis, magistri, prout ipse Magister Petrus habetur et reputatur, etc., cum auro et coloribus finibus et bonis, prout tabula Mag.ae Alexandrae Simonis de Oddis, quae est in Ecclesia S. Francisci de Perusia Portae S. Susannae, et melioribus.*'

[23] See M. Kemp, 'From *Mimesis* to *Fantasia*: The Quattrocento Vocabulary of Creation, Inspiration and Genius in the Visual Arts', *Viator*, 8 (1977), 348–61; and L. B. Alberti, *On Painting and on Sculpture*, ed. C. Grayson, (London, 1972), 94–5 (bk. 3): 'Literary men, who are full of information about many subjects, will be of great assistance in preparing the composition of a *historia*, and the great virtue of this consists primarily in its invention.'

[24] Vasari, *Le vite*, iii, 196–7: '*In S. Pietro Maggiore alla porta del fianco, fece una tavola per Matteo Palmieri con infinito numero di figure . . . tutto col disegno datogli da Matteo, ch'era litterato e valent'uomo. La quale opera egli con maestria e finitissima diligenza dipinse.*' For the iconography and fate of the painting, see M. Davies, *National Gallery Catalogues: The Earlier Italian Schools* (2nd rev. edn., London, 1961), No. 1126, 123–4.

[25] E. Borsook and J. Offerhaus, *Francesco Sassetti and Ghirlandaio at Santa Trìnita, Florence* (Doornspijk, 1981), 33–6.

[26] Vespasiano da Bisticci, *Le vite*, ed. A. Greco, i (Florence, 1976), 384, of Federico da Montefeltro, and ii, 193, of Cosimo de' Medici, for example.

Where the artists' imaginative skills had traditionally been recognized was in the depiction of histories. Durandus' familiar thirteenth-century compendium of liturgical practice, the *Rationale Divinorum Officiorum*, quotes from Horace, granting painters the licence of poets.[27] And it was in the design of histories that creative invention was most readily displayed. Vasari's choice of subject for the Martelli altar, changing it from figure and image to narrative (*storia*) attests to this. The proliferation of historiated altarpieces in the sixteenth century can be connected with the increased interest in demonstrations of invention. It is not surprising, therefore, that the paradigmatic case of subject evolution in design, Raphael's *Entombment*, should be a story and one that had at its centre an Albertian invention, the *historia* praised in Rome 'in which the dead Meleager is being carried away', a subject presenting the 'difficult' contrast of movement and inertia, of life and death.[28]

But the challenge to common usage came not only from invention understood rhetorically as the finding of topics, but invention understood scientifically as the discovery of truth or first principles.[29] It is speculative design that can be observed in Pontormo's compositional ideas for the altarpiece he painted for Francesco di Giovanni Pucci for the church of San Michele Visdomini (Plate 134). According to Pucci's will, he wished his burial chapel to be dedicated to St Joseph.[30] Pontormo was presumably given the task of painting a Virgin and Child with Sts Joseph (titular saint), John the Evangelist (donor's father), Francis (donor), and James (donor's son, named Jacopo, who died in 1515).[31] Common usage accorded the dedicatory saint the privileged position to the right of the Virgin, as he is granted here. But rather than simply accept this instruction, Pontormo seems to have considered Joseph's relation to the Virgin and Child, making his preliminary design in terms of a Holy Family (Plate 127). The compositional study for the Visdomini altar echoes, in medium, structure, and geometrical treatment, studies of the Holy Family by Fra Bartolommeo (Plates 128–130). Part of Pontormo's training had been with Fra Bartolommeo's partner, Mariotto Albertinelli. This more intimate, domestic, type of composition, where the Virgin is not enshrined as *imago* and *figura* possibly explains the enlivened, active quality of Pontormo's saints. Perhaps it suggested to Pontormo the addition of the Baptist, common to the treatment of the theme in early sixteenth-century Florence and occurring in such influential models as Raphael's *Holy Family* painted for Domenico Canigiani (Plate 131). The conspicuous pyramidal controlling structure of Pontormo's drawing (Plate 127) finds an elegant precedent in Raphael's painting and the position of St Anne in Raphael's work can be compared to the seated saint in the middle of the drawing (John the Evangelist?). Raphael's Joseph might have

27 W. Durandus, *The Symbolism of Churches and Church Ornaments*, trans. of *Rationale Divinorum Officiorum*, bk. 1, by J. M. Neale and B. Webb (Leeds, 1843), ch. III. 22, p. 68: 'But the diverse histories of the Old and New Testaments may be represented after the fancy of the painter. For 'Pictoribus atque poetis | Quod libet addendi semper fuit aequa potestas'.

28 Alberti, *On Painting*, 75.

29 Kemp, 'From *Mimesis* to *Fantasia*', 348–50.

30 D. Franklin, 'A Document for Pontormo's S. Michele Visdomini Altar-piece', *Burlington Magazine*, 132 (1990), 487–9. The will is dated 17 Jan. 1517, and expresses the wish to endow a chapel in SS Annunziata. A codicil of 9 June 1518 changes the endowment to the Pucci parish church of San Michele Visdomini. There is an inscription on John Evangelist's book, 1518.

31 Ibid. for this explanation of the inclusion of James.

inspired the pose of the leaning figure in the right background as it was first sketched. Another source that has been suggested is the *Madonna* Raphael painted for Bindo Altoviti, possibly a recent arrival in Florence (Plate 132).[32] In the final version of Pontormo's altarpiece, the Virgin is restored to her tabernacle, but the rest of the setting remains ambiguous, outside architectural containment. It seems to be a grassy bank. The empathetic design is no longer a court of heaven familiar from works such as Fra Angelico's altarpiece of the Virgin enthroned, formerly the high altar of San Marco (Plate 123). Centralized perspective is supplanted by a geometry of design connecting the figures through the 'motions of the soul'. Their gestures serve not only as examples of devotion and attitudes of prayer but as dramatic characterization and conductors of symbolic understanding.

Although one has to be very careful about iconographical remarks, or even critical ones, made about paintings in poor condition, Pontormo's composition (Plate 134) appears to be based on dramatic lighting or a drama of illumination. Mary's gesture and the sideways glances of the saints at the right have been interpreted as pointing to the high altar.[33] They do point in that direction, as though illustrating San Bernardino's injunction: 'Go to a high altar when you enter a church, and adore it, rather than stand before painted images. First give due reverence to the body of Christ, then show your devotion to the other figures which represent to you other devout saints.'[34] Pontormo's sensitivity to the site need not be doubted. It is a recognition, perhaps, of the liturgical centre as opposed to the devotional periphery of the church. But his (indeed Francesco Pucci's) altarpiece must have been conceived as more than a signpost on the way up the nave. These gestures and glances may have been informed by the opening words of the Gospel of St John:

all things were made through him . . . In him was life and the life was the light of men. The light shines in darkness . . . There was a man sent from God, whose name was John. He came for testimony to bear witness to the light . . . The true light that enlightens every man coming into the world.

The contrast of light and darkness in the Gospel is incorporated in the structure of his design, as Joseph, John the Evangelist, and the Virgin look to the source of the light and John the Baptist points upward, placed as witness of the light and forerunner of Christ. The enraptured glances of some of the figures may also have been suggested to Pontormo by his consideration of the Evangelist, a consideration that could have led him to the 1511 title-page of Dürer's *Apocalypse* series (Plate 133). His study of Dürer is particularly registered in the face of the Infant Christ (Plate 134). The fact that Dürer's narrative series of woodcuts were published as devotional books should not be overlooked when suggesting Dürer as a source for Pontormo's religious works in general. Pontormo's response to Dürer was not mere motive-hunting. It was a thoughtful reading and translation of visual texts. In designing the Pucci altarpiece, Pontormo did not act as a theologian.

[32] For this and a detailed discussion of the drawing, see J. Cox-Rearick, *The Drawings of Pontormo*, i (Cambridge, Mass., 1964), 122–5.

[33] K. W. Forster, *Pontormo* (Munich, 1966), 34.

[34] Quoted by R. Trexler, *Public Life in Renaissance Florence* (New York, 1980), 55.

His sources were neither difficult nor obscure. They included visual as well as textual prompts. His was an inventive process that interpreted his commission according to a painter's understanding. It was a form of subtle speculation on the task of representation that redefined the relationship of the painting, and the artist, to the viewer. All are more actively engaged.[35]

To be inventive was to take a risk and not always to kind reception, as Vasari reports of Daniele da Volterra's efforts in the *Assumption* he painted at Santa Trinità dei Monti in Rome: 'Because the space was limited and Daniele wanted to come up with a new invention, he pretended that the altar was the tomb, putting the Apostles around it, on the level of the altar, which pleased some, but the majority, not at all.'[36]

Still the artist was allowed to be an inventor of ingenious solutions.[37] And the altarpiece composition was not merely contracted through a drawing, but subject to the processes of design. So in 1545 when Duke Cosimo de' Medici wanted Bronzino to produce a copy of the *Pietà* to replace the one he had given to the emperor's chancellor, Cardinal Granvelle, Bronzino apparently viewed invention as the basis of his task. He wrote to the duke's majordomo, Pier Francesco Ricci, saying that Cosimo wanted the altarpiece to be exactly like the first, not more beautiful. He was told not to begin on another invention, because the existing one pleased the duke.[38] Whatever the conflict between efficiency and originality in the exchange between Cosimo and his court artist, its terms show that by this time invention was part of the discussion. And where new invention might not be necessary, all agreed that beauty was not negotiable.

Beauty had always been the basis of altarpiece commission. The contract of 15 April 1285 for Duccio's *Rucellai Madonna*, for example, specifies that he paint a most beautiful picture and that all the figures contribute to the beauty of the altar panel.[39] *Pulchritudo* was as necessary as the colours. Both were a means to represent and respect the subject. But the beauty of the contract specification was not understood to convey spiritual or moral value. By definition, as a mechanical art, painting served the material. St Bonaventure, for example, defined the beauty of painting as good craftsmanship and accurate representation.[40]

[35] This was typical of Pontormo, see Vasari, *Le vite*, vi, 169, in the altarpiece painted for Ludovico Capponi's chapel: '*che si vede apertamente che quel cervello andava sempre investigando nuovi concetti e stravaganti modi di fare, non si contentando e non si fermando in alcuno . . . la bizarra stravaganza di quel cervello di niuna cosa si contentava giamai.*' The extremely successful and contemporary career of Ridolfo del Ghirlandaio serves as a reminder that the demand for traditional, hieratic works continued.

[36] Ibid. vii, 21–2: '*E perché il luogo non era capace di tante figure et egli desiderava di fare in ciò nuova invenzione, finse che l'altare di quella capella fusse il sepolcro e intorno misse gl'Apostoli, facendo loro posare i piedi in sul piano della capella dove comincia l'altare, il quale modo di fare ad alcuni è piaciuto e ad altri, che sono la maggior e miglior parte, non punto.*'

[37] Kemp, 'From *Mimesis* to *Fantasia*', 347, notes that in

Landino's 1481 description in his commentary to Dante's *Divine Comedy*, Masaccio was called an '*optimo imitatore di natura*', but in 1564 Landino's editors added '*optimo inventore*', see *Dante con l'espositione di Cristoforo Landino e di Alessandro Vellutello . . . per Francesco Sansovino* (Venice, 1564), fo. 8ᵛ.

[38] G. Gaye, *Carteggio inedito d'artisti*, ii (Florence, 1840), 330–1, No. 233 (22 Aug. 1545): '*et aggiunse sua prefata E. io la voglio in quel modo proprio come sta quella, et non la voglio più bella; quasi dicesse non m'entrare in altra inventione, perchè quella mi piace*'.

[39] G. Milanesi, *Documenti per la storia dell'arte senese* (Siena, 1854–6), i, Doc. 16, 158–60: '*dictus Duccius . . . promisit . . . omnia e singula facere, que ad pulcritudinem dicta tabula spectabunt.*'

[40] See J. F. Took, *L'etterno piacer: Aesthetic Ideas in Dante* (Oxford, 1984), 49: '*In imagine reperitur duplex ratio pulchritudi-*

To study the question of representation here would be to investigate changes in the *style* of beauty, but there was also a change in the discussion of beauty that affected its function with respect to painting. By the early sixteenth century beauty was a popular topic. The Neoplatonic philosophy of love had migrated from the *studio* to the *salotto*, and according to Aretino, even to the street. The protagonist of Aretino's *Il Filosofo*, Plataristotile, spouts neo-platitudes. Castiglione's discourse in Book 4 of the *The Courtier* is typical of an established genre of books on beauty and love (*trattati d'amore*). He writes (using Pietro Bembo as the speaker):

of the kind of beauty . . . which is that seen in the human body . . . and which prompts the ardent desire we call love . . . this beauty is an influx of the divine goodness. . . . This goodness adorns and illumines with wonderful splendour and grace the object in which it shines . . . beauty is goodness and so the true love of beauty is good and holy . . .[41]

This ideal seems to inform the woman in the foreground of Raphael's *Transfiguration*, for Vasari 'the principal figure of that painting' (Plate 135).[42] She illustrates the gracious beauty that could mediate between corporeal and spiritual realms inflaming the soul with passion and desire for the beauty that it recognizes as good, to paraphrase Castiglione. Similar ideas were expressed by Benedetto Varchi in his book on beauty and grace written around 1543, where he defined beauty as 'nothing other than a certain grace that pleases the spirit of whoever sees it, and by pleasing moves it to desire to be united with it'.[43] Where there is beauty there is grace, and that is transcendent. Both Castiglione's and, later, Varchi's philosophical vocabulary is strikingly similar to Vasari's critical lexicon, which is actually formed of such (mis)appropriations.

To Vasari and his contemporaries the display of beauty, physical beauty, in altarpieces was seen as integral to their conception as vehicles of artistic skill, which in turn through beauty were conductors to spiritual grace and understanding. Vasari used the Life of Fra Angelico to explain and defend the artist's position:

Nor would I have any man deceive himself by considering the coarse and clumsy as holy, and the beautiful and good as licentious, as some do, who, seeing figures of women or of youths adorned with loveliness and beauty beyond the ordinary, straightway censure them and judge them as licentious, not perceiving that they are very wrong to condemn the good judgement of the painter, who holds the saints, both male and female, who are celestial, to be as much more beautiful than mortal man as Heaven is superior to earthly beauty and to the works of human hands . . . they reveal the unsoundness and corruption of their own minds by drawing evil and impure desires out of works from which, if they were lovers of purity . . . they

nis, quamvis in eo cuius est, non nisi una inveniatur. Quod patet quia imago dicitur pulchra 1° quando bene protracta est; 2° dicitur etiam pulchra quando bene repraesentat illud quem est.'

[41] B. Castiglione, *The Book of the Courtier*, trans. G. Bull (Harmondsworth, 1967), 325-7.

[42] Vasari, *Le vite*, iv, 102: 'la quale è principale figura di quella tavola'.

[43] B. Varchi, 'Libro della Beltà e Grazia', in P. Barocchi (ed.) *Scritti d'arte del Cinquecento*, ii (Milan and Naples 1973), 1672: 'la bellezza non è altro che una certa grazia la quale diletta l'animo di chiunche la vede e conosce, e dilettando lo muove a desiderare di goderla con unione, cioè . . . lo muove ad amarla.'

would gain a desire to attain to Heaven and to make themselves acceptable to the Creator of all things, from whose most perfect and beautiful nature all perfection and beauty are derived.[44]

In aesthetic, philosophical, or even theological terms there is nothing remarkable about Vasari's passage. It is based on a long tradition of discussing images, both seductive and saintly. The spiritual function of beauty was a Neoplatonic commonplace. But Vasari was not a philosopher or a theologian. He wrote, as he said, as an artist. And in his paintings he was making abstractions concrete and particular. Vasari wrote this passage as a defence of Michelangelo, whose Sistine *Last Judgement* had been attacked as indecorous for its display of nudity. Michelangelo's reputation as divine was essential to Vasari. It was a validation of his own role as a creator of truths through the skill of painting: enduring truths that were also monuments to his reputation and those of his fellow artists.

There was the obvious danger that the altarpiece was no longer subject to art in its manufacture as a devotional object, but had as its subject art, and the artist. There was, for example, the case of Bronzino's *Harrowing of Hell* (Plate 136). When set in place in Giovanni Zanchini's chapel in Santa Croce in June 1552, it was viewed as an occasion for opinion rather than devotion. A friend of Vasari's wrote to him saying that people had been going to look at it for over a week, some saying one thing, others another. He promised to send Vasari details when he had them. Vasari was an interested party because there was a three-way competition between Bronzino's altarpiece, Vasari's Martelli *Martyrdom of Saint Sigismund* (Plate 119), and Salviati's *Deposition* in the Dini chapel of Santa Croce. *Paragone* not *devotione* was primary.[45] In the rhetoric of the object, this was not an acceptable message. The Council of Trent and the Counter-Reformation were soon to reaffirm the more strictly devotional and didactic aims of images. Bronzino's *Harrowing of Hell* (Plate 136) altarpiece was to be criticized, not for its lack of artistry, but for its lascivious ladies, who seduced it from suitability.[46] What was effectively a struggle for control of the expressive power of the image was resolved in favour of its sacred function, but that struggle was a creative one, resulting in works of great beauty and originality, which in fact continue to be viewed as masterpieces.

[44] Vasari, *Le vite*, ii, 398–9: '*Ma io non vorrei già che alcuno s'ingannasse, interpretando il goffo et inetto, devoto, et il bello e buono, lascivo; come fanno alcuni, i quali vedendo figure, o di femina o di giovane un poco più vaghe e più belle et adorne che l'ordinario, le pigliano subito e giudicano per lascive non si avedendo che a gran torto dannano il buon giudizio del pittore, il quale tiene i santi e sante, che sono celesti, tanto più belli della natura mortale, quanto avanza il cielo la terrena bellezza e l'opere nostre . . . scuoprono l'animo loro infetto e corrotto, cavando male e voglie disoneste di quelle cose; delle quali, se e' fussino amatori dell'onesto . . . verrebbe loro disiderio del cielo e di farsi accetti al Creatore di tutte le cose, dal quale perfettissimo e bellissimo nasce ogni perfezzione e bellezza.*'

[45] Bernardetto Minerbetti to Vasari in Rome (1 July 1552): '*El Bronzino finalmente dette fuora la tauola del Zanchino, la quale fa tanto paragone a quella del Saluiati, che la la caccia uia, non a*

juditio mio, ma di che più sa. Sonui e popoli ogni di gia otto giorni; et chi dice una, chi un altra cosa. Io non ho potuto intender' e parerj: Li saprò et scriuero'; Frey, *Der literarische Nachlass Giorgio Vasaris*, i, No. CLXX, p. 329. See also Vincenzo Borghini to Vasari (20 Aug. 1552): '*Hora hora hora si è partito da me quel uostro cugino che sta al Monte et hammj in nome uostro uisitato, et habbiamo insieme ragionato à dilungo della tauole uostre, del Bronzino et del Saluiato. Ne ui dico nulla di più che io mi ui scriuessi per l'ultima, perche sono nella medesima opinione ne mi ui credo ingannare dentro ne son solo; et se altri ui ha scritto altrimenti, io sono certo, che uoi, quando uedrete, sarete dalla mia, benche uoi ui uedete hora in spirito e la giudicate,*' ibid. i, No. CLXXII, 332.

[46] R. Borghini, *Il riposo* (Florence, 1584), ed. M. Rosci, i (Milan, 1967) 109–10.

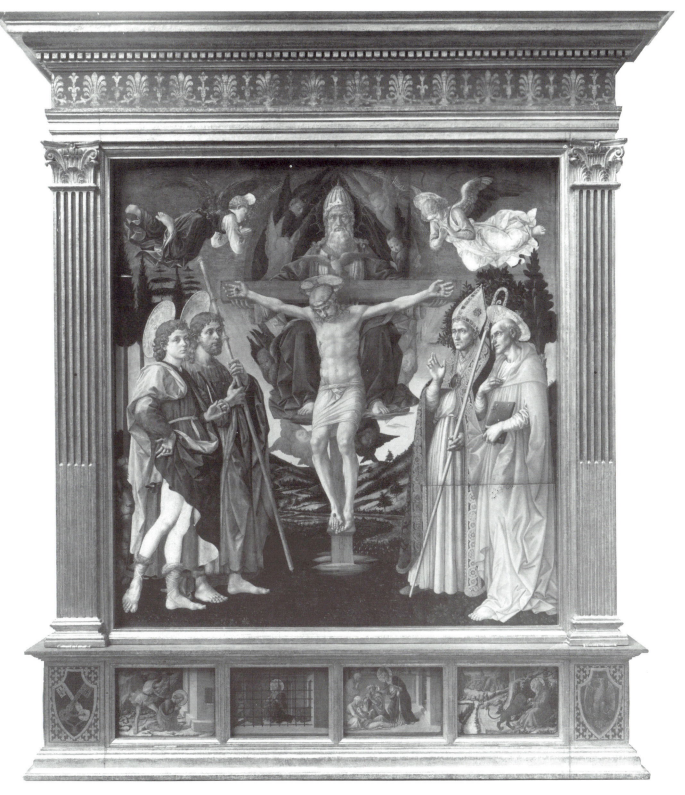

118. Francesco Pesellino and Fra Filippo Lippi, *The Trinity with Saints*, 1455–60,
main panel, 184 × 181·5 cm. London, National Gallery, No. 727.

119. Giorgio Vasari, *Martyrdom of St Sigismund*, pen and ink, 42·2 × 30·1 cm.
Lille, Musée des Beaux-Arts.

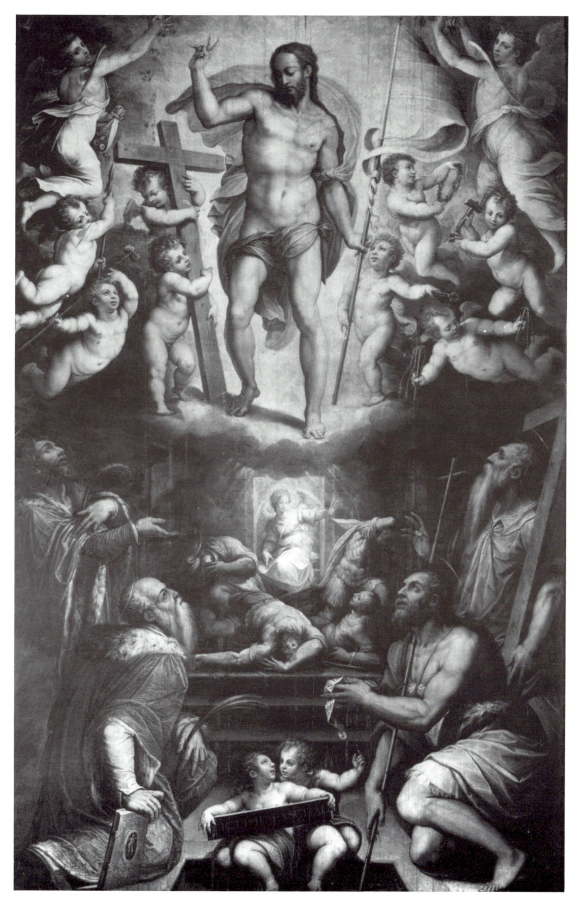

120. Giorgio Vasari, *Resurrection*, 1568, panel. Florence, Santa Maria Novella.

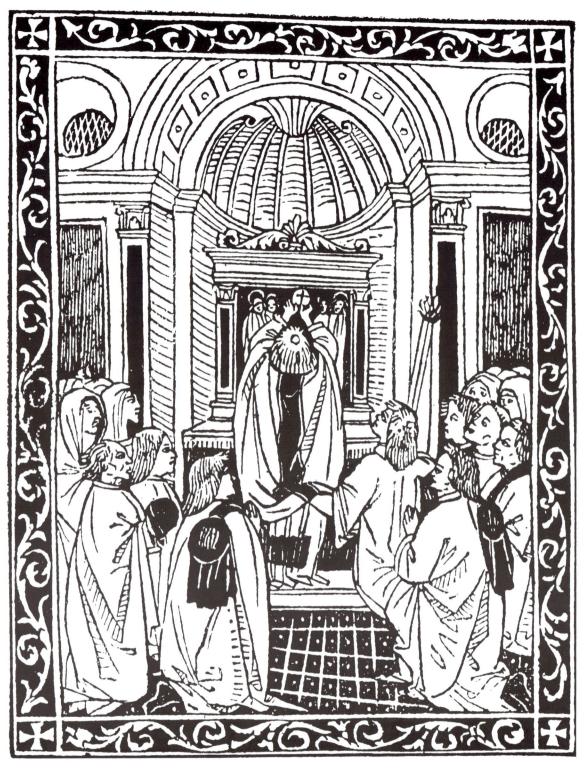

121. Anonymous Florentine, *c*.1493, *Elevation of the Host*, woodcut from Girolamo Savonarola's *Tractato del Sacramento e dei misterii della messa*.

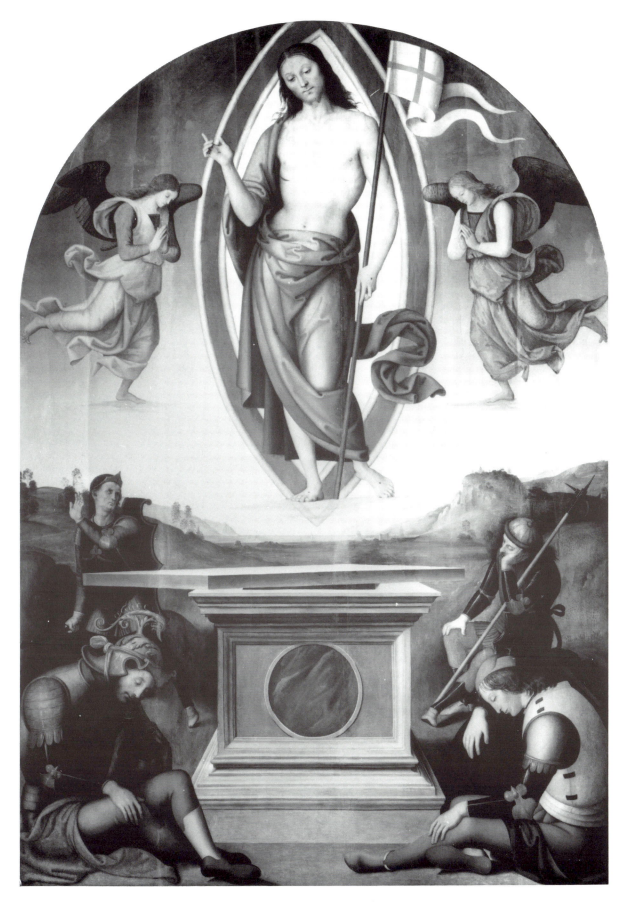

122. Pietro Perugino, *Resurrection*, 1499, panel, 233 × 165 cm. Vatican, papal apartments (originally San Francesco al Monte, Perugia).

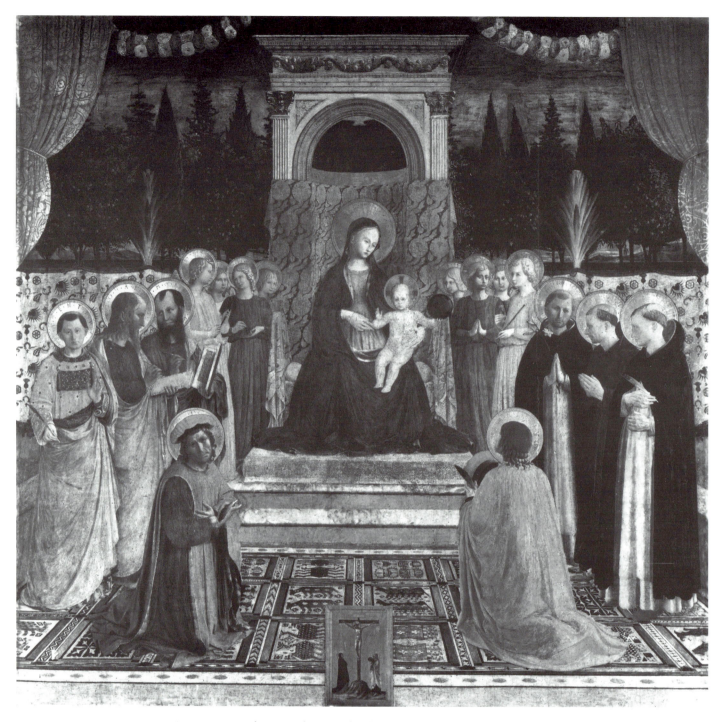

123. Fra Angelico, *Madonna and Child Enthroned with Saints*, panel,
220 × 227 cm. Florence, Museo di San Marco.

124. Leonardo da Vinci, diagram for an altarpiece, pen and ink, 10 × 7·2 cm. Paris, Institut de France, MS I, 59ʳ (after Möller).

125. Fra Bartolommeo, *Salvator Mundi*, black chalk on brown paper,
28·8 × 16·7 cm. London, British Museum, No. 1895-9-15-528.

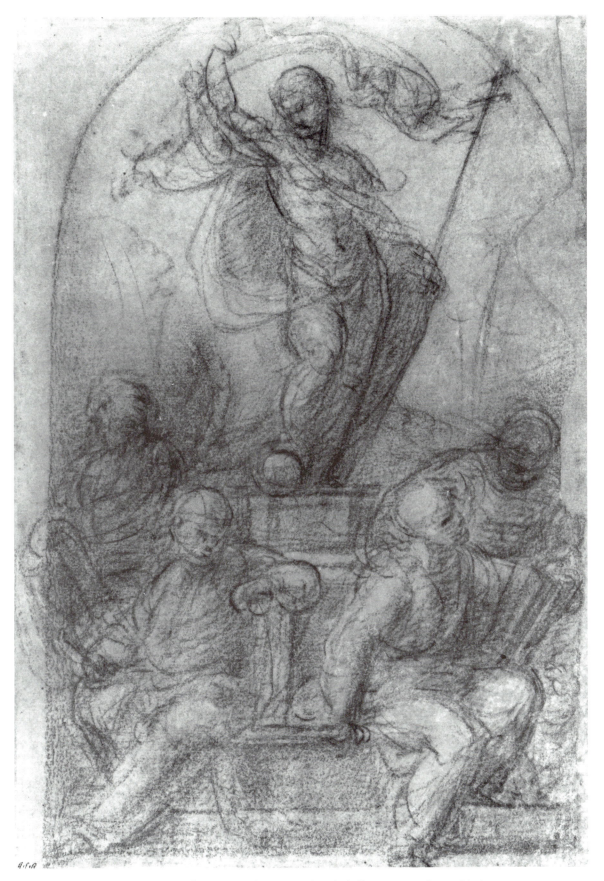

126. Fra Bartolommeo, *Salvator Mundi*, red chalk over an outline in black
chalk, 28·5 × 19·7 cm. London, British Museum, No. 1910-2-12-11.

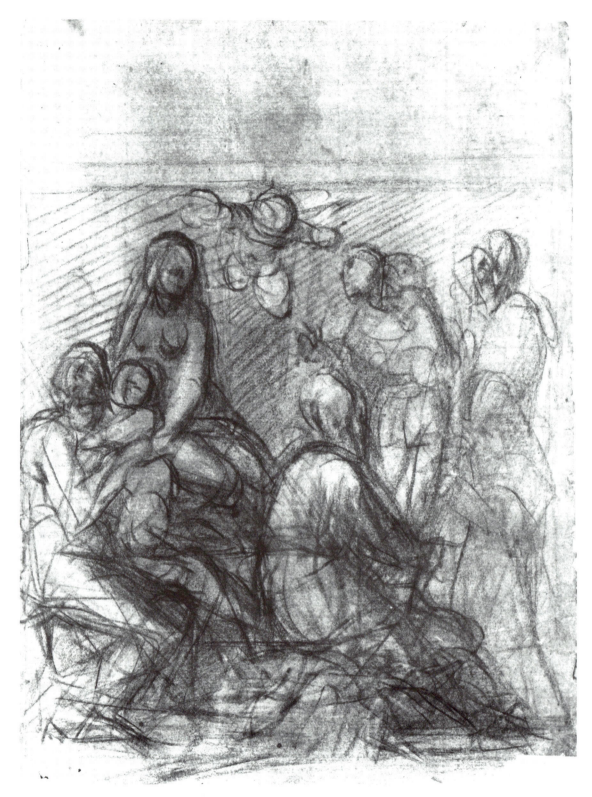

127. Jacopo Pontormo, *Madonna and Saints*, black chalk heightened with white on pink prepared paper, 21·8 × 16 cm. Rome, Gabinetto Nazionale delle Stampe, F.C. 147ʳ.

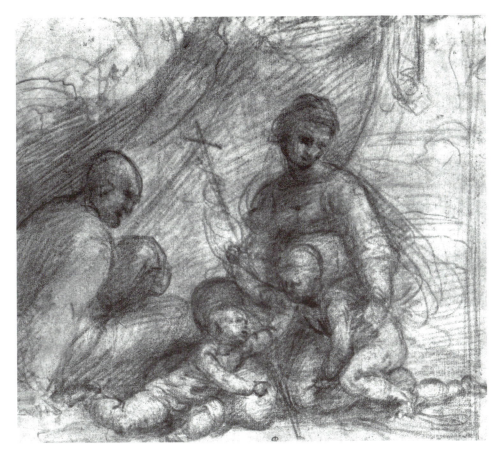

128. Fra Bartolommeo, *Holy Family*, black chalk heightened with white,
15·7 × 18·1 cm. London, British Museum, No. 1895-9-15-524.

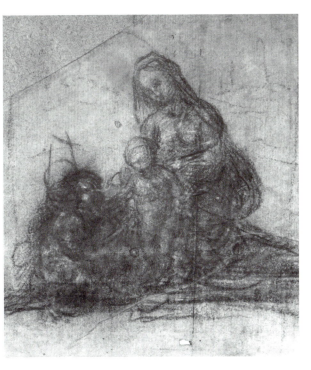

129. Fra Bartolommeo, *Madonna and Child with Infant Baptist*, black chalk on pink tinted paper, 13·6 × 10·2 cm. London, British Museum, No. 1860-6-16-103.

130. Fra Bartolommeo, *Madonna and Child with Infant Baptist*, black chalk, 14·1 × 12·4 cm. London, British Museum, No. 1860-6-16-104.

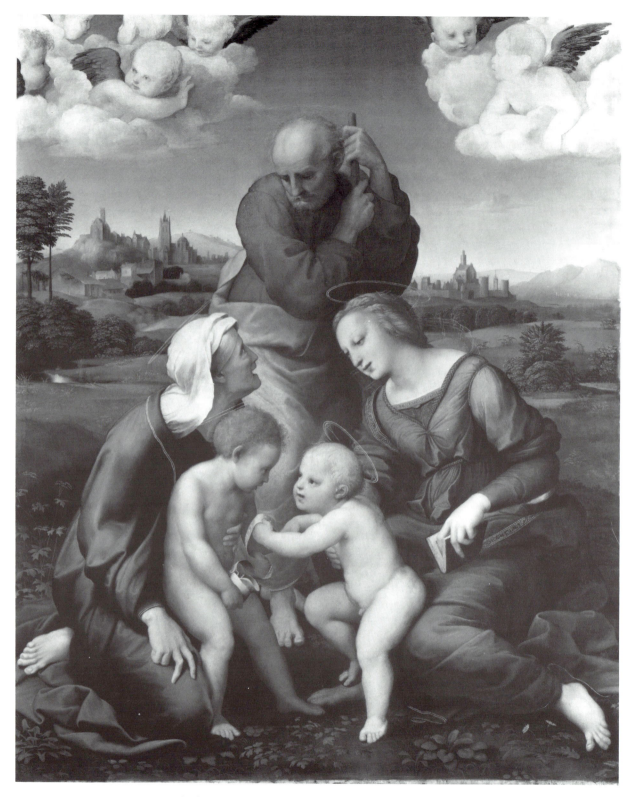

131. Raphael, *Holy Family with St Elizabeth and Infant Baptist* ('Canigiani Madonna'), panel, 131 × 107 cm. Munich, Alte Pinakothek, No. 476.

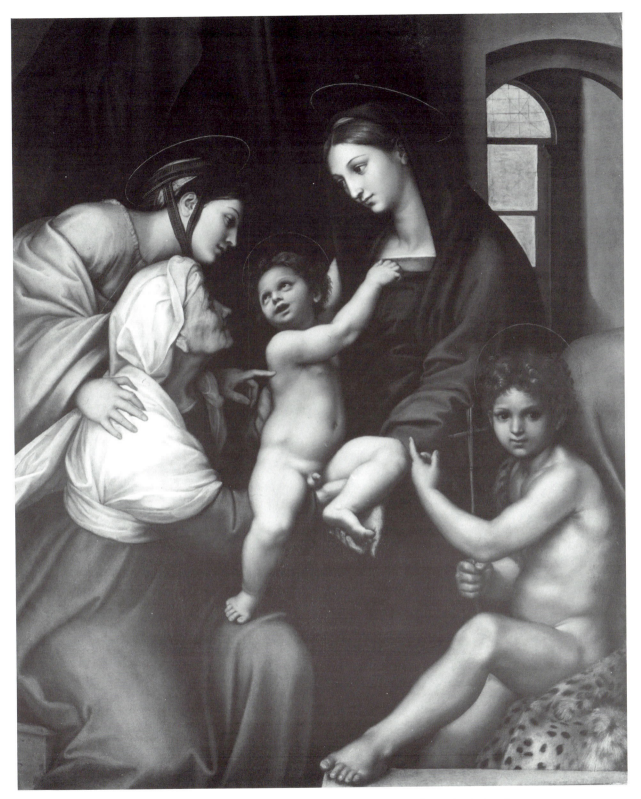

132. Raphael, *Madonna and Child with Young Baptist and SS Elizabeth and Catherine of Alexandria* ('Madonna dell'Impannata'), panel, 158 × 125 cm. Florence, Pitti, No. 94 (after restoration).

133. Albrecht Dürer, *Apocalypse*, title-page, woodcut, 43·5 × 29 cm. London, British Museum.

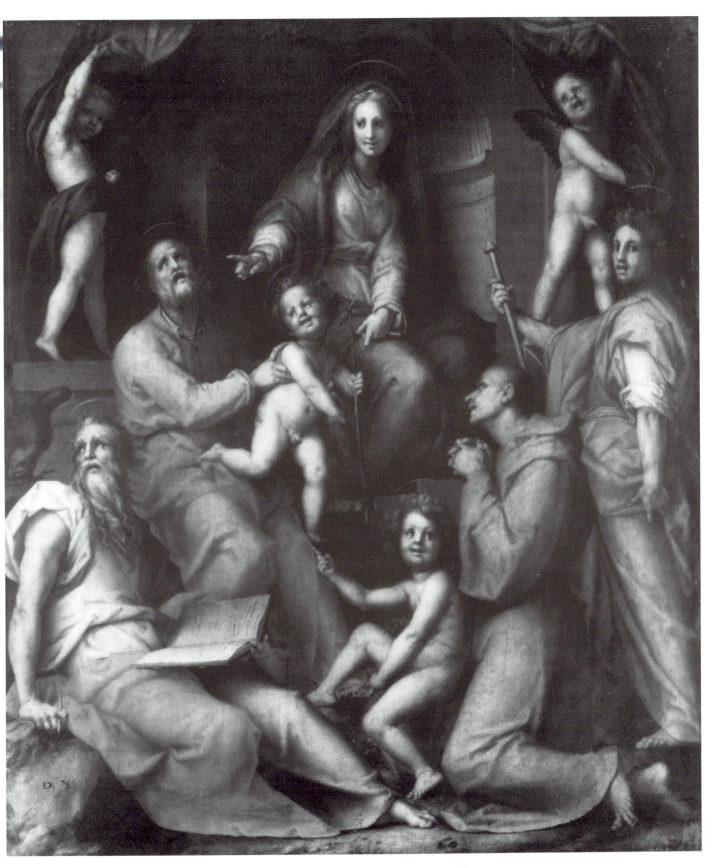

134. Jacopo Pontormo, *Madonna and Saints*, paper on panel, 218 × 189 cm.
Florence, San Michele Visdomini.

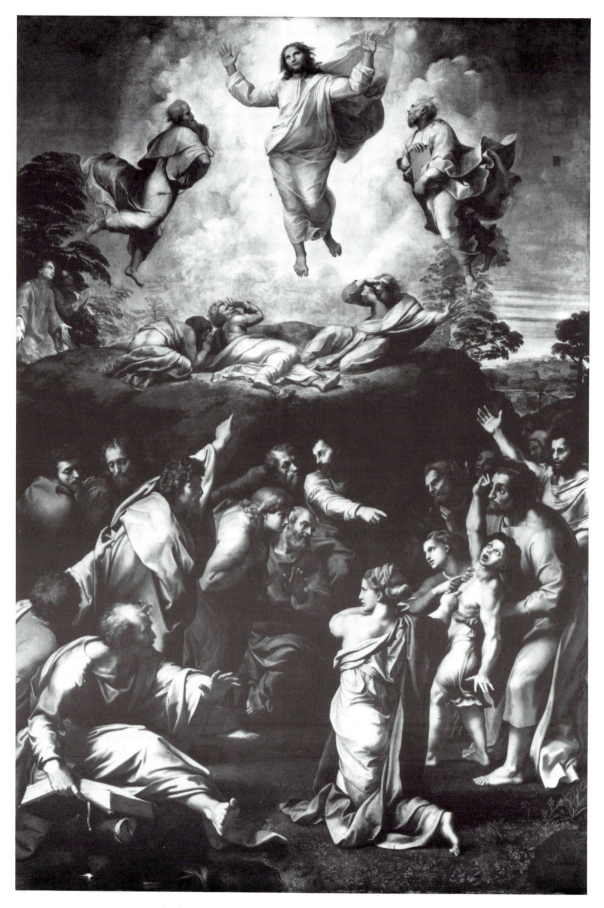

135. Raphael, *Transfiguration*, canvas transferred from panel, 405 × 278 cm.
Rome, Pinacoteca Vaticana, No. 333.

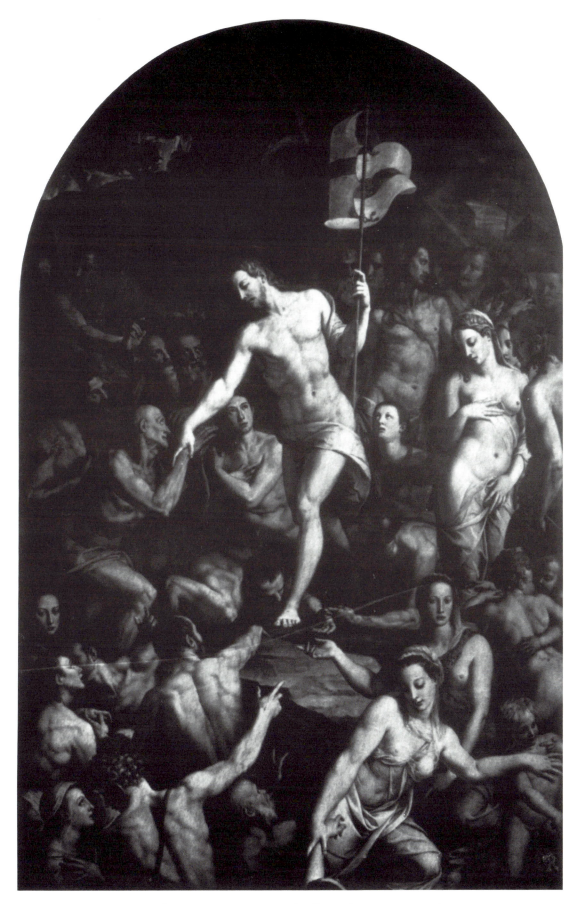

136. Agnolo Bronzino, *Harrowing of Hell*, panel, 443 × 291 cm. Florence,
Santa Croce.

8

THE ALTARPIECE IN THE BASSANO WORKSHOP: PATRONAGE, CONTRACTS, AND ICONOGRAPHY

Michelangelo Muraro

'Notto sia come feci mercà io Jacomo cum Ser Antoni et Pasqual Zatta de farli una pala a l'altaro grande . . .' (1548, c. 7ᵛ)

[Be it noted how I, Jacomo have made an agreement with Ser Antoni and Pasqual Zatta to paint a picture for the high altar . . .]

THANKS to a manuscript written between 1511 and 1588 we are able to trace all the phases in the execution of altarpieces in a workshop of the Veneto: from the event leading to the commission to its completion. This manuscript consists of a ledger (*il Libro secondo di dare e avere della famiglia dal Ponte con diversi per pitture fatte* [Plate 137]) arranged, more or less, according to the double-entry bookkeeping system recording the Bassano family's activities during the first half of the sixteenth century.[1] During this period, the shop's supervision passed from Francesco il Vecchio to Jacopo, when both patronage and artistic production assumed a different character and caused a qualitative change.

I discovered the manuscript in 1947 and subsequent study of it enabled me to enrich the corpus of works by Francesco and Jacopo dal Ponte Bassano through various publications. I was also able to point out to the organizers of the 1957 Bassano exhibition many hitherto unknown pictures, murals, and sculpture by them.[2] Thanks again to the manuscript, entire pictorial cycles by the

[1] The period with the most complete documentation is from 1520 to 1555. About fifty altarpieces are mentioned in the text. I have devoted an entire academic course to the contents of this manuscript for which the lecture notes have been given to the Biblioteca Marciana, Venice, MS. 367, c. 204: M. Muraro, *Pittura e società: Il libro dei conti e la bottega dei Bassano*, Lezioni di storia dell'arte, Università di Padova—Facoltà di Magistero, 1982–3. For the complete text, see M. Muraro, *Il Libro secondo di Francesco e Jacopo dal Ponte* (Bassano del Grappa, 1992).

[2] Cf. P. Zampetti (ed.), *Jacopo Bassano*, exhibition catalogue (Venice, 1957); M. Muraro, 'The Jacopo Bassano Exhibition', *The Burlington Magazine*, 99 (1957), 291–9.

Bassano family, such as those at Tezze sul Brenta, were discovered and repaired during the tenure of my direction of the mural restoration department of the Superintendency of Monuments for the Veneto.[3]

Furthermore, the text's 138 folios also contain much useful information regarding social aspects of art history and especially on its 'material culture'. It is in this area that I have focused my research in recent years,[4] hence the manuscript's particular importance for such matters as the social status of artists in a provincial community, their relation with patrons, types and forms of contracts, pictorial techniques, and the workshop organization of the Bassano family who had to satisfy the esthetic demands of a clientele spread out in a vast region of the Veneto centred on the town of Bassano (Plate 138).

The present study attempts to retrace the phases of how the Bassano carried out an altarpiece: an itinerary which may prove useful to the history of other works produced in the Veneto during the sixteenth century.

Diversity of Occasion

'Noto sia come a dì dito fezi marcà mi Francesco con li masari del comun da Borso de farli una palla a l'altar grando. . . .' (c. 14v)

[Be it noted that on said day I, Francesco, made an agreement with officials of the town of Borso to make a picture for the main altar . . .]

Francesco il Vecchio wrote this on 9 September 1537. The notation does not say anything about why the parish of Borso ordered this new altarpiece nor is it possible to make any deductions about it. But useful suggestions can be found in studies by Giovanni Mantese and Franco Signori, diligent scholars of provincial piety in this region.

The circumstances prompting the commission of an altarpiece were various: the reconstruction of a sacred building, the creation of a new chapel, or the establishment of a new religious confraternity which required a picture for the altar around which the faithful could gather and celebrate. Often it was the bishop who, in the course of a pastoral visitation, suggested that an altarpiece be made ('fiat pala') or renewed ('pala renovetur').[5]

Old altarpieces ruined by humidity or darkened by candle smoke were replaced for reasons of decorum as well as for changes of taste.[6] Therefore during the period under discussion a gradual

[3] Cf. M. Muraro, *Pitture murali nel Veneto e tecnica dell'affresco*, exhibition catalogue (Venice, 1961), 113–14, ill. 81.

[4] Id., 'I conti in tasca a Lorenzo Lotto', *Notizie da Palazzo Albani* (*Omaggio a Lorenzo Lotto*, Atti del Convegno, Jesi-Mogliano, 1981), 13 (1984), 144–64; id., 'Pittura come mestiere', in C. Furlan (ed.), *Il Pordenone*, Atti del convegno internazionale di studio, Pordenone, 1984 (Pordenone, 1985), 217–19.

[5] See e.g. the documents of the pastoral visits published by G. Mantese, *Bassano nella storia: la religiosità* (Bassano del Grappa, 1980), 110; F. Signori, *Storia di Pove e dei Povesi* (Bassano del Grappa, 1985), 199–200.

[6] P. Humfrey and R. MacKenney, ('The Venetian Guilds as Patrons of Art in the Renaissance', *Burlington Magazine*, 128 [1986], 322) note in this regard that also in Venice such substitutions caused the loss of many 15th-c. masterpieces.

shift can be observed from the rigidity hitherto characteristic of provincial religious piety towards an acceptance of freer Renaissance forms.

Patronage

'Misier pre' Nadale da Feltre de' dar per farli una palla a una sua giesia, cioè el quadro de le figure, et prima la Madonna, san Martin a man destra et sant Antoni abate alla sinistra, monta ducati nove . . .' (c. 81ᵛ)

[Nadale da Feltre owes for an altarpiece for his church; that is [for] the picture with figures and foremost the Madonna [with] St Martin at the right and St Anthony Abbot at the left, amounting to 9 ducats . . .]

Thus wrote Jacopo in 1542. In the production of altarpieces, it was this type of religious patronage (consisting of priests, priors, abbesses, etc.) that primarily occupied the Bassano family. Other commissions came from confraternities which were of a purely devotional nature although there is also an example from a professional guild: that of the Bassano furriers. Then there were the parish congregations and, eventually, private individuals who became the most frequent type of customers.

Being devotional objects as well as vehicles for the display of social status,[7] sometimes these altarpieces commissioned by private citizens were either installed in patrician oratories or in various churches where rights of patronage were enjoyed:

'. . . altarpiece made for said sire Bastian and [his] brothers for his altar' (c. 13ᵛ, dated 10 Apr. 1528).

As an act of munificence, a single family might donate the picture for the high altar of a parish church as was the case with the brothers Pasquale and Antonio Zatta who ordered and paid for the costly painting carried out by Jacopo in 1548 destined for the church at Tomo (Plate 139) in the Feltre area:

'Notto sia come feci mercà io Jacomo cum ser Antoni et Pasqual Zatta de farli una pala a l'altaro grande de la gesia de la vila de Tom del teritorio de Feltre . . .' (c. 7ᵛ)

[Be it noted that I Jacomo agreed with ser Antoni and Pasqual Zatta to make for them a large altarpiece for the church of the town of Tom in the territory of Feltre . . .]

On the whole, the patrons recorded in our manuscript present various kinds of scattered but very active group piety (Plate 140).[8]

[7] 'The patron who invests money in such works seeks prestige in open display, usually in church, a public place where a chapel presents the prestige of a family,' writes in this regard A. Conti in an essay essential to our study and which will be cited several times: 'L'evoluzione dell'artista', in G. Previtali (ed.), *Storia dell'arte italiana*, pt. 1, ii (Turin, 1979), 186.

[8] For the general religious situation in Bassano during the 16th c., for the appearance of individual as well as collective devotional manifestations and also for public customs and private ceremonies, see G. Fasoli and G. Mantese, 'La vita religiosa dalle origini al XX secolo', in G. Fasoli (ed.), *Storia di Bassano* (Bassano del Grappa, 1980), 451 ff.

The Figure of the Intermediary

When the confraternity or community decided to order an altarpiece,[9] generally the painter was contacted directly either through an administrator accompanied by a delegation of members or citizens, or by communal officials sometimes with the parish priest. Occasionally, their names were inscribed on the frame or within the painting itself—a custom that gradually disappeared during the sixteenth century but of which we still have an example in the altarpiece by Francesco Bassano painted for the church of Spirito Santo at Oliero (Plate 143). The inscription on this picture, published in abbreviated form by Giuseppe Gerola[10] at the beginning of this century, can now, thanks to our manuscript, be interpreted as:

'. . . being sire Martin de Franceschin, master Zulian blacksmith, sire Bastian de Zan Donà, sire Francesco de Scalco officials . . .' (c. 56v).

For the commission of the altarpiece painted by Jacopo Bassano in 1541 for Fonte, a village near Asolo, a special citizens' committee was appointed to deal with the painter:

'. . . li homini de ditto comun elletti per far ditta opera . . .' (c. 27v)

[The men of said commune elected to have said work made . . .]

Occasionally, the name of the intermediary appears along with the patrons' in the manuscript's notes. Often this person was a cleric such as 'pre' Gregorio Nichele' for the territory around Marostica. It seems to me that such people must have been particularly important for the choice of iconography. Clearly, these were men of some education and their intervention explains the special quality of those works painted by the Bassano family for remote mountain villages with only a few dozen souls.[11]

Indeed, pre' Gregorio turns out to have been a kind of agent who looked after Jacopo Bassano's interests—pressing for higher prices and more favourable terms on the painter's behalf. This is how he expressed himself to the artist in a letter included in the manuscript:[12]

'Eccelente maestro Iacobo, per la presente avisovi qualiter che l'è concluso de darvi ducati undese de l'opera . . . Fati quello vi piace, credo che faresti ben perchè questa opera tirerà driedo de le altre . . . da altri, è stà dito de farla per nove, a ogni suo intereso e compresi eciam la calcina, e tamen a vui si darà la calcina e li ducati 11.'

[9] In the case of confraternities, the decision required agreement by the majority. In fact, the *Statuti della Corporazione del Corpo di Cristo* of Bassano dating from the 15th c. prescribed in its 35th chapter: '*In qualunque capitolo in che trattar si debba di far spese che oltrepassino la somma di lire dieci, dovranno intervenire almeno due terzi dei confratelli . . .*' [In whatever meeting, when the matter of an expense arises amounting to more than 10 lire at least two-thirds of the membership must be present . . .]; Mantese, *Bassano nella storia*, 95, 307.

[10] G. Gerola, 'Il primo pittore bassanese: Francesco da Ponte il Vecchio', *Bollettino del Museo Civico di Bassano*, 4 (1907), 90.

[11] On the role of intermediaries, see also P. Humfrey, 'The Venetian Altarpiece of the Early Renaissance in the Light of Contemporary Business Practice', *Saggi e memorie di storia dell'arte*, 15 (1986), 76–7.

[12] Muraro, *Il Libro secondo*, 299.

[Excellent master Jacopo, for the present I inform you that it has been decided to pay you eleven ducats for the work . . . Do as you please, [but] I believe you would do well [to accept this] because this work will attract others . . . it is said that others would do it for nine [ducats] all inclusive—lime as well and for you too lime will be supplied plus the 11 ducats]

The Fame of an Artist

The manuscript also permits us to see with what high regard Jacopo dal Ponte was held in his world. In 1541, the city council of Bassano officially exempted him from both ordinary and extraordinary taxes '*propter excellentiam eius artis*'.[13] Among other things, the manuscript reveals that frequently private patrons as well as groups competed for works by the Bassano family often paying out sums for altarpieces and paintings far ahead of time:

'Adì dito recevì dal contra scrito per capara de dita pala un scudo d'oro . . .' (c. 127[r])

[On the said day I received a down payment of one gold scudo for said altarpiece]

appears under the date of 8 July 1532 whereas actually the picture was only painted in 1537.

In fact, in the period here considered Francesco and Jacopo Bassano (Plate 141) seemed to have had a virtual monopoly on sacred art in the vast area extending from the banks of the Brenta to the mountainous highlands of Asiago and Feltre; a territory that is still subdivided into five provinces (Vicenza, Padua, Treviso, Venice, and Belluno) and dependent upon six dioceses (Feltre in addition to the five already mentioned).

During the first half of the century, only in two instances were altarpieces made for quite distant towns. In the case of Oriago (Plate 151), at the mouth of the Brenta, near Venice, the commission from the members of the aristocratic Moro family may have been due to the fact that they had connections with Venetians resident in Bassano.[14]

Clearly, the regional success enjoyed by the Bassano family was because both artists and patrons shared a common outlook and mentality rooted in ancient traditions. What has been written of Moretto da Brescia is particularly apt also for Jacopo Bassano, himself a confraternity member (Santa Maria e San Giuseppe[15]):

[he] represents a rather rare phenomenon of an artist of high quality who gladly accepted a provincial role, who knew how to satisfy the artistic requirements of his patrons . . . who gratefully absorbed most of his

[13] G. Crivellari, 'Spigolature Dapontiane', in *Bassano e Jacopo da Ponte* (Bassano del Grappa, 1893), 10.

[14] The Moro family used their rights of patronage in the parish church of Oriago; see G. Liberali, 'Lo stato personale del clero diocesano nel secolo XVI', *Documentari sulla Riforma Cattolica pre e post-Tridentina (1527–1577)*, ix (Treviso, 1975), 192–3. For the history of the church at Oriago that was originally dedicated to St Martin and subsequently renamed in honour of St Mary Magdalen, see A. Niero *et al.*, *Culto dei santi nella Terraferma Veneziana* (Venice, 1967), 39–41.

[15] Begun perhaps in 1521, this group obtained permission to have its headquarters in the little church of S. Vittore. It is interesting to note that the painter Francesco Nasocchio was among its first members (Mantese, *Bassano nella storia*, 102–3). Several times, Jacopo was elected as its administrator ('Gastaldo'); Biblioteca dell'Archivio del Museo di Bassano, MS 261-c-1-38: G. Crivellari, *Apografi di documenti riguardanti i pittori bassanesi Da Ponte e Nasocchi*, cc. 37[v], 38[v], 41[v].

output. Furthermore, he did not limit himself to the expression and interpretation of a particular religious climate; rather, he participated in it and, to an extent, helped to shape it.[16]

Contracts and their Formulae

'Yhesus Maria, 1529, adì 28 decembre. Noto sia como adì dito fesemo marcà de la palla de la Granara con misier pre' Cabriele Zentile et masari, como apar per un scrito de man de misier Zuan Falconcino, de presio de ducati cinquanta, zoè 50 a L.6 s.4 per ducato; et a termene de darmi fina che sia finita ducati 25, et con sarà finita ducati dodexe e mezo a l'ano, che son due ani da poi sarà finita; con pati se non li piacerà che la faza stimar per persone non suspete, et se sarà stimata de manco de diti ducati 50 me dia manco, et se sarà stimada de più me dia la mità de quel più. Fazandoli in dita pala la Madona con el Fiolo in brazo, san Piero de sopra, san Rocho de soto; a tute mie spese de legname et tela et oro, monta L. 310 s.o.' (c. 57v)

[Jesus Maria, 1529, on the day 28 December. Be it noted that on said day we made an agreement for the Granara altarpiece with master Cabriele Zentile, priest, and officials as appears in the text written by master Zuan Falconcino for the price of 50 ducats; that is 50 at 6 lire 4 *soldi* per ducat. They owe me 25 ducats during the period until it is finished and then, on its completion, $12\frac{1}{2}$ ducats a year for two years from the time it is finished. It is agreed that if they don't like it, it will be valued by impartial persons and that if it be judged worth less than 50 ducats that they give me less; and that if it be valued more that they give me half of the increase. Making for them in said altarpiece [are] the Madonna with her son on her arm, St Peter above, St Roch below, [with] the wood, canvas and gold [to be] all at my expense amounting to 310 *Lire* 0 *soldi*.]

After initial contact had been made, the next phase consisted of contract negotiations. These were sometimes laborious as betrayed by the occasional corrections of prices in the manuscript as a consequence of such discussions.

In the case of less important altarpieces, an entry in the main ledger (*libro mastro*) probably sufficed to register an agreement between the parties concerned. On the other hand, for particularly important and costly works an official document might be drawn up by a notary ('*como apar nel scritto de misier Francesco Colbertaldo nodaro*', the Fonte altarpiece, c. 27v), by the so-called intermediary ('*como apar per un scrito de man de misier pre' Gabriele*', the Foza altarpiece, c. 27v), or by the painter himself ('*como apar per un scritto de mia man, qual è ne le man de ditti homeni*', the Onara altarpiece, c. 32v).

The manuscript's notations amount to a summary of the official documents and also echo the writer's style: above all the elder Francesco Bassano who wrote in a typical quattrocento hand and with a fussiness from which Jacopo shrank. His was a more casual script as he gradually assumed the characteristic features of the High Renaissance.

Significantly, the text begins with an invocation to '*Yhesus Maria*' along with the date and then opens with the impersonal communication 'be it noted'. Then come a series of names and the

[16] C. Guazzoni, *Moretto: Il tema sacro* (Brescia, 1981), 8.

requirements of the contracting patrons followed by descriptive details of the object negotiated: the altarpiece and possibly also its ultimate destination ('*a l'altar grando*' [cc. 14V, 93V], or '*a lo altaro de la Natività de s. Zuanno Batista . . .*' [c. 27V]). Then the agreed upon price is dealt with (expenses included or not), the date of consignment, the kind of payment and schedule for it with, occasionally, a clause anticipating arbitration in case of dissatisfaction.[17] Sometimes the patrons' signatures were added thus:

'Io Bastian sono contento et laudo el sora scritto pato fato con maestro Francesco dal Ponte . . .' (c. 39V)
[I Sebastian am satisfied [with] and approve the above written agreement made with master Francesco dal Ponte . . .]

The Choice of the Iconography

'In la dita palla li va santa Orsola in mezo, san Valentin d'una banda et da l'altra s. Josef . . .' (c. 49V)
[In said altarpiece, St Ursula goes in the middle, St Valentine to one side, and St Joseph on the other.]

In the agreement, the description of the subject is very brief, limited only to a list of saints to be represented. In a certain sense the iconographic choice was obligatory even when it was not supposed to repeat the subject of a work to be replaced. Generally, the patron saints of the community were represented on either side of the Madonna if the altarpiece was destined for the high altar of a church. Similarly, the patron saints of the various confraternities dear to popular piety occupied these lateral positions if the altarpiece was intended for such a group.

As one might expect, among the more than fifty altarpieces documented in the manuscript, the favourite subject by far was the Virgin Mary. Among the saints, those associated with the plague were also popular, above all St Roch, followed less frequently by John the Baptist and St Sebastian. The numerous representations of the Baptist may also have been due to the presence of hermits in the region.[18]

One of the most interesting subjects is the altarpiece Jacopo Bassano painted for the confraternity of the Holy Conception of Mary which had its seat in the Franciscan church of San Girolamo in Asolo. It represents the *Immaculate Conception* (Plate 144) as the inscription proclaims in large letters on the throne base that amounted to virtual propaganda for the doctrine 'so dear to Franciscan Marian theology'[19] that only received official sanction in the dogma of 1854 (Plate 145).

[17] Oddly, the size, which must have been an important factor in determining the work's price, is rarely indicated. On contracts, besides H. Glasser (*Artists' Contracts of the early Renaissance* [New York and London 1977]), see Conti, 'L'evoluzione dell'artista', 127–30 n. 8 who refers particularly to the situation in Tuscany.

[18] On the hermit life in the Bassano area, see G. Mantese and E. Reato, *S. Vito di Bassano* (Bassano del Grappa, 1973), 27–34.

[19] Mantese, *Bassano nella storia*, 153 n. 6. This altarpiece, signed by Jacopo and dated 1541, hitherto believed lost, wound up a century ago in the parish church of Sossano, my home town; M. Muraro, 'Ritrovamento di un'opera di Jacopo Bassano', *Arte veneta*, I (1947), 287–8. This picture is the origin of my interest in and study of the Bassano family.

These contracts did not go into the matter of formal composition because usually when these agreements were drawn up there was also an accompanying preparatory drawing.[20] Thus in 1531 Francesco Bassano promised to carry out an altarpiece for the *scuola* of Santa Maria della Rosà 'according to the drawing I gave them' (c. 41ᵛ). Jacopo on 27 December 1544 agreed with 'Zuanne the rural parish priest of Cartiggiano . . . to make an altarpiece according to the drawing I made for him' (c. 114ᵛ). The preparatory drawing for the altarpiece of the church of the Trinity at Angarano (Plate 146) actually appears on the same sheet as the contract: '. . . according to the drawing in the hands of said Egidio, the priest, which also contains the text' (c. 24ᵛ).

Occasionally, the patrons indicated an already extant picture as the model for the painting to be carried out: '*sul sesto de quela de s. Polo*' (c. 14ᵛ) [according to the shape of that in San Paolo].

Information on Painting Technique

The manuscript also provides interesting data on the technique of the work carried out: the altarpiece could be done entirely on canvas called '*terlixe*' or '*tela di Costanza*' usually costing between 13 and 16 *soldi* per *braccio* (the same price Lotto paid in Venice).[21] On the other hand, sometimes the altarpiece ordered had to be done partly as a painting and partly as statuary or as a relief ('*de mezo relevo*',[22] Plate 147). Other contracts refer to paintings in fresco on the wall directly above the altar: mural altarpieces or '*pale da muro*' as the Bassano family called them (Plate 148).

According to the practice of painters' workshops then, cartoons were used. Therefore, a successfully resolved composition might be used more than once. The Onara altarpiece (1546, Plate 150), for instance, clearly involved the same cartoon which Jacopo had used earlier for the church of the Magdalen at Oriago (Plate 151). This picture, hitherto attributed to Francesco Vecellio, and dated in 1536,[23] actually is from 1543 and is so recorded in the manuscript:

'Notto sia come adì ultimo aprile 1543 romasti d'acordo con il magnifico misier Baldisera Moro et il reverendo misier pre' Zuanmaria, plebano de la villa de Oriago, de farli una palla a l'altar grande de la chi[e]sa de ditta villa. Et d'acordo semo romasi che mi dieno ducati cento . . .' (c. 16ᵛ)

[Be it noted that on the last day of April 1543 I agreed with the noble messer Baldisera Moro and the

[20] The preparatory drawings for the frescos at Cartigliano, now preserved in the Louvre, see M. Muraro ('Gli affreschi di Jacopo e Francesco dal Ponte a Cartigliano, *Arte veneta*, 6 [1952], 42–62).

[21] L. Lotto, *Il 'Libro di spese diverse' con l'aggiunta di lettere e d'altri documenti*, ed. P. Zampetti (Venice, 1969), 234, 241, 255.

[22] Except for the blue starry sky, the altarpiece made by Jacopo for the church of S. Pietro at Godego (Plate 147) consisted entirely of sculpture (see n. 2 above). The manuscript informs us that it consisted of a Crucifix 1·2 m. high, carved in

the round, flanked by the Madonna and St John in polychromed half-relief. Dismembered during the course of time, only Christ and St John survive. Following the manuscript's account, I went to the site where I discovered the broken pieces of these figures heaped in a corner of the church which had been virtually abandoned after the new parish church had been built.

[23] F. Valcanover, 'Recupero di un dipinto di Francesco Vecellio', *Arte veneta*, 7 (1953), 166.

reverend parish priest Zuanmaria of the town of Oriago to make for them an altarpiece for the high altar of the church in that town. And we remained in agreement that they give me 100 ducats . . .]

Evidently, cartoons formed part of the workshop's stock of equipment because in his testament Jacopo decided that most of his drawings would go to Battista and Girolamo, the least talented of his sons, who would be in greater need of models for their compositions ('*invention*').[24]

Lists of purchases and notes on expenses recorded in the manuscript also mention the materials used for the paintings: '*lacca di grana*' (either red lake pigment or the material for varnish), casein glue ('*colla fatta col formaggio*'), oily blue ('*azuro da olio*'), azurite ('*azuro todesco*'), ground cinnabar ('*cenaprio trido*'); lapis lazuli, on the other hand, is never mentioned—a colour which Lorenzo Lotto liked very much for his refined palette.[25] However, one notices with what care the Bassano family selected their materials and the concern they took for the painting's durability. For instance, Francesco complained that the lime supplied him for some frescos was poorly prepared ('*mal cotta*' c. 1v); while Jacopo had a pavement laid behind his altarpiece ('*el pavimento di drio*') in the church at Mussolente so as to protect it from damp (c. 49v).

Workshop Organization

The manuscript also permits us to see how the Bassano's busy workshop was organized and how it functioned. During the period recorded by the manuscript it was Francesco who, as head of the shop, gave it solid direction scrupulously recording agreements and payments in the main ledger (*libro mastro*) even when only his sons were doing the work. On his death, which occurred between June and July of 1539, the workshop's direction was taken over by Jacopo.

Besides the masters, one also notices the activity of collaborators and helpers variously called labourers, apprentices, and pupils such as Zillio Zilliolò whose contract of apprenticeship ('*contratto di assunzione*') is preserved on one of the manuscript's pages:

'Adì 30 settembre 1550.
Notto sia come adì ditto del sopraditto anno in casa de misier pre' Evangielista, al monasterio de le monache de santo Jeronimo nel borgo del Leon, restassemo d'acordo mio barba Batista Zilliolo et io Jacomo che ditto sier Batista mi dà suo fiolo, cioè Zillio, a star cum mi per anni otto et io gli facio le spese, el vesto et l'insegno l'arte . . .' (c. 132r, Plate 149).

[30 September 1550.
Be it noted that on the above mentioned day . . . in the house of Evangielista, the priest, in the convent of the nuns of St Jerome in the town of Leon, we agreed, my uncle Batista Zilliolo and I, Jacomo, that ser Batista give me his son Zillio who will stay at my expense, dress him, and I will teach him the profession . . .]

[24] L. Alberton Vinco da Sesso and F. Signori, 'Il testamento di Jacopo Dal Ponte detto Bassano', *Arte veneta*, 33 (1979), 161–4.

[25] Lotto, Il '*Libro di spese diverse*', 66, 98.

Importance of the Frames

The shop's activities also involved other types of craftsmen: masons and, above all, carpenters and carvers. In 1546, Jacopo wrote:

'Fezi marcà cum mio compar Piero, fiolo de sier Gasparo tentor, che ditto maistro Piero marangon mi facie a tutte mie spese, cioè de legnami e chiodi, un adornamento de la palla da Cartigian, como un desegno che ha visto . . .' (c. 99ᵛ)

[I made an agreement with my collaborator, Piero the son of Gasparo the dyer, that said master Piero, carpenter, make entirely at my expense (i.e. wood and nails) an ornament for the altarpiece from Cartigian, according to a drawing that he has seen . . .]

In fact, it was frequently left to the painter to find someone to make the architectural frame completing the altarpiece. Frames were an important factor in the evaluation of pictures as well as the means of harmonizing them with their sites.[26]

As mentioned earlier, painters furnished craftsmen with drawings. Sometimes these frames involved elaborate works of carpentry and carving destined to be entirely gilded. An example of such an important frame is that ordered by Jacopo from Jeronimo Scienza, a sculptor from Feltre then resident in Venice.[27] As for the gilding, it seems that one of Jacopo's brothers, Giambattista, specialized in this craft within the family's workshop.[28]

The expense of wood, labour, and packets of gold leaf (*centenari*) for the gilding made these frames particularly costly. From the manuscript's records it turns out that an altarpiece without frame cost about 70 *lire* (an average calculated from seventeen examples), whereas a complete work including the '*adornamento*' or frame, could range in price from 200 to 620 *lire*. The average price, based on twenty-one altarpieces, was 420 *lire*, i.e. five times the cost of the painting (Plate 142). In other words, the cost of materials accounted for a large part of the altarpiece's price and definitely exceeded the value of its design and actual painting.[29]

The reverse was true of frescoed altarpieces called '*pala da muro*' by the Bassano just because the labour was much more rapid and the expenses were limited to the preparation of plaster and the purchase of colours. On average they were valued at 25 *lire*, a very modest sum compared to the 70 *lire*—the average cost for an altarpiece. The price asked for adding a figure probably to a fresco

[26] On the relations between painters and carvers and the importance of frames, aside from my articles on Lotto and Pordenone (cited in n. 4 above), see Humfrey, 'The Venetian Altarpiece', 70 ff. For the situation in Tuscany during the Quattrocento, see C. Gilbert, 'Peintres et menuisiers au début de la Renaissance en Italie', *Revue de l'art*, 37 (1977), 9–28.

[27] Cf. M. Gaggia, 'Vittore Scienza intagliatore feltrino', *Archivio storico di Belluno, Feltre, Cadore*, 11 (1939), 1122–4.

[28] Such specialization within a painter's workshop was, at least in theory, prohibited in Venice. The painters' guild (*l'arte dei depentori*) was divided into specialties (*colonnelli*) and it was vigilantly seen to that each workshop kept to its exclusive activity; E. Favaro, *L'arte dei pittori in Venezia e i suoi statuti* (Florence, 1975), 68–9. But in Bassano there were not so many painters to justify the existence of a professional guild. But for their devotional needs, the painters seemed to have gathered in the Confraternity of S. Giuseppe (see n. 15 above).

[29] Cf. Conti, 'L'evoluzione dell'artista', esp. 146–7 n. 8.

was only 2 *lire* and 8 *soldi* (c. 95ᵛ), equivalent to a day's work for Jacopo (cc. 35ᵛ, 122ᵛ) which was an average daily wage for a professional painter.[30]

Aside from frames, the painter and his shop frequently received commissions for objects and furnishings which we would call accessories for altarpieces: predellas, lunettes, ciboria, shutters ('*cexendeli*') or '*coltrine*', which were curtains or canvases that protected the painting on the days it was not on view.

The custom of covering altarpieces and sacred images was recommended by bishops during the Catholic Reform so as to draw attention to minor cults of particular saints 'in contrast to those of the Cross, the Eucharist, and the suffering Christ'.[31] Interestingly, it was a cross that Jacopo painted on the curtain for the Fonte altarpiece (c. 27ᵛ).

Phases of Execution

On the average, twelve months went by between the day of the agreement and delivery of the finished altarpiece, although it took a maximum of three years for the one made for Spirito Santo at Oliero (1523) and a minimum of five months for that of Fara (1534).

Of course it must be stressed that these periods did not correspond to the actual time it took to carry out the picture because the painter and his assistants worked on many other objects at the same time. During the years when it is known that Jacopo worked at his father's side, the pace was much faster than when Francesco worked alone when long delays are recorded.

Delivery of the Altarpiece

The day established for the work's delivery, already specified in contractual agreements, usually coincided with one of the great feasts of the liturgical year (Easter, Christmas . . .) or on the feast-day of one of the saints represented in the picture—as was the case with the Tomo altarpiece (Plate 139), which Jacopo promised to hand over in July on the feast of St James ('*Festa di san Jacomo nel mese di luio*').

Sometimes the painter promised to deliver the painting for 'St Martin', a crucial day in the agrarian calendar. Usually the Bassano observed the terms of the contract. This applies also to Jacopo who, in the period covered by the manuscript and in the provincial ambience in which he operated, appears to have kept to the old, traditional rules of the profession, remote from the liberties taken by Renaissance artists who increasingly rebelled against restrictions and deadlines.[32]

[30] See Humfrey, 'The Venetian Altarpiece', 70 n. 12, who compares the fees received by Venetian painters with the wages of civil servants in the Venetian *Cancelleria* who ranked as citizens.

[31] G. Liberali, 'La diocesi delle visite pastorali', *Documentari sulla Riforma Cattolica pre e post-Tridentina a Treviso (1527–1577)*, vii, viii, pt. 1 (Treviso, 1976), 80.

[32] Conti, 'L'evoluzione dell'artista', 147 n. 8.

As for the manner of delivery, sometimes the patrons went to collect the altarpiece and directly supervised its installation as in the case with the Granara altarpiece:

'. . . fu mesa dita pala su l'altaro per el dì de san Rocho, la fu a tor sier Andrea Contesa, ser Jerolimo Baso et li masari de la iesia.' (c. 57ᵛ)

[Said altarpiece was installed on the day of St Roch (one of the saints represented). Ser Andrea Contesa, ser Jerolimo Baso and the church officials came to take it away.]

On other occasions it was the painter who saw to transport and installation—either because the agreed-upon price anticipated this expense or because the patron was billed for it. For instance, Francesco noted on 21 December 1523 regarding the work for Oliero (Plate 143): 'the said painting was set upon the altar for the feast of Christmas' [*mesi dita pala sopra l'altaro, fu per la festa di Natale*] (c. 56ᵛ). Even though the liturgy does not provide for special ceremonies for such occasions, the very fact that an important feast was chosen for the delivery date leads one to suspect that the event was elaborately celebrated by concourse of the faithful from the surrounding countryside. This is confirmed by a document published by Mantese which comes from the parish archive of Rosà, a locality near Bassano. This consists of a list of expenses for the ornaments used in the church of St Anthony Abbot including the following:

'1593, 1 agosto. Le palle delli altari novi soprannominati furono poste sopra detti altari, fatta prima solenne processione alla quale furono invitati li preti della villa circonvicini.' [33]

[1593, 1 August. The new altarpieces cited above were set upon the said altars after a solemn procession to which the priests of the nearby villages were invited.]

Arbitration in Case of Dispute

As already mentioned, often a clause was inserted in contracts that in case of dissatisfaction the matter would be submitted to arbitration ('*lodo arbitrale*').[34] In the agreement for the commune of Borgo, Francesco recorded on 9 September 1537:

'Et se non li piacese dita pala a diti masari et omeni . . . sia in libertà de farla stimar per persona inteligiente che non sia suspecta a le parte, et, se serà stimà de più jo abia solo la mità de quel più, e se serà stimà de manco abia quelo mancho . . .' (c. 14ᵛ)

[And should said altarpiece displease said officials and men . . . they are at liberty to have it judged by an intelligent person not suspected by either side. And if it is valued more, I would receive only half of this increase; and if valued less, I would have the lesser sum . . .]

Bassano's definition of the arbitrator as a 'person not suspected by either side' was qualified by

[33] G. Mantese, *Rosà, Note per una storia civica e religiosa della comunità nel contesto del territorio bassanese* (Vicenza, 1977), 282.

[34] The arbitrator as a legal figure began to be more common in Tuscany only towards the end of the Quattrocento and is an indication of the contractual parity between artist and patron; Conti, 'L'evoluzione dell'artista', 151 n. 8.

the term that he also be 'intelligent'—i.e. that he must have the necessary practical competence to judge the painting.

From the texts of these contracts one does not understand on what the estimate was to be based: whether on a mere evaluation of time and materials, or whether such factors as stylistic criteria or esthetic qualities were considered as might be implied from the occasional appearance of the phrase: *'se non li piacesse'* ['if they don't like it'].

Actually, unlike what befell Lorenzo Lotto, the Bassano, as far as we know, were only once (c. 36ᵛ) subjected to disagreements involving arbitration. On the contrary, they were occasionally paid more than the stipulated price because the patrons were so thoroughly pleased with the finished work.[35]

Forms of Payment

The history of an altarpiece did not, in the manuscript, end with the painting's delivery and installation; rather it continued for decades during which were recorded all the payments carried out in instalments. In the agreement the established price was always expressed in Venetian ducats accompanied by the equivalent value in *lire* of the Veneto, the currency of account.

Sometimes it can be seen that after an initial cash deposit, equivalent to the down payment, the rest was paid in barter—agricultural produce or goods varying in nature according to the season or the patron's origin, such as wood from the mountain villages either to be worked or burned, wheat, cereals and wine from villages of the plain, or olive oil from the hill towns. All these products were precisely evaluated by the painter according to how much they currently fetched at market ('*quanto valeva in piazza*'), i.e. according to the prices reached that day at the market of Bassano.[36]

When payments were made entirely in cash, it is interesting to note that although the contract referred to ducats, only a part of the amount was paid in gold coin, while the rest was given in '*moneta piccola*'.[37]

Payment was seldom completed on delivery of the altarpiece: this could stretch over a long time in more or less regular instalments as was the case with the picture for Cartigliano for which monthly payments of three *lire* were paid in advance until the entire sum was paid (c. 114ᵛ).

In several examples of civic commissions, it was clearly the entire community which shared in the costs; the manuscript contains lists of the neighbourhoods involved each with its quota expressed in figures corresponding to the number of hearths. In other cases, instead of payments, cession of credits or income are recorded consisting of rights to collect rents on property belonging to religious orders and confraternities.[38]

[35] Lotto, *Il 'Libro di spese diverse'*, 60, 96. On the custom of rewarding an artist with a gift in addition to the agreed fee, see Conti, 'L'evoluzione dell'artista,' 159 ff.

[36] Ibid. 156.

[37] Ibid. 158–9.

[38] Ibid. 156.

Usually such payments were made regularly, sometimes even ahead of time. But cases of delay and insolvency were also frequent and in such instances our painters who were very careful to keep their accounts balanced, resorted to notaries and magistrates in order to obtain what was owed them down to the last penny. This was the case of the Oliero altarpiece (Plate 143). Only through the intervention of judicial authorities ('*comandamenti, pegnore et oficiali et procuratori*') did Francesco finally obtain an order of credit prepared by the notary Bastian Squario, which was signed by his debtors.[39] Nevertheless the collection on this picture went on for fifteen years before the Bassano could close the account with a sign of *solvit*. This *solvit* is the final goal of the itinerary I have attempted to reconstruct.

[39] F. Signori, *Campese e il monastero di Santa Crocz* (Bassano del Grappa, 1984), 238.

137. Page from ledger of the Dal Ponte family, c. 39ᵛ: agreement for the altarpiece made for the Confraternity of San Sebastiano at Oliero drawn up by Francesco il Vecchio, 24 Jan. 1529. Venice, Muraro Collection.

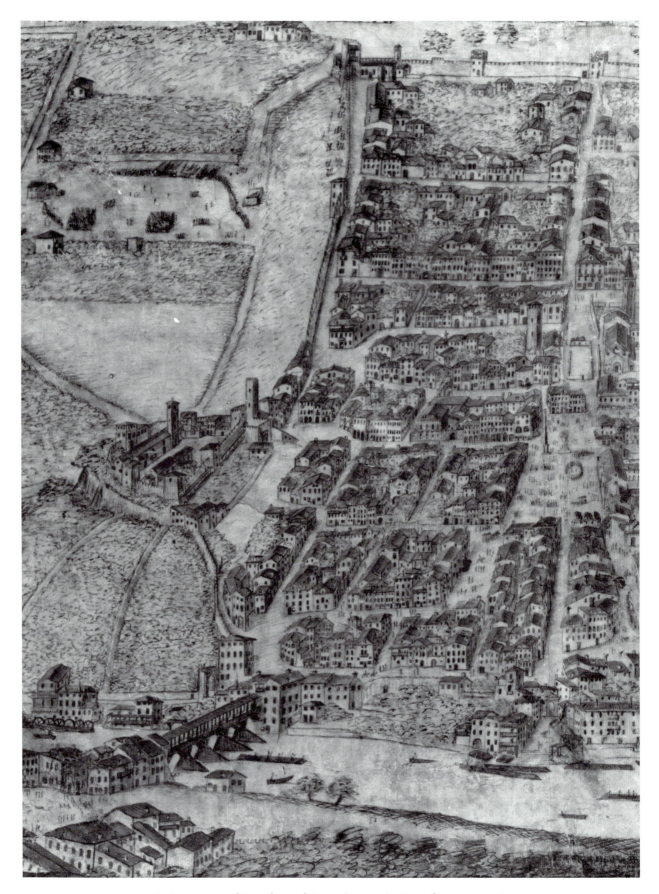

138. Francesco and Leandro Dal Ponte (Bassano), *Map of Bassano*, 1518–
1610 (detail). Pen drawing in reddish ink and watercolour, 122 × 56·5
cm. Bassano, Museo Civico.

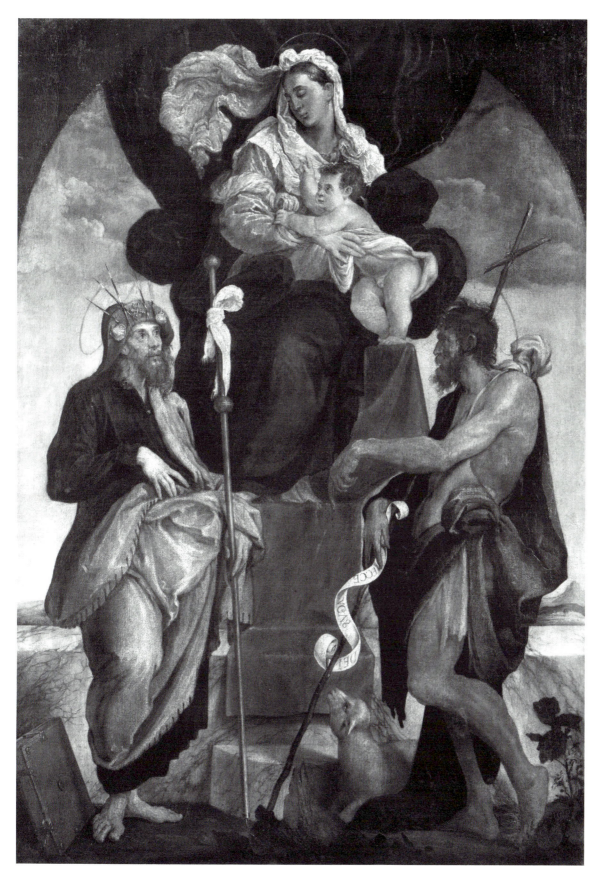

139. Jacopo Bassano, *Madonna and Child with SS James and John*, 1548, canvas, 186 × 132 cm. Munich, Alte Pinakothek, No. 5217.

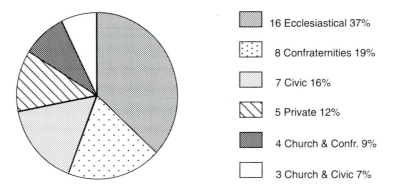

140. Chart showing the types of patrons who commissioned altarpieces from the Bassano family, 1521–1551.

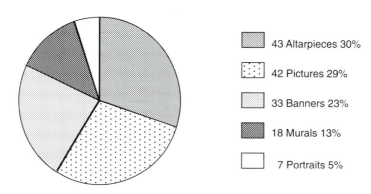

141. Chart showing the artistic production of the Bassano family between 1520 and 1555.

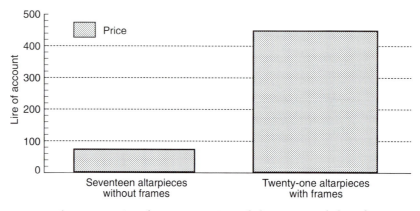

142. Chart comparing the average prices of altarpieces and their frames expressed in *lire*.

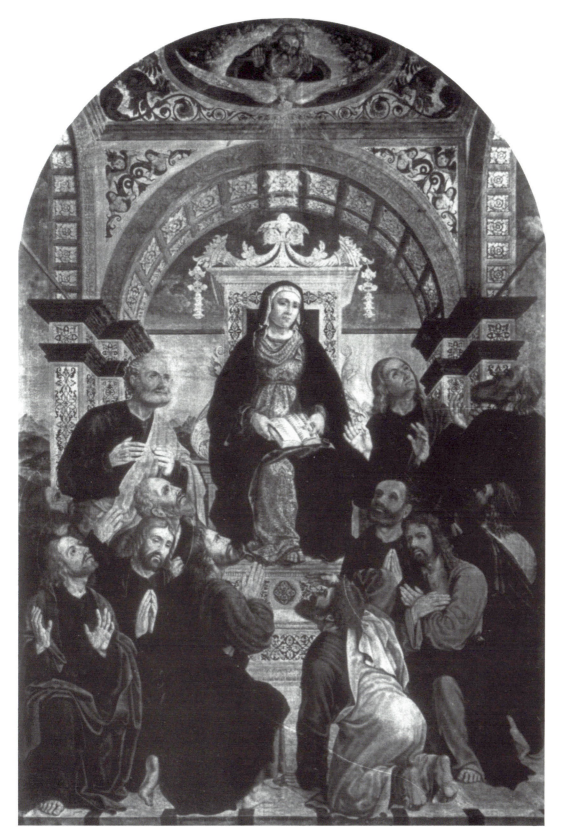

143. Francesco Bassano, *Pentecost*, 1521, canvas. Oliero (Vicenza), parish church.

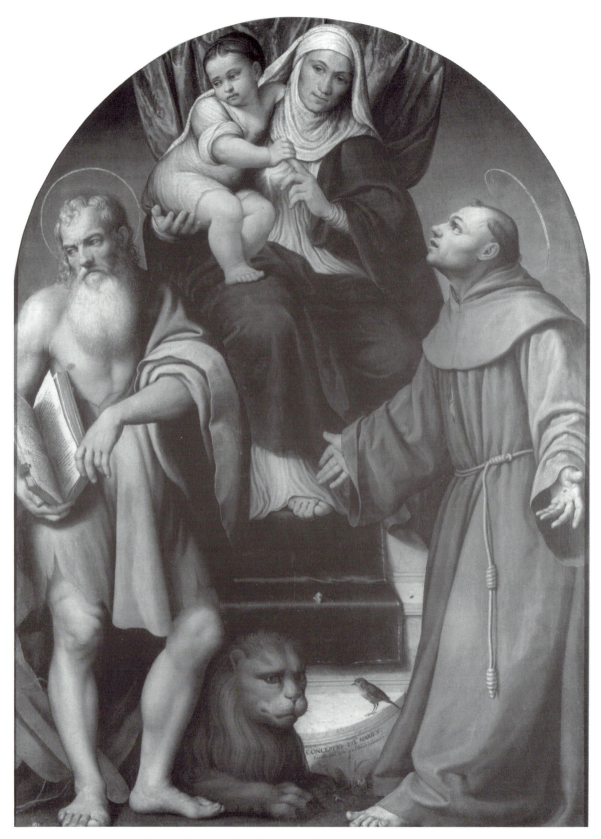

144. Jacopo Bassano, *The Immaculate Conception*, 1541, canvas, 160 × 95 cm. Bassano, Museo Civico. From San Girolamo, Asolo.

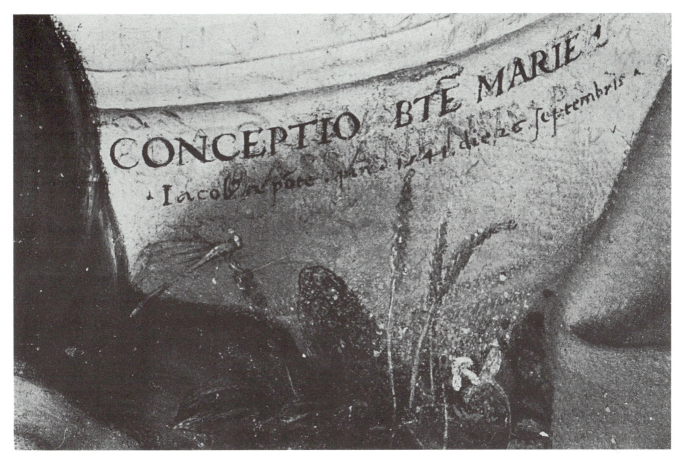

145. Detail of Plate 144.

146. Jacopo Bassano, *The Trinity*, 1547, canvas, 240 × 156 cm. Angarano (Vicenza), Santissima Trinità.

147. Jacopo Bassano, *St John*, fragment of an altarpiece executed partly in sculpture and partly in painting. Castello di Godego (Treviso), Canonica. Formerly in San Pietro.

148. Jacopo Bassano, *Madonna and Child with SS Lucy, Benedict, Justine, and Fortunatus*, 1537, fresco. Tezze sul Brenta (Vicenza), Santa Lucia.

adi 30. Settembre 1550.

149. Page from ledger of the Dal Ponte family, c. 132ʳ: contract for
the apprenticeship of Zillio Zilliolo written by Jacopo Bassano on
30 Sept. 1550. Venice, Muraro Collection.

150. Jacopo Bassano, *Noli me Tangere*, 1546, canvas, 255 × 155 cm. Onara
(Padua), parish church.

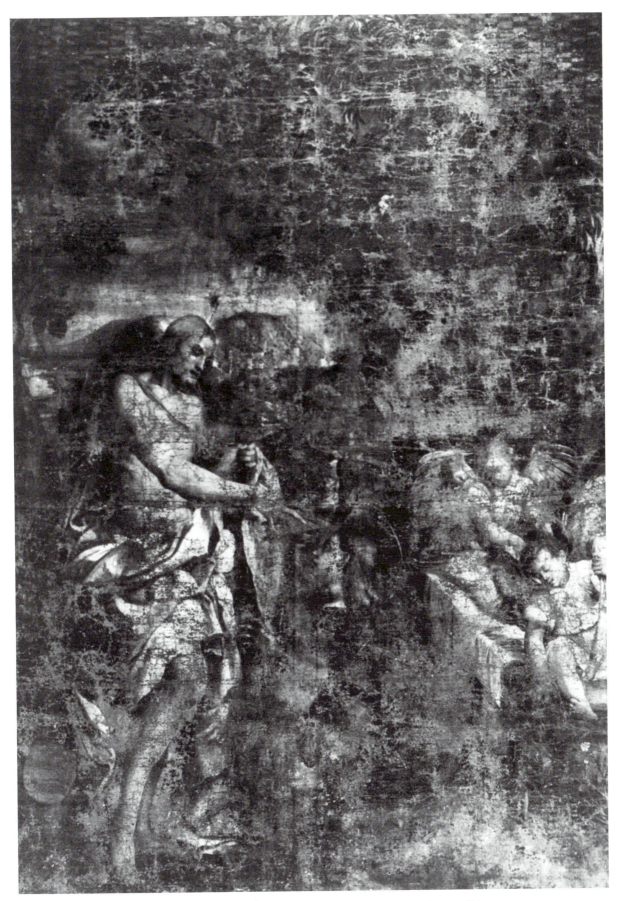

151. Jacopo Bassano, *Noli me Tangere*, 1543, canvas, 255 × 180 cm. Oriago
(Venice), parish church.

List of Plates

Unless otherwise stated, dimensions are given as maximum height and width

Acknowledgements for Plates

The publisher, the editors, and the contributors are grateful to the following for permission to reproduce the plates:

AVIGNON, Musée du Petit Palais, 24

BASSANO DEL GRAPPA, Foto Bozzetto (Cartigliano) for the Museo Civico, 138, 144

BERLIN, Staatliche Museen Preussischer Kulturbesitz (Foto Jörg P. Anders) 22, 47 (SS Matthew, James Minor, James Major, Philip, Matthias?, Elizabeth of Hungary?, Baptist with Angels, Paul with Angels, Peter with Angels, Flagellation, Entombment), 48, 54 (Madonna and Child), 85

BOSTON, Isabella Stewart Gardner Museum, 41

BRESCIA, Edizioni Fotografiche Alberto Luisa, 116; Museo Civico, 111–12, 115; Rinaldo Schreiber, 93

BRUSSELS, Institut Royal du Patrimoine Artistique, 11–12

CAMBRIDGE, Fitzwilliam Museum, 31 (SS Michael, Geminianus, Augustine)

COLOGNE, Wallraf-Richartz Museum, 31 (Madonna and Child)

COPENHAGEN, Den Kongelige Maleriog, Skulptur-Samling Statens Museum for Kunst, 53 (Madonna and Child)

FLORENCE, Alinari, 95, 114; Miklós Boskovits, 32 (lateral saints); Cristina de Benedictis, 31 (St Catherine); Fototeca Berenson, 27, 32 (St Anthony of Padua after Zeri), 33, 50–2, 53 (SS Anthony of Padua and Francis), 54 (SS Peter, Louis of Toulouse and Francis), 59 (after Pavone and Pacelli), 69 (after Lusini 1929), 88, 90, 100, 108, 124 (after Möller); Gaudenz Freuler, 71, 74; Kunsthistorisches Institut (Luigi Artini), 34, 36, 56, 76–80, 97; (Rui M. De Sousa) 81; Antonio Quattrone, 21; Scala, 104, 120, 134; Soprintendenza BAS, Gabinetto Fotografico, 1, 10, 19, 21, 25, 86, 94, 123, 132, 136

JULIAN GARDNER, 2–8, 14–18, 20

PETER HUMFREY, 84, 92, 96, 103, 105

LE MANS, Musée Tessé, 34

LILLE, Musée Wicar, 119

LONDON, Trustees of the British Museum, 107, 125–6, 128–30, 133; Courtauld Institute, 20, 121; Courtesy of the Trustees, the National Gallery, 47 (SS Bartholomew and Andrew, Simon and Thaddeus, two angel spandrels, Betrayal, Christ carrying the Cross, Deposition, Resurrection), 109, 113, 118

LOS ANGELES, County Museum of Art, 47 (central angel spandrel)

MILAN, Electa Editrice, 91, 95; Museo Poldi Pezzoli, 54 (St Dorothy)

MUNICH, Bayerischen Staatsgemäldesammlungen, 131, 139

ESTATE OF MICHELANGELO MURARO, 137, 140–3, 145, 147, 148–51

NAPLES, Soprintendenza BAS, 106

NEW HAVEN, Courtesy Yale University Art Gallery: Bequest of Maitland F. Griggs, 53 (SS John the Baptist, Peter), 54 (St John the Evangelist); Gift of Hannah D. and Louis M. Rabinowitz, 33 (SS Andrew, James Major)

NEW YORK, Colin Eisler, 98, 102; The Metropolitan Museum of Art: The Julius Bache Collection (49.7.9), 97 (Madonna and Child); Gift of Coudert Brothers 1888 (88.3.99), 54 (St Paul); The Robert Lehman Collection, 47 (Last Supper); Gift of Irma N. Straus (64.189.2), 54 (St Clare)

ALESSANDRO NOVA, 110, 117

NÜRNBERG, Germanisches Nationalmuseum, 13

PARIS, Archiv Phot. Paris (SPADEM), 23; Louvre, 54 (St Peter); Cabinet des Dessins, 88, 90, 100; Giraudon, 73

PASADENA, Norton Simon Museum, 33 (Elisha, John the Baptist)

PERUGIA, Soprintendenza BAS, 55–6

PHILADELPHIA, The Johnson Collection, 47 (Daniel)

PISA, Soprintendenza BAS, 45

PITTSBURGH, The Frick Art Museum, 54 (SS Anthony of Padua, Agnes)

PROVIDENCE, Museum of Art, Rhode Island School of Design, 54 (St Mary Magdalen)

ROME, Gabinetto Nazionale dei Disegni e Stampe (Foto Oscar Savio), 127; Istituto Centrale di Restauro, 26, 120

MAX SEIDEL, 34, 82–3

SIENA, Foto Grassi, 34, 60, 61–2; Foto Fabio Lensini, 57, 63–7; Foto Lombardi, 28; Soprintendenza BAS, 9, 26, 29–30, 33 (except for Yale and Pasadena panels), 35, 37–40, 42–3, 49, 54, 58, 68, 70, 72, 75, 109

TURIN, Accademia Albertina, 97 (lateral saints)

VATICAN, Biblioteca Vaticana, 46; Musei e Gallerie Pontificie, 122, 135

VENICE, AFI (Agenzia Fotografica Industriale), 146; Osvaldo Böhm, 87, 89, 108; Fiorentini, 150; Soprintendenza BAS del Veneto, 101

VERONA, Soprintendenza BAS del Veneto, 99

WASHINGTON, DC, The National Gallery of Art, 54 (SS Paul, John the Baptist)

WILLIAMSTOWN, The Sterling and Francine Clark Art Institute, 44

Bibliography

ABATE, GIUSEPPE, 'Memoriali, statuti ed atti di Capitoli Generali dei Frati Minori', *Miscellanea Francescana*, 33 (1933), 15–45.

ABERCROMBIE, N., *The Life and Work of Edmund Bishop* (London, 1959).

Acta cap. gen., 1312, 'Antiquiores quae extant definitiones Capitulorum Generalium Ordinis', 'Viterbense, 1312', *Analecta Augustiniana*, 3 (1909–10), 150–5.

Acta cap. gen., 1338, 'Antiquiores quae extant definitiones Capitulorum Generalium Ordinis', 'Senense, 1338', *Analecta Augustiniana*, 4 (1911–12), 177–83.

Acta cap. prov., 1315, 'Capitula antiqua Provinciae Romanae O. N.', 'Urbeveteri, 1315', *Analecta Augustiniana*, 3 (1909–10), 174–5.

Acta Sanctorum, G. Henschen, D. Papebroch, and Society of Jesus (eds.), Maii, iv (Antwerp, 1685), 622–6; Septembris, viii (Antwerp, 1643), 461–688.

ALBERIGO, J., *et al.*, *Conciliorum Oecumenicorum Decreta*, 3rd edn. (Bologna, 1973).

ALBERTI, LEON BATTISTA, *On Painting and Sculpture*, ed. C. Grayson (London, 1972).

ALBERTON VINCO DA SESSO, LIVIA, and SIGNORI, F., 'Il testamento di Jacopo Dal Ponte detto Bassano', *Arte veneta*, 33 (1979), 161–4.

ALESSI, CECILIA, and SCAPECCHI, PIERO, 'Il "Maestro dell'Osservanza": Sano di Pietro o Francesco di Bartolomeo?', *Prospettiva*, 42 (1985), 13–37.

ALVAREZ, GIULIO BRESCIANI, 'La Basilica del Santo nei restauri e ampliamenti dal Quattrocento al Tardo Barocco', in Giovanni Lorenzoni (ed.), *L'edificio del Santo di Padova* (Vicenza, 1981), 83–124.

AMICO, L. N., 'Reconstructing an Early Fourteenth Century Pentaptych by Ugolino di Nerio: St. Catherine Finds Her Niche', *Bulletin of the Krannert Art Museum*, 5/1 (1979), 12–30.

ANDRIEU, MICHEL, *Le Pontifical romain au moyen-âge*, i, *Le Pontifical romain du XIIe siècle*, Studi e testi, 86 (Vatican City, 1938).

—— *Le Pontifical romain au moyen-âge*, ii, *Le Pontifical de la Curie romaine au XIIIe siècle*, Studi e testi, 87 (Vatican City 1940).

—— *Le Pontifical romain au moyen-âge*, iii, *Le Pontifical de Guillaume Durand*, Studi e testi, 88 (Vatican City, 1940).

ANELLI, L., *La chiesa dei santi Nazaro e Celso in Brescia* (Brescia, 1977).

ARASSE, D., 'Fervebat Pietate Populus: Art, dévotion, et société autour de la glorification de saint Bernardin de Sienne', *Mélanges de l'école française de Rome*, 89/3 (1977), 189–263.

ARBESMANN, R. (ed.), 'Heinrich of Friemar's Treatise on the Origin and Development of the Order of the Hermit Friars and its True and Real Title', *Augustiniana*, 6 (1956), 37–145.

ARU, CARLO, 'Un quadro di Bartolomeo Vivarini', *L'Arte*, 8 (1905), 205–7.

AVRIL, F. *et al.* (eds.), *Dix siècles d'enluminure italienne (VI^e–XV^e siècles)*, exhibition catalogue, Paris, Bibliothèque Nationale (Paris, 1984).

BACCI, PÈLEO, *Documenti e commenti per la storia dell'arte* (Florence, 1944).

—— *Fonti e commenti per la storia dell'arte senese* (Siena, 1944).

—— 'S. Leonardo al Lago e gli affreschi lorenzettiani in una cantilena del XVII sec.', *Rassegna d'arte senese: La Balzana*, 5, NS 1 (1927), 35–9.

BAGNOLI, ALESSANDRO, 'Il Beato Agostino Novello e quattro suoi miracoli', in A. Bagnoli and L. Bellosi (eds.), *Simone Martini e 'chompagni'*, exhibition catalogue, Siena (Florence, 1985), 56–61.

—— and BELLOSI, LUCIANO (eds.), *Simone Martini e 'chompagni'*, exhibition catalogue, Siena (Florence, 1985).

—— and BARTALINI, R. (eds.), *La scultura dipinta: maestri di legname e pittori a Siena 1250–1450*, exhibition catalogue, Siena (Florence, 1987).

BALDINUCCI, F., *Vocabolario toscano dell'arte del disegno* (Florence, 1681), anastatic reprint, ed. Severina Parodi (Florence, 1976).

BANKER, JAMES R., 'The Program of the Sassetta Altarpiece in the Church of S. Francesco in Borgo S. Sepolcro', *I Tatti Studies*, 4 (1991), 11–58.

BARBIERI, FRANCO, *Pittori di Vicenza 1480–1520* (Vicenza, 1982).

BARTALINI, R., 'Maestro del Crocefisso dei Disciplinati', in A. Bagnoli and R. Bartalini (eds.), *La Scultura dipinta: maestri di legname e pittori a Siena 1250–1450*, exhibition catalogue, Siena (Florence, 1987), 96–100.

BARZMAN, KAREN-EDIS, 'The Università, Compagnia, ed Accademia del Disegno', Ph.D. thesis (Johns Hopkins University, Baltimore, 1985).

BATIFFOL, PIERRE, *Histoire du Bréviaire Romain* (Paris, 1895).

BATTISTINI, M., *La Confrérie de Sainte-Barbe des Flamands à Florence: Documents relatifs aux tisserands et aux tapissiers* (Brussels, 1931).

BAXANDALL, MICHAEL, The Limewood Sculptors of Renaissance Germany (New Haven, Conn., and London, 1980).

—— *Painting and Experience in Fifteenth Century Italy* (Oxford, 1972).

BEATSON, ELIZABETH H., NORMAN MULLER, and JUDITH B. STEINHOFF, 'The St. Victor Altarpiece in Siena Cathedral: A Reconstruction', *Art Bulletin*, 68 (1986), 610–31.

BEGNI REDONA, PIER VIRGILIO, *Alessandro Bonvicino, il Moretto da Brescia* (Brescia, 1988).

BELLOSI, LUCIANO (ed.), *Simone Martini: Atti del convegno* (Florence, 1988).

—— *Umbri e toscani tra due e trecento*, exhibition catalogue, Turin (Turin, 1988).

—— see BAGNOLI, A.

BELTING, HANS, 'The "Byzantine" Madonnas: New Facts about Their Italian Origin and Some Observations on Duccio', *Studies in the History of Art*, National Gallery of Art, Washington, 12 (1982), 7–22.

—— *Die Oberkirche von San Francesco in Assisi* (Berlin, 1977).

—— *Das Bild und sein Publikum im Mittelalter* (Berlin, 1981).

BENATI, A., 'Armanno Pungilupo nella storia ferrarese del 1200', *Analecta Pomposiana*, 2 (1966), 85–123.

BERTAGNA, MARTINO, 'L'Osservanza di Siena', *Studi storici*, i (Siena, 1963).

—— 'Vita e apostolato senese di San Bernardino', *Studi francescani*, 60 (1963), 20–99.

—— 'Vita religiosa francescano-senese sulle orme di San Bernardino nel sec. XV', *Studi francescani*, 60 (1963), 231–89.

—— 'Memorie Bernardiniane I', *Bullettino senese di storia patria*, NS 23 (1964), 5–50.

BERTHÉLÉ, J., and VALMARY, M. (eds.), 'Les Instructions et Constitutions de Guillaume Durand, le Spéculateur, d'aprés le manuscrit de Cessenon', *Académie des Sciences et Lettres de Montpellier: Mémoires de la Section des Lettres*, 2e Série, iii (1900–7), 1–148.

BINSKI, P., see NORTON, C.

BISHOP, EDMUND, *Liturgica Historica: Papers on the Liturgy and Religious Life of the Western Church* (Oxford, 1918).

BISOGNI, FABIO, 'Per un census delle rappresentazioni di Santa Chiara nella pittura in Emilia, Romagna e Veneto sino alla fine del Quattrocento', in *Movimento religioso femminile e francescanesimo nel secolo XIII*, Atti del VII convegno della società internazionale di studi francescani, Assisi, 1979 (Assisi, 1980), 131–65.

BLUME, DIETER, *Wandmalerei als Ordenspropaganda: Bildprogramme im Chorbereich franziskanischer Konvente Italiens bis zur Mitte des 14. Jahrhunderts* (Worms, 1983).

BOASE, T. S. R., *Giorgio Vasari: The Man and the Book* (Princeton, NJ, 1979).

BOLOGNA, FERDINANDO, 'Ritrovamenti di due tele del Correggio', *Paragone*, 91 (1957), 9–25.

BORGHINI, RAFFAELLO, *Il Riposo*, ed. M. Rosci, i (Milan, 1967).

BORSOOK, EVE, *Ambrogio Lorenzetti* (Florence, 1966).

—— and OFFERHAUS, JOHANNES, *Francesco Sassetti and Ghirlandaio at Santa Trìnita, Florence* (Doornspijk, 1981).

BOSELLI, C., and PANAZZA, G., *Pitture in Brescia dal Duecento all' Ottocento*, exhibition catalogue, Brescia (Brescia, 1946).

BOSKOVITS, MIKLÓS, review of J. H. Stubblebine, *Duccio di Buoninsegna and His School*, in *Art Bulletin*, 64 (1982), 496–9.

—— 'Per Jacopo Bellini pittore', *Paragone*, 23 (1985), 113–23.

—— 'Giovanni Bellini: Quelques suggestions sur ses débuts', *Revue du Louvre et des musées de France*, 36 (1986), 386–93.

—— *Gemäldegalerie Berlin: Katalog der Gemälde Frühe Italienische Malerei* (Berlin, 1988).

BRANDI, CESARE, *La Regia Pinacoteca di Siena* (Rome, 1933).

—— *Un Candelabro dipinto da Lippo Vanni*, Monographie der Abegg Stiftung, Bern, 10 (Bern, 1975).

BRAUN, JOSEF, B., *Der Christliche Altar in seiner geschichtlichen Entwicklung* (Munich, 1914, 1924), 2 vols.

BRIACCA, G., *Gli statuti sinodali novaresi di Papiniano della Rovere (a. 1298)*, Pubblicazioni dell'Università Cattolica del S. Cuore, Saggi e ricerche, ser. 3, Scienze storiche, 5 (Milan, 1971).

—— 'Papiniano della Rovere: Contributo ad una biografia', *Raccolta di studi in memoria di Giovanni Soranzo* (Milan, 1968), 60–108.

BRINK, JOEL, 'Simone Martini's *St. Catherine of Alexandria*: An Orvietan Altarpiece and the Mystical Theology of St. Bonaventure', *Annual Bulletin of the National Gallery of Canada*, 3 (1979–80), 37–56.

BROCCHIERI, E., 'Sicardo di Cremona e la sua opera letteraria', *Annali della Biblioteca Governativa e Libreria Civica di Cremona*, 11, fasc. 1 (Cremona, 1958).

BROWN, PATRICIA FORTINI, *Venetian Narrative Painting in the Age of Carpaccio* (New Haven, Conn., and London, 1988).

BRUNO OF SEGNI, 'Expositio in Exodum', in J. P. Migne, *Patrologia Latina*, 164 (Paris, 1884), cols. 233–76.

BUNJES, H., 'Die Steinernen Altaraufsätze der hohen Gotik und der Stand der gotischen Plastik in der Ile de France um 1300', Ph.D. thesis (University of Marburg, 1937).

BURCKHARDT, JAKOB, 'Das Altarbild', in *Beiträge zur Kunstgeschichte von Italien* (Basle, 1898), 1–141.

—— *The Altarpiece in Renaissance Italy*, ed. and trans. Peter Humfrey (Oxford, 1988).

BUTZEK, MONIKA, 'Altar des Sel. Augustinus Novellus', in P. A. Riedl and M. Seidel (eds.), *Die Kirchen von Siena*, i (Munich, 1985), 210–12.

CABIE, R., 'Le Pontifical de Guillaume Durand l'ancien et les livres liturgiques languedociens', *Liturgie et musique (IXᵉ–XIVᵉs.)*, Cahiers de Fanjeaux, 17 (Toulouse, 1982), 225–37.

CANNON, JOANNA, 'Dominican Patronage of the Arts in Central Italy: The *Provincia Romana*, c.1220–c.1320', Ph.D. thesis (University of London, 1980).

—— 'Simone Martini, the Dominicans and the Early Sienese Polyptych', *Journal of the Warburg and Courtauld Institutes*, 45 (1982), 69–93.

—— 'Pietro Lorenzetti and the History of the Carmelite Order', *Journal of the Warburg and Courtauld Institutes*, 50 (1987), 18–28.

CANUTI, FIORENZO, *Il Perugino* (Siena, 1931), 2 vols.

CAPELLE, B., 'L'Œuvre liturgique de Mgr. Andrieu et la théologie', *Nouvelle revue théologique*, 79 (1957), 169–77.

CARLI, ENZO, 'Una mostra Bernardiniana a Siena', *Emporium*, 112 (1950), 167–78.

—— *Dipinti senesi del contado e della Maremma* (Milan, 1955).

—— *L'Abbazia di Monteoliveto* (Milan, 1961).

—— 'Ancora dei Memmi a San Gimignano', *Paragone*, 159 (1963), 27–44.

—— *Lippo Vanni a San Leonardo al Lago* (Florence, 1969).

—— *Montalcino: Museo civico, Museo diocesano d'Arte Sacra* (Bologna, 1972).

—— 'Nuovi studi nell'orbita di Duccio di Buoninsegna', *Antichità viva*, 11/6 (1972), 3–15.

—— *Il Duomo di Siena* (Genoa, 1979).

—— *Le storie di San Benedetto a Monteoliveto Maggiore* (Milan, 1980).

—— *La pittura senese del Trecento* (Milan, 1981).

CASALINI, EUGENIO, 'La Santissima Annunziata nella storia e nella civiltà fiorentina', in E. Casalini *et al.* (eds.), *Tesori d'arte dell'Annunziata di Firenze* (Florence, 1987), 75–95.

CASTELNUOVO, ENRICO, 'Per una storia sociale dell'arte', *Paragone*, 313 (1976), 3–30; 323 (1977), 3–34, repr. in id., *Arte, industria, rivoluzione: Temi di storia sociale dell'arte* (Turin, 1985), 3–64.

CASTIGLIONE, B., *The Book of the Courtier*, trans. G. Bull (Harmondsworth, 1967).

CATALANO, N., *Fiume del terrestre Paradiso* (Florence, 1652).

CATENI, LUCIANO, 'Appunti sul "Goodhart Master"', *Prospettiva*, 45 (1986), 63–6.

CAVALCASELLE, G. B., and CROWE, J. A., *Storia della pittura in Italia dal sec. II al sec. XVI*, iii (Florence, 1885).

CENNINI, CENNINO, *Il libro dell'arte*, ed. Franco Brunello with a preface by L. Magagnato (Vicenza, 1971).

CHADWICK, W. O., *The Victorian Church*, i (London, 1966).

CHELAZZI DINI, GIULIETTA, 'Lippo Vanni', in Chelazzi Dini *et al.* (eds.), *Il gotico a Siena*, exhibition catalogue, Siena, Palazzo Pubblico (Florence, 1982), 255–75.

CHENEY, C. R., 'Church-building in the Middle Ages', *Bulletin of the John Rylands Library*, 34 (1951), 20–36.

—— see POWICKE, F. M.

CHRISTIANSEN, KEITH, *Gentile da Fabriano* (Ithaca, NY, 1982).

—— 'Fourteenth-Century Italian Altarpieces', *Bulletin of the Metropolitan Museum of Art*, 40/1 (1982), 3–56.

—— 'Venetian Painting of the Early Quattrocento', *Apollo*, 125 (1987), 166–77.

—— *et al.* (eds.), *Painting in Renaissance Siena: 1420–1500*, exhibition catalogue, Metropolitan Museum of Art (New York, 1988).

—— 'Sano di Pietro's S. Bernardino Panels', *Burlington Magazine*, 133 (1991), 451–2.

CLARKE, B. F. L., *Church Builders of the Nineteenth Century: A Study of the Gothic Revival in England* (London, 1938).

CLAUSSEN, P. C., 'Früher Künstlerstolz: Mittelalterliche Signaturen als Quelle der Kunst-soziologie', in K. Clausberg *et al.* (eds.), *Bauwerk und Bildwerk im Hoch-mittelalter* (Giessen, 1981), 7–34.

CONSTANTINUS DE URBEVETERI, 'Legenda Beati Dominici', ed. H. C. Scheeben, in *Monumenta Ordinis Praedicatorum Historica*, 16 (Rome, 1935), 261–352.

CONTI, ALESSANDRO, 'L'evoluzione dell'artista', in G. Previtali (ed.), *Storia dell'arte italiana*, pt. 1, ii (Turin, 1979), 117–263.

COOR-ACHENBACH, GERTRUDE, 'A Visual Basis for the Documents Relating to Coppo di Marcovaldo and His Son Salerno', *Art Bulletin*, 28 (1946), 233–47.

—— 'Some Unknown Representations by the Magdalen Master', *Burlington Magazine* 93 (1951), 73–8.

—— 'Contributions to the Study of Ugolino di Nerio's Art', *Art Bulletin*, 37 (1955), 153–65.

CORNICE, ALBERTO, 'Opere d'arte all'Osservanza', in *L'Osservanza di Siena: la basilica e i suoi codici miniati* (Milan, 1984), 51–154.

CORRIE, REBECCA W., 'The Political Meaning of Coppo di Marcovaldo's Madonna and Child in Siena', *Gesta*, 29 (1990), 61–75.

COX-REARICK, JANET, *The Drawings of Pontormo* (Cambridge, Mass., 1964), 2 vols.

CRIVELLARI, G., 'Spigolature Dapontiane', in *Bassano e Jacopo da Ponte* (Bassano del Grappa, 1893) 1–10.

—— *Apografi di documenti riguardanti i pittori bassanesi Da Ponte e Nasocchi*, Museo di Bassano, Archivio, MS 261, fos. 1–38.

CROWE, J. A., see CAVALCASELLE, G. B.

DANNENBERG, H., review of J. Braun, *Der Christliche Altar in seiner geschichtliche Entwicklung* in *Repertorium für Kunstwissenschaft*, 49 (1928), 48–59.

DAVIES, MARTIN, *The Earlier Italian Schools*, 2nd edn. (London, 1961), revised D. Gordon, *The Early Italian Schools before 1400*, National Gallery Catalogue (London, 1988).

DE BENEDICTIS, CRISTINA, *La pittura senese 1330–1370* (Florence, 1979).

—— 'Santa Caterina, Angelo', in A. Bagnoli and L. Bellosi (eds.), *Simone Martini e 'chompagni'*, exhibition catalogue, Siena (Florence, 1985), 47–51.

—— 'La pittura del duecento e del trecento in S. Trìnita', in G. Marchini and E. Micheletti (eds.), *La chiesa di Santa Trìnita a Firenze* (Florence, 1987), ch, ix, 89–106.

DE BENEDICTIS, CRISTINA, 'Simone Martini a San Gimignano e una postilla per il possibile Donato', in L. Bellosi (ed.), *Simone Martini: Atti del convegno* (Florence, 1988), 187–91.

DEGENHART, BERNHARD, and SCHMITT, ANNEGRIT, *Jacopo Bellini: Der Zeichnungsband des Louvre* (Munich, 1984).

—— *Corpus der Italienischen Zeichnungen 1300–1450. Teil II. Venedig: Jacopo Bellini*, v, text (Berlin, 1990).

DELANEY, B., 'Antonio Vivarini and the Florentine Tradition', *Commentari*, 29 (1978), 81–95.

DE MARCHI, A., 'Maestro Fiorentino 1300 circa', in L. Bellosi (ed.), *Umbri e Toscani tra due e trecento* (Turin, 1988), 53–8.

DENDY, D. R., *The Use of Lights in Christian Worship*, Alcuin Club Collections, 41 (London, 1959).

DE NICOLA, GIACOMO, 'Ugolino e Simone a San Casciano Val di Pesa', *L'Arte*, 19 (1916), 13–20.

DE NICOLÒ SALMAZO, ALBERTA, 'La pittura rinascimentale a Padova', in F. Zeri (ed.), *La pittura in Italia: il Quattrocento* (Milan, 1987), i, 168–83.

DESCHAMPS, P., 'Tables d'autel de marbre exécutées dans le midi de la France au Xe et au XIe siècle', *Mélanges d'Histoire du Moyen-Âge offerts à M. Ferdinand Lot par ses amis et ses élèves* (Paris, 1925), 137–68.

D'ESPEZEL, P., 'Louis Duchesne', *Dictionnaire d'Histoire et de Geographie Ecclésiastiques*, xiv (1960), cols. 965–84.

DE VECCHI, PIER LUIGI, 'Ritratto di una apparizione: Appunti in margine alla Madonna Sistina', in Paola Ceschi-Lavagetto (ed.), *La Madonna per San Sisto di Raffaello e la cultura piacentina della prime metà del Cinquecento*, Atti del convegno, Piacenza, 1983 (Parma, 1985), 34–42.

Dictionnaire de Droit Canonique, ed. R. Naz (Paris, 1924–65).

DOUTEIL, H., *Iohannis Beleth Svmma De Ecclesiasticis Officiis*, Corpus Christianorum Continuatio mediaevalis, 41 (Turnhout, 1976).

DUCANGE, CHARLES DUFRESNE, *Glossarium ad scriptores mediae et infimae Latinitatis*, v (Paris, 1754).

DUCHESNE, LOUIS, *Origines du culte chrétien* (Paris, 1889).

DURAND, GUILLAUME D., *Rationale Divinorum Officiorum* (Venice, 1568).

DURANDUS, GUILLAUME, *The Symbolism of Churches and Church Ornaments:* a translation of the first book of the *Rationale Divinorum Officiorum*, trans. J. M. Neale and B. Webb (Leeds, 1843).

DYKMANS, MARC, 'Notes autobiographiques de Guillaume Durande le Spéculateur', *Ius Populi Dei: Miscellanea in honorem Raymundi Bidagor*, i (Rome, 1972), 119–42.

EBERLEIN, JOHANN KONRAD, *Apparitio regis-revelatio veritatis: Studien zur Darstellung des Vorhangs in der bildenden Kunst von der spät Antike bis zum Ende des Mittelalters* (Wiesbaden, 1982).

—— 'The Curtain in Raphael's Sistine "Madonna"', *Art Bulletin*, 65 (1983), 61–77.

EISLER, COLIN, 'Saints Anthony Abbot and Bernardino of Siena Designed by Jacopo and Painted by Gentile Bellini', *Arte veneta*, 39 (1985), 32–40.

ELM, KASPAR, 'Gli eremiti Neri nel Dugento: Ein neuer Beitrag zur Vorgeschichte des Augustiner-Eremitensordens', *Quellen und Forschungen aus italienischen Archiven und Bibliotheken*, 50 (1971), 58–79.

—— 'Neue Beiträge zur Geschichte der Augustiner-Eremitensordens im 13. and 14. Jahrhundert', *Archiv für Kulturgeschichte*, 42 (1960), 357–87.

—— 'Elias, Paulus von Theben und Augustinus als Ordensgründer: Ein Beitrag zur Geschichtsschreiben und Geschichtsdeutung der Eremiten-und Bettelorden des 13. Jahrhunderts', in H. Patze (ed.), *Geschichtsschreibung und Geschichtsbewusstsein im späten Mittelalter*, Vorträge und Forschungen, 31 (Sigmaringen, 1987), 371–97.

FABJAN, B., *et al.*, *Perugino, Lippi e la bottega di San Marco alla Certosa di Pavia*, exhibition catalogue, Pinacoteca di Brera, Milan (Florence, 1986).

FAINO, B., *Catalogo delle chiese di Brescia* (Manoscritti Queriniani, E.VII.6 and E.I.10), ed. C. Boselli (Brescia, 1961).

FALDI, ITALO, *Pittori viterbesi di cinque secoli* (Rome, 1970).

FALLETTI, L., 'Durand', *Dictionnaire de Droit Canonique*, v (Paris, 1953), cols. 1014–75.

FARGNOLI NARCISA, 'La chiesa di San Salvatore nel Trecento', in C. Alessi *et al.*, *Lecceto e gli eremi Agostiniani in terra di Siena* (Milan, 1990), 181–209.

FASOLI, G. (ed.), *Storia di Bassano* (Bassano del Grappa, 1980).

—— and MANTESE, G. (eds.), 'La vita religiosa dalle origini al XX secolo', in *Storia di Bassano* (Bassano del Grappa, 1980), 435–64.

FAVARO, ELENA, *L'arte dei pittori in Venezia e i suoi statuti* (Florence, 1975).

FEHM, SHERWOOD A., 'A Pair of Panels by the Master of Città di Castello and a Reconstruction of Their Original Altarpiece', *Yale University Art Gallery Bulletin*, 31/2 (1967), 16–27.

—— 'Simone and the Franciscan *Zelanti*', *Fenway Court*, 1978 (Boston, 1979), 3–6.

FFOULKES, CONSTANCE JOCELYN, and MAIOCCHI, RODOLFO, *Vincenzo Foppa of Brescia, Founder of the Lombard School: His Life and Work* (London, 1909).

FILIPIAK, M. A., 'The Plans of the Poor Clares' Convents in Central Italy from the Thirteenth through the Fifteenth Century', Ph.D. thesis (University of Michigan, 1957).

FIOCCO, GIUSEPPE, *L'arte di Andrea Mantegna* (Venice, 1959).

FISCHER, CHRIS, *Disegni di Fra Bartolommeo e della sua scuola*, exhibition catalogue, Uffizi (Florence, 1986).

FLORES D'ARCAIS, F., *Guariento* (Venice, 1965).

FOCCI, GIUSEPPE, 'Il Cembalo di Dio', in *Enciclopedia Bernardiniana*, iv, *Biografia*, ed. S. Aloisi (Salerno, 1985), vol. ii, 5–220.

FOGOLARI, GINO, 'La chiesa di S. Maria della Carità di Venezia', *Archivio Veneto tridentino*, 5–6 (1924), 57–119.

FONSECA, C.-D., 'Frigionaia', in *Dictionnaire d'Histoire et de Géographie Ecclésiastiques*, xix (1981), cols. 95–9.

FOREVILLE, R., *Latran I, II, III et Latran IV*, Histoire des Conciles Œcumeniques, vi (Paris, 1965).

FORSTER, KURT W., *Pontormo* (Munich, 1966).

Francesco d'Assisi: documenti e archivi, codici e biblioteche, miniature, exhibition catalogue (Milan, 1982), 3 vols.

FRANCIS, HENRY S., 'An Altarpiece by Ugolino da Siena', *The Bulletin of the Cleveland Museum of Art*, 48 (1961), 194–205.

FRANKLIN, DAVID, 'A Document for Pontormo's S. Michele Visdomini Altar-piece', *Burlington Magazine*, 132 (1990), 487–9.

—— 'Rosso Fiorentino's *Betrothal of the Virgin*: Patronage and Meaning', *Journal of the Warburg and Courtauld Institutes* (forthcoming).

FRANKLIN, W., 'The Nineteenth Century Liturgical Movement', *Worship*, 53 (1979), 12–39.

FREDERICKSEN, BURTON, 'Documents for the Servite Origin of Simone Martini's Orvieto Polyptych', *Burlington Magazine*, 128 (1986), 592–7.

FREEDBERG, DAVID, *Iconoclasts and Their Motives* (Maarsen, 1985).

FRERE, W. H. *et al.*, *Pontifical Services Illustrated from Miniatures of the XVth and XVIth Centuries*, Alcuin Club Collections, 3–4 (London, 1901).

—— 'The Christian Altar', *Church Quarterly Review*, 103 (1926), 2–19; repr. in *Walter Howard Frere: A Collection of his Papers on Liturgical and Historical Subjects*, Alcuin Club Collections, 35 (Oxford, 1940).

FREULER, GAUDENZ, 'Andrea di Bartolo, Fra Tommaso d'Antonio Caffarini and Sienese Dominicans in Venice', *Art Bulletin*, 69 (1987), 570–86.

—— and MALLORY, MICHAEL, 'Der Altar des beato Philippino Ciardelli in S. Francesco in Montalcino, 1382: Malerei im Dienste der franziskanischen Ordenspropaganda', *Pantheon*, 47 (1989), 21–35.

—— see MALLORY, M.

FREY, KARL, *Der Literarische Nachlass Giorgio Vasaris* (Munich, 1923, 1930), 2 vols.

FROESCHLÉ-CHOPARD, MARIE-HÉLÈNE, 'Univers sacré et iconographie au XVIIIe siècle: Églises et chapelles des diocèses de Vence et de Grasse', *Annales*, 31 (1976), 489–519.

FURLAN, CATERINA, *Il Pordenone* (Milan, 1988).

—— (ed.), *Il Pordenone*, Atti del convegno internazionale di studio, Pordenone, 1984 (Pordenone, 1985).

GAGGIA, M., 'Vittore Scienza intagliatore feltrino', *Archivio storico di Belluno, Feltre, Cadore*, 11 (1939), 1122–4.

GAILLARD, ÉMILE, *Un peintre Siennois au XVe Siècle: Sano di Pietro 1406–1481* (Chambéry, 1923).

GALLAVOTTI CAVALLERO, DANIELA, *Lo Spedale di Santa Maria della Scala in Siena: vicenda di una committenza artistica* (Pisa, 1985).

GAMBER, KLAUS, *Liturgie und Kirchenbau*, Studia Patristica e Liturgica, 6 (Regensburg, 1976).

GARCIA Y GARCIA, A., *Constitutiones concilii quarti Lateranensis una cum commentariis glossatorum*, Monumenta Iuris Canonici, series A., Corpus Glossatorum, 2 (Vatican City, 1981).

GARDNER, JULIAN, 'The Stefaneschi Altarpiece: A Reconsideration', *Journal of the Warburg and Courtauld Institutes*, 37 (1974), 57–103.

—— 'Saint Louis of Toulouse, Robert of Anjou and Simone Martini', *Zeitschrift für Kunstgeschichte*, 39 (1976), 12–33.

—— 'Some Franciscan Altars of the 13th and 14th Centuries', in A. Borg and A. Martindale (eds.), *The Vanishing Past: Studies of Medieval Art, Liturgy and Metrology Presented to Christopher Hohler* (Oxford, 1981), 29–38.

—— 'The Louvre *Stigmatization* and the Problem of the Narrative Altarpiece', *Zeitschrift für Kunstgeschichte*, 45 (1982), 217–47.

—— 'Fronts and Backs: Setting and Structure', in H. W. van Os and J. R. J. Van Asperen de Boer, *La Pittura del XIV e XV secolo: Il contributo dell'analisi tecnica alla storia dell'arte*, Atti del XXIV congresso internazionale di storia dell'arte, Bologna, 1979, iii (Bologna, 1983), 297–322.

—— 'The Cult of a Fourteenth-Century Saint: The Iconography of St. Louis of Toulouse', in *I Francescani nel Trecento*, Atti del XIV convegno della società internazionale di studi francescani, Assisi, 1986 (Perugia, 1988), 167–93.

—— 'The Cappellone di San Nicola at Tolentino: Some Functions of a Fourteenth-Century Fresco Cycle', in W. Tronzo (ed.), *Italian Church Decoration of the Middle Ages and Early Renaissance: Functions, Forms and Regional Traditions* (Bologna, 1989), 101–17.

GARDNER VON TEUFFEL, CHRISTA, 'Masaccio and the Pisa Altarpiece: A New Approach', *Jahrbuch der Berliner Museen*, 19 (1977), 23–68.

—— 'The Buttressed Altarpiece: A Forgotten Aspect of Tuscan Fourteenth Century Altarpiece Design', *Jahrbuch der Berliner Museen*, 21 (1979), 21–65.

—— 'From Polyptych to Pala: Some Structural Considerations', in H. W. van Os and J. R. J. Van Asperen de Boer (eds.), *La pittura del XIV e XV secolo: il contributo dell'analisi tecnica alla storia dell'arte*, Atti del XXIV congresso internazionale di storia dell'arte, Bologna 1979, iii (Bologna, 1983), 323–30.

—— 'Lorenzo Monaco, Filippo Lippi und Filippo Brunelleschi: die Erfindung der Renaissance', *Zeitschrift für Kunstgeschichte*, 45 (1982), 1–30.

GARRISON, EDWARD B., *Italian Romanesque Panel Painting: An Illustrated Index* (Florence, 1949).

GAUDEMET, J., *Le Gouvernement de l'église à l'époque classique*, Histoire du Droit et des institutions de l'église en occident, 8/2 (Paris, 1979).

GAUTHIER, MARIE-MADELEINE, 'Du Tabernacle au retable', *Revue de l'art*, 40–1 (1978), 23–42.

GAYE, GIOVANNI, *Carteggio inedito d'artisti del secoli XIV. XV. XVI.* (Florence, 1839–40), 3 vols.

GEERTMAN, HERMAN, 'Ricerche sopra la prima fase di S. Sisto Vecchio in Roma', *Atti della Pontificia accademia romana di archeologia*, ser. 3, Rendiconti, 41 (1969), 219–28.

GEROLA, G., 'Il primo pittore bassanese: Francesco da Ponte il Vecchio', *Bollettino del Museo Civico di Bassano*, 4 (1907), 77–98.

GHIBERTI, LORENZO, *I Commentari*, in Julius von Schlosser (ed.), *Lorenzo Ghibertis Denkwürdigkeiten* (Berlin, 1912).

GIANI, ARCANGELO, OSM, *Annales Sacri Ordinis Fratrum Servorum B. Mariae Virginis*, i (Florence, 1618).

GILBERT, CREIGHTON, 'Peintres et menuisiers au début de la Renaissance en Italie', *Revue de l'art*, 37 (1977), 9–28.

—— 'Some Special Images for Carmelites, circa 1330–1430', in T. Verdon and J. Henderson (eds.), *Christianity and the Renaissance* (Syracuse, NY, 1990), 161–207.

GINORI LISCI, L., *I palazzi di Firenze nella storia e nell'arte*, ii (Florence, 1972).

GLASSER, HANNELORE, *Artists Contracts of the Early Renaissance*, Ph.D. thesis, Columbia University, 1965 (Outstanding Dissertations in the Fine Arts, Garland Publ., New York and London, 1977).

GOCKERELL, NINA, *Kirchen mit alttestamentarischen Patrozinien in Venedig: Materialen zum Geschichte der Kirchen S. Giobbe, S. Geremia, S. Moisé, S. Samuele, S. Simeone und S. Zaccaria*, Centro Tedesco di studi veneziani, Quaderni, 2 (Venice, 1978).

GOLZIO, VINCENZO, *Raffaello nei documenti . . .* (Vatican City, 1936); repr. with corrections (Farnborough, 1971).

GOMBOSI, GYÖRGY, *Moretto da Brescia* (Basle, 1943).

GORDON, DILLIAN R., 'Art in Umbria, c.1250–c.1350', Ph.D. thesis (University of London, 1979).

—— 'A Perugian Provenance for the Franciscan Double-Sided Altarpiece by the Maestro di San Francesco', *Burlington Magazine*, 124 (1982), 70–7.

—— 'Simone Martini's Altar-piece for Sant' Agostino, San Gimignano', *Burlington Magazine*, 133 (1991), 771.

—— and REEVE, ANTHONY, 'Three Newly-Acquired Panels from the Altarpiece from Santa Croce by Ugolino di Nerio', *National Gallery Technical Bulletin*, 8 (1984), 36–52.

Il gotico a Siena, see CHELAZZI DINI, G.

GOULD, CECIL, *The Paintings of Correggio* (London, 1976).

GRÉGOIRE, REGINALD, *Bruno de Segni. Exégète médièval et théologien monastique*, Centro italiano di studi sull'alto medioevo (Spoleto, 1965).

GUAZZONI, VALERIO, *Moretto: Il tema sacro* (Brescia, 1981).

GUTIÉRREZ, D., 'De antiquis O.E.S.A. bibliothecis', *Analecta Augustiniana*, 23 (1954), 163–372.

—— *Los Augustinos en la edad media 1256–1356, Historia de la Orden de San Augustin*, vol. i, pt. 1 (Rome, 1980).

GY, P.-M., 'L'Ordinaire de Mende: une œuvre inédite de Guillaume Durand l'Ancien', *Liturgie et musique* (*IX^e–XIV^e s.*), Cahiers de Fanjeaux, 17 (Toulouse, 1982), 239–49.

HACKETT, M. B., 'The Medieval Archives of Lecceto', in *Miscellanea Ordinis Sancti Augustini Historica in honorem P. D. Gutiérrez O.S.A.*, i, *Analecta Augustiniana*, 40 (1977), 17–45.

HAGER, HELLMUT, *Die Anfänge des italienischen Altarbildes*, Römische Forschungen der Bibliotheca Hertziana, 17 (Munich, 1962).

HAHNLOSER, HANS R., *Villard de Honnecourt: Kritische Gesamtausgabe des Bauhüttenbuches Ms. fr. 19093 der Pariser Nationalbibliothek* (Vienna, 1935).

HALL, MARCIA B., 'The *ponte* in S. Maria Novella: The Problem of the Rood Screen in Italy', *Journal of the Warburg and Courtauld Institutes*, 37 (1974), 157–73.

—— 'The Italian Rood Screen: Some Implications for Liturgy and Function', in S. Bertelli and G. Ramakus (eds.), *Essays presented to Myron P. Gilmore*, ii (Florence, 1978), 213–18.

—— *Renovation and Counter-Reformation: Vasari and Duke Cosimo in Sta Maria Novella and Sta Croce 1565–1577* (Oxford, 1979).

HARTZHEIM, J., see SCHANNAT, J. C.

HAUSSHERR, REINER, 'Marginalien zur Situation der kunstgeschichtlichen Mittelalterforschung', *Kunstchronik*, 40 (1987), 357–62.

—— '*Si tu es Christus, dic nobis palam!* Eine Notiz zum Soester Retabel der Berliner Gemäldegalerie', in Per Bjurström *et al.* (eds.), *Florilegium in Honorem Carl Nordenfalk Octogenarii Contextum* (Stockholm, 1987), 81–90.

—— *et al.* (eds.), *Die Zeit der Staufer: Geschichte, Kunst, Kultur*, exhibition catalogue (Stuttgart, 1977), 5 vols.

HEINZELMANN, M., *Translationberichte und anderer Quellen des Reliquienkultes*, Typologie des sources du moyen âge occidental, 33 (Turnhout, 1979).

HERKLOTZ, INGO, '*Sepulcra*', e '*monumenta*' del Medioevo: Studi sull'arte sepolcrale in Italia* (Rome, 1985).

HERMANN-MASCARD, NICOLE, *Les Reliques des Saints, Formation coutumière d'un droit*, Societé d'Histoire du Droit, Collection d'Histoire Institutionelle et Sociale, 6 (Paris, 1975).

HERZNER, VOLKER, review of L. Puppi, *Il Trittico di Andrea Mantegna per la Basilica di San Zeno Maggiore in Verona* (Verona, 1972), in *Art Bulletin*, 56 (1974), 440–2.

HOFFMANN, H., 'Bruno di Segni', *Dizionario biografico degli italiani*, xiv (Rome, 1972), 644–7.

HOFMANN, HANS, *Die Heiligen Drei Könige* (Bonn, 1975).

HOURLIER, J., 'Guéranger', in *Dictionnaire de la spiritualité*, vi (Paris, 1967), cols. 1097–106.

HUBALA, E., *Giovanni Bellini: Madonna mit Kind, die Pala di San Giobbe* (Stuttgart, 1969).

HUECK, IRENE, 'Der Maler der Apostelszenen im Atrium von Alt-St. Peter', *Mitteilungen des Kunsthistorischen Institutes in Florenz*, 14 (1969), 115–44.

—— 'Simone attorno al 1320', in L. Bellosi (ed.), *Simone Martini: Atti del convegno* (Florence, 1988), 49–54.

HUMFREY, PETER, 'The Venetian Altarpiece of the Early Renaissance in the Light of Contemporary Business Practice', *Saggi e memorie di storia dell'arte*, 15 (1986), 65–82.

—— 'Il dipinto d'altare nel Quattrocento', in F. Zeri (ed.), *La pittura in Italia: il Quattrocento*, ii (Milan, 1987), 538–50.

—— 'Jacopo Bellini: Sts. Anthony Abbot and Bernardine of Siena', in D. Garstang (ed.), *Gothic to Renaissance: European Painting 1300–1600*, exhibition catalogue, Colnaghi (London and New York, 1988), 15–26.

—— and KEMP, MARTIN (eds.), *The Altarpiece in the Renaissance* (Cambridge, 1988).

—— and MACKENNEY, RICHARD, 'The Venetian Guilds as Patrons of Art in the Renaissance', *Burlington Magazine*, 128 (1986), 317–30.

INGENDAAY, MARTINA, 'Sienesische Altarbilder des sechzehnten Jahrhunderts', Ph.D. thesis (Bonn University, 1976).

INKAMP, W., *Das Kirchenbild Innocenz III. (1198–1216)*, Päpste und Papsttum, 22 (Stuttgart, 1983).

INNOCENT III, 'De Sacro Altaris Mysterio', in J. P. Migne, *Patrologia Latina*, 217, cols. 763–916.

IOHANNES VON HILDESHEIM, *Die Legende von den Heiligen Königen*, trans. E. Christern (Munich, 1963).

ISERMEYER, CHRISTIAN-ADOLF, 'Die Capella Vasari und der Hochaltar in der Pieve von Arezzo', *Festschrift für C. G. Heise* (Berlin, 1950), 137–53.

JAMES, MONTAGUE RHODES, *A Descriptive Catalogue of the Latin Manuscripts in the John Rylands Library at Manchester* (Manchester, 1921), 2 vols.

JESTAZ, BERTRAND, *La Chapelle Zen à Saint-Marc de Venise* (Stuttgart, 1986).

JOUNEL, P., *Le Culte des saints dans les Basiliques du Latran et du Vatican au douzième siècle*, Collection de l'école française de Rome, 26 (Rome, 1977).

KAEGI, WERNER, *Jacob Burckhardt eine Biographie* (Basle and Stuttgart, 1947–82), 7 vols.

KAFTAL, GEORGE, *The Iconography of the Saints in Tuscan Painting* (Florence, 1952).

KANTER, LAWRENCE B., 'Ugolino di Nerio: "Saint Anne and the Virgin"', *Annual Bulletin of the National Gallery of Canada*, 5, 1981–2 (1983), 9–28.

—— see POPE-HENNESSY, J.

KEMP, MARTIN, 'From *Mimesis* to *Fantasia*: The Quattrocento Vocabulary of Creation, Inspiration and Genius in the Visual Arts', *Viator*, 8 (1977), 348–98.

KING, A. A., *Liturgies of the Primatial Sees* (London, 1957).

KLAUSER, THEODOR, 'Henri Leclercq 1869–1945', *Jahrbuch für Antike und Christentum*, Ergänzungsband, 5 (Münster, 1977), 1–165.

KOUDELKA, V. J., '"Le Monasterium Tempuli" et la fondation dominicaine de San Sisto', *Archivum Fratrum Praedicatorum*, 31 (1961), 5–81.

KRAUTHEIMER, RICHARD, *Corpus Basilicarum Christianarum Romae*, i (Vatican City, 1937). Published in Monumenti di Antichità Christiana, Pontificio istituto di archeologia cristiana, 2nd ser., ii.

KREYTENBERG, GERT, 'Zum gotischen Grabmal des heiligen Bartolus von Tino di Camaino in der Augustinerkirche von San Gimignano', *Pantheon*, 46 (1988), 13–25.

LACLOTTE, MICHEL, and MOGNETTI, ELISABETH, *Inventaire des collections publiques françaises*, 21: *Peinture Italienne Avignon—Musée du Petit Palais* (Paris, 1976).

LADNER, G. B., *Die Papstbildnisse des Altertums und des Mittelalters*, ii, *von Innozenz II. zu Benedikt XI.*, Monumenti di Antichità Christiana, 2nd ser., pt. iv (Vatican City, 1970).

LALORE, C., 'Documents sur l'Abbaye de Notre-Dame-aux-Nonnains de Troyes', *Memoires de la Societé Académique d'Agriculture, des Sciences, Arts et Belles-Lettres du Département de l'Aube*, 38 (1874).

LANDINI, L. C., 'St. Francis of Assisi and the Clericalization of the Friars Minor', *Laurentianum*, 26 (1985), 160–73.

LANE, BARBARA, *The Altar and the Altarpiece: Sacramental Themes in Early Netherlandish Painting* (New York, 1984).

LAZZARINI, VITTORIO, 'Gli autori della cappella e dei monumenti Gattamelata al Santo', *Il Santo*, 4 (1932), 228–33.

LECLER, J., *Vienne*, Histoire des Conciles Œcuméniques, 8 (Paris, 1964).

LEONARDI, CLAUDIO, 'Sante Donne in Umbria tra secolo XIII e XIV', in *Sante e Beate Umbre fra il XIII e il XIV secolo, Mostra iconografica*, Foligno (Foligno, 1986), 49–60.

LIBERALI, G., 'Lo stato personale del clero diocesano nel secolo XVI', *Documentari sulla Riforma Cattolica pre e post-Tridentina a Treviso 1527–1577*, ix (Treviso, 1975).

—— 'La diocesi delle visite pastorali', *Documentari sulla Riforma Cattolica pre e post-Tridentina a Treviso 1527–1577*, vii, viii, pt. 1 (Treviso, 1976).

LIBERATI, A., 'Le prime manifestazioni di devozione a S. Bernardino dopo la sua morte da parte del comune di Siena', *Bullettino senese di storia patria*, NS 6 (1935), 143–61.

—— 'La vicenda della canonizzazione di S. Bernardino', *Bullettino di studi Bernardiniani*, 2 (1936), 91–124.

—— 'La Repubblica di Siena e San Giovanni da Capestrano', *Bullettino senese di storia patria*, NS 8 (1937), 375–402.

LIGHTBOWN, RONALD, *Mantegna* (Oxford, 1986).

LITTLE, A. G. (ed.), *Tractatus Fr. Thomae vulgo dicti de Eccleston. De Adventu Fratrum Minorum in Anglia*, Collection d'Études et de Documents, vii (Paris, 1909).

—— *Studies in English Franciscan History* (Ford Lectures for 1916; Publications of the University of Manchester, lxiii, Historical Series, xxix, 1917).

LONJON, MARIANNE, 'Quatre médaillons de Simone Martini: La reconstitution du retable de l'église San Francesco à Orvieto', *Revue du Louvre*, 33 (1983), 199–211.

LOSERIES, W., 'La pala di San Giorgio nella chiesa di San Cristoforo a Siena: Sano di Pietro o il "Maestro dell'Osservanza"?', *Prospettiva*, 49 (1987), 61–74.

LOTTO, LORENZO, *Il 'Libro di spese diverse' con l'aggiunte di lettere e d'altri documenti*, ed. P. Zampetti (Venice, 1969).

LOUGH, A. G., *The Influence of John Mason Neale* (London, 1962).

LOYRETTE, HENRI, 'Une source pour la reconstruction du polyptyque d'Ugolino da Siena à Santa Croce', *Paragone*, 343 (1978), 15–23.

LUCCHESI RAGNI, E., 'La vicenda del polittico', in Bruno Passamani (ed.), *Il polittico Averoldi di Tiziano restaurato* (Brescia, 1991), 89–110.

LUSINI, ALDO, 'Un rotulo Bernardiniano', *La Diana*, 4 (1929), 161–70.

LUSINI, V., [Mostra ducciana] 'Catalogo dei dipinti', *Rassegna d'arte senese*, 8 (1912), 105–54.

—— 'Per lo studio della vita e delle opere di Duccio di Buoninsegna', *Rassegna d'arte senese*, 9 (1913), 19–32.

McANDREW, JOHN, *Venetian Architecture of the Early Renaissance* (Cambridge, Mass., 1980).

MACCARINELLI, FRANCESCO, *Le glorie di Brescia, 1747–1751*, ed. C. Boselli (Brescia, 1959).

MACCARONE, M., 'Innocenzo III teologo dell'Eucaristia', *Divinitas*, 10 (1966), 362–412; repr. in M. Maccarone, 'Studi su Innocenzo III', *Italia Sacra*, 17 (Padua, 1971), 339–431.

MacKenny, R., see Humfrey, P.

Maginnis, H. B. J., 'The Thyssen-Bornemisza Ugolino', *Apollo*, 118, No. 257 (1983), 16–21.

—— 'Pietro Lorenzetti: A Chronology', *Art Bulletin*, 66 (1984), 183–211.

Mallory, Michael, 'An Altarpiece by Lippo Memmi Reconsidered', *Metropolitan Museum Journal*, 9 (1974), 187–202.

—— and Freuler, Gaudenz, 'Sano di Pietro's Bernardino Altar-piece for the Compagnia della Vergine in Siena', *Burlington Magazine*, 133 (1991), 186–92.

—— see Freuler, Gaudenz.

Mansi, J. D., *Sacrorum Conciliorum Nova et Amplissima Collectio*, xxii–xxv (Florence and Venice, 1759–98; repr. Graz, 1961).

Mantese, G., *Rosà, Note per una storia civica e religiosa della comunità nel contesto del territorio bassanese* (Vicenza, 1977).

—— *Bassano nella storia: la religiosità* (Bassano del Grappa, 1980).

—— and Reato, E., *S. Vito di Bassano* (Bassano del Grappa, 1973).

—— see Fasoli, G.

Marchini, Giuseppe, *Filippo Lippi* (Milan, 1975).

Marcucci, Luisa, *Gallerie Nazionali di Firenze: I dipinti toscani del secolo XIII°, scuole bizantine e russe* (Rome, 1965).

Mariani Canova, Giordana, 'Alle origini del Rinascimento padovano: Niccolò Pizolo', in *Da Giotto a Mantegna*, exhibition catalogue, Padua (Milan, 1974), 75–80.

Martindale, Andrew, *Simone Martini* (Oxford, 1988).

Marubbi, Mario, *Vincenzo Civerchio: Contributo alla cultura figurativa cremasca nel primo Cinquecento* (Milan, 1986).

Matthew Paris, in H. T. Riley (ed.), *Gesta Abbatum Monasterii Sancti Albani a Thomas Walsingham regnante Ricardo secundo ejusdem ecclesiae praecentore compilata*, i (London, 1867).

Meattini, Umberto, *Santi senesi* (Poggibonsi, [1974]).

Meersseman, Gilles Gerard, 'La Prédication dominicaine dans les congrégations mariales en Italie au XIII^e siècle', *Archivum Fratrum Praedicatorum*, 18 (1948), 131–61.

—— and Pacini, Gian Piero, *Ordo Fraternitatis: Confraternite e pietà dei laici nel medioevo* (Rome, 1977), 3 vols.

Meiss, Millard, 'A Dugento Altarpiece at Antwerp', *Burlington Magazine*, 71 (1937), 14–25.

Meoni, Noemi, 'Visite pastorali a Cortona nel Trecento', *Archivio storico italiano*, 129 (1971), 181–256.

Merkel, Ettore, 'Il *S. Crisogono* di San Trovaso, fiore tardivo di Michele Giambono', *Quaderni della Soprintendenza ai beni artistici e storici di Venezia*, 8 (1979), 33–44.

—— and Martinelli, E., 'Catalogo delle opere', in T. Pignatti (ed.), *Le Scuole di Venezia* (Milan, 1981), 33–49.

Mertensl, Phil, see *Musées Royaux*.

Milanesi, Gaetano, *Documenti per la storia dell'arte senese* (Siena, 1854–6), 3 vols.

Miller, Robert, 'Regesto dei documenti', in *I Campi e la cultura artistica cremonese del Cinquecento*, exhibition catalogue, Cremona (Milan, 1985), 456–81.

Mina, G. A., 'Studies in Marian Imagery: Servite Spirituality and the Art of Siena c.1261-c.1328', Ph.D. thesis (University of London, 1993).

MISCIATELLI, PIERO, 'Iconografia Bernardiniana', *La Diana*, 7 (1932), 247–52.

MÖLLER, E., 'Leonardo da Vincis Entwurf eines Madonnenbildes für S. Francesco in Brescia (1497)', *Repertorium für Kunstwissenschaft*, 35 (1912), 241–61.

MONACO, GIORGIO et al., *Museo di Villa Guinigi: La villa e le collezioni* (Lucca, 1968).

MOORMAN, J. R. H., *Medieval Franciscan Houses* (New York, 1983).

MORETTI, LINO, 'Di Leonardo Bellini, pittore e miniatore', *Paragone*, 99 (1958), 58–66.

MORONI, GAETANO, *Dizionario di erudizione storico-ecclesiastica*, xxxiv (Venice, 1845).

MOSCHINI MARCONI, SANDRA, *Le gallerie dell'Accademia di Venezia*, i, *Opere d'arte dei secoli XIV e XV* (Rome, 1955).

MULLER, NORMAN, see BEATSON, ELIZABETH.

MURA, ANNA MARIA, 'Il pubblico e la fruizione', in *Storia dell'arte italiana Einaudi*, pt. 1, vol. ii (*L'artista e il pubblico*) (Turin, 1979), 265–315.

MURARO, MICHELANGELO, 'Ritrovamento di un'opera di Jacopo Bassano', *Arte veneta*, 1 (1947), 287–8.

—— 'Gli affreschi di Jacopo e Francesco da Ponte a Cartigliano', *Arte veneta*, 6 (1952), 42–62.

—— 'The Jacopo Bassano Exhibition', *Burlington Magazine*, 99 (1957), 291–9.

—— *Pitture murali nel Veneto e tecnica dell'affresco*, exhibition catalogue, Venice (Venice, 1961).

—— *Paola da Venezia* (University Park, Pa., 1970).

—— *Pittura e società: Il libro dei conti e la bottega dei Bassano*, Lezioni di storia dell'arte, Università di Padova—Facoltà di Magistero, 1982–3 (Venice, Biblioteca Marciana, 367).

—— 'I conti in tasca a Lorenzo Lotto', *Notizie da Palazzo Albani* (*Omaggio a Lorenzo Lotto*, Atti del convegno, Jesi-Mogliano, 1981), 13 (1984), 144–64.

—— 'Pittura come mestiere', in C. Furlan (ed.), *Il Pordenone*, Atti del convegno internazionale di studio, Pordenone, 1984 (Pordenone, 1985), 217–19.

—— *Il Libro secondo di Francesco e Jacopo dal Ponte* (Bassano del Grappa, 1992).

Musées Royaux des Beaux-Arts de Belgique: Catalogue inventaire de la peinture ancienne (Brussels, 1984), ed. Phil Mertensl.

Museo di Villa Guinigi, Lucca: La villa e le collezioni (Lucca, 1968). See MONACO, G.

NAZ, R., see *Dictionnaire de Droit Canonique*.

NEALE, J. M., and WEBB, B. M., see DURANDUS.

NERI DI BICCI, *Le Ricordanze (10 marzo 1453–24 aprile 1475)*, ed. Bruno Santi (Pisa, 1976).

NIMS, M. F., *Poetria Nova of Geoffroy de Visnauf* (Toronto, 1967).

NORTON, CHRISTOPHER, DAVID PARK, and P. BINSKI, *Dominican Painting in East Anglia* (Woodbridge, 1987).

NOVA, ALESSANDRO, 'Girolamo Romanino: Introduzione a un catalogo ragionato', Ph.D. thesis (University of Milan, 1986).

NOVELLI, L., 'Costituzioni della chiesa bolognese emanate nel sinodo diocesano del 1310 al tempo di vescovo Uberto', *Studia Gratiana*, 8 (1972), 449–552.

NUSSBAUM, O., *Kloster, Priester-mönch und Privatmesse: Ihr Verhältnis im Westen, von Anfängen bis zum hohen Mittelalter (Theophaneia)*, Beiträge zur Religions und Kirchengeschichte der Altertums, xiv (Bonn, 1961).

NUTTALL, PAULA, '"Le tavele Sinte Barberen": New Documents for Cosimo Rosselli and Giuliano da Maiano', *Burlington Magazine*, 127, No. 987 (1985), 367–72.

OFFERHAUS, JOHANNES, see BORSOOK, EVE.

OFFNER, RICHARD, *A Corpus of Florentine Painting*, Section 3: *The Fourteenth Century*, iii (New York, 1930); v (New York, 1947).

ORLANDI, STEFANO, OP, *Necrologia di S. Maria Novella* (Florence, 1955).

PAATZ, WALTER and ELIZABETH, *Die Kirchen von Florenz*, ii, iii (Frankfurt, 1940, 1952).

PADOA RIZZO, A., 'La cappella della Compagnia di Santa Barbara della nazione tedesca alla Santissima Annunziata di Firenze nel secolo XV: Cosimo Rosselli e la sua impresa artistica', *Antichità viva*, 26, No. 3 (1987), 3–18.

PADOVANI, SERENA, 'Una tavola di Castiglione d'Orcia restaurata di recente', *Prospettiva*, 17 (1979), 82–8.

—— in *Mostra di opere d'arte restaurate nelle provincie di Siena e Grosseto II*, Siena (Genoa, 1981), 31–2.

PAGE, W. (ed.), *Victoria County History of Norfolk*, ii (London, 1906).

PAGLIA, FRANCESCO, *Il giardino della pittura*, ed. C. Boselli, supplemento ai 'Commentari dell'Ateneo di Brescia' (Brescia, 1967).

PALLUCCHINI, RODOLFO, *I Vivarini* (Venice, 1962).

—— *Tiziano* (Florence, 1969), 2 vols.

PANAZZA, GAETANO, *et al.*, *Mostra di Girolamo Romanino*, Brescia (Brescia, 1965).

—— see BOSELLI, C.

PARK, DAVID, see NORTON, C.

PASSMORE, T. H., *The Sacred Vestments* (London, 1899).

PAVONE, M. A., and PACELLI, V. (eds.), *Enciclopedia Bernardiniana* (Salerno, 1981), ii: *Iconografia*.

PÉANO, P., and SCHMITT, C., 'Die Ausbreitung der Franziskaner bis 1300', in H. Jedin, K. Latourette, and J. Martin (eds.), *Atlas zur Kirchengeschichte* (Freiburg im Bresgau, 1970), 42*–3*.

PEYER, HANS CONRAD, *Stadt und Stadtpatron im mittelalterlichen Italien*, Züricher Studien zur allgemeine Geschichte, 13 (Zürich, 1955).

POCKNEE, CYRIL E., *The Christian Altar* (London, 1963).

POLIDORO, VALERIO, *Le religiose memorie . . . della chiesa del glorioso S. Antonio confessore di Padova* (Venice, 1590).

PONTAL, O., *Les Statuts synodaux français du XIIIᵉ siècle*, i, ii (Paris, 1971, 1983).

—— *Les Statuts synodaux, typologie des sources du Moyen âge occidental*, fasc. 11 (Turnhout, 1975).

POPE-HENNESSY, JOHN, *Sassetta* (London, 1939).

—— *Heptaptych: Ugolino da Siena* (Williamstown, Mass., 1962).

—— *Fra Angelico*, 2nd edn. (London, 1974).

—— and KANTER, LAWRENCE, *The Robert Lehman Collection*, New York, The Metropolitan Museum of Art, i: *Italian Paintings* (Princeton, NJ, 1987).

POWICKE, F. M., and CHENEY, C. R. (eds.), *Councils and Synods with Other Documents Relating to the English Church, A.D. 1205–1313* (Oxford, 1964), 2 vols.

PRESTINI, R., *La chiesa di Sant' Alessandro in Brescia: storia ed arte* (Brescia, 1986).

PREVITALI, GIOVANNI, 'Introduzione ai problemi della bottega di Simone Martini', in L. Bellosi (ed.), *Simone Martini: Atti del convegno* (Florence, 1988), 151–66.

PROCACCI, UGO, 'La creduta tavola di Monteoliveto dipinta da Spinello Aretino', *Il Vasari*, 2 (1928), 35–48.

REICHERT, B. M., *Acta Capitulorum Generalium Ordinis Praedicatorum*, Monumenta Ordinis Fratrum Praedicatorum Historica, 3, 4 (Rome, 1898).

RICHTER, JEAN PAUL (ed.), *The Literary Works of Leonardo da Vinci*, 3rd edn. (London, 1970), 2 vols.

RIDDERBOS, BERNHARD, *Saint and Symbol: Images of Saint Jerome in Early Italian Art* (Groningen, 1984).

RIDOLFI, CARLO, *Le maraviglie dell'arte ovvero le vite degli illustri pittori veneti e dello stato* (1648), ed. D. Von Hadeln, i (Berlin, 1914).

RIEDL, PETER ANSELM, and SEIDEL, MAX, *Die Kirchen von Siena*, i (Munich, 1985).

RICE, E. F., Jr., *St. Jerome in the Renaissance* (Baltimore, 1985).

RITZLER, REMIGIO, 'Gli Atti della visita apostolica del 1581 ai conventi di S. Maria Gloriosa e di S. Nicoletto dei Frati Minori Conventuali in Venezia', *Miscellanea Francescana*, 69 (1969), 153–86.

ROBERTSON, GILES, *Giovanni Bellini* (Oxford, 1968).

ROMANO, GIOVANNI, 'Gottardo Scotto', in *Zenale e Leonardo: tradizione e rinnovamento della pittura lombarda*, exhibition catalogue, Milan (Milan, 1982), 80–4.

ROSAND, DAVID, 'Titian in the Frari', *Art Bulletin*, 53 (1971), 196–213.

—— *Painting in Cinquecento Venice: Titian, Veronese, Tintoretto* (New Haven, Conn., and London, 1982).

ROTH, E., 'Cardinal Richard Annibaldi: First Protector of the Augustinian Order (1243–1276)', *Augustiniana*, 2 (1952), 26–60, 108–49, 230–47; 3 (1953), 21–34, 283–313; 4 (1954), 5–24.

ROWELL, G., *The Vision Glorious* (Oxford, 1983).

ROWLANDS, ELIOT W., 'Fillippo Lippi's Stay in Padua and its Impact on His Art', Ph.D. thesis, Rutgers University, New Brunswick, NJ, 1983 (University Microfilms, Ann Arbor, Mich., 1984).

RUDT DE COLLENBERG, WIPERTUS, 'État et origine du haut clergé de Chypre avant le grand schisme d'après les registres des papes du XIIIᵉ et du XIVᵉ siècle', *Mélanges de l'école française de Rome*, 91/3 (1979), i, 197–332.

RUSSO, DANIEL, *Saint Jérôme en Italie* (Rome, 1987).

SACCHETTI, FRANCO, *Opere*, ed. A. Bortolenghi (Milan, 1958).

SALIMBENE DE ADAM, *La Cronica*, ed. F. Bernini, ii (Bari, 1942).

Sante e Beate Umbre tra il XIII e il XIV secolo, Mostra Iconografica (Foligno, 1986).

SANTI, BRUNO, *Galleria Nazionale dell'Umbria: dipinti, sculture e oggetti d'arte di età romanica e gotica* (Rome, 1969).

—— 'Ambrogio Lorenzetti: Madonna in Maestà', in *Mostra di opera d'arte restaurate nelle provincie di Siena e Grosseto I*, Siena, 1979 (Genoa, 1979), 60–6.

SARTORI, ANTONIO, *La chiesa di San Lorenzo in Vicenza* (Vicenza, 1953).

—— 'La cappella del Sacramento al Santo decorata da Ludovico Pogliaghi', *Il Santo*, 10 (1970), 182–204.

SAUER, JOSEPH, *Symbolik des Kirchengebäudes und seiner Ausstattung in der Auffassung des Mittelalters* (Freiburg im Breisgau, 1924).

SCAPECCHI, P., see ALESSI, C.

SCHANNAT, J. C., and HARTZHEIM, J., *Concilia Germaniae . . .*, iii–iv (Cologne, 1759–60).

SCHMITT, O. (ed.), *Reallexikon zur deutschen Kunstgeschichte*, i (Stuttgart, 1937), 412–19, 529–64.

SCHULZ, ANNE MARKHAM, *Antonio Rizzo, Sculptor and Architect* (Princeton, NJ, 1983).

SCHULZ, H. J., *The Byzantine Liturgy* (New York, 1986).

SEIDEL MAX, 'Die Fresken des Ambrogio Lorenzetti in S. Agostino', *Mitteilungen des Kunsthistorischen Institutes in Florenz*, 22 (1978), 185–252.

—— 'Die Fresken des Francesco di Giorgio in S. Agostino in Siena', *Mitteilungen des Kunsthistorischen Institutes in Florenz*, 23 (1979), 3–108.

—— 'Il Beato Agostino Novello e quattro suoi miracoli', in A. Bagnoli and L. Bellosi (eds.), *Simone Martini e 'chompagni'*, exhibition catalogue, Siena (Florence, 1985), 56–72.

—— 'Ikonographie und Historiographie, "Conversatio Angelorum in Silvis", Eremiten-Bilder von Simone Martini und Pietro Lorenzetti', *Städel Jahrbuch*, NS 10 (1985), 77–142.

—— 'Condizionamento iconografico e scelta semantica: Simone Martini e la tavola del beato Agostino Novello', in L. Bellosi (ed.), *Simone Martini: Atti del convegno* (Florence, 1988), 75–80.

—— see RIEDL, P. A.

SEYMOUR, CHARLES, Jr., *Early Italian Painting in the Yale University Art Gallery* (New Haven, Conn., and London, 1970).

SHEARMAN, JOHN, *Andrea del Sarto* (Oxford, 1965), 2 vols.

—— *Pontormo's Altarpiece in S. Felicita* (Newcastle-upon-Tyne, 1971).

SICARDO DA CREMONA, *Mitrale*, in J. P. Migne (ed.), *Patrologia Latina*, 213, cols. 13–434.

SIGNORI, F., *Campese e il monastero di Santa Croce* (Bassano del Grappa, 1984).

—— *Storia di Pove e dei Povesi* (Bassano del Grappa, 1985).

—— see ALBERTON VINCO DA SESSO.

Simone Martini: Atti del convegno (Florence, 1988) see BELLOSI, L. (ed.).

SINDING-LARSEN, S., *Christ in the Council Hall: Studies in the Religious Iconography of the Venetian Republic*, Acta ad archaeologiam pertinentia, 5 (Rome, 1974).

SPECK, P., 'Die *ΕΝΔΥΤΗ*. Literarische Quellen zur Bekleidung des Altars in der byzantinischen Kirche', *Jahrbuch der Österreichischen Byzantinischen Gesellschaft*, 15 (1966), 323–75.

STEINHOFF, J., see BEATSON, ELIZABETH.

STUBBLEBINE, JAMES, *Guido da Siena* (Princeton, NJ, 1964).

—— *Duccio di Buoninsegna and His School* (Princeton, NJ, 1979), 2 vols.

SYDOW, ECKART VON, *Die Entwicklung des figuralen Schmucks der christlichen Altar-Antependia und Retabula bis zum 14. Jahrhundert*, Zur Kunstgeschichte des Auslands, 97 (Strasburg, 1912).

TANFANI CENTOFANTI, L., *Notizie di artisti tratte dai documenti pisani* (Pisa, 1897)

TESTI, LAUDEDEO, *La storia della pittura veneziana*, ii (Bergamo, 1915).

TESTINI, P., *San Saba*, Le Chiese di Roma Illustrate, 68 (Rome, 1961).

TIRABOSCHI, H. (Girolamo), *Vetera Humiliatorum Monumenta*, iii (Milan, 1768).

TOMMASEO, N., and BELLINI, B., *Nuovo dizionario della lingua Italiana*, vol. i, pt. 2 (Turin, 1865).

TOOK, J. F., *'L'etterno piacer': Aesthetic Ideas in Dante* (Oxford, 1984).

TORRITI, PIETRO, *La Pinacoteca Nazionale di Siena: I dipinti dal XII al XV secolo*, i (Genoa, 1977; 2nd edn. Genoa, 1980).

TREXLER, RICHARD, C., *Synodal Law in Florence and Fiesole, 1306–1518*, Studi e testi, 268 (Vatican City, 1971).

—— *Public Life in Renaissance Florence* (New York, 1980).

TRIMPI, E., 'Matteo di Giovanni: Documents and a Critical Catalogue of his Panel Paintings', Ph.D. thesis University of Michigan, 1987 (University Microfilms International, Ann Arbor, Mich.).

TRÜBNER, J., *Die stilistische Entwicklung der Tafelbilder des Sano di Pietro (1405–1481)* (Strasburg, 1925).

TURNER, NICHOLAS, *Florentine Drawings of the Sixteenth Century*, exhibition catalogue, British Museum (London, 1986).

Umbri e toscani tra due e trecento, exhibition catalogue, see Bellosi, L.

VALCANOVER, FRANCESCO, 'Recupero di un dipinto di Francesco Vecellio', *Arte veneta*, 7 (1953), 166.

VAN DIJK, S. J. P., and HAZELDEN WALKER, J., *The Origin of the Modern Roman Liturgy: The Liturgy of the Papal Court and the Franciscan Order in the Thirteenth Century* (London, 1960).

—— *The Sources of the Modern Roman Liturgy: The Ordinal by Haymo of Faversham and related Documents (1243–1307),* Studia et Documenta Franciscana, 1 (Leiden, 1963).

VAN LUIJK, B., *Gli eremiti Neri nel Dugento con particolare riguardo al territorio Pisano e Toscano: Origine, sviluppo ed unione* (Pisa, 1968).

—— *Le Monde augustinien du XIIIᵉ au XIVᵉ siècle* (Assen, 1972).

VAN OS, HENK W., '"Text and Image": The Case of a Jewish Prophet in Carmelite Disguise', in M. Gosman and H. van Os (eds.), *Non nova sed nove: Mélanges de civilisation médievale, dédiés à Willem Noomen* (Groningen, 1984), 163–8.

—— *Sienese Altarpieces 1215–1460: Form, Content, Function* (Groningen, 1984, 1990), 2 vols.

—— 'The Earliest Altarpieces of St. Francis', *I Valori Francescani*. Simposio in occasione dell'VIII Centenario della nascita di S. Francesco (Amsterdam, 1985), 7–16.

VARCHI, BENEDETTO, 'Libro della Beltà e Grazia', in P. Barocchi (ed.), *Scritti d'arte del Cinquecento*, ii (Milan and Naples, 1973), 1671–81.

—— 'Lezzione nella quale si disputa della Maggioranza delle arti e qual sia più nobile, la scultura o la pittura', in P. Barocchi (ed.), *Trattati d'arte del Cinquecento fra Manierismo e Controriforma*, i (Bari, 1960), 1–82.

VASARI, GIORGIO, *Le vite de' più eccellenti pittori scultori ed architettori*, ed. G. Milanesi, iii (Florence, 1878).

—— *Le vite de' più eccellenti pittori scultori e architettori*, ed. P. della Pergola, L. Grassi, and G. Previtali, ii, iii, iv, vi, vii, viii (Milan, 1962–6).

—— *Le vite de più eccellenti pittori, scultori e architettori nelle redazioni del 1550 e 1568*, ed. R. Bettarini and P. Barocchi, ii, iv, vi (Florence, 1967, 1976, 1987).

VERTOVA, LUISA, 'What Goes With What?', *Burlington Magazine*, 109 (1967), 668–72.

VESPASIANO DA BISTICCI, *Le vite*, ed. A. Greco (Florence, 1976), 2 vols.

VOGEL, CYRILLE, 'L'Œuvre liturgique de Mgr. M. Andrieu', *Revue des sciences religieuses*, 37 (1957), 7–19.

—— '*Versus ad Orientem*. L'Orientation dans les "ordines romain" du haut Moyen Âge', *Studi medievali*, ser. 3/1 (1960), 447–69.

—— *Introduction aux sources de l'histoire du culte chrétien au moyen-âge*, Biblioteca degli Studi medievali, 1 (Spoleto, 1966; anastatic repr. 1975).

VOLPE, CARLO, 'Ambrogio Lorenzetti e le congiunzioni fiorentine-senesi nel quarto decennio del trecento', *Paragone*, 13 (1951), 40–52.

WAGNER-RIEGER, RENATE, 'Zur Typologie italienischer Bettelordenskirchen', *Römische Historische Mitteilungen*, 2 (1957), 266–98.

WAINWRIGHT, VALERIE, 'Andrea Vanni and Bartolo di Fredi', Ph.D. thesis (University College, London, 1978).

WALEY, DANIEL, *The Papal State in the Thirteenth Century* (London, 1961).

WAZBINSKI, ZYGMUNT, '*L'Annunciazione della Vergine* nella chiesa della SS. Annunziata a Firenze: Un contributo al moderno culto dei quadri', in A. Morrogh *et al.* (eds.), *Renaissance Studies in Honor of Craig Hugh Smyth*, ii (Florence, 1985), 533–53.

WEBB, B. M., see NEALE, J. M.

WEBB, C. C. J., 'Benjamin Webb', *Church Quarterly Review*, 75 (1913), 329–48.

WEBB, G., *The Liturgical Altar* (London, 1935).

WEITZMANN, K., 'Crusader Icons and Maniera Greca', in Irmgard Hutter (ed.), *Byzanz und der Westen*, Österreichische Akademie der Wissenschaften Philosophisch-Historische Klasse, Sitzungberichte, 432 (Vienna, 1984), 143–70.

WHITE, JOHN, 'Donatello's High Altar in the Santo at Padua', *Art Bulletin*, 51 (1969), 1–14, 119–41, 412.

WHITE, J. F., *The Cambridge Movement: The Ecclesiologists and the Gothic Revival* (Cambridge, 1962).

WILSON, STEPHEN (ed.), *Saints and Their Cults* (Cambridge, 1983).

WOLTERS, WOLFGANG, *La scultura veneziana gotica 1300–1460* (Venice, 1976), 2 vols.

WOOD-LEGH, K. L., *Perpetual Chantries in Britain* (Cambridge, 1965).

WORDSWORTH, C., *Notes on Medieval Services in England* (London, 1898).

WORMALD, FRANCIS, 'Some Pictures of the Mass in an English XIVth Century Manuscript', *Walpole Society*, 41 (1966–8), 39–45.

ZAMPETTI, PIETRO (ed.), *Jacopo Bassano*, exhibition catalogue, Venice (Venice 1957).

Die Zeit der Staufer, i (Stuttgart, 1977), see HAUSSHERR.

ZERI, FEDERICO, *Italian Paintings: The Florentine School* (A Catalogue of the Collection of the Metropolitan Museum of Art, New York, 1971).

—— *Diario di lavoro*, ii (Turin, 1976).

—— 'Quattro tempere di Jacopo Bellini', in id. *Quaderni di Emblema*, i (Bergamo, 1971), 42–9.

Index